FROM A PHOTOGRAPH

FROM A PHOTOGRAPH

Authenticity, Science, and the Periodical Press, 1870–1890

Geoffrey Belknap
University of Leicester, UK

BLOOMSBURY VISUAL ARTS
LONDON · NEW YORK · OXFORD · NEW DELHI · SYDNEY

BLOOMSBURY VISUAL ARTS
Bloomsbury Publishing Plc
50 Bedford Square, London, WC1B 3DP, UK
1385 Broadway, New York, NY 10018, USA

BLOOMSBURY, BLOOMSBURY VISUAL ARTS and the Diana logo
are trademarks of Bloomsbury Publishing Plc

First published in Great Britain 2016
Paperback edition first published 2020

Cover design: Louise Dugdale
Cover image from University of Leicester Library

A catalogue record for this book is available from the British Library.

Library of Congress Cataloging-in-Publication Data
Names: Belknap, Geoffrey, author.
Title: From a photograph : authenticity, science and the periodical press,
1870-1890 / by Geoffrey Belknap.
Description: London, UK ; New York, NY, USA : Bloomsbury Academic, an imprint
of Bloomsbury Publishing Plc, 2016. | Includes bibliographical references.
Identifiers: LCCN 2016025274| ISBN 9781474266727
(HB : alk. paper) | ISBN 9781474266758 (ePub) | ISBN 9781474266734 (ePDF)
Subjects: LCSH: Photojournalism–History–19th century. | Journalism,
Pictorial–History–19th century. | Phototographs–Publishing–History–1
9th century. | Photography–Scientific applications–History–19th century. |
Popular culture–Great Britain–History–19th century. | Popular
culture–United States–History–19th century.
Classification: LCC TR820 .B39 2016 | DDC 070.4/9–dc23 LC record available at
https://lccn.loc.gov/2016025274

ISBN: HB: 978-1-4742-6672-7
PB: 978-1-3501-4133-9
ePDF: 978-1-4742-6673-4
eBook: 978-1-4742-6675-8

Typeset by Integra Software Services Pvt. Ltd.

To find out more about our authors and books visit
www.bloomsbury.com and sign up for our newsletters.

CONTENTS

LIST OF ILLUSTRATIONS

LIST OF FIGURES

ACKNOWLEDGMENTS

This book has been shaped and reshaped over a number of years and through the guidance and support of too many people to name—but I will make an attempt to name a few. My interest in history of science, and the germ of this book, was first sparked when I was a student in Bernard Lightman's MA course on Victorian science at York University in 2006, and he has been a guiding influence since then. The bulk of the research was developed while I was a PhD student at Cambridge University where I had the great fortune of being supervised by Simon Schaffer. Without his generosity and spirit of giving time, dedication, and support for my work this book would have looked very different. I would also like to thank my advisor, Jim Secord, whose advice and direction have been invaluable throughout my career. Since completing my PhD I have had the opportunity to work on projects which have given me the time to develop my research and have brought me into contact with scholars who have shaped this book through their feedback and support. In particular I would like to thank Janet Browne and Gowan Dawson for their invaluable help and support while I was working as a postdoc with them.

I am very grateful to the funding bodies that have allowed me to pursue this project. They are the Overseas Research Scholarship, the Cambridge Commonwealth Trust, the Rausing and Williamson Fund of the Department of History and Philosophy of Science, and the University of Cambridge and Corpus Christi College, Cambridge. I have also been given time while working as a postdoc on two funded projects, so my thanks go to the National Science Foundation and the Arts and Humanities Research Council for their help and support. Additionally, I am very thankful to the British Society for the History of Science for the research grant which helped to cover image rights and reproduction costs for this book.

I am particularly thankful for the advice and helpful criticism of a number of scholars in the history of photography. Kelley Wilder—through her scholarship and friendship—has played a crucial role in making this the best book it could be. Similarly, Elizabeth Edwards and Jennifer Tucker have tirelessly given guidance throughout this entire process of writing, research, and publication. I am also very thankful to anonymous reviewers who have all given sharp and insightful

help in making this a stronger book. Other scholars and friends who have read chapters or helped shape my thinking in some way include Chitra Ramalingam, Mirjam Brusius, Nick Hopwood, Nick Jardine, and James Mussell. Chapter 3 was researched and written while I was an intern at the Science Museum, London, in the summer of 2009, and Chapter 5 while an intern at the National Maritime Museum, Greenwich, in the summer of 2008. Peter Morris and John Liffen at the Science Museum and Gloria Clifton, Richard Dunn, and Rebekah Higgitt at the National Maritime Museum were very helpful with my research during these internships. In addition, the participants of the Scientific Images Seminar in the Cambridge History and Philosophy of Science Department have created a great atmosphere to discuss my work and the work of image history more broadly. The high-quality images that appear throughout this book are reproduced largely with the help of Simon Dixon of the University of Leicester Library, Andrea Hart of the Natural History Museum, London, Grant Young of Cambridge University Library, Allison Akbay of the Iris & B. Gerald Cantor Center for Visual Arts at Stanford University, and Emma Lefley of the National Maritime Museum. My thanks also go to my editors at Bloomsbury, Davida Forbes and Molly Beck, who have been very supportive throughout the entire process.

Many thanks also go to people whose friendship has supported me intellectually and personally throughout the writing of this book. In particular Efram Sera-Shriar, Nanna Katrine Lüders Kaalund, Susannah Gibson, Caitlin Wylie, Katy Barrett, David Feller, Allison Ksiazkiewicz, Katie Taylor, Andrew Inkpen, Dani Hallet, and Jonathon and Amanda Kocz were extremely helpful in making my book actually readable. My family, Shane and Inga Belknap, Andrew Belknap, Carrie Rickwood and my niece and nephew Naomi and Alex Belknap, and my adopted Coskeran family—Margaret, Thomas, Louise, Sarah, and Siobhán—have all been indescribably supportive over my, far too many, years of education. And finally to my partner, Helen Coskeran. This book and my life would be much poorer if it was not for her.

My thanks, though incomparable to the actual support given, go to all of the above and anyone else I have missed out.

INTRODUCTION

The crude realism of the picture, possibly harmless enough in its effect upon others, overpowered and sickened her. By a curious fascination she would look at it again and again, till every line of the engraver's performance seemed really a transcript from what had happened before his eyes.[1]

Could Lady Vivette Constantine, the protagonist in Thomas Hardy's 1882 novel *Two on a Tower*, trust the image before her eyes? Confronted by an engraving of her estranged husband's suicide in Africa, in an illustrated newspaper, she was shocked by the reproduction. But it was not just the content of the image that made it visceral for her, it was the "engraver's performance," transforming the original image made in situ at the scene of the horror into a "transcript" of the event. This language of trust and authenticity was, for Hardy, a narrative device—an object to be imagined by his readers. In other words there was no picture for the reader to see. Yet, what Hardy doesn't explain is what kind of image this fictive engraving was made *from*. Considering the limitations of making images while traveling through rugged terrain in the late Victorian period, a reader might assume that it had been made from a drawing. However, the description given fits much more closely the definition of a photograph—especially one that had been engraved and reproduced in a periodical. The image was simultaneously a "performance" and "transcript" that provided Lady Constantine with a true and authentic representation of the scene being described.

The fact that Hardy uses language that compares the interpretation of an image to the reading of a newspaper is no coincidence: it is in the periodical press that a Victorian reader would have encountered Hardy's novel in the first place. To read an illustrated paper was also to be exposed to photography; by the 1880s photography was increasingly becoming the dominant form of image reproduction in the periodical press. As such, Hardy's description takes on a new meaning—one that requires the reader to move beyond the novel itself—and draw on his or her

knowledge of the visual and textual context in which it is being read. In other words, it requires that they are a reader of illustrated periodicals.

Two on a Tower is not a story about photography, but one of love and astronomy, which sets its scene in and around nineteenth-century science.[2] First published as a serial novel in the *Atlantic Monthly* magazine between May and December 1882, this astronomical fiction necessitated an audience of active readers who read both the contexts and contents of science in the periodical press and were able to transpose this into their reading and comprehension of fiction.[3]

The publication of *Two on a Tower* was timed to coincide with the spectacularly illustrated coverage of one of the largest national scientific expeditions of the nineteenth century—the 1882 Transit of Venus expedition. The Transit of Venus, which is the point at which Venus moves across the disc of the Sun, happens twice a century. For Victorians, Venus transited the Sun first in 1874 and then again eight years later in December 1882—the very month in which Hardy's final instalment of *Two on a Tower* would appear in the *Atlantic Monthly*. The Transit of Venus was an essential point of interest in institutional and astronomical science in the late nineteenth century and gave rise to questions surrounding the limitations of visual observation. The reproduction of both the narratives of Transit observations in England and the subsequent images that came from those observations were legitimized through their reproduction in the periodical press. Periodicals like the *Illustrated London News* (*ILN*) and the *Graphic* had a history of reproducing engravings of the Transit as well as the preparations, instruments, and stations of observations (Illustrations I.1 and I.2). The question surrounding these images became: could a reader trust the images before them when they were depicting phenomena that were either very far away or impossible to see by the unaided eye?

Two on a Tower was a story that was told first through the periodical press, and the reading of this story—similar to the reading of a photograph—was informed by the space in which it was printed. This is a book about the reproduction of photographs in one such space, the Victorian periodical, and how they became valued as an imaging technology that could be trusted. To read a photograph in any context was never a straightforward act of seeing and ascribing value. Photographs are invested with multiple layers of meaning—meaning produced by the author, agent of reproduction, and the reader themselves.[4] For the nineteenth-century illustrated periodical press, the use of photographic objects, the explication of photographic evidence, and the explanation of the development of photographic and print technologies were intimately connected. To read a photograph in the periodical, and give it a value as either authentic or inauthentic, was thus a process of disentangling layers of reproduction. The photograph and the nineteenth-century periodical are, in this way, intertwined histories, where narratives about the production of an image; the production of the periodical; and technological,

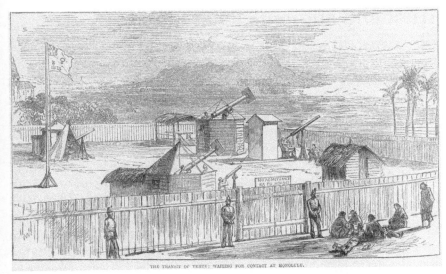

ILLUSTRATION I.1 Wood engraving—"The Transit of Venus: Waiting for Contact at Honolulu," *Illustrated London News*, 66, no. 1850 (January 24, 1875): 72. Reproduced by permission of the Cambridge University Library.

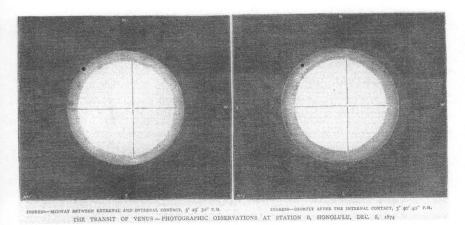

ILLUSTRATION I.2 Wood engraving—"The Transit of Venus—Photographic Observations at Station B. Honolulu, Dec. 8, 1874," *Graphic*, 11, no. 270 (January 30, 1875): 116. Reproduced by permission of the University of Leicester Library.

scientific, and popular meanings of the photographic images in print were affected by factors such as who put the image there, who made it, and who was viewing it. This story is one that involved the mechanical, scientific, and visual as much as it involved textual and narrative meanings of the photograph.

Trust and authenticity in the nineteenth-century periodical press

Who is this reader, and how in particular did a photograph come to be evaluated as trustworthy or not? There are two central concepts here, which, in teasing apart their intended meaning for the text and images in this book, will clarify what it meant for a Victorian reader: first the notion of authenticity—or what constitutes an authentic photograph—and second what/who constitutes the "public."

Periodicals and photographs do not necessarily share the same audience, or the same values of authenticity, and yet there are significant crossovers when considering them as mediums and technologies of communications. Lynda Nead has pointed out that a medium—such as the periodical or the photograph—is always concerned with conveying meaning through images and that these two technologies are both makers and intermediaries of visual information.[5] When a photograph is reproduced in a periodical, its intended original meaning or value gets changed. This change depends on how the periodical talks about the photograph as authentic and where the image is placed within the broader visual context of the issue or journal itself. Yet this sense of a photograph being trustworthy simultaneously relies on a broader culture of authenticity outside the particular context of media production. Lynn Voskuil, in her study of Victorian performance, argues that for nineteenth-century culture, the theatrical and the authentic were complementary aims and that authenticity, for Victorians, was a "habit of the mind."[6] The same goes for the photograph: the representational, the technological, and the narrative performance all worked together to give photography a value of showing the real. Alan Thomas, in his early article on photography, authenticity, and Victorian audiences, points out that photography has a "power of the actual," invested in its technological origins, while it simultaneously borrows from pictorial conventions which give it a secondary label of the authentic.[7]

Thomas also argues that the large majority of both producers and consumers of photographs in the latter half of the nineteenth century were part of that amorphous group, the middle class.[8] This was, as Richard Altick has reminded us, the age of the mass consumption of printed media, and the periodicals that form this investigation were capturing this market on an unprecedented scale.[9] The range of periodicals that form the basis of the analysis that follows, while not uniform, often overlapped. A reader of *Nature* was also likely to be a reader of the *ILN*; they each offered a different type of information about the Victorian world, and to this end, presented their images with different layers of trust. The question of trusting these various forms of information was encapsulated in processes and values placed on the photographic image in the periodical. The placement of this trust was invested with technological verisimilitude and with the textual systems that describe and evaluate the image. The underlying assumption of this book is

that the readers of the periodicals reflect the makeup, on a larger scale, of the writers and contributors to the periodical themselves. Thus the evaluation of the meaning of a photographic image will be taken from what the authors and makers of the images and texts say about them—so, what their intended meanings were— rather than their ultimate meanings.

This analysis will look closely at a set of events that occurred in the periodical press and will necessarily circulate around a group of readers, authors, and photographers. Norman Lockyer, Richard Anthony Proctor, Warren De la Rue, Alfred Brothers, Jules Janssen, Eadweard Muybridge, Étienne-Jules Marey, Gaston Tissandier, and Henry Baden Pritchard wrote about, produced, editorialized, and critiqued the use of photography in both scientific and nonscientific genres of periodical print throughout the 1870s and 1880s. This book is not, however, a prosopography. Rather, these individuals highlight the diverse forms in which photography was used in the latter half of the nineteenth century: some of them were ardent professionalizers of science, some advocates of amateur science, some editors, some popularizers, some photographers, and some all of the above. What is particularly compelling about these individuals is that when they either spoke of photography or used photographic images in a periodical, they did so in a way that placed a value on photography as a technology for authenticating their experiments or points of view. Through this association of authenticity they produced a meaning for the way in which the photographic image should be read in the periodical press—as a complicated, imperfect tool for communicating information, objects, and places.

Yet this imperfect tool is a particularly useful lens for investigating the value and meaning of photographic images in both scientific and popular Victorian culture. The periodical press had been growing widely throughout the nineteenth century, with 125,000 journals published by 1900.[10] Photography and the illustrated periodical press grew up together and reached an unprecedented point of technological development in the 1870s. There was already a strong culture of amateur and professional photography, thousands of photographic studios around England, and significant scientific uses of photography by the 1870s.[11] The 1870s thus serve as a particularly valuable period in which the technologies of photography and the print press align in a way that offers a unique perspective on the use of images in the periodical press. This is in part because the decade between 1869 and 1879 saw the formation of some of the most influential illustrated periodicals, such as the *Graphic* and *Nature*. This was a period before photographic images could be reproduced cost-effectively without the aid of an engraver. It is also the period during which photography was undergoing considerable change with the development of the Woodbury printing process (1864), the development of gelatin dry prints (1868), and the invention of what would be called "instantaneous photographs" (1872). The 1870s, much more than the 1880s, was a period of change and transition for both printing and visual

technologies.[12] The main focus of the case studies in this book is therefore to tease apart the application of photography throughout the 1870s. While there are points at which the analysis will move into the 1880s, the examples in these cases will act as boundary objects. An examination of the use of photography in a print space that necessitated a form of reproductive mediation, such as engraving, allows us to ascertain the value and reliability of the photographic image and the particular role of the periodical in communicating this trust.

The fact that technologies of print reproduction were essential to the photographic image's level of credibility compels a close analysis of the technical aspects of photographic and print production. The value of this type of close reading is to draw out the forms in which print and images become socially constructed and thereby dissolve assumed disparities between the two mediums of communication. The focus of the analysis in the following chapters will read photographic images and periodical print as sometimes complementary and sometimes conflicting forms of media. By looking at what was said about photographs, what they were made to say, and where they were placed in the periodical, we can move beyond the traditional historiography of photography that focuses either on the technology of photography or the objects that photographs represent.[13] An analysis that looks at photography as both a tool and a topic brings out the very reflexive nature through which photography was used and invoked in the periodical press.

Like the photographic image itself, the analysis in this book is not static but moves between and makes its meaning through the perspective of a set of historiographical lenses. Borrowing the tools forwarded in periodical history, history of science and art, and photographic history, the case studies in this book triangulate a new methodology for the reproduced photographic image.

The nineteenth-century periodical press as both a source material and lens through which to understand the communication of science has recently gained considerable attention.[14] In particular the three books that came out of the project on science in the Victorian periodical, or SciPer, have established that the periodical was a central site for the production and communication of Victorian science.[15] All three books bring forward the main methodological concerns when addressing periodicals as a source base. In particular, they show how they act as the main site of scientific controversy; as a key medium for communicating and popularizing science; and as a central space for legitimizing scientific discovery, professionalization, and discipline formation. In this way they show how the Victorian periodical was one of the key locations for both the production and reproduction of Victorian science.

In terms of the analysis of the visual content of the periodical press, Peter Sinnema in his investigation of the *ILN* has reinforced that, when examining the visual content of a periodical, it is essential to address the interplay between the image and the text.[16] James Mussell, on the other hand, has pointed to the intimate

relationship between space and time and the physical makeup of the periodical and argues that the essential character of the periodical as a print medium is its immutability across space and its mutability across time.[17] These two approaches to periodical history, combined with the methodological frames of analyses articulated by the SciPer project, are crucial to understanding the way in which photographs were mobilized in the popular and scientific periodical presses. When reproduced in the periodical press, the photograph became an object that could not escape its association with space and time. And it was this very association between these two spatial and temporal mediums—the photograph and the periodical—that gave the images credibility. This credibility, though not able to produce a complete sense of visual authenticity, was essential to the way in which journal editors used photographic images. In no other print space were the image and print tied together so fundamentally.

While the SciPer project has forwarded and fleshed out some of the central questions for addressing the ways in which information (specifically scientific information) was made and communicated through the periodical, James Secord has suggested a broader notion of the way information travels. Through his discussion of "knowledge in transit," Secord argues that we need to shift toward "thinking always about every text, image, action, and object as the trace of an act of communication, with receivers, producers, and modes and conventions of transmission. It means eradicating the distinction between the making and the communicating of knowledge."[18] The reproduction of photographic images in the late Victorian periodical press is a form of knowledge transmission that was tied to the material object of the periodical itself. We cannot separate out the image from the text but instead need to look at how the photographic object in the periodical operated alongside and with the technological, textual, and epistemological structure of the periodical itself.

The history of visual epistemology has equally been gaining much attention in the history of science. Historians of art and science have seen the development of photography as a point of fundamental epistemological change in the way in which the world was visualized. Jonathan Crary, in his classic work on the *Techniques of the Observer*, argues (with photography as a later example) that the 1820s and 1830s saw the development of a "modern observer" for whom the object or referent in the image no longer referred to just itself but was enmeshed in a web of transmission and exchange.[19] Comparatively, John Tagg, in his study of nineteenth-century photography, argues that changes in technologies of observation were coupled with social and institutional changes of record-keeping and observation that emerged in the latter half of the nineteenth century.[20] More recently, Daston and Galison have argued that scientists in the late nineteenth century strived for a type of objectivity, manifested through the technology of photography, which they label "mechanical objectivity."[21] These epistemological shifts—while useful generally when thinking about nineteenth-century

photography, particularly with regard to the ways in which photographs operate as social and cultural objects—do not tell the entire story. When we think about the way in which the periodical press used photographs and wrote narratives around photographic technologies, there was not a singular notion of mechanical objectivity, or an explicit idea of a new or modern observer. Rather, the genre of the periodical, the intent and credibility of the individual author, and the specific object being discussed or visualized operated simultaneously (sometimes together and sometimes in opposition) to create the meaning, value, and credibility of the image on the page.

Another form of opposition has traditionally been attributed to art history, which has tended to separate images as art and nonart.[22] This opposition, which erases the implications of the technological, material, or textual aspects of an image, has been criticized by historians such as Horst Bredekamp, who points to the significance of *bildwissenschaft* in the German art historical tradition, where the representational, scientific, and contextual aspects of images are seen as falling under the same conceptual umbrella.[23] Similarly, Stephen Bann, in his work on the relationship between practices of painting, engraving, and photography, surrounding the years of photography's invention, has highlighted just how blurred the boundaries between these seemingly distinct practices of production and reproduction were for Victorian artists.[24]

As Alfred Gell has so controversially argued, images, objects, and artifacts are never purely aesthetic items but have an agency of their own and must be understood within the matrix of their social context.[25] In other words, how images were *produced* and *reproduced* is as important as their aesthetic values. In debates over the history of photography, this discussion regarding the value of an image as either art or nonart has taken on particular relevance. As Steve Edwards has pointed out, a history of photography cannot focus solely on aesthetics but must be understood within the context of photography's relationship to science, industry, and commerce.[26]

Taking on board the productive concerns of Bredekamp, Bann, Gell, and Edwards, the following case studies thus explicitly take up the middle ground between oppositions such as art and nonart, or original and reproduction. The photograph in the periodical is fundamentally and irrevocably embedded in the textual, discursive, and cultural forms that surround it. When speaking of the photographic image in this book, it is not the image alone to which I refer. Rather it is to the images themselves, the narratives around them, and the processes of reproduction that created their value and meaning for a Victorian reader. Building upon these distinctions, this book will demonstrate that in addition to sites of production and consumption, a photographic image was inextricably a product of *reproduction* and that the mediums and processes of reproduction matter as much to the production of photographic meaning as its aesthetic, commercial, or scientific value. Moreover, it is through the lens of the periodical—as a medium of

mass communication—that the value of photography as an object of reproduction takes on its greatest meaning.

While this book will build upon the isolated methodologies of periodical history, visual epistemology, and art history to create a unified methodology for the photographic image in periodical print, over the past two decades, three historians of photography and science have been detailing just how blurred these boundaries really are.

Through her work on photography of the invisible world, Jennifer Tucker has shown that the production and interpretation of photographs was far from straightforward, especially when it came to contested images such as spirit photographs.[27] Moreover, Tucker shows that with the application of photography for science, the photograph was not imbued with a notion of absolute trust. Rather, it was used to make observations and often failed as a form of visual and material evidence.[28] Elizabeth Edwards, in her seminal work on anthropology and photography, has shown that the interpretation of photographic reproductions in the periodical is about reading the social biography of the image. When photographs were reproduced, the reader was not seeing a photographic object, but rather a visual object mediated though various forms of reproduction and situated against and around the text and perspective of the journal space in which the image was reproduced.[29] Alongside Tucker and Edwards, Kelley Wilder has addressed the relationship between the production of photographs and the use of photographs in science. By coupling her interpretation of photography in science with that of photographic objects and developments in the science and technologies of photography, Wilder is able to draw out more effectively the ways in which photographs were considered to be reliable by those viewing them.[30] This distinction between photographs *of* science and photographic science is essential in order to tease apart the ways in which the periodical presses, both scientific and popular, used and discussed photography.

"From a Photograph"

The interpretation of the reproduction of photographic images in the periodical press will take its starting point from these developments in the history of periodical print and the history of photography. However, this points to the general and does not indicate the specific path through which photographic images were imbued with a sense of trust. I rely on three concepts of translation: Bruno Latour's notion of the "chain of translation"; the relationship between the image and the text; and the relationship between space and time.

Until the 1890s, when periodicals presented photographic images to their readers, they were, in most cases, reproducing photographs through wood

engravings, and in others, through lithography. In order to position the value of the image, they needed to give it a textual inscription. The inscription of an image as being "from a photograph," whether placed directly below it or in a dislocated textual description, was a label of technological credibility and allowed the photographic image to be given special privilege.[31] Latour has argued that the production of scientific evidence, whether in the laboratory or in the field, necessitates the development of visual data. The value of the evidence is formed when the chain of translation between the original referent and the visual product is made identifiable and verifiable.[32] The example that Latour uses is based on the way in which topographical, local, and physical information of the Amazon forest gets translated back to a European laboratory and finally into a textual document. While a photograph is sometimes, but not always, a tool used to communicate information to colonial, experimental, and institutional spaces, what Latour highlights is the central importance of investigating the processes of translation. To understand the photographic image in the periodical is to investigate the multiple chains of translation between the creation of an image—whether for scientific purposes or not—and its reproduction within the contexts of print communication.

The chain of translation, when applied to the periodical press, takes on different forms, depending on who constituted the audience of the specific periodical under investigation. When an author presented a photographic image in a scientific periodical like *Nature*, the chain of translation between the production and reproduction of the photographic image needed to be explicit in order to authenticate the data. Without the chain of translation, the image itself would have to carry the weight of scientific evidence. In a period when photographic reproductions were costly and inconvenient, this was not a possibility. For the popular periodical press, the chain of translation was less obvious. The inscription of an image as being "from a photograph" did create a sense of authority for the image but—as they did not rely on the photographic image as a form of data—the precise forms of translation were not as important. Nevertheless, in both scientific and popular periodicals, labeling an image as being "from a photograph" performed the same function: it elevated the photographic image for its veracity and verisimilitude. Moreover, by classifying an image in this way, the periodical press was making a comment on how the reproduction of a photographic image was never self-contained—either as a topic of discussion or as a tool of representation.

Images and texts have a complicated relationship—and this becomes especially true when looking at the reproduction of photographs in the periodical. Considering each of these communication mediums carries its own particular relationship between the iconographic and the textual systems which describe them, to understand how a photographic image was read in the context of the Victorian periodical requires some unpacking. The image and the text were, for the nineteenth-century periodical, inseparable. W.J.T. Mitchell, in his philosophy

of iconology, has posited that when we speak of images—to take a genealogical tree metaphor—they fall under different lineages. There are "graphic," "optical," "perceptual," "mental," and "verbal" images.[33] He goes on to argue that there are oppositions within this tree, with one of the most prevalent being that between the graphic and the textual.[34] This is also an opposition that emerged from the way in which historians have looked at images as a source material. While Mitchell points to these oppositions, he also demonstrates that discursive and visual systems have fundamental interrelationships. Tom Gretton mobilized this interrelationship as a central aspect of his analysis of the placement and organization of images in nineteenth-century illustrated periodicals, with particular effect. He has shown that reproduction, placement, and intended visual and textual meaning of images in the illustrated print changed depending on the genre of the periodical itself and its pecuniary performance in a shifting marketplace.[35]

A key aspect to understanding the processes of translation that a photograph underwent when placed in the contexts of a periodical is in teasing apart the particular relationship between space and time in both photographs and news media. Time and space are embedded in the production and reproduction of photographs. Photographs, to a certain degree, capture a specific moment in time. They represent space, both in terms of the objects or places they visualize, and—through the materiality of the photographic negative and positive—also allow representations and visual data to move between people and places. Alongside the idea of the chain of translation and the interaction between image and text, the relationship between space and time and periodical production is necessary to understand the value placed on the photographic image in the periodical.

Yet the relationship between space and time in photography and the print press is part of a larger shift in the notion of time in the nineteenth century. Transportation was faster, information was being delivered to a wider audience on a daily basis, and time was being compartmentalized on an industrial and personal scale.[36] Conceptions of lengths of time were also changing throughout the nineteenth century with the development of technologies to capture an instant and concomitant changes in the way in which time was experienced within Victorian society.[37] With the shortening of time and the speeding up of industry and culture, the pace of Victorian life was changing significantly. This change in time was reflected in both the way in which photographs were discussed and how information and images were communicated through the periodical press. Chapter 4, on the notion of instantaneity, demonstrates how photographic technologies to capture shorter periods of time were first announced, discussed, and translated in the periodical press. A technology of time, such as photography, was both a discursive and visual object for the periodical press, and it is in this culture of use and interaction that the value of the photographic object was made discernable.

While photography captured time, it also made space into a serial form. Some of the most famous photographs of the nineteenth century, such as the horse in

motion by Eadweard Muybridge, are crucial examples of the way in which images and their meanings were formed through a succession of movement. However, the production of images and the relationship between the seriality of the image and the seriality of the periodical press go beyond the reading of successive images. Hopwood et al. in their recent edited articles on seriality have pointed out that the periodical is about reading across and over space and that this changed the way in which scientific experiments were legitimized.[38] The communication of news in the nineteenth-century illustrated periodical was fundamentally about the serialization of information and images across space and time. Each of the following chapters therefore looks at images and text in terms of their organization in a single periodical, but also across periodicals.

With that being said, this book—while building upon the structures of seriality expressed in Hopwood et al.—considers seriality as much more than a binary relationship between production over space and time. Seriality, in the story of photography's application to the periodical, is located both in the reading of an image and also in its reproduction and movement through print. Seriality in this perspective is about movement across time—not just movement located in the referent, but movement of the photographic object across space. And the periodical—with its own type of seriality—is an inextricable component of the seriality of photography. While concentrating on the seriality, the specific value of photography for the various genres of illustrated periodicals can be evaluated while simultaneously bringing forward the broader implications of the ways in which information traveled and was ameliorated across discursive print spaces.

Chapters 1 and 2 are to be read together. Chapter 1 investigates the use of photographs in the popular press, and in so doing, draws out some of the basic concerns of this book: what kind of photographic images were privileged, how photographic images were placed in and across periodicals, how the intended audience and the editors of a periodical reflected the way images were used, and what was the route through which photographs were legitimated in the popular press. Chapter 2, on the other hand, looks at photography in the scientific press. The questions that are raised in this chapter reflect similar concerns to those dealt with in Chapter 1, but also act in contradistinction. For example, while Chapter 2 does address questions over how images get placed and valued in the scientific periodical press, it also speaks about more specific questions relating to the way in which scientific data and information were communicated. In Chapter 2, the use of photography in the periodical press is tied much more explicitly to concerns of personal and journalistic credibility and scientific controversy, while it also investigates how photographic technology lends a sense of veracity to scientific experiment. Together these two chapters establish the methodological framework that the rest of the book follows and bring forward the key concerns involved in looking at images in the illustrated periodical press: how genre affects the content and use of images, and where and how photographic images are used.

The remaining chapters take three case studies of journalistic and scientific events relating to photography that occurred during the 1870s and 1880s in the periodical press. Chapter 3 addresses how photography became a technology for solving the problem of communication between besieged Paris and the rest of Europe during the Franco-Prussian War through the use of hot air balloons, pigeons, microphotographs, and newspapers. Photography in this chapter is expressed much more explicitly as an object that materially moves between places. The periodical in this example is shown to be not just a place where photography gets reproduced, but rather also where it becomes an object of reproduction itself.

Chapter 4 extends the technological argument of Chapter 3 to look at the way in which the concept of instantaneous photography was developed, discussed, and reproduced in the periodical press. This chapter highlights the relationship between photography and the periodical press as mediums invested in space and time. It refocuses on the narratives of photographic technological development that have traditionally been told with Eadweard Muybridge and Étienne-Jules Marey as the central characters, toward a history of instantaneity which concentrates on the periodical press as the site where instantaneous photography was tested, discussed, and reproduced.

Finally, similar to Hardy's narrative in *Two on a Tower*, this book ends with a discussion of the Transit of Venus. Chapter 5 focuses on how a scientific observational expedition that was besieged by problems of visual observation moved into the periodical press. The Transit of Venus brings together many of the concerns which run throughout the book as a whole: how controversies around forms of observation were articulated through the periodical press, how photography was valued as a mode for visual reproduction even when it failed as a tool for scientific investigation, how the reproduction of photographs in the press represented concerns of scientific photography and the photography of science, and how a visual event became valued and interpreted in different ways depending on the audience and content of the periodical in which the images and stories of the Transit were reproduced.

The rest of this book is, therefore, about the nature of photographic trust in the periodical press. It promotes a way of interpreting the visual content of a periodical that brings together the representational, the technological, and the discursive. It is about the way in which journals ameliorated and produced a meaning for photography in a period before they could be reproduced photomechanically. It is about the interaction between the image and the text and about the relationship between space and time in both photography and the periodical. And it is about repositioning the history and use of photography in its social, scientific, and reproductive contexts. For this reason, the illustrations that accompany this argument have been inserted alongside, and sometimes in opposition to the text. Unlike Hardy's invocation of the value of the image in the middle of *Two on a Tower*, when looking at photography in the illustrated periodical press, there is very much a picture to see. And it matters how you see it.

SECTION ONE

PLACING TRUST IN PHOTOGRAPHS

1 ILLUSTRATING VICTORIAN CULTURE: PHOTOGRAPHY AND THE POPULAR PRESS

n her work on photography in Victorian science, Jennifer Green-Lewis points out that "the appetite for gathering, collecting, taking, and reading cultural signs has no purer expression in the nineteenth century than photography."[1] By the 1870s, photography was becoming a dominant presence in the Victorian world. Amateur photographers abounded and had access to a variety of technical and nontechnical photography manuals and periodicals.[2] Photographic images were becoming more and more commonplace through *cartes de visites*, photographic travel narratives, and illustrated periodical press. While the photographic marketplace was certainly essential for Victorians to know about photography and its value for representing the world, it is within the domain of the illustrated print media that photography took on its greatest application as a tool for visual accuracy. Through their discussions and presentation of a new technology of visual representation, the illustrated periodicals were able to help produce and reinforce notions of photographic authenticity in ways in which no other media was able to. Yet the processes for producing this authority were distinctive for each periodical genre—the popular presses used and discussed photographs in very different ways from the scientific press. Unlike the illustrated scientific press, when an illustrated popular periodical reproduced or discussed a photographic image, the value of the photograph was its ability to make the foreign local. In other words, the photograph was useful for the popular press because it visualized people, places, and objects that a reading audience could not easily see for itself. Only through understanding the specific visual authenticity which photography lent to the illustrated popular periodicals of the late nineteenth century can we conceptualize how graphic material was published and received by a Victorian reading audience.[3]

Unlike the daily and weekly periodicals of the late Victorian period that displayed the week's news in an entirely textual form (such as the *Review of Reviews*, the *Times*, and the *Edinburgh Review*, to name but a few), the illustrated press was a unique entity of knowledge dissemination and formation. While the illustrated periodical relayed similar information to the non-illustrated papers, the emphasis on visual news fundamentally augmented how this information was communicated. The images and text in the illustrated press offered a duality of visual information; by examining more closely how the two were used in this context, we can understand the relationship between the application and cultural impact of the photograph in the late Victorian period, all in the context of reading a newspaper.[4]

The analysis of the use and development of photographic authenticity in the popular periodical press in this chapter will focus specifically on the period between 1870 and 1880 for two reasons. The 1870s was a period in which photographic technology had developed to a point where good quality photographs could be taken with fairly short exposures and with ease of convenience, while the technology of printing could not yet reproduce photographs in a cost-effective and timely manner.[5] The use of photographs as the basis for traditional woodcuts and engravings is a valuable site for historical enquiry as it can help us to understand the value of photography outside the direct material referent of the photographic image.

Rather than making a comparative study of various popular illustrated periodicals, this chapter will focus on one: the *Graphic*. In doing so, it will explicate the ways in which a print form, which was founded on and around illustrated material, mediated and produced the value of photography for print communication. Although other illustrated periodicals were certainly conscious of the importance of their images, it is the particular notion of photographic authenticity that the *Graphic* utilized both within a discursive and visual framework that situates it as a representative example of the epistemological assertion of photographic trust.[6]

The *Graphic*, which began in early December 1869, was founded by William Luson Thomas (1830–1900). Thomas, who had been an engraver for the *Illustrated London News* (*ILN*), left the newspaper to start his own illustrated periodical after the *ILN* refused to allow him to publish a memorial of the work of his brother and fellow *ILN* engraver, George Housman Thomas (1824–1868). According to Williamson, the decision to create the *Graphic* was a direct result of the actions of the *ILN*.[7] In Thomas' biographical note in the *Oxford Dictionary of National Biography*, it is pointed out that "[t]he *Graphic* was an immediate success and became known for the excellence of its wood-engravings and the notable artists who worked on the paper."[8] These notable artists were some of the best illustrators and wood engravers of the time. According to Williamson, Mr. Henry Sutherland Edwards (1828–1906), the first editor of the *Graphic*, stole the best artists from the *ILN* which made the "*Graphic's* illustrations … a higher artistic standard than generally seen in contemporary illustrated papers."[9]

The *Graphic* differentiated itself from its rivals by focusing on the veracity of its images. In the preface to one of the first volumes, the *Graphic* made explicit the value of its images: "Our aim has been to produce a weekly paper which should not be merely of temporary interest, but should be worthy of being preserved as a constant source of entertainment, and as a faithful literary and pictorial representation of the times."[10] In the *Graphic*, photography gained an elevated status as an objective tool of observation. More explicitly, as we will see, photography in the *Graphic* was more than just a tool for accurate representation; it was a tool of preservation; it gave a medium that was inherently ephemeral (the newspaper) an association with permanency. Photography, for the photographic theorist Roland Barthes, was innately linked to death and preservation in a way in which other forms of representation were not.[11] Looking at how photography was discussed and used in a periodical, which prided itself on the veracity of its images, changes our understanding of the cultural implications of the applications of a scientific tool within popular culture.

In order to identify photographic authenticity in a period when photographic images were far from the most common form of visual reproduction in the periodical press, a distinct demarcation needs to be made between photographic and nonphotographic illustrations. The reproduction of photographs through wood engravings and lithographs, which were the primary modes of reproducing photographs in this period, creates a distinct reading of the reproduction and reinscription of visual material in the illustrated press. Through both its reproduction and discussion of photographic images in broader Victorian culture, the *Graphic* created a demarcation by presenting photographs as visually authentic while ascribing an interpretive quality to nonphotographic images.

Discussing photography

The position of photographic images in the *Graphic* was designated in numerous ways. It was partially produced through the spatial organization of the image on the page, partially through the text that described the image, and partially through the comparison of photographic images to nonphotographic images. Equally important as the material presence of photography was the discursive framework through which photography was discussed by the illustrated press. The implications of the discussions of photography in the *Graphic* are intimately linked to the production of photographic trust in the subsequent reproduction of photographic images. Only after first addressing the ways in which the mechanical processes of photography were talked about textually can we understand how the visual aspect of photography was displayed and used in the *Graphic*. These discussions, which occurred across technical, commercial, and artistic milieus, created a backdrop against which photography could be established as the dominant mode for representing an authentic view of the Victorian world.

Unsurprisingly, while searching through a popular illustrated periodical such as the *Graphic*, one of the most common occurrences of the word "photograph" is found within the context of the commercial use of photography and photographic devices.[12] One example from early in the decade is particularly revealing:

> The company [The London Stereoscopic Company] have ... introduced a "New Scientific Mystery" which is likely to be the popular Christmas toy. The photograph, whether portrait, view, or art subject, is embedded in the centre of a massive square block or crystal. Nothing can injure or destroy the subject, and while capable of being framed, it is an ornament or an object of use for the library table.[13]

Similar to the quotation made in the preface of the *Graphic*, this article emphasized the permanency of photography. Not only did the photograph allow for a person, object, or place to be represented for future generations, but by locking the image within a crystal, any possibility of damage to the photograph was virtually eliminated. In this story the photograph in the periodical was much more than just an object of representation.

Although this article has tones of advertising, it was not placed at the back of the issue with the rest of the weekly advertisements, but instead was embedded in the text under the section "Literary and Artistic Gossip" alongside articles on Tennyson, and reviews of etching and engraving techniques. In surrounding this discussion of a commercial photographic object with cultural references to art and literature, as well as various engraving techniques, the *Graphic* was implicitly creating multiple values for photography in the illustrated periodical—as a point of cultural discussion and as a mechanism to illustrate these discussions.[14] Moreover, it discussed photographic toys as "scientific mysteries" which were to become common in the Victorian home. This particular scientific mystery allowed for the preservation of fragile photographs and the pervasiveness of photography and photographic devices helped establish the framework through which the *Graphic* could claim legitimacy to visual representations of the Victorian world. If the public already understood and valued photographs, then the *Graphic* could harness this trust to reinforce the legitimacy of its own photographic images.[15]

Following commercial discussions of photography, there was also a considerable amount of commentary on the cultural implications of photography to the Victorian readership. Of particular interest was an ongoing discussion of the inherently alien nature of portrait photography.[16] With slight sardonic wit and very long sentences, an author for the *Graphic* wrote:

> Can anything be described as soon over which allows time for such a succession of distracting thoughts and maddening temptations as are compressed into the

period which elapses between the removal of that brazen cap which covers what may be called the eye of the photographic instrument and the restoration of the said cap to its place. In that interval—they call it brief—what amazing thoughts and sensations will prey upon the mind and body of the sitter! He has time for many strange and terrible experiences. He has time to feel that he must suddenly spring from his seat and execute a savage dance accompanied with war whoops; time to feel the presence of the photographer standing beside the instrument with that cover in his hand counting one, two, three is wholly unsupportable; time to feel as if strange and unaccountable proceedings were taking place in connection with every one of his features; time to feel that he is not looking straight before him, but on the contrary, that he is squinting awfully; that his eyes are gradually closing as if they were going to have a seizure or fit of some kind; that the knob, or handle, or fringe, or tassel on which he has fixed his gaze is increasing in size, is changing in shape, is in motion, is surrounded with a kind of whirling aureole, or nimbus. Nor is this all. Suddenly he is conscious that he has moved, he is aware of a slight twitch, and can see (without looking at him) that the photographer is aware of it too. Indeed, that gentleman alludes to the circumstance as he replaces the cover with an uninjured air, and as if to prepare his victim for a not wholly unsatisfactory result of the séance. Such preparation is needed, the portrait proving in consequence to that unfortunate twitch to have two noses, and a dim supplementary eye in the middle of the forehead.[17]

What is intriguing about this quotation is that although it is inherently criticizing the process of photography as a nonhuman, alien process, it is the very mechanical nature of photography that gives it its legitimacy. The length of exposure time was the essential condition for what Walter Benjamin would later call the "aura" of the image: the direct impression of the subject onto the image. This aura, Benjamin argues, was not as prevalent in later photographs because there was less time to imbue the essence of the subject into the image.[18] Through the alliteration and hyperbolic sentences of this article, the *Graphic* reproduced the mechanized and unnatural nature of sitting for a photographic portrait. However, in this paragraph it was not the machine that was false, it was the subject who presented a false self to the camera. The primary culprit for this false impression was not necessarily the machine, but the period that elapsed while taking the picture.[19]

The solution to this awkwardly long exposure was presented to the reader a week later. The *Graphic* recruited the opinion of a professional photographer, "Mr. Adolphe Beau, of 283, Regent Street" to validate the trustworthiness of photography:

I wish to call public attention to a new system, which consists in taking the photograph when the expression is actually being produced, as for instance while speaking. It is just the sort of expression which one's friends are sure

to know. For several years I have been in the habit of taking such portraits, and have obtained the most successful results, while the sitter no longer dreads the *séance* as he would dread an appointment with a dentist. These speaking likenesses must not be instantaneous: time should be allowed (say twenty to thirty seconds) for the complete display of the muscles of the face, to produce the expression; and the impression so printed on the negative is the medium result of that expression during the time of sitting.[20]

Mr. Beau was pointing to an important question in the 1870s—which recurs more fully in Chapter 4—concerning the production of photographic images: what was considered an instantaneous photograph, and how essential was the shortening of time to the production of certain images, such as portraits. By pointing out those portraits that showed action (such as speaking portraits) did not necessitate instantaneity, Beau was using a broader technological debate about photography to reflect a value for photographic reproductions in the illustrated periodical. Through these discussions, a perception of continuity in the discussion of the visual authenticity of photography was presented to the readership of the *Graphic* in order to reinforce the prevalent notion of photographic trust. Furthermore, the *Graphic* was assuming the readership had an interest in the mechanical science of the photograph. Although the *Graphic* did not shy away from criticizing the process of photography, this criticism was couched in mechanical terms, which invariably reinforced the authenticity of photographic trust.

Discussions of the chemical and mechanical processes of photography occurred frequently in the *Graphic*, primarily in the section "Scientific Notes." This section offered weekly updates on the latest scientific discoveries for the perusal of the readership. On a number of occasions, the science under discussion was developments in the photomechanical process. In one such article the process of phosphorescent illumination, which had been discovered by Mr. Woodbury, was related to the reader.[21] The author of the note pointed out that:

> We have … the great pleasure in noticing a new development of the Woodbury process, by which very beautiful results are obtained by very simple means. The gelatine image, instead of being transferred to metal, as in the familiar Woodburytype, is passed under a steel cylinder together with a sheet of paper. This paper consequently becomes in its turn embossed by the gelatine, and when held up to the light shows every little detail of the original photograph after the manner of a watermark. As a means of decorating paper for fancy purposes, or even embossing a man's likeness upon a visiting card, this invention is likely to be made much use of.[22]

The discussion of this new process has two implications. First, it is couched in technical terms that would have required the reader to have knowledge of how

the printing process, and particularly the photomechanical process, worked. This implies that the *Graphic* expected a large portion of its readership to have technical understanding to comprehend this development and also to care about the developments in printing technologies. Second, this article was referencing the very process through which the paper (along with its illustrations) was printed, reinforcing the notion that the reading of a material document implies a knowledge of the mechanical process through which it was made. Extending this outward, this implied knowledge points to the tacit understanding that the readership had on the importance of photographic fidelity to the representation of the Victorian world.

Aside from the overt expressions of photographic authenticity, the *Graphic* also referred to the authenticity of photography in subtle ways. Embedded within the text of seemingly unrelated articles to photography were references to the usefulness of photography for its accuracy to perceived notions of reality. It is within this subtext that the reliability and importance of photography to the illustrated press can be seen not just as manifest in explicitly photographic discussions, but in the text of the periodical more broadly.

Although the variety of subtextual reference is varied, one example is particularly illuminating. In the weekly section "New Novels," the *Graphic* reviewed the latest books for its readership. One of the recurring tropes used by the authors of these reviews was to relate photographic trust to character authenticity. In a review of Mrs. Oliphant's latest novel *Squire Arden*, one of the characters in the book is described by an anonymous writer in the following terms: "Arthur Arden is a London photograph, resembling too many men of his class to be very agreeable."[23] In this review, Arthur Arden is given the claim of being a true representation of a London type. Later in the same article, the Pimpernel family is described as "amusingly drawn." Both of the terms used to describe these characters in *Squire Arden* were meant to demonstrate the artistic fidelity of Mrs. Oliphant's prose. By using language that reinforced the ideal of photographic verisimilitude while simultaneously juxtaposing this to a drawing as "amusing," rather than visually accurate, the author for the *Graphic* was making a subtle distinction between photography and drawing. Moreover, the fact that this trope is built into the very language of literary description speaks about the fact that the photograph was not just an image for the periodical, but was a form of description itself.

This discursive framework through which the *Graphic* evaluated photography is integral to the production of photographic authenticity. By juxtaposing photography to drawing, the *Graphic* was able to elucidate the reliability that was given to photography in the illustrated popular periodical press. The fact that these discussions of photography were casually placed within the broader contexts of the textual space of the periodical implies that photography had relevance for the periodical outside of the images themselves. Building on this value for photography, the *Graphic* was able to apply this reliability when reproducing its

images. However, unlike the discursive use of photography, when photographs were used for the basis of illustrations, this was done primarily in contested sites of visual authenticity.

Locations of photographic trust

During the 1870s, the *Graphic* chose to use photographs as the visual referent for some of its woodcuts, engravings, and lithographs. The reproductions of photographs in the periodical press were, however, limited to the use of engravings and lithographs because the printing of photographic positives was neither economical nor logistically simple. So instead they relied on photographic trust to validate the origins of their images. The reliance on visual authenticity in the illustrated press was not a new occurrence, nor solely linked to photography. In her work on the graphic periodicals of the first half of the nineteenth century, Celina Fox has shown that this print genre stressed the importance of demonstrating the authenticity of their images. "Throughout the early decades, in the descriptions attached to the news illustrations, there was a constant stress on authenticity— 'an accurate and most faithful sketch,' 'a spirited and authentic sketch,' a 'faithful delineation'—as if to convince themselves and others of their rather shaky claims to fulfill the artistic virtue of 'exact description.'"[24] The difference in the 1870s was that photographic authenticity was not a "shaky claim." Unlike artistic renderings, photographs carried with them the claim to visual authenticity based on the mechanical nature of the source material.

It is also important to reiterate that the photographic images reproduced in the *Graphic* were not actual photographs but rather engravings, lithographs, and woodcuts based on original photographs. This is an integral point as it forms how we interpret these images: it is in the reinscription of the photographic image through engravers and lithographers that the images gain their formative value. Similar to the use of photographic images in the scientific press, the visual authenticity of these images was not based in the material object itself (which held no inherent truth because they were reproduced though the lens of an artist). However, unlike the scientific press, the claim to authenticity of the image was not based in the chain of translation between the photographic original and the reproduction. Instead, for the illustrated popular press, the authenticity of these images relied on the reinterpretation of the image and in the production of these images as a mechanical rendering of the intended subject.[25] As Tagg puts it, "what is real is not just the material item but also the discursive system which the image bears."[26] It is the discursive system of photographic reproduction that is integral to the understanding of photographic authenticity in the popular periodical press during the late nineteenth century.

Portraits

One of the most common uses of photography as the basis of an image in the *Graphic* was in the reproduction of portraits. A photographic portrait, according to Benjamin, was an entirely unique visual form, which captured not just the likeness of an individual, but associated it much more explicitly than painted or drawn portraits with the actual.[27] The photographic portrait was also one of the most prevalent forms by which a Victorian audience came to experience photographic images. Borrowing on the established convention of the painted portrait and the silhouette, by the middle of the nineteenth century, photographic portraits had become widespread in cities and provincial towns throughout England and Continental Europe. Individuals could purchase *cartes de visites*, family portraits, animal portraits, and individual portraits at local studios and either send them to friends or mount them on the wall or desk.[28] The ubiquity of the photographic portrait was no less relevant in the illustrated periodicals. Cashing in on the celebrities of the day was primarily engendered by the reproduction of portraits for the reader to cut out, frame, and hang up on their wall. In this way, photography had a regular and highly visible presence in the *Graphic*. This presence, and descriptions that defined their value, gave a particular claim to the authenticity of the photographic portrait more broadly.

While they could vary in size and quality, the number of photographic portraits greatly exceeded the number of drawn portraits. Between December 3, 1869, and December 27, 1879, the *Graphic* reproduced 1450 portraits with the inscription "from a photograph" or a slight variant thereof—averaged over their 520 issues, that is, just under three photographic portraits in each issue. That is not counting the 636 other photographic images reproduced in the same period (Graph 1.1).

In one particularly telling advertisement in the *Graphic*, the importance of celebrity photography becomes evident. The advertisement was looking to sell

EIGHTY-ONE PHOTOGRAPHS of ROYAL and DISTINGUISHED PERSONAGES, all taken from life sittings, and guaranteed authentic. The collection includes photographs of Her Majesty the QUEEN, the PRINCE and PRINCESS of WALES, Princes ALBERT VICTOR and GEORGE of WALES, DUKE and DUCHESS of EDINBURGH, Emperor of Germany, King of Italy, Pope Leo XIII., King of Spain, Emperor of Austria, Earl of Beaconsfield, Mr. Gladstode [sic], Prince Bismarck, Earl of Derby, Cardinal Manning, M. Gambetta, Marshal MacMahon, Von Moltke, Osman Pasha, Victor Hugo, Carlyle, Tennyson, &c.[29]

The readers of the *Graphic* would have been aware of each of these celebrities due, primarily, to their presence in the periodical press. If they were regular readers of the *Graphic*, they would have already seen many of these celebrities'

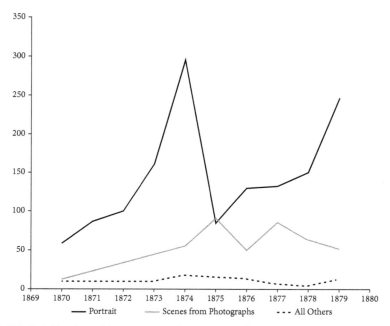

GRAPH 1.1 Number of images reproduced in the *Graphic* between December 1869 and December 1879 with the inscription "from a photograph," separated into subject groups. Produced by the author.

likenesses reproduced in earlier issues.[30] The key element in this advertisement is the reference of "taken from life sittings, and guaranteed authentic" indicating that these images were genuine, that is, photographic, representation of the individual. In the *Graphic*, portrait photography was the most common application of photographic authenticity, and it is a category that warrants further examination of the particular locations in which this trust was applied.

While the *Graphic* published celebrity portraits across the cultural spectrum, the type of celebrity visualized was not the most important aspect of the image. Scientists, literary giants, politicians, royalty, and weekly heroes claiming their fifteen minutes of fame were all depicted in the periodicals. By the start of the period under examination, these portraits all had in common the phrase "this portrait is from a photograph" or a variant thereof somewhere in the surrounding text. The photograph as a source material was invariably used to lend authenticity to the realism of the individual being depicted. However, while the stability of the photographic referent remained the same, depending on who was being portrayed, the spatial position of the portrait on the page changed, depending on who was being depicted, and what meaning the portrait was meant to convey.

When reproducing the image of a celebrity, regardless of whether they were a scientist, like Charles Darwin; an author, like Charles Dickens; or a foreign emperor,

like Napoleon III, the *Graphic* used the same visual framework to reproduce the image of these individuals (see Illustrations 1.1, 1.2, and 1.3). All three of these images, although they come from three separate years, carry the same or very similar poses, shading, and—most importantly—the same frame. By reproducing a photograph of each of these individuals within the same frame, the illustrators for the *Graphic* were alluding to the continuity between these individuals, while at the same time, demonstrating the importance of their stature. Darwin, Dickens, and Napoleon III, although very different in their cultural, economic, and political authority, were literally placed within the same visual context, indicating to the readers the cultural importance of these portraits.

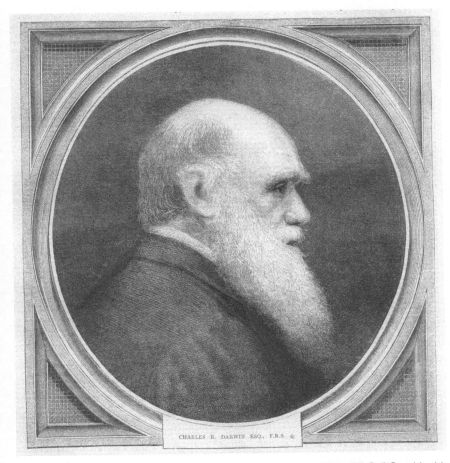

ILLUSTRATION 1.1 Wood engraving—"Charles R. Darwin, ESQ., F.R.S.," *Graphic*, 11, no. 278 (March 27, 1875): 278. Reproduced by permission of the University of Leicester Library.

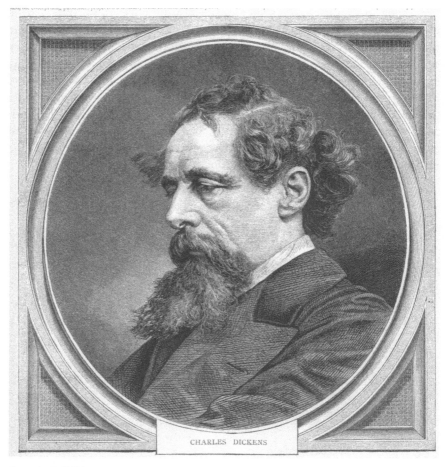

CHARLES DICKENS

ILLUSTRATION 1.2 Wood engraving—"Charles Dickens," *Graphic*, 1, no. 17 (March 26, 1870): 389. Reproduced by permission of the University of Leicester Library.

Comparatively, the nonvisual portrayal of these individuals seemingly undermines a textual continuity across separate issues. Taken together, the image and the text for these portraits offer very different textual and visual codifiers. For example, the text for the Dickens portrait is based on the experiences of a journalist for the *Birmingham Paper* and focuses on his reminiscences of the author, while the article on Darwin is based on an examination of this prominent scientist's life works and generally acts as a scientific biography. Conversely, the text for Napoleon III examines the political intrigue of the French monarch and his exploits in London.

While these three articles are disconnected in style, their reference to the visual authenticity of the portraits is unmistakable. In the article on Dickens, the

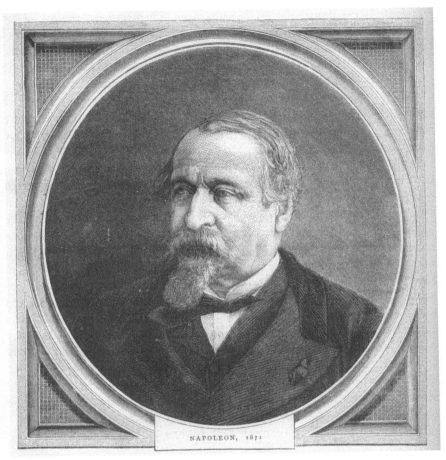

ILLUSTRATION 1.3 Wood engraving—"Napoleon, 1871," *Graphic*, 3, no. 77 (May 27, 1871): 468. Reproduced by permission of the University of Leicester Library.

text reinforces the legitimacy of photography as a new technology of accurate visualization by relating a story where, in a time previous to the advent of photography, the audience at a Dickens reading mistook an attendant for Dickens himself.[31] It is through the propagation of photographic portraits like that displayed by the *Graphic* that the Victorian public came to know the "real Dickens." The photograph was essential to the presentation of celebrity portraits as it offered the pretense of the material presence of the famous individual—something artistic portraits could not offer.

In the article on Darwin there was no direct reference to photography; however, the article lists Oscar Gustaf Rejlander (1813–1875) as the photographer of the portrait. Rejlander was a famous photographer in the late nineteenth century and

was the primary photographer for Darwin's *Expressions of the Emotions in Man and Animal*, which had been published four years earlier.[32] By using a photographer of repute, instead of listing a photographic company such as the Berlin Photographic Company, or the London Stereoscopic Company (both regular contributors), the *Graphic* could evoke Rejlander's reputation to legitimize its depiction of Darwin.

Finally in the article on Napoleon III, there was a reference to "the period most celebrated in the annals of Gore House: and the 'd'Orsay statuette' of Prince Napoleon … made its appearance, with the fashionable portraits, lithographed from Count d'Orsay's drawings, by Mr. Lane, in the windows of the Bond Street Library."[33] This statement was placed directly above the inset portrait of Napoleon III, creating a direct causal relationship between the image and the text, which rendered a comparison to the outdated style of portrait reproduction based on artistic sketches. Through this comparison, the photographic portrait was made the standard of modern portraiture, thereby normalizing the photograph. These three articles, although very different, all point to the legitimacy of portrait photography, which was further reinforced by the pervasive cultural connection to this medium. As in the case of the article on the crystal block to preserve photographs, these three portraits were meant to be objects of preservation—something the readers could keep for years to come. And finally the reproduction of these three portraits across various issues of the *Graphic* points to a visual and textual continuity: while they were printed in different years, the form of the reproduction and the authenticity of the photograph remained the same. The celebrity portrait, for a periodical like the *Graphic*, was both borrowing on the popularity of photographic portraits more broadly and also creating the impression that the images reproduced could be trusted—that they were a true likeness of a celebrity.

Objects

Outside of portraiture, the *Graphic* regularly used photographs to reproduce objects. While the number of objects photographed for reproduction is considerably lower than the number of photographs used for portraits (37 between 1870 and 1879) (see Graph 1.1), when the *Graphic* did decide to reproduce an object from a photograph, the reasons often circulated around a need for verisimilitude. Unlike the portrait, this desire for verisimilitude in an object photograph was most often tied to a desire for the accurate reproduction of text embedded in the image itself. Authenticity, in this context, is much more explicitly tied to reading rather than representation.

Two examples surrounding the discovery of ancient artifacts exemplify the ways in which the *Graphic* mobilized photography on particular occasions when visual reliability was in question. When contemporary archaeological discoveries were

displayed to the audience of the *Graphic*, the most common source for the visual reproduction of these discoveries was photographs.[34] In the 1870s, there are two particularly intriguing examples of ancient relics that were reproduced through photography—one relates to the discovery of inscribed tablets from Babylonia, and the other ancient Israel.

The first is the Chaldean tablet (Illustration 1.4), which has the subtitle of "the tablet containing the Chaldean account of the deluge." This subtitle implies that within this tablet, there is inscribed knowledge, both physically and metaphorically, which was decipherable, and therefore knowable. Upon investigating the illustration of the tablet more closely, we find that the tonal gradient of the image is very subtly reproduced. This is significant as the cuneiform inscriptions in the tablet were the primary focus of the image. The reproduction of the tablet as a photograph allowed the transcription of the stone to be transmitted to different decipherers, making this large immobile object moveable and decipherable.[35] The original photograph, outside its reproduction in the periodical press, was enmeshed in a network of

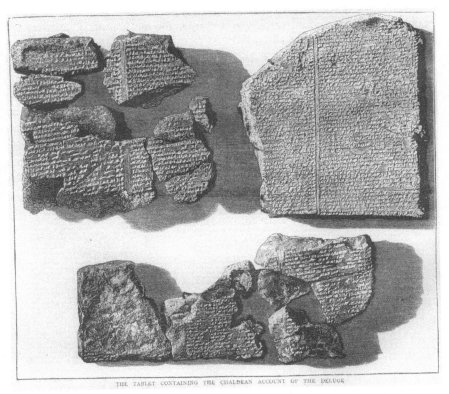

THE TABLET CONTAINING THE CHALDEAN ACCOUNT OF THE DELUGE

ILLUSTRATION 1.4 Wood engraving—"The Tablet Containing the Chaldean Account of the Deluge," *Graphic*, 6, no. 160 (December 21, 1872): 580. Reproduced by permission of the University of Leicester Library.

archaeological knowledge exchange. When it was reproduced in the periodical press, instead of the image operating as an object of investigation, the reliability attributed to the image within the scientific community was used by the *Graphic* to reinforce its credibility as a purveyor of reliable visual information. Moreover, by reproducing this image in a periodical like the *Graphic*, the periodical was reinforcing the credibility of the scientists who found and deciphered the stone itself. While reproduced in great detail, the reader of the *Graphic* could not, and should not, transcribe the stone. It was solely for communication, not an object of decipherment like the original photograph.

The visual and textual importance of this image was reinforced when, in a later issue of the *Graphic*, the tablet was revisited by the presentation of a portrait of the discoverer and decipherer of the tablet, Mr. George Smith. The original photograph of Mr. Smith's engraved portrait was attributed to Mr. S. Thomson of the British Museum.[36] By ascribing the discovery, decipherment, and photograph to professionals at well-respected academic institutions, the *Graphic* was associating these images as scientific and photographic—in other words, trustworthy.

The second archaeological photograph reproduced by the *Graphic* is the boundary stone of Gezer, which was a marker for the boundary limits of the ancient town of Gezer (Illustration 1.5). The inscription was written in both Hebrew and ancient Greek and states ΑΛΚΙΟΥ זור סחת, or "The Hebrew is Tahum Gezer 'boundary of Gezer', and the Greek is Alkiou, 'of Alkios.'"[37] By transcribing the language on the photographed stone, the *Graphic* was asking the reader to physically move from the image to the text and back to the image for a fluid transcription of the meaning of this visual and textual language. Like the Chaldean tablet, the image was not intended to be an object of investigation for the reader, but rather was an object that needed description and translation. The fact that it was a photographic reproduction of the stone reinforced the reliability of the inscription. Moreover, the visual reliability of the photograph acted to reinforce the reading of this image for its implied textual language.

PALESTINE EXPLORATION — BOUNDARY STONE OF GEZER FOUND BY M. CLEMENT GANNEAU

ILLUSTRATION 1.5 Wood engraving—"Palestine Exploration—Boundary Stone of Gezer Found by M. Clement Ganneau," *Graphic*, 10, no. 257 (October 31, 1874): 416. Reproduced by permission of the University of Leicester Library.

These examples are particularly useful as they are the representations of ancient and unseen material objects through the technology of photography. The illustrators for the *Graphic* could have used an artist to draw these objects but instead presented these stones through photographic sources. The visual product presented to the reader in the *Graphic* is thrice inscribed with visual and textual knowledge: first as the original stone, second as a photograph of that stone, and third as a reproduction of the photograph. The information presented to the reader through this image is not just the apparent visual evidence of the ancient languages of Babylonia and Hebrew, but the inherent reference to reinscribed knowledge. In this way, these images are direct examples of how visual knowledge transferred across time and space.[38]

When comparing these two images, the duality of language and image is quite striking; they present a textual language inscribed onto stone and reinscribed with a secondary visual language. The readers of the *Graphic* were not actually seeing the Chaldean tablet or the Gezer boundary stone but they were led to disregard this visual boundary because the image was produced with the faithful accuracy of the camera. The images were meant to be material objects in themselves, inscribed with tangible knowledge. It is this tangibility that the *Graphic* was aspiring to when it stated, "this engraving is from a photograph."[39]

Foreign landscapes

A third source of photographic trust in the *Graphic* was in the depictions of foreign landscapes and people. Foreign human subjects were a popular and lucrative enterprise for the illustrated press because the unknown and mysterious had cachet in the Victorian society.[40] Said argues that "Orientalism derives from a particular closeness experienced between Britain and France and the Orient, which until the early nineteenth century had really meant only India and the Bible lands."[41] This "closeness" was not based primarily on physical interactions of British and Oriental subjects (although this was part of Orientalism), but instead it was facilitated by the visual display of the physical and social landscapes of the empire through the periodical press.

John Thomson (1837–1921), who was a travel photographer during the late nineteenth century, was able to widely disseminate images of his travels throughout Britain through three of his highly popular photographic essay books: *Illustrations of China and Its people*, *The Straits of Malacca*, and *Through Cyprus with the Camera*.[42] The first of these books, *Illustrations of China and Its People*, was first printed in three volumes in 1873–1874, but experienced an even greater audience through the publication of over 200 of Thomson's prints in the *Graphic* between 1872 and 1874.

As has already been pointed out, the *Graphic* was the perfect venue for the display of Thomson's pictures, because unlike the *ILN*, the *Graphic* identified itself as *the* paper with the most accurate representation of the Victorian world. This notion of pictorial realism is echoed in the preface to *Illustrations of China and Its People*:

> It is a novel experiment to attempt to illustrate a book of travels with photographs, a few years back so perishable, and so difficult to reproduce. But the art is now so far advanced, that we can multiply the copied with the same facility, and print them with the same materials as in the case of woodcuts and engravings. I feel somewhat sanguine about the success of the undertaking, and I hope to see the process which I have thus applied adopted by other travellers; for the faithfulness of such pictures affords the nearest approach that can be made towards placing the reader actually before the scene which is represented.[43]

The presentation of Thomson's photographs in the *Graphic* is thus fruitful ground for understanding the cultural and illustrative value of photography in the periodical press.

We can access this location of photographic trust through the analysis of a single Thomson photograph reproduced across different print and visual reproduction formats. In a sense this is what Elizabeth Edwards would call tracing the "social biography" of an image; however, instead of following the original photograph, we will trace its reproduction in print and thereby help locate the value that was placed on this image across multiple print formats.[44] The images in question were all entitled "A Chinese Artist," or a variant thereof, and first appeared in the *Graphic* on January 11, 1873, as the frontispiece for the issue[45] (Illustration 1.6). This picture represents a typical artist in Hong Kong, producing a portrait of a Chinese woman. The image is borrowing on, and speaking about, the long-standing convention of portrait painting. Both the subject matter itself and the framing and pose of the sitter reflect the centrality of Western portrait painting. The photograph that this image reproduces alludes to stability across visual genres: the importance of photography here does not seem to be essential to the value of the image. Yet, when looking across the reproductive contexts of this image, this stability weakens. The original photograph in Thomson's first volume of *Illustrations of China and Its People* is strikingly different from its reproduction (Illustration 1.7). Although the subject is the same, these are two very different pictures: the only similarities are the posture and pose of the artist. It is likely that the *Graphic* only used the artist in the original photograph for the engraving and fabricated the rest of the image.[46] The difference in the content of these two images is conspicuous. In particular, the presence of the subject of the painting in Illustration 1.6 creates a very different reading of the image. In Illustration 1.7, the focus is on the painting created by the artist (with a number of his paintings hanging in the background) and the skill

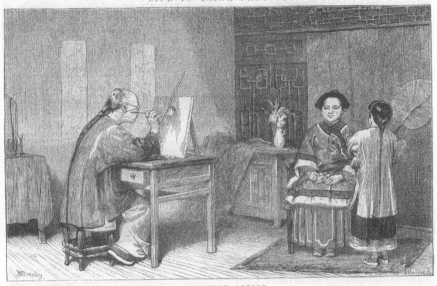

A CHINESE ARTIST

ILLUSTRATION 1.6 Wood engraving—"A Chinese Artist," *Graphic*, 7, no. 163 (January 11, 1873): 21. Reproduced by permission of the University of Leicester Library.

of the artist in making a new portrait. However, in Illustration 1.6, this focus is eradicated, and instead the narrative of the image becomes the process of sitting for one's portrait. What these two illustrations demonstrate is that while the *Graphic* used a photograph to assist its illustration, it strayed considerably from the original content. It is interesting to note that this particular reproduction does not have the caption "from a photograph." The veracity of the scene was not a central concern of the image, and the engraver could manipulate the image to suit their own design.

An engraving of "A Chinese Artist" which offered greater fidelity to the original photograph appeared in one of Thomson's later books entitled *The Land and the People of China* (Illustration 1.8). The book where this image appeared is drastically different from *Illustrations of China and Its People* as it is primarily textual, and in fact the only image displayed in the chapter on Chinese arts is "A Chinese Artist." In fact, the *Graphic* was the first venue for the presentation of this image, and this may be the reason why its reproduction was so different from the original photograph and the subsequent reproduction.

When comparing Illustrations 1.7 and 1.8, the content, positioning, and organization of the scene are accurately reproduced. However, upon closer inspection, there are slight variations that tell us something about what an accurate reproduction of a photograph entailed in a popular illustrated periodical. In the

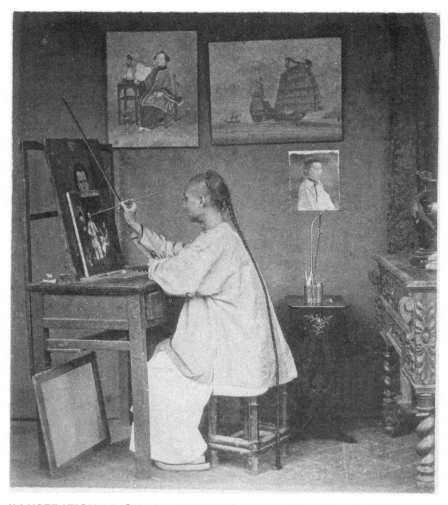

ILLUSTRATION 1.7 Collodion print—John Thomson, "A HongKong Artist," *Illustrations of China and Its People: A Series of Two Hundred Photographs, with Letterpress Descriptive of the Places and People Represented*. London: S. Low, Marston, Low, and Searle, 1873, Plate 4. © Wellcome Library, London.

background of Illustration 1.8, the paintings on the wall and on the table stand give a fair representation of those depicted in Illustration 1.7, but they are not *exactly* reproduced (the slightly crooked position of the paintings on the wall are justified in the engraving). The most obvious difference between the two illustrations is the removal of the piece of furniture in the far right of the photograph. What this comparison shows is that images taken from photographs and published in varying popular periodicals elicited different notions of what reproductive fidelity was. The primary difference between the value of the photograph in the popular and

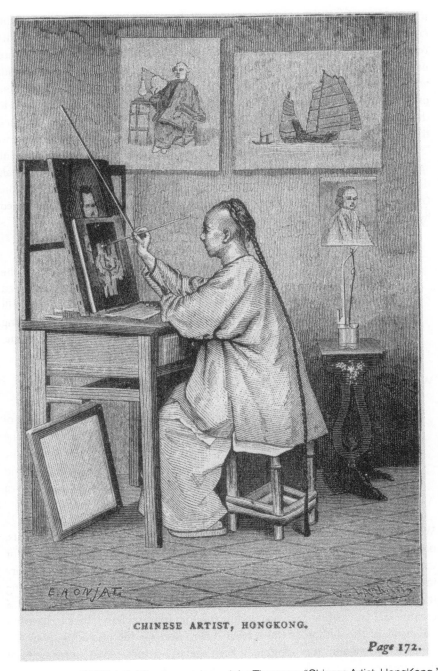

CHINESE ARTIST, HONGKONG.

Page 172.

ILLUSTRATION 1.8 Wood engraving—John Thomson, "Chinese Artist, HongKong," *The Land and the People of China*, London: Society for the Promotion of Christian Knowledge, 1876, 172. Reproduced by permission of the Cambridge University Library.

the scientific illustrated periodical presses was in what was being pictured, and the credibility that needed to be vested in the technology of the image produced and its reproduction. So, for instance, in the popular periodical press, photographs were used for objects, people, and places that could not be easily accessed in England, while in the scientific periodical press, photographs were primarily used as forms of data. Thus, for the scientific press, the photographic image needed to include the processes of reproduction, or—as will be demonstrated in Chapter 2—to trace the "chain of translation" between the original image and its reproduction in print.

When taken together, the reproduction and the original photographic print seem to be two completely different pictures. These boundaries of difference break down when the textual descriptions for the images are read together. Like the *Graphic*, in *Illustrations of China and Its People*, each photograph was accompanied by a short description.

The *Graphic* described the image as:

These limners have frequently a number of bodies in stock, to which the gentleman who confines himself to painting physiognomy will add the head of a customer in an hour or two; while his partner who paints costumes will make a few alterations to suit the requirements of dress. In this way of dividing artistic labour the work can be finished in a day, placed in a flattering frame, and delivered to its owner, who pays the painter about thirty shillings.[47]

While *Illustrations of China and Its People* gave a strikingly similar description:

The occupation of these limners consists mainly in making enlarged copies of photographs. Each house employs a touter [sic], who scours the shipping in the harbour with samples of the work, and finds many ready customers among the foreign sailors. These bargain to have Mary and Sue painted on a large scale and at as small a price as possible, the work to be delivered framed and ready for sea probably within twenty-four hours.[48]

While both of these refer to the reproduction of artistic portraits for migrants, only the original photograph reinforces this story visually. It was not necessary for the image to be an exact replication of the original photograph; instead it was more important to invoke the authenticity of the photograph by textually reinforcing the presence of the photographer. John Thomson, like Oscar Rejlander, had a commercial and public presence within the Victorian society.[49] By emphasizing Thomson as the author of the textual description for his photographs in the *Graphic*, this significantly reinforced both the visual and textual authenticity of these images.

One final aspect that links all three of these images is their self-reference to reproduction. The images depict an individual being painted. Upon reading the

text, the reader finds that they also show a local artistic practice of portraiture, incorporating sight painting on a canvas that already contains prefabricated forms. The visual space surrounding the images is also covered in reproductions: there are paintings on the wall, on the ground, and on the painter's easel. The continual self-reference to reproduction in both the images and texts for "A Chinese Artist" creates a causal link between the original mechanism of the image's production (the photograph) and the technology of print reproduction (the engraver and print press). "A Chinese Artist," across its uses in different formats, is a visual and textual referent to reproduction.

Graphic vs. ILN

The importance of labeling an illustration "from a photograph" becomes clear when extending the comparative model exemplified in the examination of "The Chinese Artist," to a comparison of reproductions of the same scene in two competing illustrated periodicals: the *Graphic* and the *ILN*. In mid-August 1872 the annual meeting of the British Association for the Advancement of Science (BAAS) took place in Brighton. The illustrated periodicals, keen to cash in on this scientific event, each sent their own artists and journalists to capture the affair. While the *ILN* chose to send an artist to draw the scene, the *Graphic* solicited photographs from a number of photography firms for their reproductions. The final engravings for the *Graphic* and the *ILN*, although they are from two diametrically opposed sources, are strikingly similar in content and organization: both images portray the landscape and architecture of Brighton with the classical perspective lines and distance (Illustrations 1.9 and 1.10). The major difference in these images lies not in the content, but instead in the way in which they describe the scenes textually and visually.

Firstly, the *ILN* clearly indicated that the images it reproduced were "leaves from a sketch book," demonstrating the casual nature of the images (they are the jottings of an artist while walking through Brighton and Sussex). Although these sketches give good representations of Brighton and Sussex, the visual authorship was produced through the perspective of the artist. The *Graphic* on the other hand clearly indicated the photographic origins of its images when it stated two pages previous to the images: "The View of Bramber Village is from a photograph by Mr. E. Fox, of Brighton; that of Hastings from a photograph by Mr. Mann of Hastings and those of Arundel and Lewis Castle from photographs published by S.C. Wilcox, London."[50] In addition to reinforcing the photographic origins of the images, the *Graphic* was also showing that it had a range of photographic contributors (unlike the *ILN* which had one artist supply its images). Moreover, the *Graphic*'s visual authorship was reinforced by the mechanical nature of the photographic lens. The

THE MEETING OF THE BRITISH ASSOCIATION

VIEW OF HASTINGS WITH THE NEW PIER

BATTLE ABBEY

NORMAN HURST, RESIDENCE OF MR. T. BRASSEY, M.P.

VILLAGE OF PEASMARSH

NORMAN GATEWAY AT ARUNDEL CASTLE

TOMB OF WILLIAM, NINETEENTH EARL OF ARUNDEL. (DATE 1488)

LEWES CASTLE

QUADRANGLE OF ARUNDEL CASTLE

ILLUSTRATION 1.9 Wood engraving—"The Meeting of the British Association," *Graphic*, 6, no. 143 (August 24, 1872): 164. Reproduced by permission of the University of Leicester Library.

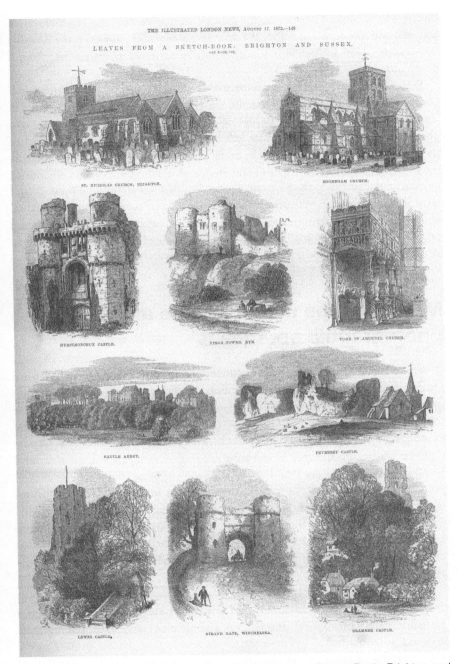

ILLUSTRATION 1.10 Wood engraving—"Leaves from a Sketch-Book: Brighton and Sussex," *Illustrated London News*, 61, no. 1719 (August 17, 1872): 149. Reproduced by permission of the University of Leicester Library.

final products of the *Graphic* and the *ILN* are similar because the original source material was processed through the lens of an engraver; however, the *Graphic* was able to claim greater visual authenticity because the images were "from a photograph."

Secondly, the surrounding visual space of these two images produces two distinct conceptions of their visual authenticity. The *Graphic* framed each of its images in clean, square boxes, indicating perspective and giving the reader the illusion of a photographic print. The *ILN* on the other hand reinforced the artistic aspect of its images by blurring the image's boundaries, leading the reader to see them as human interpretations of Brighton and Sussex. Evaluating the visual authenticity of a particular image in the periodical press requires one to both figuratively and technically look outside the box; only after taking into consideration the textual and physical space surrounding an image can we understand the impact and intention of the print. What is clear is that the illustrated press used photographic and artistic sources in a complicated and sometimes conflicting manner.

Mediating the use of artistic and photographic sources

Where and when the *Graphic* chose to utilize photography and when it chose to use artistic renderings was primarily determined by the availability of a photograph over an artist's sketch and the content of the image being depicted. Because the major concern over the source of reproduction—whether photographic or nonphotographic—primarily lay in the reproduction of places and objects that the readership did not have access to, this section will circulate around illustrations where the content dictated the mode of image makeup. The central point of analysis will be the locations and objects in which artistic drawings were valued over photographic prints and how this reflected or undermined notions of photographic trust in the *Graphic*. An analysis of the locations in which artistic drawings were valued over photographic prints is essential in order to determine how this reflected or undermined the value placed on the photographic image.

One location where one would expect to see the use of photographic trust is in the visualization of machines and inventions.[51] Considering that the camera is a mechanized device for image reproduction, it would make sense to use photography to depict other machines. On the contrary, however, most devices in the *Graphic* were reproduced from artistic sketches. Take for example the reproduction of "Roger's Life-Saving Apparatus" which was a tool invented to help launch lifeboats more quickly (Illustration 1.11). The image is embedded within the text describing it, giving the reader a direct visual reference to the information in the text. The

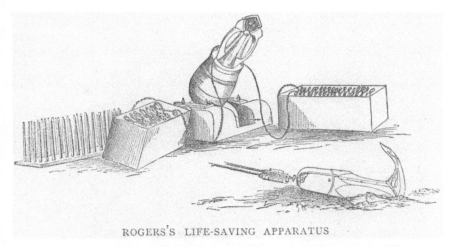

ROGERS'S LIFE-SAVING APPARATUS

ILLUSTRATION 1.11 Wood engraving—"Roger's Life-Saving Apparatus," *Graphic*, 1, no. 13 (February 26, 1870): 306. Reproduced by permission of the University of Leicester Library.

background is stripped away in this drawing, which removes the context of where the apparatus would have operated and gives a singular view of the operation of this device by forcing the reader to refer to the text for contextualization. The image itself holds no inherent information, unless read alongside the text.

This is the same for artistic renderings that involved greater detail, and where the image was separated from the text. For example Illustration 1.12 shows the operation of the recently improved printing machine used by one of the largest periodicals of the period, the *Times*. The reason that the image was based on a drawing instead of a photograph was most likely due to the fact that photographic technology at that stage was unable to accurately capture fast-moving objects. While this would change by the end of the 1870s, in the early part of the decade, the *Graphic* needed to rely on its artists to present this material. The effect of the image is significantly different from the effect caused when it had had the authenticity of the photograph, which would not have just represented the material object of the press but would also have carried with it the visual currency of saying "this machine is as it is represented."

By producing this image, the *Graphic* was supplementing the textual information of the article with the graphic information of the image. Like "Roger's Life-Saving Apparatus," the graphic information in the Walter press was intended to illustrate the information given in the text, not add to it. The text for this image leads the reader by drawing their perspective across the visual plane. They are told, "the reel of paper is shown at right. The paper is led from the reel into a series of small cylinders, where it gets clamped, and is then brought between the first and

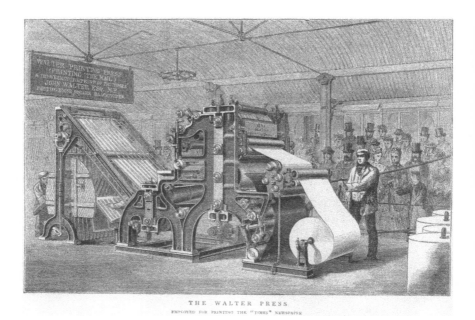

THE WALTER PRESS
EMPLOYED FOR PRINTING THE "TIMES" NEWSPAPER

ILLUSTRATION 1.12 Wood engraving—"The Walter Press," *Graphic*, 6, no. 139 (July 27, 1872): 80. Reproduced by permission of the University of Leicester Library.

second of the four cylinders, raised perpendicularly above each other."[52] The image is primarily a visual aid to understanding the textual material—an aid that was not available in the *Times*, giving the image its unique marketable value. Furthermore, by producing this image, the *Graphic* was commenting on the production of its own paper; while the *Graphic* did not use this exact press, it was reinforcing the value of mechanical printing and making a reflexive reference to the way in which the *Graphic* itself was printed. When the *Graphic* used an artist's drawing, text was needed to explain and contextualize the image; a photograph, on the other hand, had a much more complicated relationship to the text in which it could add to—and possibly contradict—the surrounding description.

On some occasions, the *Graphic* used photographers and sketch artists to depict the same topic but in different ways. The visualization of war was a popular theme in the 1870s as there were a number of foreign wars to report on throughout the period. When the *Graphic* first came on the scene in 1870, the Franco-Prussian War became a catalyst for graphic media to capitalize on this visual event.[53] The type of visual media that the *Graphic* chose to use to visualize the war during this period was not static: sometimes it used artist sketches and sometimes it used photographs. In the ten-year period between 1869 and 1879, the *Graphic* reproduced 522 photographs of foreign and local scenes, and sixty-

one were depictions of sites of war or preparations for war (see Graph 1.1). The main difference between a publication choosing to use a photographic and nonphotographic source, however, remained in how these different mediums were used and the level of authoritative visual value each of these images was given.

During the Second Afghan War of 1878–1879 the *Graphic* was keen to capture the events of the war for its audience both through war correspondents telling the story and through special artists visualizing the story. One sketch in particular was sent to the *Graphic* by a lieutenant in the war who had witnessed a clash between the Afghan and British armies. His sketch was duly published in the *Graphic*, accompanied by a textual explanation of the events described by the artist, Lieutenant J.F. Irwin (Illustration 1.13). The sketch supplied by Lieutenant Irwin was a stylized conception of the British army overcoming the Afghan "hoards" against the odds. The Afghans in the image have the clear advantage of being at the top of the hill; however, the British are overcoming them. The only fallen soldier in the image is an Afghan man in the center of the image, and the British are holding rifles while the Afghans only have sabers (although the British do not seem to use their guns but fight the Afghans primarily with their own sabers and bayonets).

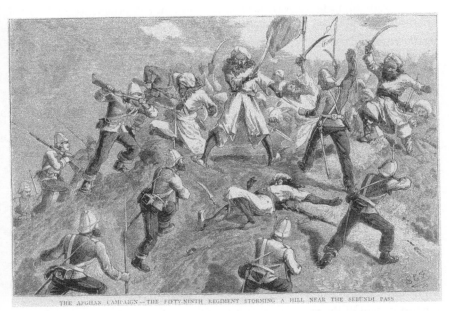

THE AFGHAN CAMPAIGN—THE FIFTY-NINTH REGIMENT STORMING A HILL NEAR THE SEBUNDI PASS

ILLUSTRATION 1.13 Wood engraving—"The Afghan Campaign—the Fifty-Ninth Regiment Storming a Hill near the Sebundi Pass," *Graphic*, 20, no. 526 (December 27, 1879): 636. Reproduced by permission of the Cambridge University Library.

The text for this image offers a complimentary story which is told in the image itself. Lieutenant Irwin described the scene:

> The scene I have depicted occurred. Captain Sartorius ordered his men to fix bayonets, and to clamber up. The hill was very steep, and when they had got within a few feet of the top the Afghans sprang up with yell, and, sword in hand, slashing right and left, simply jumped down upon our fellows ... We lost one man, and Captain Sartorius was wounded in both hands. These fanatics were splendid, though ferocious-looking, scoundrels, and fought like fiends, having evidently made up their minds to die, and to do as much damage as possible before doing so.[54]

The key aspect of this testimonial is the assertion by Lieutenant Irwin that "the scene I have depicted occurred." This both justifies the authorial vision of the image as coming from a reliable source and ensures the reader that the events depicted actually did occur. However, the reader was not led to believe that the events occurred *exactly* as depicted in the drawing. Because this was a sketch made by the person who was also giving the narrative of the text, the image could reinforce his perception of the attack. If a comparable photograph had been taken, this continuity between the image and the text would have been straightforward. The image, in this instance, was meant to reinforce the authorial vision of the artist, but it was not intended to have the authoritative value of a photograph; if it had, the text would have stated, "this image is from a sketch." A photograph could not have been taken for this scene because the technical capacity of photography to capture action was limited. A sketch was required to supplement the graphic needs of the illustrated periodical, but not to supersede the authenticity of a photograph.

Conversely, when photography was used to capture images of war for the *Graphic*, the types of images that were reproduced were based on notions of photographic vision. Group shots, landscapes, and generally posed scenes of nonactive duty were the milieu of war photography during the 1870s (Illustration 1.14). The purposes of these images were very different from that of the war sketches; they were supposed to represent authentic views of a distant war front. The text that accompanied these images of the Russian front reinforced their authenticity. "These four engravings are from photographs taken during the campaign, and are interesting from the fact that this is the first time that photography has been in any noteworthy degree utilised to illustrate the events of a campaign."[55] The events that these photographs were depicting were very different from that of the sketch of the Afghan campaign. Instead of showing action, they depicted the preparations and support system of the war. Like the text for the sketch, the text for these images reinforced the idea that these images were from the war front. Unlike the sketches, the legitimacy of the photograph is reinforced as a legitimate visual device. The text continues:

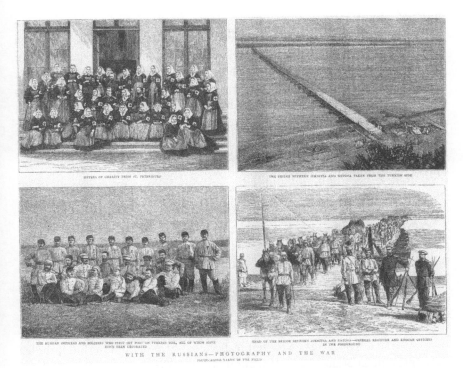

WITH THE RUSSIANS—PHOTOGRAPHY AND THE WAR

PHOTOGRAPHS TAKEN IN THE FIELD

ILLUSTRATION 1.14 Wood engraving—"With the Russians—Photography and the War," *Graphic*, 16, no. 402 (August 11, 1877): 125. Reproduced by permission of the University of Leicester Library.

The subjects need little description. Two represent views of the bridge which was constructed by the Russians between Simnitza and Sistova after they had succeeded in crossing the Danube and securing the latter town. We gave an account of the manner in which the bridge was constructed at the time. "Sisters of Charity from St. Petersburg" are some of those patriotic and courageous woman who, after a brief education in nursing and medicine at the Russian capital, flock to the theatre of war to succour the sick and wounded. The last illustration depicts a group of the first Russian officers and soldiers who set their foot on Turkish soil during the recent crossing of the Danube, and who have all accordingly been decorated for their ardour in an expedition which at the time was looked upon as a most dangerous undertaking. As it was, the first soldier to land had to do so under a most withering fire from the Turks.[56]

By prefacing this discussion with "the subjects need little description," the *Graphic* was suggesting a familiarity with the topic that the readership would have had if they were regular subscribers to the weekly news. Moreover, it

reinforces the visual authenticity that this image displays; unlike a sketch, there is little supplementary information needed for a photograph in the illustrated press. The information that was given within the text was contextual, not explanatory. While the text for a sketch formed a set of correlative knowledge, the text for a photograph was primarily contextual, allowing the image to dominate the knowledge formation. Although photographs could not be used to depict every situation (due to the technical limitations of the camera or the lack of available photographers), when they were available, the graphic content of the image was used to legitimize the reproductions made by the illustrated press.

Conclusion

Speaking of the Victorian reading audience, Dawson, Noakes, and Topham have noted that "technological developments offered ways of catering for this growing and diversifying taste, both with the development of increasingly efficient machines and with the rapid expansion of Britain's railway network which greatly aided the distribution of printed matter."[57] The impact of these technological developments were not realized solely in periodicals but included the improvement of the photomechanical process. Although visual material was introduced in periodicals well before the invention of the photographic process, the information relayed through the images was entirely different. Before the 1870s artistic renderings were included alongside textual information to illustrate events being described in the periodical. Unlike photography, sketches and drawings were intended as supplementary visual material, not as a central conduit of knowledge formation. Inherent in nonphotographic renderings was an evaluative judgment on the visual content of the subject matter. Photography, on the other hand, although manipulated by a human observer, seemed fundamentally mechanical in nature, and therefore carried a level of visual authenticity.

This chapter has investigated the historical use of photography in one of the illustrated periodicals of the late nineteenth century. The *Graphic* acted within the genre of the illustrated press with a particular emphasis on visual veracity and is a valuable case study for the application of photography in the illustrated popular press. However, the *Graphic* was also a unique illustrated periodical as it relied on the authenticity of its images to demarcate itself in the periodical market. The *Graphic* both produced and utilized this visual authenticity through the stories it told about photographs and through its use of photography as a source for illustrations. For the popular illustrated press, photography was a tool that allowed the representation of people, things, and scenes that could not easily be seen by

the readership. Photography in this particular generic context gave credibility to specific illustrations, which was reinforced by the periodical through the textual discussion made about photography. When the subject and readership of the periodical changed, so did the claim to photographic authenticity. The application of photography within other periodical spaces, such as the scientific periodical press, emphasized and authenticated photography in very different ways—which was largely dependent on what was being visualized.

2 ILLUSTRATING *NATURE*: PHOTOGRAPHY AND THE SCIENTIFIC PRESS

On February 23, 1871, an obscure Manchester photographer by the name of Alfred Brothers (1826–1912) published a two-page article in *Nature* detailing a recent solar eclipse and the application of solar photography to the observation of that eclipse. The central claim of his article was that the prominences visible around the Sun during an eclipse were products of the Sun's corona and not (as was hotly contested) from chromatic distortion by the Earth's atmosphere. He justified his claim by reproducing a photograph he had made during a solar eclipse (Illustration 2.8). While that article was not particularly unusual or significant for its content or authorship, it encapsulates the multiple forms through which photography was applied to questions of astronomical observation in the scientific press during the 1870s and 1880s. In that and other articles in *Nature*, Brothers demonstrated the importance of photography to the collection of scientific data. He achieved this by tracing the chain of translation in the reproduction of his images—in other words allowing the reader to follow the process of reproduction and interpretation from the object on the page to the site of its production.[1] In his *Nature* articles, Brothers demonstrated the importance of photography for the production and communication of scientific evidence in very particular ways, and through this lens, we can examine the epistemological weight of photography in the production of scientific credibility (or the verification of scientific data) in the illustrated scientific press. Moreover, the interlocutions of Brothers' visual and textual arguments in *Nature* can further identify the degree to which the author's personal experience and professional perspective formed the way in which he marshaled photographic evidence.

Yet Brothers did not stand alone in his use of photographic authenticity within the pages of *Nature*. Two other individuals, in particular, Henry Baden Pritchard and Warren De la Rue, represented differing perspectives on photographic

science. The former was a journalist and professional photographer, while the latter was a central character in the development of chemical and astronomical photography. Brothers, Pritchard, and De la Rue each articulated a unique form of photographic authenticity, mediated through their own claims to the scientific establishment. Though different in epistemic theories, Brothers', Pritchard's, and De la Rue's use of photographs found common ground in the imposition of a chain of translation between the production of their images and the photographic referent.

For Brothers, Pritchard, and De la Rue, the genre of the periodical mattered to the meaning and implications of their photographic images. Because they were reproducing their images within the visual and textual contexts of a scientific periodical, the reading of their images and arguments changed. Who they were, what they said, and what their images were made to say changed the epistemological value of the photographic image. Unlike the *Graphic* or the *Illustrated London News* (*ILN*), where photographs were trustworthy if they could claim to depict the unseen, unknown, or far away, the photograph in a periodical like *Nature* was an object of scientific communication. In this way, *Nature* is a particularly relevant periodical through which to examine the development of photographic authenticity.[2] It started production in 1869, during a period when science was undergoing significant formative shifts. What Richard Yeo has called a "scientific culture"—where science became established within broader Victorian culture—emerged in the 1870s and was specifically enmeshed in the production of periodical literature.[3] This scientific culture emerged in the shifting ground between science and religion and the institutionalization of the sciences in university laboratories that helped to formalize the division between the professional scientist and the amateur.[4]

Print and photomechanical technologies were constantly changing as well and were altering the way in which the periodical press produced and communicated its content. In this emergent context, the authors' personal experience and position within the scientific community—and in *Nature*—were of great importance to their claim to scientific credibility. *Nature*'s editor Norman Lockyer (1836–1920), in particular, had significant personal and professional investment in the development of the use of photography in late nineteenth-century science.[5] This investment, articulated through the organization and content of *Nature*, became even more significant in the context of photography's uneasy association with art and commerce when placed within a scientific context.[6] The terms of photographic science in this period were unstable. *Nature* and Brothers, in particular, capitalized on this instability in order to make their own meaning for a photographic image and for photographic science. When a photograph was reproduced or talked about in *Nature*, the image was not just illustrative; it was producing a meaning of photographic evidence for the scientific periodical and for scientific culture more broadly.

Competition and controversies

Nature vs. *Knowledge*

Controversy was an important part of the weekly dialogue in nineteenth-century periodicals. Cantor, Dawson, and Noakes et al., point out that "periodicals thrived on controversy and intellectual disputes like no other nineteenth-century mode of cultural production."[7] *Nature* was no different in this respect. The development and communication of scientific controversies legitimized *Nature*'s place as *the* forum for debate and discussion over scientific issues and points of contention in the 1870s. Barton has pointed out that controversy was a part of *Nature* from its inception, as Lockyer balked at the influence of the X-Club members over the journal, and instead figured *Nature* as a scientific periodical free from disciplinary and community bias.[8] The role of *Nature* within the politics of a divergent scientific community was to act as a tool of communication for the entire scientific community; yet the controversy within its pages represented the opinions of sections of the scientific community expressed through the pages of *Nature*.[9] Alongside this, the presentation of controversies in *Nature* helped to establish a community (partially imagined) of scientific professionals who attempted to mediate and contain the terms of scientific observation and practice. However, these controversies were rarely confined to the pages of *Nature* and spread outside a singular periodical space, operating across competing journals.

The editorial, visual, and textual controversy and competition between *Nature* and one of its key competitors, *Knowledge*, in particular, demonstrates the struggle for dominance within the late nineteenth-century scientific community. Controversy served as both an impetus behind and a mode of operation for the scientific press in a period when the terms of science were undergoing transformation. While the commencement of *Knowledge* in 1881 was partially motivated by the opportunity of financial gains, the commercial rivalry between *Nature* and *Knowledge* was based on far more than just economics.[10] In his biography of Lockyer, A.J. Meadows has pointed out that the personal relationship between Lockyer and Richard Anthony Proctor (1837–1888) (the founder and editor of *Knowledge*) had long been one of bitter competition.[11] Lockyer and Proctor were both astronomers who vied for professional status within the scientific community.[12] While Proctor never made it into the circle of the X-Club, Lockyer was able to establish himself firmly within the scientific community. This disparity in personal achievement was reflected in the readership of the two periodicals: while *Nature* represented the journal of the scientific community, *Knowledge* was designed as the voice of the scientifically disenfranchised.[13] That difference manifested itself not just in a narrative/textual difference between the two journals, but also in the way in which images were used and presented to their readerships. The personal relationship between Proctor and

Lockyer is therefore essential to understanding the competition between *Nature* and *Knowledge*.

The complexity of this rivalry is printed, in black and white, on the back page of an early issue of *Knowledge* (Illustration 2.1). Advertisements for *Nature* and *Knowledge* were adjacent to each other in a strangely disjointed relationship—the advertisement of *Nature* on top of that of *Knowledge*. While *Nature* is given primacy of place above *Knowledge*, the implication of the advertisement is to privilege *Knowledge*. The price disparity between the two periodicals was considerable (6d a week versus 2d a week), and the information given about the journals is very different. It is unclear whether the *Knowledge* advertisement was placed in this issue after *Nature* solicited theirs, or whether it was merely happenstance. Through this disjunctive display, Proctor may have been trying to demonstrate that *Knowledge* was more of a companion than a competitor to *Nature*. Nevertheless, it is the only time that it occurred in either journal.

In his work on the popularization of science in the late nineteenth century, and particularly the competition between *Nature* and *Knowledge*, Bernard Lightman has pointed out that the differences between two "journals" titles, objectives, format, content, and the background of the contributors can demonstrate how

ILLUSTRATION 2.1 Wood engraving—"*Nature* and *Knowledge* Advertisements," *Knowledge*, 1, no. 2 (November 11, 1881): 26. Reproduced by permission of the Cambridge University Library.

the personal rivalry of two editors manifested itself within the journal's physical organization.[14] For Lightman, in order to understand how the journals operated as tools for the popularization of science, it is necessary to understand the personal relationships of the editors and how those relationships affected the content and organization of their journals. Considering that these journals identified themselves as "illustrated journals of science," evaluating their visual content is a necessary addition to this framework.[15] The differences between how images were used in these two different periodicals will help to deepen our understanding of the way in which the use of images within a similar periodical genre varied depending on their content, organization, and intended readership.

While speaking about the visual content of *Knowledge* in the 1890s, James Mussell argues that for an argument to be scientifically valid, the images reproduced in the journal needed to be made from photographs; woodcuts were not sufficient for scientific evidence.[16] By focusing on the transition of editors from Proctor to Arthur Cowper Ranyard (1845–1894) in 1888, Mussell shows that Ranyard's experience in photography affected the visual content of *Knowledge*, repositioning the epistemic value of photography for the scientific periodical in the 1890s. However, while examining the period preceding Ranyard's acquisition of *Knowledge*, 1870–1885, it was found the value placed on photographic reproductions was very different— due to the absence of the technology necessary to produce cost-effective, direct photographic reproductions. In the period of Proctor and Lockyer's editorships, it was not necessary for an image to be reproduced through photomechanical means in order for it to gain scientific credibility. Instead, photographic authenticity depended upon whether the chain of translation could be traced back to a photographic source. The manifestation of this photographic trust in competing scientific periodicals demonstrates how editorial control, and personal rivalry, helped to make a visual style that was unique to each periodical. These styles in turn affected the way in which scientific evidence was presented *through* the images.

In May 1881, a comet appeared in the sky over England and was observed, calculated, and commented on by both *Nature* and *Knowledge*.[17] This event, though fleeting, encapsulates the difference in visual styles between the two periodicals and how these differences helped produce the value that they placed on photography and photographic science. Moreover, the way in which each of these periodicals communicated this astronomical event reveals the epistemic value of both images generally, and photographic images specifically, to the communication of scientific evidence in the scientific press; and finally how Lockyer and Proctor each influenced these values.

Nature began its commentary on the comet in June 1881 with a serial article written by a group of scientists—R.S. Newall (1812–1889), a Scottish telegraph engineer and amateur astronomer who ran a private observatory on Tyneside; William Huggins (1824–1910), the pioneer of celestial spectroscopy; Edward James Stone (1831–

1897), the chief assistant at the Royal Observatory Greenwich since 1860; William Christie (1845–1922), the new Royal Astronomer; Father S.J. Perry (1833–1889), an astronomer and member of the Royal Astronomical Society (RAS) who participated in many eclipse expeditions and the Transit of Venus; and George Mitchell Seabroke (1838–1919), a lawyer, curator of the Temple Observatory at Rugby School, and one of the founders of the British Astronomical Association.[18] The article was presented over two separate issues and incorporated nine engravings of the comet.[19] Six months later the commentary continued with the addition of photographic proof[20] (Illustration 2.5). *Knowledge*, on the other hand, presented a series of five articles on the comet, written by Proctor himself, illustrated with fourteen woodcuts (one of which was repeated). While they may have been commenting on the same astronomical event, the reproductions of these images in *Nature* and *Knowledge* present the visual observation of the comet in very different ways.

The purpose behind *Nature*'s articles on the comet was to present a series of observations and to identify the elements that composed the nucleus and its tail. Proctor's articles, on the other hand, explained away mythical perceptions of comets, gave a history of their observations in England, and posited what these observations meant to science. The relationship between the history of an astronomical event and the images that were used to depict that history were important corollaries for Proctor. The uses of historical astronomical observations—and specifically images of those observations—were used by Proctor, and others, to legitimize modern astronomical observation. For *Knowledge*, therefore, the primary purpose of the article on comets was to educate its readers in order to justify modern astronomy. For *Nature*, the central importance of the images and the article was communication of scientific data.

Images thus perform very different functions in the different journals. For example, the first three images in the *Nature* article were based on drawings made by R.S. Newall of the comet on the evening of June 22, 1881 (Illustrations 2.2 and 2.3). After producing these images for the reader to see, Newall then described *what* they were seeing: "The no. 1 Drawing shows a most singular appendage round the nucleus, in the shape like a milkmaid's yoke, the nucleus occupying the hollow, which is black." He later continued,

[l]ast night, the 27th, I was surprised to find a great change had taken place— the yoke-shaped central luminosity appeared as if it had turned round in the nucleus and occupied the usual position, while the nucleus itself had thrown out a bright tail, which gave it the appearance of a small comet lying across the bright envelope (Figs. 2, 3).[21]

Together these woodcuts were operating as visual referents to an observable change in the comet's structure. Through these images, Newall was offering the readers of *Nature* a first-hand account of his observations of the comet and reinforcing this

Fig. i.

ILLUSTRATION 2.2 Wood engraving—R.S. Newall, "The Comet," *Nature*, 24, no. 609 (June 30, 1881): 198. Reproduced by permission of the University of Leicester Library.

account by leading the reader through the images that he created on the night. This process of reading the image was essential for establishing Newall's claim to scientific credibility.

For Proctor, the images he used were meant to illustrate the point he was making; but they did not need to be photographic because they were not meant to prove an observational point. For example, when Proctor was describing the

The first envelope on the preceding side took a sudden bend from the circular form to a straight line, while the outer envelope retained its parabolic form.

Last night, the 27th, I was surprised to find a great change had taken place—the yoke-shaped central luminosity appeared as if it had turned round in the nucleus

FIG. 2.

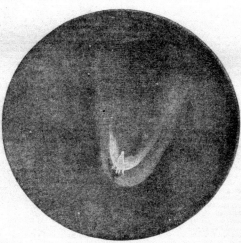

FIG. 3.

and occupied the usual position, while the nucleus itself had thrown out a bright tail, which gave it the appearance of a small comet lying across the bright envelope (Figs. 2, 3). The outer envelope on the following side was interrupted in its continuity, or seemed wanting. The positions I got are as follows:—

ILLUSTRATION 2.3 Wood engraving—R.S. Newall, "The Comet, Figures 2 and 3," *Nature*, 24, no. 609 (June 30, 1881): 199. Reproduced by permission of the University of Leicester Library.

different forms of the tail of a comet, he produced a drawing from a comet of 1744 (Illustration 2.4) and explained, "Some comets have more than one tail. One appeared in 1744 which had no less than six tails, symmetrically disposed (if one can trust the pictures handed down to us) in the figure of a half-opened fan (Fig. 2)."[22] The woodcut in this instance is useful only as a placeholder for Proctor's textual description. Through this statement Proctor was questioning the very credibility of the image itself as a moment of historical observation. For Proctor, the image acted as a secondary reinforcement of the text; while for Lockyer and *Nature*, the image held the primary form of data.

For *Nature*, where the image came from was of tantamount importance. For Lockyer the woodcut observations by Newall were suitable for the time being, but if those observations were to have any scientific value, they needed to be photographically memorialized. In fact, positioned just above "figs. 2 and 3" in the article was an endorsement of the photographic image which was to be presented in a later issue:

M. Janssen has presented to the Academy of Science, at its sitting of June 27, the *cliché* of a photogram of the comet, which was taken with the large telescope he

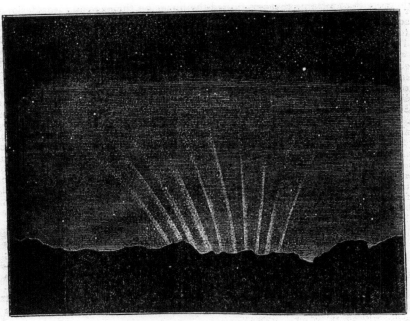

Fig. 2.—The Comet of 1744 (*Chesezue*). F

ILLUSTRATION 2.4 Wood engraving—Richard Anthony Proctor, "The Comet of 1744," *Knowledge*, 1, no. 2 (November 11, 1881): 26. © The Trustees of the Natural History Museum, London.

described a few weeks ago, constructed for the purpose of astral photography … On the photograph, which will be printed in *Nature*, and which our correspondent has examined, the stars are visible through the tail.[23]

While the drawings of the comet were important frames of reference for the discussion of its composition, they were ancillary to the presentation of the photographic image, which is where the true scientific credibility lay. Moreover, the photograph for Lockyer was valuable because it offered a type of vision that was not available to the observer, and particularly the observer/draftsman; with a photograph one could see the stars through the tail, and thus position the comet more accurately and verify the observational value of the image. Finally, the author of the image reinforced the trust claim, as Jules Janssen (1824–1907) was a famous French astronomer and innovator of astronomical photographic technologies.[24] In order for the full value of this celestial event to be communicated, the reader had to wait until December of that year when Janssen's photograph was finally reproduced.[25]

When the article with the photograph of the comet finally appeared in *Nature*, the textual argument had already been made, so the emphasis of the article was primarily on the image. The article in its entirety was little over half a page long, and the photographic image took up most of it (Illustration 2.5). The text became little more than a frame that positioned the image on the page and was designed to reinforce the validity of the photographic referent—in other words, to trace the chain of translation. In fact, the caption takes on the most descriptive significance. It pointed out that the image is a "[f]acsimile of a photograph of the Great Comet B 1881, taken at the Observatory of Meudon, July 1, 1881."[26] This small but significant piece of text gives the reader all of the information he or she needed to validate the source of the image: that it was a "facsimile" or direct copy, where and when it was made.

If the reader was still skeptical, he/she could delve deeper into the article. Positioned just a little under the caption, the text states, "the woodcut we give to-day of Comet B is from our French contemporary *La Nature*, and has been revised by Dr. Janssen himself, so that it may be accepted as a faithful reproduction of his photograph."[27] Not only did the scientist who exposed the plate in the first place guarantee the reproduction, but the image was also reproduced in a preeminent French scientific periodical.[28] While the image presented to the readers of *Nature* had undergone multiple processes of reproduction and "revision," this process was made explicit, and, in turn, the image became trustworthy. For *Nature*, the reproduction of a photographic image was essential to the validation of scientific evidence presented in the periodical, but unlike Ranyard's use of photographs in the 1890s, it was not necessary for the readers to trust the mechanism of reproduction as long as they could attribute the image as being "from a photograph."

Because images were subservient to the text in *Knowledge*, the use of photographs as source material was not necessary; there was no need to prove the credibility

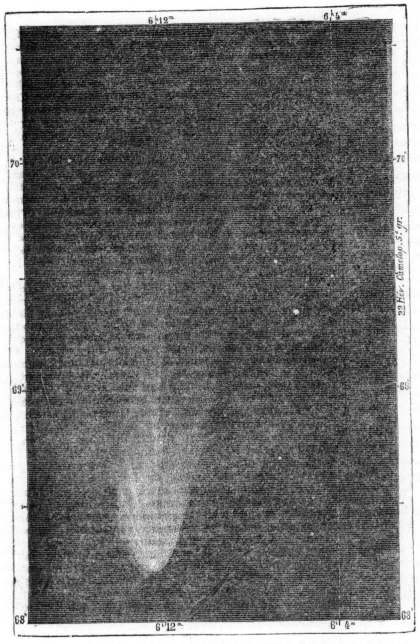

Facsimile of a photograph of the Great Comet B 1881, taken at the Observatory of Meudon, July 1, 1881.

ILLUSTRATION 2.5 Wood engraving—"Photograph of Comet B," *Nature*, 25, no. 631 (December 2, 1881): 132. Reproduced by permission of the University of Leicester Library.

of the image in this instance. Instead, Proctor focused on using visual language. From the outset of *Knowledge*, Proctor was keen to point out that, unlike *Nature*, his journal would speak in prose that was straightforward and uncomplicated by scientific jargon. This extended to the journal caption, which read "Knowledge, an Illustrated Magazine of Science. Plainly Worded—Exactly Described."[29] This focus on language also, inescapably, extended into his use of images. Often Proctor would use descriptive language which invoked visual scenery but did not actually present an image to reify this description. At one point when Proctor was trying to explain that comets do not follow planetary orbits, he encouraged the reader to imagine for themselves that over "here we see a comet travelling in a path of moderate extent and not very eccentric; there another which rushes from a distance of two of three thousand millions of miles."[30] This notion of seeing for oneself is essential in this example as it underlines the way in which Proctor conceived of the usefulness of images in his text. If there was not an image available that supported what he was saying, then descriptive language was just as good. Photographs, for Proctor, served no different purpose from drawings in *Knowledge*.

While *Nature* and *Knowledge* were both illustrated scientific periodicals, the visual styles in these periodicals were significantly different. In other words, a relationship in genre does not dictate a relationship in the value of an image. The value placed on photography in *Nature* was motivated by a need to validate scientific observation. For *Knowledge*, the education and communication of science to a larger audience was paramount, and the images presented to the reader therefore did not need to focus on observational validity. Because *Nature* was always worried about the validity of the experimental evidence communicated in their pages, the images reproduced—and specifically the photographic images—came under much more scrutiny. That is not to say that *Nature* was able to produce scientific credibility solely through its reproduction of photographic plates; there needed to be a culture of photographic authenticity extant within both the readership and the periodical in general to reinforce this validity.

The development of scientific authenticity in its myriad forms and functions within the latter half of the nineteenth century is encapsulated in the controversy that raged between *Nature* and one of the first societies for the promotion of photography and photographic science. It is here—in this debate between two arbiters of photographic practice—that we can evaluate the development and reinforcement of photographic trust in the illustrated scientific periodical press.

London Photographic Society

The Photographic Society, which began in 1853 under the influence of Roger Fenton, welcomed scientists, artists, and professional photographers into its

membership.[31] However, because of this broad identification of the society's aims and members, it struggled to position itself within the domains of science, art, and commerce in a period when photography itself was facing similar questions of placement.[32] The society acted as both a place to present papers of scientific and artistic merit and a channel through which these papers could be published (*The Journal of the Photographic Society of London [JPS]*). The society's place of authority vis-à-vis photographic science did not come easily, and certainly not quickly.[33] Before the Photographic Society could be seen as a place for photographic authority, its position within the scientific community needed to be debated, which necessarily occurred outside of the confines of the society and its publication. The controversy within *Nature* over the Photographic Society raises questions over the placement of photographic trust in both social and cultural places and textual and visual spaces. This intersection and interaction between the legitimization of a scientific society, and the authentication of an instrument of observation, opens a window through which the social, visual, and textual can be seen to aid in the formation of what was—and what was not—considered science in the late Victorian period.

The controversy over the value of the Photographic Society first gained momentum in *Nature* after an article by an unnamed author was published in early 1874, attacking the society. The article began by pointing out that

> The Metropolitan photographic journals contain evidence that the Photographic Society of London is menaced with revolution or dissolution. If both were to befall it, the interests of Science would hardly suffer, since a more singularly inefficient organisation, under the guise of a scientific body, it would be difficult to find, or one whose results in the scientific world are so trivial.[34]

The revolution that the article was referring to related to how the selection of the committee for the society was maintained. Up to 1874, the ruling committee members were appointed and the regular members of the society had no say in who was on the council. Moreover, if the majority of the council agreed, any members could be withdrawn from the committee and the society at will.[35] The author of this article, standing behind a shield of anonymity, focused his or her vitriol less on the political constitution of the society, but what they believed constituted photographic science. Through this attack, the author highlighted the particularly contested position which photography occupied in the late Victorian period, both in the periodical press and in scientific societies.

After establishing the general failings of the society, the author then went on to point out what he or she considered to be the particular faults of the society's lack of science. The society "has done absolutely nothing for so many years but organise itself into a pocket borough in the directions of which no man of eminent scientific capacity takes part; which not only has no scientific reports or even investigations,

but seems to care only to make itself a weak mimicry of an art club."[36] For the author, a proper scientific society—especially for a science like photography that had an unfortunate association with art—needed to have an eminent scientific fellowship, a tool of communication for scientific articles, and a clear separation from the artistic world. In essence, what the Photographic Society needed to do to secure respectability within the scientific world was to be more like *Nature*.

In a later article by the same unnamed author, the allusion to *Nature* as a proper model for building a scientific community was made explicit. The author argued that the *JPS* was inadequate because "the numbers contain eight pages each, the pages little more than half the size of that of *Nature*, and in the whole year's proceedings there are twelve pages devoted to science ... [and the rest] much of which the charity of any semi-learned society would be largely strained in giving paper to ink."[37] This is primarily a spatial argument about the value of the *JPS*: the size of each issue was too small to contribute anything of value, and within that space science was not given a priority. This argument for "proper science" was not only based on the value of the members or the content contributed to the society, but the physical organization of the society's journal itself. If the Photographic Society wanted to become a valued part of the scientific community, the *JPS* needed to physically reflect the organization of *Nature*—a weekly volume at least twenty-five pages in length with important scientific contributors. The controversy with the Photographic Society therefore lay in not just who was a member and how they did science, but importantly, how they communicated their science.

The Photographic Society's rebuttal came quickly. A week later Henry Baden Pritchard (1841–1884), the secretary of the society at the time, was quick to point out the scientific merits of the society and the *JPS*.[38] After first asking *Nature* "to make public the transactions of the society so the readers of *Nature* can judge for themselves," Pritchard then went on to point to the scientific merit of the journal through all the eminent scientists who were part of the Photographic Society and who contributed papers to the *JPS*: James Glaisher (1809–1903), an astronomer, balloonist, and meteorologist; Captain James Waterhouse (1842–1922), a career soldier, photographic scientist, and contributor to the large photographic project *Peoples of India*; Prof. George Gabriel Stokes (1819–1903), the Lucasian Professor at Cambridge; Captain William de Wiveleslie Abney (1843–1920), an instructor and photographic scientist who organized the Egyptian site of the 1874 Transit of Venus; and himself, to name but a few.[39] Importantly, most of the scientists that Pritchard mentioned in his response were also contributors to *Nature*.[40] Pritchard's response was targeted to undermine, point by point, the criticism made against the society—the most important points to defend relating to the value of the contributors and the scientific value of the journal. What was included, however, is as interesting as what was left out of this defense—he ignored the spatial question of the organization of the *JPS*, and thereby missed one of the most damning criticisms of the earlier article. The value of spatial organization for *Nature* was

acutely important. This difference is demonstrable not just in the words of the unnamed critic of the Photographic Society, but also in the spatial organization of *Nature* itself.

The authority given to the articles in *Nature* on the controversy at the Photographic Society differed significantly, depending upon their placement within the text. While the original article by the unknown author was given a full page, and placed in the main text of the article, the response by Pritchard was printed in the "Letters to the Editor" section, and given much less space. In fact, the response by Pritchard was not solicited, and instead represented a member of the Photographic Society's committee taking it upon himself to refute the criticisms of the society's scientific value.[41] The spatial difference between Pritchard's authority and the authority of the unnamed author was compounded when the rebuttal to Pritchard was again printed as an article in the main text. The position that Pritchard and the unnamed author gave photography through *Nature* must be understood not only by what was in the text, but by where the text was placed. *Nature* therefore implicitly supported the argument made against the Photographic Society and thereby put forward a specific viewpoint through which photographic science was viewed by the journal.

The position that *Nature* took toward photographic science, articulated through its conception of the value of the Photographic Society, is more complex if viewed outside of the perspective of a single point of controversy. While the articles on the Photographic Society and the response by Pritchard reflect a general conception of what should and should not be considered photographic science, the position of the Photographic Society was not so easily construed. The cultural and scientific value of photography was produced within *Nature* in various ways, and the particular role of the Photographic Society in creating this value is evident in both the advertisement of the society meetings and the articles by society members that made it into the pages of *Nature*.

One of the most curious facts about *Nature*'s discussion of the Photographic Society is that while it condemned the society in its articles, it continued to advertise the society within its "Societies and Academies" section. For the period between the start of *Nature* (November 1869) to the publication of the article on the Photographic Society, *Nature* published over thirty notifications of the Photographic Society's meetings. Furthermore, from 1875 to the end of decade, *Nature* continued to advertise for the Photographic Society and published a similar number of notifications as it did in the first half of the decade.

While this fact alone may seem inconsequential, the placement of the Photographic Society notifications within the text is not. The "Societies and Academies" section of *Nature* was placed at the very end of each issue on the back page where a casual reader would have a good chance of coming across it. This section was designed to give cursory information in a small amount of space, such as the date and time of society meetings and the lectures that were going to be

given. "Societies and Academies" was a space within the journal to advertise for the very societies that were contributing papers to *Nature*. Other societies that were often mentioned in this section include the Royal, Chemical, Linnaean, Royal Astronomical, and the Geological Societies. Placing the Photographic Society meetings alongside these other scientific societies created an implicit association between these groups and their claims to scientific credibility.

This credibility was reinforced by the reproduction of the occasional article from the Photographic Society meetings within the notification of "Societies and Academies." For example, at the December 14, 1869, meeting of the Photographic Society, Dr. Van Monckhoven presented a paper on the production of artificial light for photographic production and enlargement.[42] A little less than a month later, *Nature* printed this paper as a two-page article. What was particularly intriguing about the article was its placement within the "Societies and Academies" section and the four woodcuts that accompanied it (Illustrations 2.6 and 2.7). Typically, the whole of the "Societies and Academies" section was a little over two pages long and offered a paragraph of information for each society. Furthermore, this section was usually dedicated to the announcement of upcoming meetings, not the publication of papers made during meetings that had already passed. First, the inclusion of this article in this particular section indicates that it was probably an article solicited by *Nature* after being presented at the Photographic Society and therefore must have been seen as containing considerable scientific value. Second, the images in this article were not merely used for illustrative value—they were intended to instruct the reader on how a device for artificial light was made. Each image has lettered markers that correspond to a point in the text that gives an explanation of how the particular piece of the mechanism works. The inclusion of images, alongside the spatial organization of the text within *Nature* as a whole, clearly demarcates this paper from the rest. This demarcation demonstrates a position of credibility for Dr. Van Monckhoven—and by association, the Photographic Society—while also representing a separation from the mainstream of scientific research presented in *Nature*. While the editors and contributors to *Nature* clearly felt the need to criticize the Photographic Society for its lack of scientific merit, it nevertheless continued to promote the society as a place for credible science.

The production of photographic authenticity within *Nature* rested on both an inculcation of what photographic science could be defined by, and how this operated in both textual and social spaces. This authority was then utilized to reinforce the visual currency of the images presented in *Nature*, and in competition to *Nature*'s primary competitor, *Knowledge*. *Nature* reinforced the credibility of its images by tracing a chain of translation through the points of reproduction, back to the photographic referent. The ways in which photographs were utilized for their scientific credibility, however, varied, depending on how the image was presented and who presented it. *Nature* offered a place for the publication of discussions about photographic science for a variety of authors from different professional

of chromium is produced at a very high temperature, and at the same time, a flame of such extraordinary chemical power, that chloride-of-silver paper held at a distance of twenty centimetres (eight inches) blackens sensibly in thirty seconds, or about as quickly as in full daylight. The same experiment may be conducted with equal success with chloride of titanium, which gives a blue flame of extraordinary chemical power. Unfortunately, these chlorides can be manipulated only by persons well versed in scientific research, as they become decomposed under the influence of moist gases, and the lamp then emits a considerable amount of vapour, as in the case of metallic magnesium. Magnesium, chromium, and titanium, all of which exist in the sun, are the sources of light most suitable for the purpose. The author is at the present moment occupied in establishing the coincidence of the ultra-violet rays of the spectrum with those of these metals. For the purposes of photographic enlargement, the author uses the Drummond system, substituting for the cylinder of lime, one of very pure carbonate of magnesia, free from soda, silica, and iron, either alone in a very compressed state, or containing titanate of magnesia obtained by a mixture of chloride of titanium and carbonate of magnesia. The pillars are square at their base, three centimetres in diameter, and eight in height; they burn for an hour and a half, and cost less than half a franc apiece. They emit a very brilliant and economical light. Instead of pure hydrogen gas, ordinary coal gas, or even alcohol, together with oxygen, may be used. The preparation of oxygen, on the author's plan, is very easy, and free from danger. He employs for the purpose calcined oxide of manganese; it is then finely powdered and passed through a sieve. The chlorate of potash he uses is also pulverised and sifted; 600 grms. of brown manganese and 1,200 grms. of chlorate are well mixed by hand in an earthen vessel and sifted, care being taken not to allow any organic matter to enter, and the whole is then introduced into the wrought-iron retort A (fig. 1). The cork stopper E, covered with tinfoil, is put into its place, and the junction F,

oxide of manganese subsides. The clear water is decanted off, and the black deposit put upon a plate near the hearth to dry, after which it is again ready for repeated employment as often as desired. With ordinary native manganese a much higher temperature is necessary, and the operation becomes dangerous. For this reason it is advisable to use a cork stopper, E. A kilogramme of chlorate of potash yields 270 litres of oxygen, and this quantity will supply the lamp for two or three hours; thus the cost of our light, including coal-gas and the magnesia, amounts to two francs per hour. The oxyhydrogen burner used (shown in figs. 2 and 3) is very

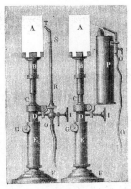

FIG. 2 FIG. 3

convenient. Those who have gas laid on in their houses will use the apparatus with two jets of gas (fig. 2); others will find it more expedient to employ the spirit-lamp arrangement (fig. 3). In both figures the same initials refer to similar details; A is the pillar of magnesia fixed upon a stem, B, which may be turned, lowered, or raised upon the rod C. E F is the stand or support, and G the pinion by means of which the light is adjusted in the centre of the apparatus. The jets for the two separate gases are formed by two concentric tubes, R, S T, sliding at S, so that the upper portion of the tube S T may be raised when it is desired to heat the top of the magnesia pillar A. Two stopcocks, O, P, lead the gases into the apparatus, the letters H and O being marked upon them to distinguish the oxygen supply-tube from that of the hydrogen or coal-gas. By means of a screw, I, the tubes R, S T, may be approached to, or removed from, the magnesia pillar. The coal-gas does not mix with the oxygen, excepting in the flame itself. The manner of employing the apparatus is exceedingly simple. The tube and stopcock marked H (connected with the supply of coal-gas), is first opened and the gas ignited; the stopcock marked O (in connection with the bag of

FIG. 1.

which places the retort, by means of the leaden pipe G and rubber tube I, in communication with the gas-bag, is adapted. The delivery tube (I) should be of at least half an inch internal diameter, and the wash-bottle H must be half filled with water. A small quantity of ignited charcoal is thrown into the little furnace B C, or a gas jet may be used, and after the lapse of a few minutes the india-rubber bag begins to inflate, and in twenty minutes it is full of oxygen; it is necessary during this operation to remove the weights and pressure-boards from the top of the bag. When the operation is finished and the retort somewhat cooled, the junction F is unscrewed, the cork E taken away, and warm water poured in until the retort A is filled. The water is allowed to remain for an hour, and the contents are then poured into a large jar, where, after the lapse of an hour or so, the

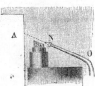

FIG. 4.

oxygen) is also opened, and the tube B then raised in such a manner that the top of the pillar A is heated by the flame, the extremity of the tube T being brought almost into contact with the magnesia. The heat soon indents the pillar, and *it is only when a cavity has been formed that the light attains its highest*

ILLUSTRATION 2.6 Wood engraving—"Dr. Van Monckhoven's New Artificial Light for the Production of Photographic Enlargements: Fig. 1—Wrought Iron Retort; Fig. 2 & 3—The Oxyhydrogen Burner," *Nature*, 1, no. 10 (January 6, 1870): 272. Reproduced by permission of the University of Leicester Library.

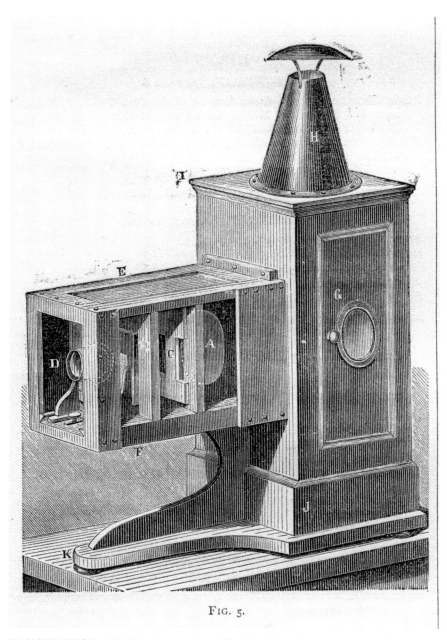

FIG. 5.

ILLUSTRATION 2.7 Wood engraving—"Dr. Van Monckhoven's New Artificial Light for the Production of Photographic Enlargements: The Enlarging Apparatus," *Nature*, 1, no. 10 (January 6, 1870): 273. Reproduced by permission of the University of Leicester Library.

and cultural positions. Three authors, in particular, Alfred Brothers, Henry Baden Pritchard, and Warren De la Rue, represented the professional spectrum through which photographic authenticity was formulated, controlled, and utilized.[43] A closer examination of these three authors' interactions with photographic authenticity within the pages of *Nature* will help demarcate the boundaries within which photography, journalism, and the serial organization of image and print were used to establish scientific credibility.

Developing photographic authenticities in *Nature*

Alfred Brothers

Alfred Brothers teetered on the edges of the scientific community. He gained legitimacy as a fellow of RAS—the primary scientific institution for astronomical science in the nineteenth century—and played a part in the development and application of photographic technologies.[44] But even with these credentials, Brothers played a peripheral part in the astronomical scientific community and was instead largely a commercial photographer, operating a photographic studio on St. Ann's Square, the central marketplace in Manchester.[45] While Brothers did produce a photographic history and manual later in his life (1892), his main claim to scientific authority during the 1870s was his inclusion in the 1870 eclipse expedition to Syracuse. Thus, when Brothers first wrote for *Nature*, he was coming from a background in commercial photography but with an interest and investment in photographic science. His position within the scientific community was a tenable one and his work in *Nature* offers a unique vantage point from which to examine how photography was used to reinforce one's own scientific credibility.[46]

In Brothers' first article, which was a little over a page long, the primary focus was the half-page wood engraving with the caption "The Late Eclipse, as photographed at Syracuse" (Illustration 2.8). Upon investigating the text which surrounds and envelopes the image, the reader finds that the eclipse that Brothers was both describing and visualizing was that of December 22, 1870. This article and image, which appeared two months and a day from the actual event, demonstrate the type of content that *Nature* was communicating to its readership: not immediate news (whether political, social, or scientific) but instead important scientific events of the recent past separated from the immediacy of the moment which was so much a part of the daily and weekly popular periodical press.[47]

For Brothers, the value of his article on the recent solar eclipse not only came in the discovery that he made—the red prominences of the Sun, visible only during an eclipse and demonstrating its coronal atmosphere—but was also the medium through which he captured this scientific event. The first paragraph of Brothers'

prominences ; some parts of the first light shade can be seen, but the outer rays are altogether invisible. When, however, the plate is viewed by reflected light, the whole of the detail is distinctly seen. The negative was the last one taken ; four others were exposed for the corona, but owing to the presence of cloud very little detail is visible.

It will be noticed that there is more of the corona shown on the west side of the moon than on the east, north, or south. This feature is shown on all the plates, so that there can be no question that there was more coronal light on the west side of the moon than at the other points. In explanation of the great display of the outer rays (I use the term *rays* for want of a better—perhaps *outer light* would be more correct, for there is no indication of lines or rays on any of the plates), I had supposed that the east side might have been partially covered with cloud ; but in conversation with Prof. Eastman I found that he was observing for the reappearance of the sun, and he is quite certain that there was no cloud at the time the photograph was taken—that is, at about thirteen seconds from the end of totality. Mr. Fryer also is equally certain that there was no cloud. The plate was exposed eight seconds. It will be noticed also that the prominences are more numerous on the side where the corona is brightest.

Various opinions have been expressed as to the quality of the light of the corona. The effect we saw was that of moonlight, but not of the *full* moon, excepting the brilliant light close to the moon's limb, which is equal to the brightest moonlight, and I think its action on the sensitive plate confirms this opinion.

A point of much interest to be noticed is, that the light of the corona had been considered to be much less active than it really is ; eight seconds were sufficient to produce on the plate an effect of light extending beyond the moon's limb, at least one and a half millions of miles.

I leave it to others to account for the cause of the great gaps or rifts in the corona ; also their identity in position with those shown in the photograph taken by the American photographers at Cadiz. The identity of one of the rifts

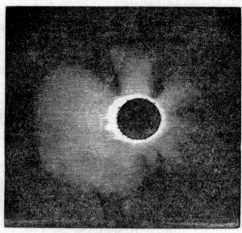

THE LATE ECLIPSE, AS PHOTOGRAPHED AT SYRACUSE

is absolutely fixed by the two prominences between which it appears in the photographs, and this one gives the relative places of the others.

When the two photographs are compared, there is an apparent difference in the places of the rifts with respect to their angular position on the moon's circumference. How this difference arises I am not prepared to say, as I have no information as to how the American picture was taken, and there is no mark on the transparency which has been lent to me by Prof. Young, to indicate the north point. In the engraving from my photograph the top is the north.

It is perhaps necessary to say that it is quite impossible to represent in an engraving on wood the delicate detail of the corona. The cut fairly gives the main features, but it is *hard* when compared with the original ; the contrast should not be so great ; the ground should not be perfectly black ; and the effect should not be produced by *lines*. No woodcut has ever yet accurately represented the phenomena of the eclipsed sun.

When the photograph No. 5 is combined in the stereoscope with the one taken about one minute earlier, stereoscopic relief is produced—the corona is distinctly seen beyond the moon. It may be thought that this is merely the effect of contrast, but I believe it is really due to the change in the position of the moon. No such relief is seen when two copies of the same photograph are combined stereoscopically.

In order to see the woodcut with the best effect, it should be placed at a few feet distance from the observer, so as to lose all trace of the lines of the engraving ; the effect is then very accurately given of the corona as seen by the unaided eye. A. BROTHERS

THE LATE EAST INDIA COMPANY'S MUSEUM—A ZOOLOGIST'S GRIEVANCE

THE late East India Company in their former palace in Leadenhall Street were in possession of a valuable Zoological Museum. It contained specimens in all departments of science, received from the Company's Oriental dominions. These had been contributed by

article authenticated the value of this image: "The accompanying woodcut is a copy of a drawing made from negative No. 5."[48] This sentence is striking because it sets out, in the first instance, to demonstrate to the reader that even though this image had gone through various modes of reproduction, it was the *original* mode of production that mattered. Not only does he tell his readers that, yes, this image was a woodcut that has been carefully "copied" from a drawing, but that more importantly, the image was based on an *original* negative.

Brothers then went on to point out the inadequacies of the wood engraving for expressing what was seen, and what was actually captured on film during the passing of the solar eclipse: "It is perhaps necessary to say that it is quite impossible to represent in an engraving on wood the delicate detail of the corona. The cut fairly gives the main features, but it is hard when compared with the original." He then continued, "no woodcut has ever yet accurately represented the phenomena of the eclipsed sun."[49] With this paragraph, Brothers was doing two things: first, valuing the photograph as a superior medium of image production and communication, and second, undermining the value of wood engraving as an effective mode of visualization. Surely if Brothers could have reproduced his original photographic negative, he would have preferred it, but he could not. Hedged in by the costs and limitations of periodical publication in the 1870s, Brothers used the means available to him. Limited to woodblocks, he needed to authenticate his observations, and subsequent images, using alternative means.

For Brothers, the reading of this image depended on the reader trusting the chain of translation through which this image was reproduced. Moving beyond Latour's original configuration of the chain of translation, in order for the image to fully authenticate Brothers' argument, it was necessary for the chain to lead back to a process of image capture, which had both a preconceived cultural authority and a claim to visual authenticity. The first paragraphs in this article led the reader to follow this image backward from a wood engraving, to a drawing and finally to the photographic negative, catalogued and in the possession of the author. To read this image, it was not necessary for the reader to understand the image itself, but instead required a recognition that the authority of the image was in its connection to the original object, which was produced and held by the author. This reading is impossible without examining the image in relation to the text; together they create the authority of the scientific evidence on display through the image.

The authority of the photograph as the point of origin in the chain of translation is reinforced in *Nature* when Brothers entered again into the journal two weeks after his first visual and textual foray. His second article was not only a continuation of his original argument, but also a rearticulation of the inadequacy of the modes of production. In "Photographs of the Eclipse," Brothers lamented the mistake in the production of "The Late Eclipse, as Photographed at Syracuse."[50] Brothers was allowed to reproduce his photograph surrounded by new text—this time the right way around (Illustration 2.9).

on the Eclipse Expedition. In Mr. Lockyer's article it is stated :—"Now at Syracuse Mr. Brothers also photographed rifts, three rifts, but the sketches did not record a single one ;" forgetting, evidently, that at Syracuse no

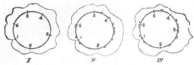

I	*II*	*III*
From Prof. Watson's Drawing.	From American Photo. taken at Cadiz.	From Photograph taken at Syracuse.

attempt was made to sketch the Corona either by our own party or the Americans. At Agosta Mr. Brett was stationed, but as the Eclipse was only visible there for about *five seconds*, of course in that time no artist could pretend to make a drawing. It happens, however, that

Prof. Watson was at Carlentini, and being favoured with a clear sky he succeeded in making a very careful drawing, which I had the good fortune to see and compare with my photograph No. 5 a few days after the Eclipse. An outline of this drawing I now give, so that it may be compared with the photographs made in Spain and at Syracuse.

There are two or three points which must be considered in comparing drawings and photographs. The photographs will differ according as they are made with a camera or telescope, and the drawings will differ according as they are made with the aid of a telescope or without. With the telescope the field of view is limited, and the eye is naturally attracted chiefly by the intense light of the red prominences and the corona near the moon's limit. Naked-eye drawings ought to be as valuable as photographs, but I doubt if any two artists will ever be found to make sketches agreeing in every particular. On photography must we depend for settling doubtful points of this nature, and it seems to me in this case to be absolutely settled that three rifts are identical. The outline sketches speak

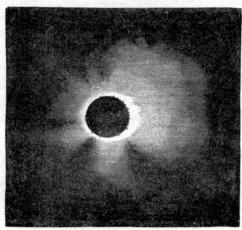

for themselves. A pair of compasses applied to the points formed by lines drawn from the moon's centre to the centres of the depressions (or rifts) in the corona, will show whether or not the places of the three gaps are the same.

It may be said that Lord Lindsay's photographs taken five miles from the station occupied by the American observers in Spain, do not show the rifts. This, I think, must be accounted for by the presence of cloud. The cloud may have been so thin as to be quite invisible in the feeble light of the Eclipse, but yet sufficient to prevent the photographic delineation of the rifts. Three of my photographs were taken through cloud, and they show us traces of rifts. The fifth plate shows three distinctly, and less plainly five or six others.

Professor Watson's drawing shows two gaps corresponding with 1 and 6 in both photographs, and depression in the corona agreeing very closely indeed with my picture.

This evidence seems to me to be absolutely irresistible as to the identity of the great rifts in the corona.

In explanation of the way the outline drawings have

been made, I may say that the points marked from 1 to 6 have been pricked through the photographs, Professor Watson's drawing having been reduced to the same scale as the photographs, and pricked off in the same manner.

A. BROTHERS

EXPEDITION OF THE "DUQUESNE"

M. RICHARD, master in the Royal Navy, directed the Expedition, and is now attached to the Lille aëronautic station for the Department of the North. I have interrogated him and elicited from him the following details, which can without inconvenience be placed before the eyes of the general public. The French Republican Government having in view the promotion of general knowledge, as well as the defence of the national integrity, did not object to any communication which is not directly connected with warfare.

The aërostat, "Le Duquesne," was despatched from Paris on January 9, at three o'clock in the morning, before a large attendance, among them some members of the French Institute. The

Similar to his first article, Brothers started by apologizing to the readers for the mistake, and then went on describe what had gone wrong. "Permit me to call to your attention the position of the woodcut illustrating my remarks on the Eclipse Photographs. The south point is where the north should be," he wrote. He then finished his paragraph by saying "as what I have now to say refers to the picture I shall feel obliged if you permit me its reinsertion in its true position."[51] In this preamble, Brothers pointed to the image's importance to his argument while at the same time undermining the value of the object on the page; one could not, necessarily, always trust the image on the page to be reproduced correctly. The image needed to be re-presented to the reader because if he left it unchanged he (and his image) could have come under scrutiny for its value and because it was a necessary visual aid for the continuation of his argument.[52] However, the reproduction of this photograph is also an example of the value of the visual object: only when read with the text, set outside of the boundaries of a single issue and interpreted though the aid of reproduction, could it be considered as authentic scientific evidence.

Brothers' emphasis on photography over drawing is stated unambiguously later in the article when he compares the value of eclipse observations made by hand and those made by photographs:

> Naked-eye drawings ought to be as valuable as photographs, but I doubt two artists will ever be found to make sketches agreeing in every particular. On photographs must we depend for settling doubtful points of this nature [the solar corona], and it seems to me in this case to be absolutely settled that three rifts are identical.[53]

Brothers valued photographs not for their inherent mechanistic worth over drawings, as many drawings were produced during the Syracuse expedition, but rather the way they dealt with contested sites of observation, that is, whether or not the solar corona had rifts and, if so, how many.[54] While drawings "ought to be" as useful as photographs, the reality was that when it came to questions on the observation of precise details on an image, the photograph was placed above a drawing as a mode for authentic, and verifiable, visualization. The chain of translation relied on photography being the point of origin, not drawings.

Final support for Brothers' claim to scientific authority can be found in *Nature*'s letters to the editor, where the magazine offered space for contested subjects. In this section, issues such as the prominences of the corona were debated by the reading community, and the section as a whole acted as a space for authors to redirect controversial points.[55] Due to this dialogical aspect, "letters to the editor" offers a fruitful venue for assessing the reader response to a particular issue (albeit a response from a very specific community).

Over a period of two months, between May and June 1871, Brothers entered into a debate with Mr. D. Winstanley over the validity of his photographs. The only information Winstanley gave about himself was a vague biographical note that he was "an ardent and not inexperienced votary of photography" from Manchester.[56] Winstanley does not turn up in the archives of nineteenth-century photographers, or scientists, and it is likely that he was an amateur photographer, probably a gentleman, who used the pages of *Nature* to extend a debate about the uses of photography for astronomical science. The public correspondence between Brothers and Winstanley represents the struggle for authority between a professional and amateur in the astronomical community during the last quarter of the nineteenth century.[57]

The dialogue between Brothers and Winstanley primarily revolved around the usefulness of photography in advancing astronomical science. In his first letter to *Nature*, Winstanley argued that "I cannot myself look with any very great degree of satisfaction upon the photographs of the late solar eclipse either as examples of photography or as evidence contributing to our knowledge of solar physics."[58] His justification for this was that Brothers' photographs were inconclusive because he had personally observed the Sun on a clear cloudless day when the Sun was not eclipsed, and at that time, had witnessed a solar corona which must have been the result of the Earth's atmospheric moisture.[59] Here Winstanley was using his own personal observation to undermine the image and evidence of Brothers.

Brothers' response to this attack on the authenticity of his photographs was to reaffirm the primacy of photography in the chain of translation. Attacking the center of Winstanley's argument, Brothers wrote back: "It would have given me much pleasure to have shown Mr. Winstanley the original negatives of the photographs of the late eclipse of the Sun if he had called on me to see them, and by so doing he would have avoided falling into the mistakes which his letter contain."[60] The wood engravings that adorned Brothers' first two articles were valuable as objects of visual reference. If the images were contested, it was necessary for the critic to trace the chain of translation back to the original mode of production, and at that point the evidence would be visually authenticated. This visual and authorial position was particularly suited for a scientific reading audience (as opposed to a general reading public). For Brothers, the photographic image was a fundamental technology of visual validation for his theory of the corona of the Sun, which he replicated through the chain of translation; for Winstanley, the image—however it was reproduced—mattered not. In a context where there was a developed and active knowledge community, and constant public correspondence, the image presented to the reader did not need to be authentic, as long as the chain of translation was evident and led back to the photographic referent.

Henry Baden Pritchard

In ways similar to Brothers, Henry Baden Pritchard was a man on both the inside and outside of the scientific community in the latter half of the nineteenth century. Pritchard was born into a family of opticians and instrument-makers in 1841 (at the beginning of the introduction of photography and photographic science). He followed a career path very similar to that of Lockyer, working for most of his life in the War Department as a photographic advisor, while at the same time immersing himself in both the scientific and professional photographic communities. By the 1880s, he was both a fellow of the Chemical Society and the editor of one of the earliest photographic periodicals, the *Photographic News*. Before editing that journal, he published articles in numerous scientific and popular periodicals, such as *JPS*, *Chemical News*, and more specifically, *Nature*.[61] As has already been pointed out, he also played an important role in the Photographic Society where he acted as the society secretary and defender of photographic science. Finally, Pritchard also published two important books on photography: *Beauty Spots on the Continent* and *The Photographic Studios of Europe*.[62] Pritchard was therefore a man with influence in the scientific, professional, and editorial world of photography in the late nineteenth century. Operating in these textual, social, and professional spaces, Pritchard worked to legitimize photography as a valid scientific pursuit and subject by three means: a visual argument for photographic authenticity; a textual argument for the establishment of a history of photographic science; and establishing the connection between the development of the chemical production and printing methods of photography.

In the first decade of *Nature*'s publication (1869–1880), and just prior to becoming the editor of the *Photographic News*, Pritchard published ten articles in *Nature*. The first four were related to the development of photography as a science, and the latter six were on the application of science to war.[63] The first four articles, published between 1872 and 1873, indicate Pritchard's entrance into the scientific community on a subject that he would later publish widely on in *Photographic News*. A comparison between Pritchard's discussion and use of images (or lack thereof) in both his articles in *Nature* and his editorial control of the *Photographic News* will help illuminate how the content of the material published in these periodicals dictated varying visual modes in competing periodical genres. Pritchard's discussion of photography in *Nature* circulated around three central concerns: the use of photography for science, the development of a history of photography, and the applications of photomechanical printing processes. All three of these concerns reinforced his argument for the inclusion of photography as a legitimate science. Yet none of these arguments were made visually in *Nature*, and instead were short, articulate, textual arguments.

Soon after Pritchard started contributing articles to *Nature* he presented readers with a two-page article on "Photography as an Aid to Science." The article

detailed the development of photography and the important role that it played in scientific investigation. In one particularly revealing passage, Pritchard argued that "the accuracy and fidelity with which the pencil of light performs its functions, combined with the facility with which such reliable records are obtained, make photography indeed one of the greatest boons at the disposal of scientific men."[64] This statement is intriguing; it enforces the value of photography for the future of science, while at the same time alluding to the development of photography by invoking the title of William Henry Fox Talbot's (1800–1877) book, *The Pencil of Nature*.[65] Talbot was the inventor of the positive/negative paper photographic process, and *The Pencil of Nature* was the venue through which he presented this new process. While questions over the value of photography as a tool of accurate visualization were of key concern in the 1870s, by using the term "pencil of light," Pritchard was reinforcing the long history that photography already had, while at the same time demonstrating that this "pencil of light" was imbued with "accuracy and fidelity."[66]

After establishing the value of photography generally, Pritchard then spent the rest of the article outlining the specific value of photography within certain disciplines of science: astronomy, medicine and microscopy, and physiology and spectroscopy. Within each of these sections, Pritchard was careful to point out the value of photography to the collection of "proofs" and "data" of each specific discipline. For example, speaking about medicine and microscopy, Pritchard argued that "the large, clearly defined diagrams of microscopic objects and medical preparations [made from photographs], which we are wont to see at many school and colleges, cannot be prized too highly forming as they do the best and most reliable proofs in support of facts and data, and being indeed of value alike to the professor as the student."[67] The photograph therefore operated in the microscopic world of the body to bring the scientist verifiable proofs and data.[68] Moreover, all of the examples that Pritchard gave within this article related to picturing the very small, the very big, or the unseen.[69] The photograph was for Pritchard a useful aid to the advancement of science, especially for those disciplines where photography could act as a mechanical tool for the observation of objects and data that were not visible or verifiable with the eye alone.

Although photography had great importance for science at the time when Pritchard was writing his article, in order to reinforce this credibility, he needed to demonstrate a cultural value for photography as well. Pritchard achieved this by creating a scientific history of photographic development. The creation of a history for photography was in many ways similar to the work of Proctor, discussed in Chapter 5, to relate astronomy to historical observation. By creating a history of observational practice through photography, Pritchard was legitimizing the science of photography in the 1870s.

In a short, separate article located adjacent to the section for "letters to the editor," Pritchard made one of his first forays into *Nature*. Under the title "The

History of Photography" Pritchard argued for the commemoration of Abel Niépce de St. Victor (1805–1870) as a central character in the history of photography.[70] While there were many commemorations in *Nature* of people like Talbot and John Herschel—both Englishmen who significantly aided the development of photography—there was a general lack of interest in French inventors such as de St. Victor and Louis Jacques Mandé Daguerre (1757–1851).[71] In this article, Pritchard was also advertising the collection of de St. Victor's plates that were in the possession of de St. Victor's wife who was in dire financial straits after the death of her husband. The plates, according to Pritchard, were subsequently sold to the Photographic Society where interested parties could investigate them. Similar to the debate between Brothers and Winstanley, Pritchard was telling the readers of *Nature* that if they wanted to see the photographic evidence of de St. Victor, they could visit the Photographic Society and see the positives first hand. Thus for Pritchard, this article was a place not only to expand upon the history of photography but also for advancing the collection of the Photographic Society.

The third theme that Pritchard advocated in his writing was the development of scientific authority and photographic history with the intersection of print technology. In his first article in *Nature* Pritchard described the "Photographic Processes of the Day." This article was entirely dedicated to the discussion of printing processes and paid little attention to the actual process of capturing photographs. The article began by stating:

> The last two or three years will certainly mark an era in Photography, for not only have several novel and important printing methods been discovered during the period, but other processes of less recent origin have of late been so elaborated and improved as to have become at the present moment practical and easy of manipulation.[72]

Pritchard was here setting out photography as a mechanism with continual and perpetual improvements—a process which was developing with greater and greater speed, creating better ease of use and wider application of photographic practice.

After discussing the processes by which photography could be printed for personal and professional use, Pritchard then moved toward the application of photography in the periodical press. Pritchard stressed that "by far the most important of all methods yet discovered is the Woodbury engraving process. So simple, and at the same time so perfect in its work, a casual observer cannot but fail at once to appreciate its value."[73] By reinforcing the value of photography to the printing press, within a space that used the very process he was discussing, Pritchard created a type of chain of translation, a chain that did not need an image, but instead reinforced the chain through a solely textual discussion. Pritchard was tracing the chain of translation from photography's use, history, and

production within the periodical press to reinforce the value of the photographic referent. Moreover, he was saying that if a reader wanted to witness the history of photography they could view de St. Victor's original plates in the collection of the Photographic Society and complete the chain of translation. The only difference was that the reader did not need to trust the form of image reproduction, but only the narrative arc of Pritchard's prose. Set alongside the other articles, Pritchard created a narrative for photography that reinforced the use of photography in the press by articulating both its history as an instrument of observation and its development as a science and *for* science. Furthermore, this narrative worked to reinforce the authenticity of photography without ever showing an image.

Pritchard continued to utilize this textual chain of translation when he became the editor of the *Photographic News*. In one of his serial articles, which occurred frequently throughout the pages of the journal, Pritchard dedicated one of the sections to "Photography and Woodcutting." In this section Pritchard reiterated the textual chain of translation in the art of photographic reproductions:

> Amongst the many applications of photography to the arts there is none that has so silently—and we may, systematically—made a way into the trade as that of aiding the wood-engraver in his work. In at least one of the scientific periodicals of the day we know that many of the most complicated diagrams have been printed by photography on the block itself, and thus eliminated all chance or error arising from the imperfections of the draughtsman's copy.[74]

Through this textual point, Pritchard was not only demonstrating the "lack of error" in the chain of reproductive translation, but he was also reinforcing this chain within "at least one scientific periodical." Given that *Nature* was the most important scientific periodical at the time when he was writing, and that he had been a regular contributor to its pages, it is safe to say that Pritchard was referring to *Nature* in this quotation. Through this casual discussion in a serial article, Pritchard was thereby reinforcing a textual chain of translation that could be read both in a single article and across different periodicals. The way in which Pritchard demonstrated photographic authenticity speaks to his position within the scientific community: he did not have the observational data to prove his scientific worth, so instead he focused on journalistic modes of narrative composition to articulate a place for photography within scientific periodical publication.

Warren De la Rue

While Brothers authenticated photography within *Nature* through the use of photographic images, and Pritchard authenticated it through the creation of journalistic and professional connections between science and photography,

photography was also used in *Nature* as a method for scientific observation and a tool of scientific proof. And while Brothers and Pritchard struggled to authenticate both their position in the scientific community—and the authenticity of their images—scientists who already operated within the community presented claims to scientific evidence through photographic means in very different ways. Following the serial production, placement, and visual and textual organization of a single experiment within *Nature*, which presents photographic authenticity through a member of the scientific community, will further elucidate the multivalent categories of photographic trust produced within the pages of *Nature*.

In 1878, Warren De la Rue (1815–1889) and Hugo Müller (1833–1915) wrote two articles on "The Electric Discharge with the Chloride of Silver Battery" which appeared in *Nature* over a three-week period in June. De la Rue was born into a family of printers and stationers and later took over the family business.[75] But De la Rue would not stay confined to the life of a printer. Soon after the completion of his education, he entered into the scientific community through his work on solar photography in the 1860s, becoming the president of the Chemical Society, a fellow and winner of the gold medal from the RAS and a fellow and winner of the royal medal from the Royal Society. In addition to his associations with these institutions, he played an instrumental role in the assessment and use of photography to record the Transit of Venus in 1874.[76] Hugo Müller, on the other hand (who was also a fellow of the Royal Society), was De la Rue's assistant and worked as a chemist and consultant in the dyestuffs industry.[77] With experience in astronomy, photography, chemistry, and instrument-making, and connections to the scientific community and their societies, De la Rue and Müller were able to publish within the pages of *Nature* with an established scientific authority—an authority which reinforced their application of photographic authenticity.

The articles on electrical discharges by De la Rue and Müller are particularly compelling for a number of reasons. The experiments they performed were based on an examination of electrical discharges within glass tubes filled with gas. The discharges were photographed and the subsequent visual configurations of the discharges were measured and compared. The purpose of their experiment was to prepare a series of photographic data in order to develop a theory of the stratification of the discharges when passed through rarefied gas. The experiments were conducted by comparing photographic images of discharges made across a long series of individual tubes.[78] De la Rue produced hundreds of these electrical discharges and subsequent photographs and evaluated each discharge in relation to its size, spatial organization, and comparative value to the rest of the data. Within these experiments, photography played the critical role of capturing the visual data which could not be captured by an individual observer. The examination of the unseen through photography was of key importance to science in the late nineteenth century and has received considerable analysis within the historiography of science and photography.[79]

Ramalingam has argued that De la Rue and Müller's experiments should be understood as a long series of experimental observations that operate as scientific evidence only when analyzed together.[80] The experimental process is not the only type of seriality present within these observations: their textual and visual reproduction in print, and across print, add a secondary layer of seriality that reinforced the authenticity of their experimental data. "The Electrical Discharge with the Chloride Battery" operated as a serial textual document in two distinct ways: first, as an article appearing over a series of weeks in a periodical; and second, as a textual document operating across separated print genres and mediums. Moreover, the reproduction of De la Rue and Müller's experiments in *Nature* through a set of photographic images represents a departure from the serial presentation of this experiment in the *Philosophical Transactions of the Royal Society* (*Phil. Trans.*) and operates on a different level of visual evidence in the context of periodical print production. Leaving aside the inclusion of the visual argument in these articles for the moment, an analysis of the two textual forms of seriality will help contextualize the spaces, places, and mediums through which De la Rue and Müller authenticated their experiments to a scientific reading audience.

"The Electric Discharge with the Chloride of Silver Battery" first appeared in *Nature* on June 19, 1879, as a five-page article and was completed one week later with another five-page article.[81] The analysis of these articles requires a reading across the temporal makeup of the journal. In order for De la Rue and Müller to prove to the readership that their images of stratified discharges were valid, their argument needed to be separated from its temporal disjunction, and for the multiple articles and images to be read together. The periodicity of a journal like *Nature* and length of their experiment itself necessitated a disjunction of their argument. This separation, though not an aspect of the experiment, makes for a distinct reading of this text. The first article, which contained nine figures and one full-page facsimile of photographs (which will be discussed in detail later), did not contain any analysis of these images. Instead the textual argument for these images was made in the following article, thus targeting a certain readership (one which subscribed to the periodical and read it each week), as well as indicating the purpose of the image (as ancillary to but separate from the text). This temporal separation of the textual argument, although not unique, augments the way the readers would have interacted with the evidence being presented to them.

Moreover, to read the full context of De la Rue and Müller's article is to move beyond the confines of a single journal—a reader had to move across print genres. The first appearance of this paper was in the *Phil. Trans.*, a periodical that had a much smaller circulation and readership than *Nature*.[82] While the textual structure of the arguments in *Nature* and the *Phil. Trans.* is similar—in that they were separated into two articles—the temporal break between the articles is significantly different: the first part of the article appeared in the *Phil. Trans.* as the fifth issue of the year while the second did not appear until thirty pages later

(positioned as the seventh issue).[83] Moreover, the articles in the *Phil. Trans.* were physical referents to auditory lectures given at the Royal Society. The temporal separation between these lectures is even more distinct than the textual break; the first lecture was given on December 13, 1877, with the second on May 16, 1878. The disjunction between the presentations of these textual arguments within the *Phil. Trans.* was thereby reinforced by the disjunction in their auditory presentation that was communicated to readers by announcing the date of the lectures on the title page of each issue.

Finally, the seriality of the textual argument in the *Phil. Trans.* varied from that of the articles in *Nature* in size and content. While *Nature* contained short, concise articles positioned within the narrative of a weekly journal set alongside contrasting articles on various scientific subjects, articles containing the same argument in the *Phil. Trans.* were separated from any other arguments, were not periodically distributed, and were each well over sixty pages long. The articles presented to the reader in *Nature* thus constituted a very different notion of seriality from that of the *Phil. Trans.* While some of the readers of *Nature* may have read or attended the original lecture at the Royal Society, others would not have been equally informed. The presentation of these articles within *Nature* as a legitimate scientific argument was buoyed by its association with the *Phil. Trans.*, but the textual organization of this article operated through its production in multiple print genres and through its serialized production across time to create a sense of scientific authority.[84]

The other main form of seriality within "The Electric Discharge with the Chloride of Silver Battery" pertains to the organization of the visual space within the articles. Similar to the textual argument, the images operated as serial objects both in terms of the referents within the images and the way in which the images were reproduced. The most striking example of seriality within these articles is a facsimile of photographs of a set of discharge striations[85] (Illustration 2.10). These photographs mark the first time that *Nature* reproduced such a facsimile— probably a photolithograph or screen print—which allowed for a photographic negative to be developed directly onto a lithographic stone and printed without the mediation of a lithographic artist.[86] Similar to Brothers' wood engravings, this image presents the chain of translation that leads the reader to the authenticity of the source referent (as indicated in the caption "fac-similie of photograph"). In contrast, however, the modes of translation in this image reinforce the authenticity of the photograph. The intention is that the reader will follow the image as a series of photographic productions, leading back to the original source negative. These photographs therefore operate as both a break from and a corollary to the seriality of the article and of the images.

Ramalingam has pointed out that the individual images within this photograph represented a shift in the theoretical understanding of electrical discharges. Prior to De la Rue and Müller's experiments it was believed that the discharge was one continual mass. However, the photographs presented in their article demonstrated

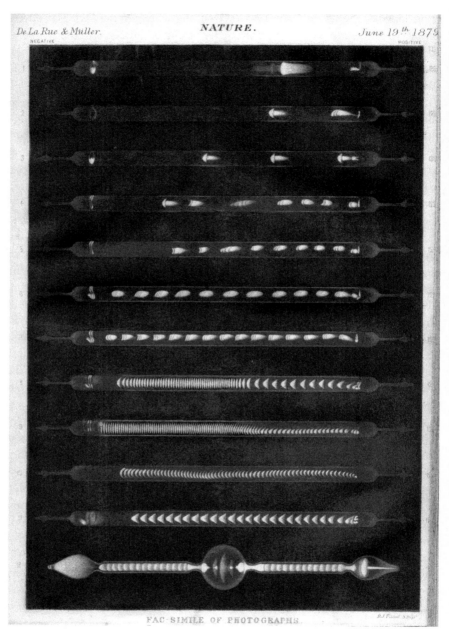

ILLUSTRATION 2.10 Screen print—photography by W. De la Rue and H. Müller, and printing by D.J. Pound, "Fac-Similie of Photographs," *Nature*, 20, no. 503 (June 19, 1879): 176–177. Reproduced by permission of the University of Leicester Library.

that the discharge was actually a sequence of temporally separated masses of energy. Importantly, as Ramalingam has pointed out, this discovery was made through two devices: a rotating mirror and a photographic camera.[87] Before even being printed on the page, the photograph itself represented the serial organization of electrical particles.

The reading of this image necessitates an understanding of its placement within the text. Because it was a lithograph, it was separated from the pagination and narrative of the article and placed on an individual sheet of hard paper and bound between the third and fourth page of the article. By placing this image outside the boundaries of the sequence of the article, it separated the photographs from this seriality.

This separation outside of the boundaries of the article reflects the transitory position of the image itself as a claim to experimental veracity, but this claim needed to be communicated to the scientific community in order to establish this credibility. The placement of the images in a periodical situates the trust claims of both the experiment and the photographic image in a very different context from that of its reproduction in the *Phil. Trans.* In the popular scientific periodical, the photograph held value when the chain of translation could be traced. De la Rue and Müller's images therefore became important not solely for the serial organization of the experiment and its association with other reproductions of the experimental images in different spaces—though this does help the credibility of the image and argument—but in knowing that all individual striations represented in the reproduction were "from photographs," and even more importantly in this instance as "fac-similies." Within *Nature*, these photographs still operated as a constituent part of the article because they were interlaced with, and in a sense broke up, the text. The same image in the *Phil. Trans.*, however, was completely separate from the text and placed at the back of the volume.[88] Thus, for *Nature*, the image operated both inside and outside the serial nature of the article, while in the *Phil. Trans.*, it was ancillary to it.

An analysis of photographic authenticity within this article would be incomplete if one were to solely examine the photographic images. Instead, a deeper understanding of the place of photographic trust can be garnered by evaluating the "image interplay" or the interaction between multiple modes of visual reproduction within a single textual space. De la Rue and Müller's article included three different types of images: the photographic, the line drawing, and the illustrative.[89] The first category is the photolithographs already discussed above, while the second and third are wood engravings. What distinguishes the two latter categories from the first are the information held in the image and the level of detail of the engraving (Illustrations 2.11 and 2.12). Illustration 2.11 represents two line drawings: fig. 15 indicating a "tongue form" toward the positive end of the tube; and fig. 16 representing strata toward the positive end of the tube. Illustration 2.12,

FIG. 15.

the negative glow; G and C disappeared in the strata, and F was very faint.

Tube 139, *Hydrogen.*—Pressure 6·319 mm., 8,314 **M,** 8,040 cells. Three arrow-headed luminosities as depicted in Fig. 3 in the Plate, copied from a photograph and a drawing made at the time. The photograph was obtained in 2 seconds.

Pressure 9·502 mm., 12,526 **M,** 6,960 cells. One luminosity of which a photograph was obtained in 10 seconds but has not been copied. Another photograph obtained

FIG. 16.

ILLUSTRATION 2.11 Wood engraving—"Fig. 15 and Fig. 16," *Nature*, 20, no. 504 (June 26, 1879): 201. Reproduced by permission of the University of Leicester Library.

on the other hand, represents a detailed engraving of the mechanism (the rotating mirror) through which this phenomenon was observed.

While these three different types of images contained various types of information, the reading of these images necessitates an understanding of their interplay. This interplay was communicated to the reader through the textual narrative given to these images. For example, when describing fig. 15, De la Rue and Müller move from examining the image to a justification of their means of observation:

> With 174000 ohms resistance, making with the battery and tube a total of 261,000, the current measured was 0′00879 W. The strata turned pink and assumed the tongue-form. Fig. 15 … In the rotating mirror a flow *towards the positive* was observed until a break occurred in the stratification; the flow was then irregular and backwards and forwards. [emphasis original][90]

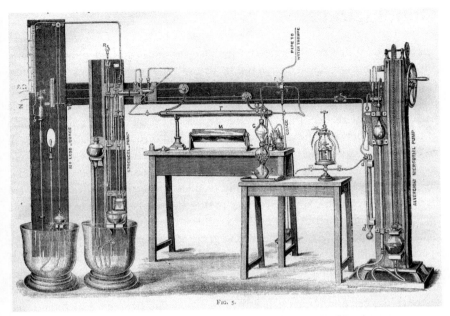

ILLUSTRATION 2.12 Wood engraving—"Fig. 5," *Nature*, 20, no. 504 (June 26, 1879): 175. Reproduced by permission of the University of Leicester Library.

The observational value of the rotating mirror had already been established to the reader in the previous article when a detailed outline of the operation of the machine was discussed. Illustration 2.12 operates as a detailed (not line) drawing of the intricate mechanisms of the device. The reader gained a further understanding of this instrument by examining the text that guided him or her through the image by means of letter markers placed on the image. Not only was the visual content of the engraving more detailed, but the image encoded visual iconography before moving back to the original referent. Thus while the images required a chain of translation, the argument of De la Rue and Müller was reinforced though a textual connection and textual data.[91] The line drawings in Illustration 2.11 authenticated De la Rue and Müller's experimental observation only when viewed in association with Illustration 2.12.

There was also a secondary interplay between the photographic images and the line drawing. While each of the photographic images represented a full temporal sequence of the striation (moving from the positive current to the negative), the line drawings represented a "snapshot" in time and on the tube. The line drawings were therefore a constitutive part of the visual authentication of their observation. While the photograph represented the whole, the line drawing represented a part. The chain of translation in this instance moves between the images, the perceived scientific authority of the authors, and the places in which they were published.

Conclusion

The ways in which the illustrated scientific periodical utilized photographs to authenticate observational data in the 1870s and 1880s were complex, conflicting, and based on individual editorial and authorial preference. Nevertheless, photographs were used in the pages of *Nature* to validate the scientific evidence presented to the reader. This validation depended on the reliability of the chain of translation between the photographic source and through the varied modes of reproduction. At the end of the century, reproductive techniques were sufficient to allow the photographic image to stand on its own, but in the 1870s and 1880s, an image produced in *Nature* was only credible if the chain of translation led back to a photographic source. Further to this, the source needed to be available for inspection upon request in order to validate the chain and the observational data. Finally, the readership, content, and genre of the periodical helped direct the specific ways in which photographic authenticity was utilized. The application of photographic authenticity in *Nature* differed significantly from that of *Knowledge*, the *JPS*, the *Photographic News*, or the *Phil. Trans*. Even within the same periodical genre of the scientific press generally, the use of photographs, and their serial placement within the text, differed, depending on the intended audience and the perceived intent of the editor. Photographic images within the periodical press in the latter half of the nineteenth century therefore underwent considerable change in the way in which they were used.

SECTION TWO

PHOTOGRAPHIC TRUST IN USE

3 THE PIGEON, THE MICROPHOTOGRAPH, AND THE HOT AIR BALLOON: TECHNOLOGIES OF COMMUNICATION

Photography is more than a technology of representation. It was embedded in processes of image production and reproduction in the nineteenth-century press and was enmeshed in questions of conservation—of information, of objects and places, and of historical and political events. Photography was also, crucially, a technology of communication.[1] It allowed for objects and information to be moved across space. In many similar ways to discussions of traditional technologies of communication in the nineteenth century—the telegraph, the telephone, and the railway—photography shrunk space and time and brought visual objects to diverse audiences within relatively short periods of time. The association of photography and time, in this instance, is crucially different from the discussion of the production of photographs and instantaneity.[2] When photographs moved across space, in an example like the Siege of Paris during the Franco-Prussian War, the veracity of the photographic image was not at stake. Instead what was valued was how the photograph could shrink information, allow for it to travel, and be reproduced both for individuals and within the periodical press. The photograph, in this chapter, is not a representational object, but instead becomes a data object—a technology which can shrink information and allow it to move.

In the winter of 1870–1871, the periodical presses of England were filled with news of strange events. There had been war in Europe for the past six months, and Paris was besieged by Prussia. Nothing could get into the city, and nothing could get out—or so it seemed. Amid the stories of the Siege of Paris

pervading the periodical press lay a set of technologies that operated to affect the processes of communication and which were simultaneously topics of that communication. These technologies are at odds with the typical narrative of technological communication during the nineteenth century; they are not the telegraph or the telephone or the railway. They were the pigeon, the air balloon, and the photograph. Together these three technologies allowed for news, letters, periodicals, and objects to move outside of Paris and back in again. Moreover, the stories told about these three technologies in the periodical press—and later in books—were dependent on each other for information about the siege, but also for the forms of communication that the information took. Photography in particular, within this triumvirate of technologies, acted as a key tool of information movement and visual codification. In narratives about the production of photographic instantaneity, discussed in Chapter 4, time became a fundamental object embedded in the image; for the example of the Franco-Prussian War, the photograph shortened time by allowing for news to travel. While news traveled more slowly by photograph, air balloon, and pigeon than by telegraph line, it did still travel. Tracing its movement provides a vantage point for evaluating photographs as temporally and spatially shifting objects, rather than static images locked in space and time. The photograph, in this story, is fundamentally a material object—a glass plate, a paper negative, a projection onto a screen, and an image in print. The information these images captured became valuable only through their movement across space. The meaning for the photograph in this instance changed not only when it moved into print, but also by way of its physical movement out of Paris.

When photographs traveled, they often ended up in odd places. One of these odd places was the diary of Lady Anne Blunt, Baroness of Wentworth.[3] In her diary, the role of photography as a tool of communication and transportation and its association with the periodical press is particularly evident. Similar to the protagonist Swithin St. Cleeve in Thomas Hardy's *Two on a Tower*, who had to travel around the world to make his astronomical observations, the reproduction of stories about people, objects, and images in the periodical press was often circumscribed by showing the foreign—whether French or otherwise. The Franco-Prussian War, pigeon, periodical press, and hot air balloon were foreign objects for Lady Blunt, as we will see, which were normalized and reconstructed through her diary.

Lady Blunt, the granddaughter of Lord Byron, wrote a particularly valuable diary throughout her lifetime. With a particular interest in science, specifically the science of horse breeding, and a keenly developed eye for the visual, Lady Blunt filled her diary with drawings, scraps from newspapers, photographs, diary entries, and mementos of her travels.[4] In so doing, she was participating in an action of Victorian female agency. She was, according to Patrizia di Bello, producing a "crucial site in the elaboration and codification of the meaning of photography,

as a new, modern visual medium."[5] In the making of this scrapbook, Lady Blunt was able to conceive of science and society through her own particular lens. At the same time, this lens was inescapably tied to the iconography of nineteenth-century print culture. Her diary therefore offers a particular vantage point from which to view the interweaving of photography, imagery, print culture, and popular science within the fabric of a personal narrative.

Looking more closely at Lady Blunt's diary necessitates a better definition of what she was making. "Diary" tends to ignore the multiple forms of visual and textual entries that she made; rather, it falls much more accurately under the definition of a scrapbook rather than a diary.[6] Lady Blunt's scrapbook-diary is both a daily narrative of the life of an aristocratic family in the nineteenth century and a compilation of pieces of information and images collected from the world outside of the Wentworth estate. This particular aspect of her scrapbook-diary is an example of the interaction between the visual and the textual, the quotidian events of the individual, and the daily events of national and international news. Lady Blunt's scrapbook-diary is a single place where space and time collapsed and were reconstructed into a unique visual and textual object.

Within the visual and textual content of her scrapbook-diary, Lady Blunt wrote primarily of current affairs and of the daily activities and concerns of her life and her husband. These concerns were particularly excited in the first quarter of 1871 when Paris capitulated to the Prussians after the Siege of Paris.[7] For a Victorian Lady, there was plenty to write about in local and national affairs. Among other things, the scrapbook-diary discussed both personal opinions about the war as well as information sent from the war itself. In one entry on February 25, Lady Blunt wrote that "[w]e got a letter from Julia dated 21st—it has been quick—she says there is yet no coal nor no wood, at Paris and 'Je sortier' today to get some but it is always the same. 'Toujours les courses inutiles.'"[8] Although the identity of Julia is unknown, it is clear that Lady Blunt was getting her news about Paris from sources other than the newspaper.

What is particularly interesting about the above scrapbook-diary entry is that Lady Blunt was receiving any letters at all from Paris during the war. While it is unclear how she received this letter—whether by balloon post or otherwise—she was certainly aware of the use of balloons, pigeons, and photography to send information out of the city during the war. In a journal entry three days later, Lady Blunt wrote about a trip to London to prepare for a voyage to Spain. While in London she stopped at the shop "Chanots," seemingly for news rather than for a purchase. She wrote, "Chanot said he had had five balloon letters from Paris, where his son a boy of 13 was during the whole of the Siege."[9] While Lady Blunt was not directly affected by the war or the siege, it is clear from her scrapbook-diary entries that she took a strong interest in the conditions of Paris during the siege and that she relied on the technologies that were allowing for messages and information to be communicated.

After the end of the war, Lady Blunt's interest in the siege, and the photomicrographs used during the siege in particular, remained. A few days after her trip to Chanots, she picked up a memento of the war at the London train station on her way to the seaside, before she sailed on to Spain. The memento was a small card (approximately 10 centimeters × 6½ centimeters) containing a photomicrograph sent into Paris during the siege (Illustration 3.1). The photomicrograph, which displayed a page of the *Times*, was placed in Lady Blunt's scrapbook-diary without

ILLUSTRATION 3.1 Diary page of Lady Blunt with photomicrograph—March 2, 1871. © The British Library Board, Add. 53834 f283.

any more discussion than the details of where she had purchased it.[10] After the war, this specific photomicrograph took on a very different meaning from its original use: it became separated from its value as an object of communication and turned into a representation of the war itself. The photomicrograph was removed from its technological origins and its use in a periodical and became instead an object of curiosity situated in the private scrapbook-diary of Lady Blunt.

Even though this photomicrograph was removed from its context of use, the memento still retained a connection to photography and pigeons as technologies of communication. Surrounding the photomicrograph was written:

A Pigeon's letter. A MEMENTO of the GREAT WAR of 1870–1 when Paris for several months, depended solely on the carrier pigeons for all information from the outer world. The TIMES containing several columns of French Advertisements to Relatives in Paris. [photomicrograph] This Photograph was sent to M. Gambetta for Transmission by Pigeon from Bordeaux. When received in the Bureau at Paris, it is magnified by the aid of the Magic Lantern, to an enormous size and thrown upon a screen. A staff of clerks immediately transcribe the messages, and send them off to the parties indicated.[11]

With this inscription, the periodical takes center stage both as a place for the reproduction of this photomicrograph and as a technology of communication. Moreover, this photomicrographic object was not meant to be read for its content. The only thing discernible in it is the title of the *Times*, and the rest of the image is invisible to the eye. As this object is actually a photomicrograph itself and could possibly be read if placed under a microscope or magic lantern, the fact that it was pasted to a white card removes the possibility of reading this object as originally intended. Rather, this memento in Lady Blunt's diary is a visual and technological object of memory.[12]

This photomicrograph, and Lady Blunt's scrapbook-diary more broadly, are useful for tracing the way in which photographs moved, both in terms of physical objects and as objects of reproduction. While images of the war were largely produced through the periodical coverage of the event, the technological object of the photomicrograph had a wider life than its reproduction in books and newspapers. After the war, some of the photomicrographs used during the siege were sold as mementos. Susan Stewart argues that a memento is built around notions of materiality and temporality; we only seek mementos that represent events that are inherently unrepeatable and were lacking material representations.[13] They act to bring the ephemeral and the fleeting moment into the concrete, in similar ways to the periodical. The particular memento of a photomicrograph in Lady Blunt's scrapbook-diary was more than just a pretty object to remember an event in her lifetime. It was an object embedded in various print media which represents an alternative context of the use for pigeons, photographs, and hot air balloons after

the war. They were not just communication technologies, but objects in print and in picture that held a moment of time.

Balloons, pigeons, hot air balloons, and the periodical press

Discussion of travel and communication in the nineteenth-century periodical press was inherently tied to notions of space and time. Photography was a technology that visualized space but also shrank it—making a large amount of information into small, mobile amounts of data. This alternative narrative allows for a reexamination of photography outside of its traditional conceptualization within the histories of art and science. Photography, in situations of communication, cannot be decontextualized from the technologies that are associated with it. In the first half of the 1870s, photography was discussed both in the periodical press and in popular scientific literature as a technology that allowed for information to travel when it otherwise would not have.

The other two technologies in this historical incident are also tied to notions of time and space. The pigeon was an important subject of scientific experimentation in the late nineteenth century and was of particular interest to Étienne-Jules Marey and his investigations into animal movement. The pigeon was also a tool of communication: the carrier pigeon acted as an occasional transmitter of information throughout the nineteenth century. The hot air balloon, similarly, was a topic of scientific and popular interest and was the subject of investigation concerning the aerial movement of people and objects across space. The balloon, pigeon, photograph, and periodical were all serial—they simultaneously moved and represented movement and were tied together in this seriality. Thus, we cannot understand them without contemplating their seriality. This chapter is therefore an examination of the extraordinary, both in terms of historical locations and also in terms of the ways in which objects in this narrative get used—in particular it is a story about how three technologies of scientific investigation and communication interacted and produced information within varying forms of print.

The pigeon post in the periodical

In the summer of 1870, France and Prussia entered into war, with the escalation of tensions between the two countries beginning after the swift defeat of Austria in the 1866 Austro-Prussian War.[14] War did not necessarily come quickly, but it did end in the decisive defeat of France after the Siege of Paris between the middle of

September 1870 and the end of January 1871. The defeat of the French has been lauded as a technological success, a defeat aided by the railway, the telegraph, and the new machine gun.[15]

The Siege of Paris also represents an important juncture in reexamining the use of technologies of communication and the histories created around them. The telegraph and the railway were seen to shrink time and space by fundamentally shifting the speed at which information traveled.[16] In the nineteenth century, the postal system (which had typically carried the news and correspondence of governments, corporations, and individuals alike) became associated with machines that allowed for a much larger proportion of the population to have access to information.[17] In particular the telegraph—which had recently connected North America and Europe through the transatlantic telegraph cable—was again shifting the speed and frequency of communication. The effective removal of the postal system from Paris highlights an unstable moment in what was considered a stable technological object.

During the Siege of Paris, these technologies were cut off, forcing the inhabitants of Paris to find alternative forms of communication. David Edgerton argues that in times of crisis there is often a use of what he calls "reserve technologies"—older technologies that regained their use.[18] The technologies mobilized during the siege were not, however, just old technologies used in a new way. Instead they were a mixture of old and new technologies made to overcome the logistical issues of a specific problem. When the telegraph and the railway failed, the carrier pigeon, the photographic camera, the aerial balloon, and the print press were used together to overcome Paris' spatial separation from the rest of the world. It was through alternative technologies, each affected by time and space in different ways, that Paris regained contact with the external world.

With the city surrounded by Prussian troops, there was little going in or out of Paris, save for a few hot air balloons and a large number of pigeons.[19] These hot air balloons carried precious cargo—in one of them the photographer, aeronaut, and science journalist Gaston Tissandier (1843–1899) flew out under the cover of night. More important than the human cargo, however, were the cages of pigeons, which flew in and out of the city carrying messages, letters, and newspaper articles.[20] The balloons and the carrier pigeons were not new in terms of communications technologies; pigeons had been used since the Roman period to carry messages and the air balloon was used under various guises for communicating at distances.[21] What was new was the inclusion of photography. To make the pigeons carry more information, photographic images were taken of documents and the subsequent negatives were rephotographed (or photomicrographed) together to allow for thousands of pages of text to be transported in one photographic negative. Upon arrival, the photographs could be read through a microscope or projected onto the wall using a magic lantern. Through the conjunction of these three technologies, news and information traveled when it was supposed to stand still.

In addition to the technologies doing the traveling, there was another important technology that both carried and informed the public about the carrying. Periodicals such as the *Graphic* and the *Illustrated London News* (*ILN*) told of news from inside Paris through letters sent by carrier pigeon while at the same time telling stories about the carrier pigeons themselves. The scientific periodicals could not ignore this important international event either. However, instead of focusing on the sensational aspect of the siege and the process of delivering news over the Prussian army, periodicals like *Nature* focused on the sciences doing the transmitting—balloons and photography. By tracing the representations of these three technologies within the periodical press, a different understanding of the place of these technologies can be understood within broader communications settings. Upon entering the space of the periodical, the discussion of photography, balloons, and carrier pigeons used during the Franco-Prussian War took on a new meaning imbued with a reflexive notion of time as well as a varied audience. The value of the war for these two genres of periodical print (the popular and the scientific) is encapsulated in the visual and textual narrative for the aeronaut Gaston Tissandier. These narratives were made in two very different periodicals—one in the *ILN* and one in *Nature*—and examining them illuminate the ways in which the value of photography shifted depending on where and how it was being discussed and displayed.

In the attempts to communicate over the Prussian army, Tissandier was a key character in facilitating the communication of letters and pigeons in and out of Paris. He had direct scientific experience in both ballooning and photography and utilized these talents during the Franco-Prussian War. His main areas of interest intersected with the three central communications technologies of the siege; he wrote prolifically for French newspapers and later started his own scientific periodical, *La Nature*; he had a keen interest in the science of photography, with training at the Sorbonne and Conservatoire des Arts et Metiers in chemistry; and was an avid balloonist.[22] Tissandier was at the meeting point of these three technological spaces and therefore offers a unique perspective on the relationship between them.

During the Siege of Paris, Tissandier was stuck in the city. Using his knowledge of balloons and photography, he became one of the aeronauts who took flight in a balloon to bring messages outside of Paris.[23] The *ILN* picked up on the adventures of Tissandier and published a story about one of his daring escapes from Paris. According to an artist working for the *ILN*, who had happened to be at Dreux, Tissandier and his balloon *Celeste* had descended into the outskirts only to find what he believed to be the Prussian cavalry, or Uhlans. Upon landing Tissandier found that the cavalry was actually the French coming to greet him, and his important cargo, to his great relief.[24] Along with this story, the artist at Dreux sent a picture of the scene (Illustration 3.2).

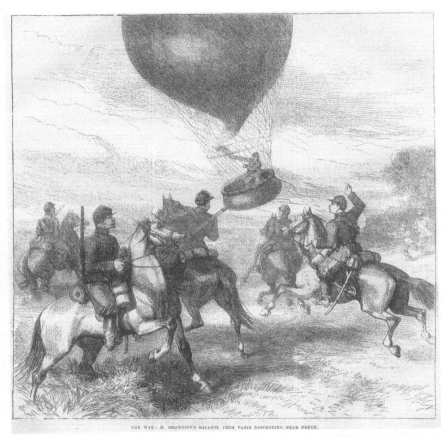

THE WAR: M. ISSANDIER'S BALLOON FROM PARIS DESCENDING NEAR DREUX.

ILLUSTRATION 3.2 Wood engraving—"The War: M. Issandier's [sic] Balloon from Paris Descending near Dreux," *Illustrated London News*, 57, no. 1619 (October 22, 1870): 429. Reproduced by permission of the University of Leicester Library.

What is particularly striking about this illustration and the article that accompanied it is that Tissandier's name is spelled incorrectly. The caption to Illustration 3.2 states, "The War: M. Issandier's [sic] Balloon from Paris Descending near Dreux" and this mistake is later repeated in the text when describing the illustration: "Another artist, who happened to be at Dreux, on the Eure, fifty miles west of Paris, when the balloon Celeste, managed by M. Issandier [sic], effected its descent at that place, contributes a sketch of this scene."[25] Tissandier was a very famous French scientist and aeronautic adventurer, so this oversight is telling. He was mentioned in the *ILN* five other times between 1869 and 1890—once before the above incident and four times after.[26] In each of those other instances, Tissandier's name was spelled correctly. The misspelling in Illustration 3.2 highlights the instability with which information traveled through the pigeon and balloon post.

The consistency of the misspelling in the article points to the fact that it was not a typographical error, but that the information given to the *ILN* was either incorrect or was changed in the processes involved in both the technological and linguistic translations.

The aim in both the article and Illustration 3.2 was the logistics of the removal of Tissandier and the messages from Paris. Illustration 3.2, which significantly is a drawing, shows the danger and chaos involved in landing the balloon—the horses are chasing the balloon as it rapidly descends at an acute angle to the ground. This image represents the absence of the photographic camera—the scene depicts an action that could not have been photographed. The image, and indeed the article as a whole, focuses on showing the dramatic instance of Tissandier's landing and escape from Paris. The object of importance was the balloon; photography was neither a specifically important object for the *ILN* in this instance nor was it valuable for making the image.

The balloon story was not given special importance by the *ILN* because it described the processes of aeronautics. Rather, it was valued for the sensational content that the balloon carried. The author of the article pointed out that "[t]he frequent dispatches of balloons from Paris, conveying persons and bags of letters, when the wind serves, to the departments not yet occupied by the Prussian forces, whence they are forwarded to their destinations by railway or post-chaise, is a remarkable incident of the present siege."[27] The stress here was on both the messages carried by the balloon and the technologies used to carry the messages to their final destination. This latter point is particularly important as it demonstrates the complexity of the integration of different technologies in bringing news from Paris. While the balloon was able to take the objects out of Paris, it was the railway and the chaise that facilitated the final forms of communication—three technologies developed in varying time periods, but used together to facilitate a common aim.

The other important point about this statement is that the messages themselves were both a part of the story as well as the means of producing the story. The *ILN* and all other newspapers in the period of the war relied on the pigeon, the photograph, and the hot air balloon to get their news from inside Paris. The *ILN* had sent correspondents to Paris at the start of the war who stayed in the city while it was under siege. While Illustration 3.2 was produced and sent to the *ILN* from a correspondent outside of Paris, the article also incorporated news from their "Paris Correspondent." The Paris correspondent relayed information about the condition of the city and offered first-hand experience of the state of French morale.[28] This information was not useful in itself, but only became useful when it was transported across the Prussian lines. While it was not explicitly stated, this news story was dependent on the carrier pigeon and the hot air balloon. Through this article, the *ILN* was making a commentary on a novel form of technological communication. However, by printing this commentary in a newspaper, the *ILN*

was linking these novel technologies to print media. It was only in connecting the information of the correspondent, transported by the photograph, pigeon, and air balloon, and finally printing in the periodical that this story and these technologies gained meaning.

Nature, on the other hand, did report on Tissandier's balloon ascents out of Paris (and back into Paris) during the time of the siege, but the focus of their articles was different. The only mention of Tissandier between the period of autumn 1870 and spring 1871, when Paris was under siege, was in an article written by Tissandier's flight companion, Wilfrid de Fonvielle (1825–1914). In his article, entitled "Balloon Ascents for Military Purposes," de Fonvielle gave an account of the use of balloons and the aeronauts who flew them during the siege. He recounted two ascents made by Tissandier and Tissandier's brother leaving Paris—one of which was fired on by the Prussians.[29] The basis of the article was to demonstrate the logistical problems of launching the balloons—where they should be launched and how much weight they could carry. This account is valuable as it indicates that *Nature* did relate current news to its audience, but that it was couched in terms of its importance for science. Moreover, unlike the article in the *ILN*, there were no images depicting the ascents, and *Nature* did not rely in the same way as the popular newspapers on the content being transmitted by the pigeons and the balloons—rather the news came from the aeronauts themselves, such as de Fonvielle, when they reached London.[30] Thus the dependent relationship between these technologies for the popular press was not the case for the scientific press. As such, the separation of time and space was much more acutely important for the popular press than it was for the scientific press.

When *Nature* did eventually discuss Tissandier's use of carrier pigeons, photography, and balloons during the siege in textual *and* visual terms, it was not until well after the end of the war.[31] Moreover, the discussion of this technological event was positioned well outside the boundaries of current events or news and was instead part of a review of Tissandier's recent book, *A History and Handbook of Photography*. The article entitled "Tissandier's Photography" by Raphael Meldola (1849–1915) was a discussion of the use of carrier pigeons, photography, and hot air balloons set outside the temporal boundaries of the same discussion in the popular press.

Meldola was an active chemist working in London who had a keen interest in photography.[32] The selection of Meldola as the reviewer for Tissandier's work thereby reinforces the fact that this historical incident needed to be interpreted in *Nature* by someone with expertise; it was not just a political event, but a scientific one. In *Nature*, the use of these technologies during the war was couched in terms of a spatial and temporal separation—the information and images represented were transmitted through the review of another textual space and were not, like the article in the *ILN*, a direct communication from Paris by the technologies which were under examination.

Two images were, however, reproduced in the review by Meldola of Tissandier's photography manual. While the article was intended to be an examination of Tissandier's work as a whole, an examination of these two images illuminates the visual value of photographic technologies within the scientific periodical space. The images that *Nature* chose to reproduce to represent the central concern of Tissandier's work were a photomicrograph and the photoelectric microscope, which were reproduced later the same year in a chapter on the Franco-Prussian War in Tissandier's book (Illustration 3.3). Importantly, these two images stood out among Tissandier's book as representative examples of the value of photography; *Nature* did not reproduce one of the myriad other illustrations from the other sections of the book, but rather chose the two images that most effectively demonstrated the value of photography in action.

new act of partnership, at length discovered (accidentally, according to the present account) the action of light upon a film of silver iodide. "Photography was henceforth a fact"—unfortunately, however, at this time his partner died, and Daguerre was left to continue his work alone.

The history and progress of the new art of Daguerreotype is then traced, its purchase by the Government described, and the discovery of accelerating and fixing agents gone into. The editor at this stage reminds us that the use of sodium hyposulphite was first made known by Sir John Herschel, but Mr. Thomson erroneously terms this salt a "developing agent." We next arrive at that period of the history when the improvement in lenses effected by Chevallier enabled the time of exposure necessary for a Daguerreotype plate to be reduced, but even then the sitter had to remain motionless for four or five minutes in full sunshine! The torments of the unfortunate patient undergoing this ordeal are very graphically described. The name of Fox Talbot, who had succeeded in fixing the photographic image on paper

some years before Daguerre's discovery was made known, does not appear till rather late in this history,

FIG. 1.—Facsimile of a microscopic despatch used during the siege of Paris.

and then in a position which we cannot but consider as too subordinate, to which effect the editor has added a note.

FIG. 2.—Enlarging microscopic despatches during the siege of Paris.

ILLUSTRATION 3.3 Wood engraving—"Fig. 1—Facsimilie of a Microscope Despatch Used during the Siege of Paris; and Fig. 2—Enlarging Microscopic Despatches during the Siege of Paris," *Nature*, 13, no. 324 (January 13, 1876): 205. Reproduced by permission of the University of Leicester Library.

The two woodcuts in Illustration 3.3 hold different values of reproduction. The woodcut on the top, a reproduction of a photomicrograph (see Illustration 3.9 for its subsequent reproduction in *A History and Handbook of Photography*), was originally reproduced in Tissandier's science periodical *La Nature* in 1873, a year before its publication under the title *Les Merveilles de la Photographie*.[33] The image of the photomicrograph underwent the most translation and transmission of all of Tissandier's images in the context of his history of photography. However, it is important to note that this image, as well as the subsequent image of the photoelectric microscope reproduced at the bottom of Illustration 3.3, would likely not have entered the English periodical press if it were not for the translation of Tissandier's book into English. While this image was intrinsically tied to the periodical press, the context of its reproduction was also tied to the book.

When examining the image of the photoelectric microscope in detail (in Illustrations 3.3 and 3.9), we can see that the inscriptions of the author and the engraver of the image, located on the bottom corners of the image, are the same. Moreover, the sizes of the images reproduced on the page are identical. These two images most likely came from the same woodblock. In addition to this, the images are given the same subtitles as in Tissandier's book. This is particularly important for the microscopic dispatch as it informs the reader of the veracity of the reproduction. The spatial organization of the visual objects in both *Nature* and *A History and Handbook of Photography* is identical and represents a direct movement of images from one print space to another.

The only difference between the use of the images in the book and the periodical, in this instance, is in the spatial organization of the images. While Illustrations 3.9 and 3.10 were separated in *A History and Handbook of Photography* onto their own pages—and were used to create a different narrative where photography was linked to the use of carrier pigeons—in *Nature*, the images acted together to demonstrate the singular importance of photography to the Franco-Prussian War. While *Nature* did refer to the carrier pigeon in its discussion of Tissandier's work, the visual and textual emphasis was on photography. For example the description of Illustration 3.3 pointed out that

> The method of sending micrographic dispatches by carrier pigeon adopted during the siege of Paris will be of interest to our readers. The dispatch having been printed was reduced by photography on to a collodion film, which was then rolled up and enclosed in a quill, which was fastened to the tail of the pigeon. We here reproduce a facsimile of one of these microscopic dispatches.[34]

The emphasis here was on the veracity of the image and the importance of the event as a whole; the photograph was both a central part of the process and a method for visualizing it. Meldola then emphasized the connection between the two images when he continued to explain that "to read the dispatch sent in

this way the collodion film was unrolled by immersion in weak ammonia water, dried, placed between two glass plates and a magnified image projected on to a screen by means of a photoelectric microscope (see Fig. 2)."[35] In similar ways to the reproduction of these images in *A History and Handbook of Photography*, these two images reflect the interrelationship between how an image was made and the larger role that it played in communication. However, unlike the image in Tissandier's book, these images add another dimension—the reflexivity of the genre of periodical publication. By printing these images in the periodical press, they took on a new meaning that was a constant reflection of its production and its earlier forms of publication. They are visual objects moving across time and space, which take on new and multivalent meanings.

This is not to say that the movement of an image related to balloons, pigeons, or photography from a book to a periodical did not happen in the popular illustrated periodical press as well. In the early weeks of 1870, the *ILN* published a review of James Glaisher, Camille Flammarion (1842–1925), William de Fonvielle, and Tissandier's *Voyages Aériens*, the original French version of *Travels in the Air* (a book on the aeronautic investigations of the authors which would appear a year later). In this review, there is one particularly striking illustration: Illustration 3.4 is a woodcut that depicts a terrifying scene.[36] James Glaisher, the only British aeronaut involved in *Voyages Aériens*, is shown to be immobilized from oxygen deprivation while his companion, Mr. Coxwell, scaled the wires of the balloon while they were 29,000 feet in the air in order to release some of the air and descend to a safer altitude.[37] The illustration is similar to Illustration 3.3 in the sense that it had moved from one print media to another and related a sensational event that was not current news but rather an event of the recent past first articulated in the narrative of a printed book. However, after reading the image in context, the epistemological value of Illustration 3.4 can be seen to be significantly different from that of Illustration 3.3.

The primary difference between these two images is in the content they depict. While both images are sensational, they evaluate sensation in different ways. In Illustration 3.3 (fig. 2), the scene in "Enlarging Microscopic Despatches from Paris" is not particularly compelling. It depicts a relatively static set of actions with a mise-en-scène that compels the viewer to look around the image, moving from the projector on the right to the screen on the left and then to the group writing in the middle. The reading of this image requires one to view it in tandem with the photomicrograph that was positioned above the image (Illustration 3.3, fig. 1). Together these two images, informed *through the text*, produce a compelling story of the movement of news out of a city under siege.

Illustration 3.4, on the other hand, is visually compelling on its own. Reading this image, the eye is centered on the middle of the frame where Glaisher lolls just on the edge of the balloon basket and Coxwell hangs precariously outside the balloon catching the lion's share of our attention. Upon reading the text, we learn

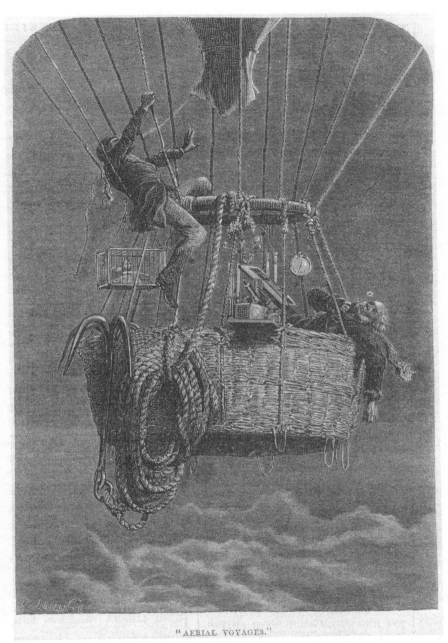

"AERIAL VOYAGES."

ILLUSTRATION 3.4 Wood engraving—"Arial Voyages," *Illustrated London News*, 56, no. 1576 (January 16, 1870): 84. Reproduced by permission of the University of Leicester Library.

of the circumstances of this image, but the text is not necessary for understanding what is going on in the image. While Illustration 3.3 works as a singular point in a process of moving between the image and the text, Illustration 3.4 stands on its own, producing its own visual sensation. This difference is significant as it demonstrates how the reading of an image affected how it was valued within the periodical.

The interaction between the text and the image is an essential aspect in the evaluation of the event in question. For example, in Illustration 3.3, the value of photography and the interaction between photography, hot air balloons, and pigeons become evident when examining the two images and the textual discussion surrounding these images. The text that surrounds Illustration 3.4, on the other hand, gives a valuable account of Glaisher and Coxwell's ascent on September 5, 1862, from Wolverhampton, but it does not connect this instance to the broader implications of balloon science and the use of hot air balloons, pigeons, and photography during the Franco-Prussian War. If, however, the reader of the *ILN* were to take the advice of the newspaper and read the account of Glaisher in *Voyages Aériens*, then the connection between balloons and pigeons would become apparent.

In a particularly revealing passage in the book, Glaisher recounted his incorporation of pigeons in his ascent over Wolverhampton:

> In this ascent six pigeons were taken up. One was thrown out at the height of three miles, when it extended its wings and dropped like a piece of paper; the second, at four miles, flew vigorously round and round, apparently taking a dip each time; the third was thrown out between four and five miles, and it fell downwards like a stone. A fourth was thrown out at four miles on descending; it flew in a circle, and shortly alighted on the top of the balloon. The two remaining pigeons were brought down to the ground. One was found to be dead; and the other, a carrier, was still living, but would not leave the hand when I attempted to throw it off, till, after a quarter of an hour, it began to peck at a piece of ribbon with which its neck was encircled; it was then jerked off the finger, and shortly afterwards flew with some vigour towards Wolverhampton. One of the pigeons returned to Wolverhampton on Sunday the 7th, and it was the only one I ever heard of.[38]

Pigeons in Glaisher's account were experimental objects, which reacted differently, depending on their breed and their training. The only bird in this account to survive, interestingly, was the carrier pigeon. What this shows is the combined role that the pigeon and the hot air balloon played in earlier investigations of the upper atmosphere. Unlike the reproduction of Illustration 3.4 in the *ILN, Aerial Voyages* was able to give greater context for the scene by printing this passage just before the image itself. Upon closer inspection of the image, a cage of pigeons located

just beside Mr. Coxwell's right foot can be easily distinguished. The reading of this image therefore becomes much more nuanced in *Travels in the Air* regarding the multifaceted use of technologies during aerial voyages—a nuance that is missing from the periodical reproduction where the image and the text do not operate together.

When narratives of pigeons, hot air balloons, and photography entered the periodical press they were referred to in different terms, depending on where the narrative was being told and the emphasis placed on each of the individual technologies. For the popular periodical press, the focus was on a self-reflexive discussion of communication: it was about the sensational nature of the movement of information outside of Paris when the city was under siege. For the scientific periodical press, the focus was much more on an analysis of the technology being used and placing that within a narrative of technological development. For periodicals like *Nature*, the hot air balloon, photography, and pigeons were not necessarily reserve technologies, but held their own specific value, both culturally and scientifically. Nevertheless, within both the periodical genres, the narratives they produced were about the movement of information, objects, and images between different print media. The book was present in discussions of the use of pigeons, hot air balloons, and photographs because it was the source of much of the information and much of the visual material. The book therefore acted as a mediator between this particular narrative of communication and the periodical.

The pigeon post in the book

Tissandier was a staunch advocate of the scientific implication of balloon voyages. In a large edited volume, published shortly after the end of the Franco-Prussian War, Tissandier related a series of aerial voyages that he made in the late 1860s. The book, entitled *Travels in the Air*, published similar narratives by Glaisher, Flammarion, and de Fonvielle—the three other important nineteenth-century aeronautical scientists. De Fonvielle, in particular, had accompanied Tissandier on five of his seven aerial voyages recounted in *Travels in the Air*, and their narratives point to the place of ballooning in the broader scientific culture of the time articulated through the technology of the book.

While *Travels in the Air* was aimed at reinforcing the scientific validity of balloon science, it is important to note that having Tissandier, Flammarion, and de Fonvielle as the primary authors gave the book a much broader readership. Tissandier, Flammarion, and de Fonvielle were three of the most popular scientific writers in France and were well known abroad.[39] These three authors straddled both scientific and popular spaces and aimed to present theoretical arguments situated in their practical aeronautical experience. Reading *Travels in the Air* involves a

complicated interaction between the social impact, the visual organization, and the textual content of the book. By looking more closely at *Travels in the Air*, we see that the content of Tissandier, Flammarion, and de Fonvielle's prose was more than just an argument for the use and development of balloon science, and was instead an argument wrapped up in the materiality of print communication.[40]

For Tissandier and de Fonvielle, aerial ballooning was another technology in the line of transportation and communication technologies that had transformed the nineteenth century. They believed that "what has happened for railways, steamboats, or even ordinary ships, will likewise happen for balloons."[41] The integration of hot air balloons as daily forms of transportation was a central concern for Tissandier and de Fonvielle, as they believed that the balloon could transform travel in the same way in which the railway and the steamship were shrinking the space between countries and between continents. However, their advocacy for balloons went beyond the quotidian operation of consumer travel. While the balloon was not yet a feasible form of transportation, due to its inability to be effectively steered, it did allow the scientist to probe new spaces—primarily the upper atmosphere. The balloon narratives of Tissandier and de Fonvielle were therefore based on their scientific investigations of the atmosphere but were also reliant on the balloon in technological terms—as a multifaceted object that affected science, transportation, and communication.[42]

While Tissandier did not use or discuss photography in *Travels in the Air*, he did make an important visual dynamic in his chapters which points to a value for drawing and for photography.[43] Tissandier and de Fonvielle included a large number of images in their chapters—37 in total—and used a number of different methods for capturing their images. While the majority of the images were based on drawings, this was for a good reason—more than half of the images depict scenes either from the balloon in the air or the balloon in motion. Drawings were the only medium that could effectively capture these scenes without the balloon being tethered to the ground—otherwise a photograph would have appeared to be blurry or underexposed.[44]

Tissandier and de Fonvielle were keen to establish the value of their images. Their images were important because, as Tissandier and de Fonvielle argued, they were the *first* scenes of aerial ballooning to be represented for a popular audience:

Nevertheless, this book, we sincerely hope, will make an epoch in the history of aerostatics, for it is the first time that a series of aerial scenes have been published as observed by aeronauts. It is the first time that artists have gone up in balloons for the purpose of familiarizing the eyes of the public with the scenes they have been called upon to reproduce with the pencil.[45]

This statement is particularly compelling because they were very clearly not the first images made from the vantage point of the air balloon. In fact, drawings had

been made from aerial balloons from the time of their very first ascents in the eighteenth century.[46] Moreover, successful aerial photographs had been made by Felix Tournachon (1829–1910), otherwise known as Nadar, in 1858. The intentional neglect of Nadar in Tissandier and de Fonvielle's account reveals how important it was for the authors to create a unique visual perspective within their aerial accounts. The drawings made from their balloons, and their subsequent communication in print, were the crucial aspects in establishing the science of ballooning for Tissandier and de Fonvielle, and they needed it to be *their* images that mattered. Tissandier and de Fonvielle reiterated this importance, and their clear oversight of Nadar and others, when they stated:

> If balloons, so much neglected in modern times, had merely placed before the gaze of the aerial explorer these incomparable panoramas, these magnificent scenes, before which the Alps themselves grow small, whilst earthly sunsets are eclipsed in splendour, and the ocean itself drowned in an ocean of light still more vast, would they not have done enough for the glory of Montgolfier and Pilâtre?[47]

Nadar was one of the most famous photographers of the nineteenth century.[48] He began life as an artist but quickly moved into commercial photography where he made a lucrative business out of photographing famous celebrities and selling their likenesses to a growing public audience. Shortly after establishing his photographic career, Nadar took up an interest in balloon aviation.[49] It was through the congruence of these two technologies—photography and hot air balloons—that Nadar was able to take the first aerial balloon photographs over Paris. Nadar's popularity as an aerial photographer reached its zenith when he was caricatured by Honoré-Victorin Daumier (1808–1879), one of the most famous satirists of the nineteenth century, in 1862[50] (see Illustration 3.5).

In this lithograph (which was sold individually, but also originally reproduced in the periodical *Le Boulevard*), Nadar is shown to be tottering dangerously in his balloon basket as he takes photographs of the cityscape below him.[51] The irony of the image is that Nadar was taking a photograph of a landscape that is filled entirely with photographic studios. Daumier was here commenting on both the novel fashion of photographic studios and Nadar's position as an interlocutor in this novelty. In order to make more compelling and lucrative photographs, Nadar had to leave the confines of the photographic studio and enter the upper atmosphere. This image is, in this way, primarily about spatial shifting.

The second layer, which this image reflects upon, is the dynamic between science and art in the use of photography and hot air balloons. In his title to the lithograph, Daumier puns on both the theoretical relationship between the technologies and also the spatial relationship: "Nadar, Élevant la Photographie á la Hauteur de l'Art," or "Nadar Raising Photography to the Level of Art," textually

reinforces the position in which Nadar places himself in the lithograph—he is literally raising photography above art (which is situated in the photographic studios) through the science of the air balloon. The evaluation of the legitimacy of photography and the scientific authority of the balloon in Daumier's caricature is the same argument that Tissandier and de Fonvielle made in *Travels in the Air*.

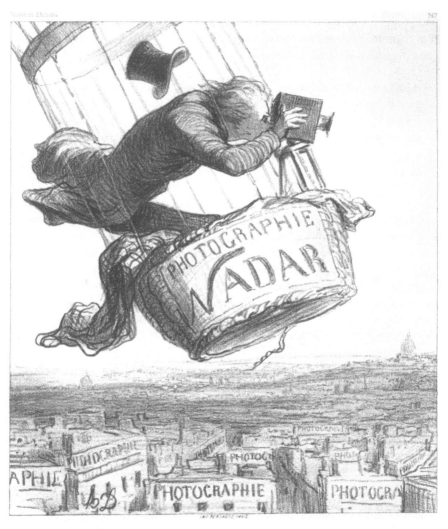

ILLUSTRATION 3.5 Lithograph—Honoré Daumier, "Nadar, Élevant la Photographie á la Hauteur de l'Art," © Metropolitan Museum of Art, Harris Brisbane Dick Fund, 1926, 26.52.4.

Considering the popularity of Daumier's image, and Nadar's popularity as both a studio photographer and aerial celebrity, Tissandier and de Fonvielle's omission of Nadar is intriguing. The reason for this omission may lie in the confusion of the boundaries between science and art that Daumier highlights in his lithograph. For Tissandier and de Fonvielle, their central aim was to raise ballooning to the level of a legitimate science. A visual history that undermined this would have been seen as problematic. Tissandier and de Fonvielle wrote their narrative to produce a visual framework that reinforced the scientific legitimacy of ballooning, rather than serving to undermine it.

While Tissandier and de Fonvielle relied primarily on artistic drawings for their chapters, they did occasionally use photographs that were then reproduced as woodcuts. The subjects made from photographs were typically scenes of preparation. For example, the title image from chapter 6 of *Travels in the Air*, "Departure from the Gasworks of La Villette," is one example of an image made from a photograph (Illustration 3.6). The scene is intended to represent the aeronauts, the spectators, the balloon, and its surrounding. Tissandier described the narrative of the image as follows: "At eleven o'clock the aerostat was balancing itself gracefully in the breeze; my brother and myself took our seats in the car together with our new captain, and a photographer who had come forward with his camera demanded permission to take a proof of us."[52] Interestingly, the image is supposed to be proof of the travelers' participation in the aerial event, but it focuses little on the actual people—depicting very small, unrecognizable characters surrounding the much more visually impressive balloon. While the original photograph would have depicted the individuals in much greater detail, the woodcut was limited. The reduction of the human element and the focus on the balloon and surrounding scene reflects the way in which the reproduction of this photograph allowed the print space to focus on the sublime nature of the balloon and its relationship to industry (seen through the association with the buildings in the background). The image therefore stands as a valuable example of how the photographic object lay not in the actual image, but in its inscription in the text.

Illustration 3.6 also helps to demonstrate how logistics played a central role in whether or not a photograph or a drawing was used as the original method to represent the scene. Shortly after the quotation above, Tissandier wrote: "in spite of the darkness of the morning the photographic artist succeeded in obtaining a good plate, from which the drawing at the head of this chapter was made."[53] Successful photographs were reliant on both the skill of the observer and the cooperation of Mother Nature. Without a steady position and the right light, a photograph could not be made. When depicting scenes from inside the balloon, Tissandier therefore relied on drawings. However, when he could take a photograph, he did. This visual and technological evaluation made by Tissandier and de Fonvielle in their work on ballooning is key to understanding how Tissandier later tied together notions

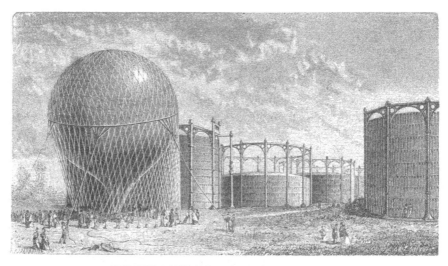

DEPARTURE FROM THE GASWORKS OF LA VILLETTE.

ILLUSTRATION 3.6 Wood engraving—"Departure from the Gasworks of La Villette," *Travels in the Air*, London: Richard Bentley, 1871, 329. Reproduced by permission of the Cambridge University Library.

of complementary technologies of communication and visualization when he discussed the instance of the use of photography, balloons, and the carrier pigeon in the Franco-Prussian War.

Returning briefly to Tissandier's *A History and Handbook of Photography*, we can see that the particular value that Tissandier placed on the use and development of photography did not exist in just one of his works, but moved across his writings—regardless of whether his arguments were made in a book or in a periodical.[54] *A History and Handbook of Photography* was designed both to give a history of the development of photography and to give a detailed discussion of the modern process of taking photographs, printing photographs, and photographic reproductive techniques—such as the Woodbury process, or as Tissandier called it "photoglypty."[55] One of the techniques Tissandier drew particular attention to in his book was microphotography—or the photographic imprint of microscopic investigations. Besides this discussion of microphotography, Tissandier dedicated an entire chapter to a particular instance of microphotographic application. In section three, chapter 6, entitled "Microscopic Despatches during the Siege of Paris," Tissandier integrated a discussion of the value of photographic technological development with a discussion of the integration of this technology with his other passion—hot air balloons.

Tissandier's argument in this chapter needs to be examined through multiple lenses to evaluate its full impact. The value of photography was made by Tissandier

textually and visually, but also spatially. The position of the images and the text within the book as a whole and within the chapter specifically can help illuminate the interstices of the relationship between the visual and textual object. Moreover, the relationship between the spatial organization of the image and the text on the page reflects the broader spatial implications of the technology of transporting images across space. Photography, for Tissandier, was crucially wrapped up in a complex discussion of spatial organization and transmission.

Tissandier started chapter 6 of *A History and Handbook of Photography* by pointing to the unique importance of photography in communicating outside Paris during the siege:

> During the war of 1870–71, when Paris was invested by the enemy, photography succeeded in reducing the size of the messages sent by carrier-pigeons, so as to render them almost invisible to the naked eye. No philosopher could have imagined this use of photography called forth by the dire necessity of war.[56]

The value of photography was expressly articulated here by pointing to the novel genius of photography's use during the war. For Tissandier, the carrier pigeon and the balloon were useful and commendable in the service of the beleaguered city, but it was in the photograph that the true value lay.

Tissandier located this particular value in photography when he later stated that photography "solved the difficulty as no other art could have done; it reproduced on a film of collodion weighing less than a grain, more than three thousand despatches, that is to say, the amount of sixteen pages of folio printed matters."[57] Photography's value in this particular historical and technological instance lay not in its ability to give an accurate representation, or necessarily in its value to be reproducible. Instead photography was valuable for its ability to reduce and thus carry much more visual and textual data, which in turn allowed it to be transmitted. The movement of the object was more important than the accuracy of the image.[58]

In similar ways, the images reproduced in this chapter reflect a value placed on the photographic objects. The subjects of the images displayed by Tissandier fall into two categories: the mechanisms for transporting the images and the mechanisms for displaying and reading the images once transported. In both of these categories the focus was on the photographic referent rather than the process of transportation or display. The first figures that Tissandier reproduced fall under the first category. Illustrations 3.7 and 3.8 depict the ways in which the photographic negatives were attached to the carrier pigeon. These images were intended to work in tandem—the first image to represent the whole view of the pigeon with the device attached, and the second to give more details on how it was specifically attached. The reading of these as joint images was reinforced in their textual descriptions: "Several of these [photographic] films representing a

Fig. 54.

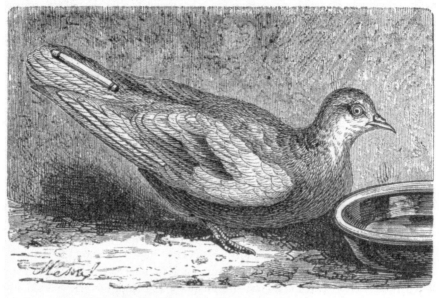

CARRIER-PIGEON WITH PHOTOGRAPHIC DESPATCHES.

ILLUSTRATION 3.7 Wood engraving—"Carrier-Pigeon with Photographic Despatches," *A History and Handbook of Photography*, London: Sampson Low, Marston, Low & Searle, 1876, 236. Reproduced by permission of the Cambridge University Library.

Fig. 55.

QUILL CONTAINING MICROSCOPIC DESPATCHES FASTENED TO A TAIL-FEATHER OF CARRIER-PIGEON.

ILLUSTRATION 3.8 Wood engraving—"Quill Containing Microscopic Despatches Fastened to a Tail-Feather of Carrier-Pigeon," *A History and Handbook of Photography*, London: Sampson Low, Marston, Low & Searle, 1876, 237. Reproduced by permission of the Cambridge University Library.

considerable number of despatches were rolled up and enclosed in a quill about the size of a tooth pick. This light and novel letter-box was attached to the tail of the pigeon as represented in figs. 54 and 55."[59] Viewed together, these images produce a specific frame of view where the pigeon became just a point of reference: an object that primarily showed where and how the photographic images were placed on the pigeon. In the case of these images, a need for simulacrum was deemed unnecessary. However, when it came to displaying the actual object under investigation, a very different textual and visual dynamic was articulated.

When Tissandier discussed and depicted an example of the microphotographs that were transmitted during the siege, the value placed on the image was very different. Illustration 3.9, which has the subtitle "Facsimile of a Microscopic Despatch during the Siege from Paris," is distinct from the images either before or after it because it carried the inscriptive value of being a facsimile—literally translated from Latin meaning "to be made similar." While this textual inscription carried a different connotation from saying it was "from a photograph" (in that the process of reproduction was not at stake), the evaluative function of stating that the image is a facsimile is the same. In comparison with pictures of the pigeon with the quill attached to it, this object held a higher representative value.

The textual valuing of this image moved beyond the subtitle as well. In his description of the image, which was located on the facing page, Tissandier pointed to the process of image production: "We have endeavoured to give the exact appearance of one of these despatches in our figure 57. The reduction was made to the eight-hundredth part of the size of the original."[60] Through this passage, Tissandier was showing that the image in particular, which was based on a photographic negative, was an exact reproduction and could be spatially imagined despite its minute size. As Stewart has pointed out, the miniature object is dependent on a narrative of space; that is, "whereas speech unfolds in time, the miniature unfolds in space."[61] The spatial shifting from normal size to miniature and back to normal size functioned to highlight the movement of the photomicrograph. Size and movement was a fundamental concern for Tissandier in his discussion of the application of photography to the Siege of Paris. The reduction in size of visual information was the main technological hurdle that the photograph overcame in this instance. Its mobility, not its objectivity, was the key concern.

One of the interesting aspects of Illustration 3.9 is that the text in the image is not readable, nor was it meant to be read. The image stands for photography's technical ability to reduce images and text to the microscopic level. While it was important for Tissandier to demonstrate that the image itself was a true reproduction, it functioned as a way to give the reader an idea of the technological difficulties involved in producing, transporting, and reading these objects. While Tissandier had already discussed how these photographs were produced and transported, he had yet to discuss what happened when they were received. To overcome the

Fig. 57.

FACSIMILE OF A MICROSCOPIC
DESPATCH DURING THE SIEGE
OF PARIS.

ILLUSTRATION 3.9 Wood engraving—"Facsimile of a Microscopic Despatch during the Siege of Paris," *A History and Handbook of Photography*, London: Sampson Low, Marston, Low & Searle, 1876, 239. Reproduced by permission of the Cambridge University Library.

technical limitation of reading these photographic objects, Tissandier pointed to another photographic technology—the photoelectric apparatus.

The process of reading and interpreting these images held important technological implications. In order for the photographic objects to be read they needed to be mediated by a device that could change the size of the object. Tissandier described this instrument as "a very powerful magic lantern" and called it a "photo-electric microscope."[62] By labeling it thus, Tissandier was ascribing a value of technological advancement to the instrument; it was the combination of old and new technologies that each held their own cultural value for time, space, communication, and vision. The photoelectric microscope allowed the unreadable to be read while at the same time making a self-reflexive point about space. The magic lantern displayed an object that had moved from being large to being very small and back to large again, and this shrinking also allowed it to be moved across space. It was the display of the invisible, spatially shifted, object.

The association of the device with the magic lantern also gives rise to a different reading of this object. It makes the object more knowable, something the reading audience would have come into contact with regularly during public lectures and in their homes.[63] In her article on the instrument maker John Benjamin Dancer, Marina Benjamin demonstrates the widespread fashion of viewing microphotographic objects within Victorian culture.[64] By the time that these microphotographs were displayed within the periodical press and in Tissandier's books, it would have been a familiar object and held specific reference to both commerce and science. In the instance of Tissandier's publication of these images, they were intended to connect the use of three technologies—the pigeon, the balloon, and the photograph—to the technologies of public communication. The readings of these photomicrographs were not just about the content sent, but the places they went to and the processes of transportation and translation they underwent. They were textual and visual objects circumscribed through the book and the periodical.

The image Tissandier used to visualize the photoelectric microscope reinforces this dynamic. The device is not shown on its own, like Illustration 3.9, separated from its surroundings. Instead the microscope is shown in use—projecting a microphotographic slide onto a screen where a group of men interpret and translate the image (Illustration 3.10). The image operated on a number of levels; it conveyed the technological complexity of the device itself while the instrument's dependence on electricity is clearly demonstrated by the electrical coils situated at the center of the device and the electrical wires coming from it. It is also centered on a reflexive notion of display; it is a picture of a projection of a picture that is being read by both the reader of the book and the individuals in the image. The image is about the collapse of vision and its subsequent communication—in person, in books, and most importantly, in the periodical press.

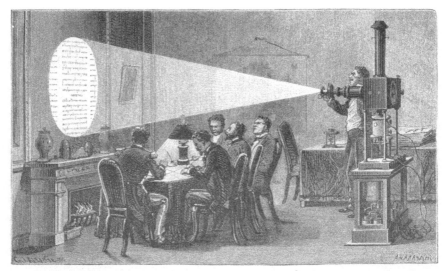

FIG. 58 [Page 241

ENLARGING MICROSCOPICAL DESPATCHES DURING THE SIEGE OF PARIS.

ILLUSTRATION 3.10 Wood engraving—"Enlarging Microscopical Despatches during the Siege of Paris," *A History and Handbook of Photography*, London: Sampson Low, Marston, Low & Searle, 1876, 240–241. Reproduced by permission of the Cambridge University Library.

The images presented in chapter 6 of *A History and Handbook of Photography* were meant to represent photographic objects used in the Franco-Prussian War for communication. The value placed on the reproduction of the image changed, depending on whether it was the process or the object of communication that was being visualized; however, the form of reproduction stayed the same. All of the images presented in chapter 6 were made from engravings. In fact, all of the images presented in Tissandier's book were made from engravings, save one. Opposite the title page, Tissandier reproduced a photo-tint portrait of a young lady (Illustration 3.11). This image operated under different evaluative functions for Tissandier, and it is useful to compare the implications of this image with the rest of the images in the book and to draw out how and where the form of the reproduction mattered.

Illustration 3.11 was separated from the visual framework of the rest of Tissandier's book in a number of ways. First, the image was positioned outside the textual space of the book. It was placed at the start of the book, before the title page, to act as an object reference for the subject of the book; this "portrait from life" was meant to be the kind of image that could be achieved if the reader was to follow the advice of the rest of the book. Subtitling the image "portrait from life" also reflects an objective value that Tissandier does not place on the rest of

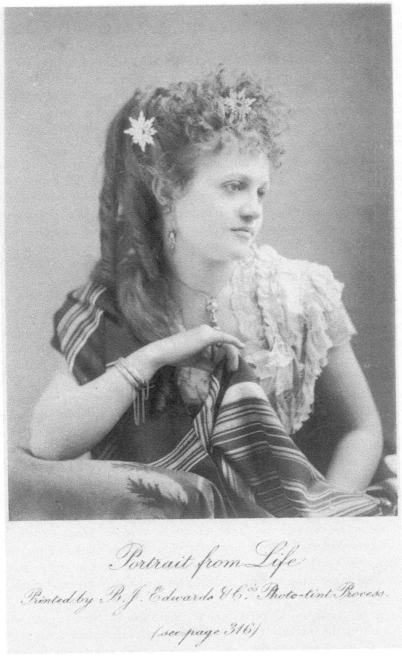

Portrait from Life

Printed by B.J. Edwards & Co's Photo-tint Process.

(see page 316)

ILLUSTRATION 3.11 Photo-tint process, B.J. Edwards—"Portrait from Life," *A History and Handbook of Photography*, London: Sampson Low, Marston, Low & Searle, 1876, Frontispiece. Reproduced by permission of the Cambridge University Library.

his images. Moreover, this objective value is reinforced by the inscription on the image—"Photo-tint Process (see page 316)." Tissandier was here encouraging the reader to find out more about the process of printing this image by delving into the book itself. The photo-tint reproduction was placed as an object lesson; it is both an object to be admired for its simulacrum to the visual referent and an object that displays the very processes Tissandier discussed in the rest of the book. When he reflected on the images in chapter 6, Tissandier did distinguish between a facsimile and a reproduction, but he did so in a way that valued the object visualized, not the process of visualization.

In addition to the specific textual and visual argument made by Tissandier within the chapter on carrier pigeons and the Franco-Prussian War, the position of this political and technological event becomes apparent upon examining the broader spatial organization of the chapter within the book as a whole. Sandwiched between a chapter on microphotography and a chapter on astronomical photography, chapter 6 functions as an important photographic intervention that demonstrates the technological importance of photography in both scientific and political contexts (see Illustration 3.12).

Chapter 5 comes just prior to the carrier pigeon chapter and is concerned with microphotography, specifically its application to scientific investigation. The object of the chapter is to explain how a microphotographic apparatus should be set up and to explain the types of objects that could be visualized by microphotographs.[65] As Tissandier stated at the start of this chapter, the aim of chapter 5 was to demonstrate the services that microphotography gave to the natural sciences.[66] Similarly chapter 7, on astronomical photography, was designed to demonstrate the uses and value of photography for the investigation of the heavens.[67] Tissandier positioned this chapter specifically in tandem with chapter 5. He began chapter 7 by stating that "[p]hotography furnishes inestimable resources to all the sciences. We have seen that it places under the eyes of the naturalist the enlarged images of the grains of the pollen of the flower *infusoria*, and of forms of vegetable and animal life invisible to the naked eye."[68] This is a particularly telling passage by Tissandier, as he was self-consciously admitting that photography's value was in the movement of space—about moving from the small to the large and back again. Tissandier further reinforced this spatial value of photography when he went on to explain that in the same way in which photography makes the very small visible, it was also useful for seeing the very far away.[69]

Together these two chapters position the value of photographic science for capturing the invisible. Chapter 6 thus operates under the auspices of an established visual and textual authority of photographic authenticity. By working alongside this scientific value of photography, Tissandier was able to position

ILLUSTRATION 3.12 Part III, contents page—*A History and Handbook of Photography*, London: Sampson Low, Marston, Low & Searle, 1876. Reproduced by permission of the Cambridge University Library.

photography's unique technological position in the tri-technological achievement of communicating over the Prussian army:

> The admirable use of microscopic photography, bringing to the aerial post by balloons and pigeons the indispensable complement of light messages, is a fine example of the close correlation which unites the different branches of modern science, and which enables them at a given moment to co-operate towards the same result.[70]

It is through this combination of the scientific authority established in the surrounding chapters, and the technological authority established within chapter 6, that Tissandier was able to finally make the assertion that the microphotograph was not an inferior technology and that "the electric telegraph and railway could not have done better."[71]

Conclusion

In the years following the end of the war, pigeons, photography, and hot air balloons continued to capture the attention of both the scientific and popular periodical press. The association of photography, flight, and pigeons also continued to be used to address questions of travel and communication. In these discussions, the three technologies were not necessarily reliant on each other, but they did reflect the continued value of alternative technologies of communication. Moreover, their discussions in print—both visually and textually—were made around narratives of scientific investigation (as in the case of the hot air balloon) and the science of movement. Nevertheless, it was during the five months at the end of 1870 and the start of 1871 where the interactions of these three technologies reflect an important example of how information traveled in the nineteenth century. The telegraph and the railway were not universal in communication technologies; their ability to connect spatially separated places was fragile, and when they failed, alternative technologies were used. These technologies were wrapped up in their own, specific, notions of time and space, which were explicitly framed in geographic terms; information, in the form of a photograph, could be moved outside of Paris to affect the content of the national and international news media. As we will see in Chapters 4 and 5, this is a very different notion of time and space from that which is evoked for the development of instantaneity or for photographing the Transit of Venus. Through their discussion both in print and beyond, photomicrographs used during the Franco-Prussian War took on a value that reflected multivalent meanings, incorporating self-reflexive notions of print space, the collapse of time, and the iconography of war. They were objects, images, and technologies and they reflect an instance when these boundaries were indistinct.

4 PHOTOGRAPHING THE INVISIBLE: THE PERIODICAL AND THE REPRODUCTION OF THE INSTANT

The way that time was experienced in the nineteenth century was changing, and this was due in large part to the machines that allowed for humans to extend their observational lens into a period of time that escapes the human eye, otherwise known as the instant. The tangible experience of shifting concepts of time was reflected widely in the periodical press, through both images and the textual narratives reproduced on their pages. Similar to the reproduction of Thomas Hardy's novels within the periodical, the Victorian reader was surrounded by complicated and sometimes contrasting notions of time.[1] Photography, in particular, was seen as a tool that could investigate aspects of the physical world, which had previously escaped the vision of scientists: a flash of lightning, the break of a wave, or the gait of a horse. Yet, this compartmentalization of time was not only a scientific experimental object, but was tied explicitly to technological developments—specifically the dry plate gelatin photograph and mechanical shutters. The instant became a material object linked to the photographic plates that held the evidence of the instantaneous referent, as well as the print technologies that reproduced the instant for a broader reading audience. While photography in the late 1870s became a technology that could capture time, the instantaneous photograph was an object that was fundamentally embedded in other technologies that created, contained, and communicated a moment in time. Whereas the photograph became important when it moved out of Paris in Chapter 3, the value and meaning of a photograph in the story of instantaneity became tied up in the problem of visualizing time. The solution for the periodical press was to make its own meaning for the photographic instant, and the value of photographic science.

The investigation of the physiologically imperceptible moments of time was an especially crucial area of interest for the sciences involved in precise measurement, and most explicitly for astronomy. The "personal equation," as it came to be known, quantified the difference between two individuals in the observation of minute measurements. This was both a psychological and technological concept, circulating around the mediation of human error.[2] Jimena Canales has shown that the personal equation was stabilized when the limit of human perception was experimentally associated with the tenth of a second.[3] Canales has further demonstrated that instantaneous photography, in cases where observations were shorter than the tenth of a second, acted as a technological validation of the experimental observations.[4] The interaction between photographic technologies, observational practices, and the psychological concept of the instantaneous was crucially interrelated in the last decades of the nineteenth century.

By the late 1870s, a precise definition of what constituted an instant was far from established, and the pictures that captured the instant were affected by this uncertainty. Photographs—and specifically instantaneous photographs—were imbued with complicated notions of time and space. Instantaneous photographs, much more so than other types of photographic images, were made as a series of images rather than a singular static photograph. When it came to their reproduction within the periodical print press (which itself was built around very specific notions of time and space), this communication of the visual instant became even more unstable. These two types of time and space—when it came to the production and reproduction of photographs—circulated around two types of seriality: the seriality of the instantaneous image and the seriality of periodical print production.

With the development of what came to be known as instantaneous photography, the trust invested in photography changed. With the increasing speed of the chemical solutions used and the development of better and faster cameras and shutters, things unseen could be captured on photographs. This created new and problematic trust claims for photography, where the authority of the image was tied much more explicitly to the technologies that created them. Because earlier photographs had been limited in the speed at which they could capture images, the human eye could verify the objects visualized. With the instantaneous photograph, the camera pictured things that were invisible to the naked eye.[5] This difference in verification affected the way that images were read. The instantaneous photograph, therefore, was not a stable concept. Thus, when examining this shift toward instantaneous photography in the nineteenth-century periodical press, the difference between what the photographic image was meant to show and how it was shown becomes essential.

The "instant," captured through the photographic camera, carried with it very different concerns and questions regarding how one sees and what can be

seen. The narrative given of instantaneous photography in this chapter will focus on the ways in which broader discussions of instantaneity within scientific and popular cultures were contextualized and reproduced within the periodical press. By looking at the photographic instant outside of the traditional narratives of its invention and situating it instead within a broader context of technological interaction, a new form of visual epistemology of the image in nineteenth-century communication emerges.

History of instantaneity

The story of instantaneity is not just about the production of an image. The way it was told and where it was told also matter. For many people in the nineteenth century, the first instantaneous image that they saw would not have been in a studio or on the street. Rather, the spectacular experience of witnessing a moment trapped in time would likely have been while turning the pages of their Saturday newspaper. Seeing an image such as Illustration 4.4, the whirlpool rapids at Niagara Falls, would soon have been followed by a reader scanning for a description, a text that could elaborate on the story of what they were seeing. Looking more closely at the content and context of the reproduction of instantaneity in the nineteenth-century periodical allows us to examine how the technologies used to create the very images reproduced within the pages of the newspapers become fundamentally entrenched in the stories told about them. The content and narrative of that image are inexorably interconnected.

One narrative in particular about the history of photography reproduced through the pages of one of the more popular scientific journals of the late nineteenth century—*Knowledge*—reveals the importance of the technological changes in photography, and what this meant more broadly to the practice of photography. Alfred Brothers—a professional photographer working in Manchester in the latter half of the nineteenth century (see also Chapters 2 and 5)—contributed a set of twelve articles to *Knowledge* between March and August 1882. These articles entitled "Photography for Amateurs" were aimed at teaching the general public how to take their own pictures. Brothers was particularly keen to undermine the disparity between the amateur and professional photographer. In an early article in *Knowledge*, Brothers wrote: "the chief difference between the amateur and the professional photographer is that the latter has more practice, but there is no reason why the work of the amateur should not equal that of the professional."[6] This democratization of participation in a realm of science was a particular aim of *Knowledge* (see Chapter 2) and presents an example of the way in which the ideology of a particular periodical shaped the way that the content was produced and described.

This was a decade before the advent of the Kodak "snapshot" photograph, which allowed for photography to become more widely accessible. The production of photographs, while becoming easier, still required skill and expertise. In the period when Brothers wrote these articles, photography was becoming more commonly used by amateurs, but was still not practiced on a wide scale. Brothers' articles therefore targeted a specific development for photography that was situated in a period of gradual technological advancement.

In order to situate the use of photographic technologies at the beginning of his articles, Brothers first established the history of photography up to the period of the 1880s. Starting with the standard narrative of the first investigations into the productions of images on leather by Herschel and Wedgewood, and moving through the development of the two various processes of Niépce, Daguerre, and Talbot, Brothers ended this account by privileging the positive/negative process, due to its ability to reproduce photographic images more easily.[7] Brothers then spent the bulk of his articles, talking about two photographic processes in particular: the wet collodion process, developed by William Scott Archer in the 1850s, and the dry gelatin process developed by Richard Leach Maddox in the early 1870s.[8] The key difference between these two processes was the speed at which they captured a photograph—the dry process allowing for at least 1/5,000 of a second exposure. Exposure time was essential because it allowed for the budding photographer to take scenes that appeared to him or her, in "real time." The notion of capturing the "instant" was what the new technological developments in photography offered: the reduction of exposure times. Brothers told his reader that with dry plates "so rapid, indeed, is the action of light upon the plate, that, for out-door work, the effect is as instantaneous as the exposure can be made by mechanical means."[9]

Instantaneity, for Brothers, was not a stable concept. This is clear from the fact that he qualified dry plates to be "as instantaneous as the exposure can be made," instead of saying that the dry plates allowed simply for instantaneous pictures. Brothers extended this position on instantaneity in further discussions of the uses of gelatin dry plates. After teaching his readers first how to make gelatin dry plates, he instructed that

> The plates [dry gelatine] can be purchased ready for use, of various degrees of sensitiveness, from five to twenty times that of wet collodion, and, if desired, this degree of sensitiveness may be exceeded; but for all ordinary purposes, ten times rapidity of wet collodion is quick enough and much to be preferred. If the plates are very rapid, it becomes extremely difficult to time the exposure as to obtain the best result—over exposure resulting in weak negatives—and a weak gelatine negative cannot be so easily identified as one of a similar kind taken with wet collodion.[10]

The instantaneous photograph, while certainly a useful technology for obtaining photographic images, did not eradicate the value of the wet plate photographic process. Brothers also extended this limitation on instantaneous photographs to those made for scientific purposes—he pointed out that no dry plate photograph had exceeded the value of a wet plate astronomical image, due primarily to the ability of the wet plate to be enlarged without significantly distorting the proportions of the image.[11]

Instantaneity, for Brothers, was a valuable technological development but it did not negate other photographic technologies. Nor was the development of instantaneity solely linked to chemical advances—but was also largely a mechanical development. Near the end of his article, Brothers wrote: "if really instantaneous effects are required, some kind of mechanical shutter must be used, and these can be had in a variety of forms."[12] Instantaneous photographs were thus tied directly to the development of mechanical apparatus, rather than just the invention of faster chemical solutions.[13]

This focus on the mechanical nature of instantaneous photography extended outside of Brothers' articles into the broader periodical space of Knowledge. In a section entitled "Inventors' Column," there were occasional articles on photographic patents. Two, in particular, were about instantaneous shutters that were developed to be attached to various photographic apparatus and allowed the amateur photographer to make their own instantaneous images more effectively (Illustrations 4.1 and 4.2). What these two short articles demonstrate is that the development and application of instantaneous photography was by no means just a chemical one. It was the result of various changes—both chemical and mechanical—which allowed for the photograph to compartmentalize time. In their classical theories of photography, Roland Barthes and Susan Sontag both stress the central associations of time with the invention, development, and use of photography, pointing out that time cannot be removed from the photographic object but is rather embedded in it.[14] Yet, the mechanisms that allowed for the production of these images were as important as the chemical solutions used to increase the speed of the image captured.[15]

In addition to the multiple forms of technological value (mechanical and chemical) placed on instantaneity, part of the reason that it was not a stable concept in the 1870s and 1880s was that it was used in varied contexts within the periodical press. One of the most common usages of the word "instantaneous" in both the illustrated and non-illustrated presses was when referring to a death, that is, "his death was instantaneous." Barthes has argued that photography is centrally concerned with death, as it allows for the dead to maintain a presence through their photographic portraits. The association of death with instantaneity outside of photography broadens the relationship between notions of photography and instantaneity.[16] While the use of instantaneous in terms of one's death is fairly straightforward, it was also used more abstractly. In one reoccurring full-page

Our Inventors' Column.

PHOTOGRAPHIC SHUTTER.

[Patent No. 7,792. 1884.]—In exposing sensitive plates for instantaneous photographs it has always been a desideratum to obtain a comparatively longer exposure for the foreground than for the distance.

This result is obtainable by use of this shutter, patented by Mr. Heath and manufactured by Messrs. Marion & Co., in the following manner :—Two plates are cut obliquely and made to pass over one another, in opposite directions, by a parallel motion, the result being that in their transit the bases of the apertures exposing the lower portion of the lens are the first to be uncovered and the last to be closed, thus very greatly increasing the proportionate exposure of that portion of it.

The movement is communicated to the plates from a coiled steel spring, by means of arms with slots, traversing and driving pins in the same.

A break is attached by which speed can be reduced from an instantaneous exposure to one of two or three seconds. The spring working the plates is released by the depression of a small stud shown on the bottom of the frame. This is accomplished by urging forward a small piston in the cylinder adjacent to the stud. The pneumatic device patented by Cadet is employed for this purpose.

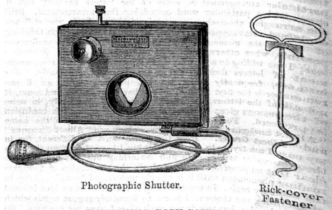

Photographic Shutter. Rick-cover Fastener.

FASTENING RICK-COVERS.

[Patent No. 9,040. 1884.]—H. G. Norrington, of Bonhay-road, Exeter, has patented a simple but effective fastener for fixing galvanised corrugated iron sheets, now generally coming into use, to both hay- and corn-ricks. It is applied by punching a hole on the top of a corrugation in the sheet, inserting the end of the fastener, and screwing it in, when it draws itself into the rick, until the grooved washer firmly fixes down the sheet, the groove at the same time fitting the corrugation so as to prevent any rain entering the hole made. There are many advantages apparent to agriculturists in being able at any time to permanently cover their ricks without having to wait for a thatcher. Curved sheets can be used for the ridges, and ventilation, if necessary, can be secured by leaving the space between the hay and the ridge.

ILLUSTRATION 4.1 Wood engraving—"Photographic Shutter," *Knowledge*, 8, no. 196 (July 31, 1885): 102. © The Trustees of the Natural History Museum, London.

ADJUSTABLE INSTANTANEOUS SHUTTER.

[Patent No. 7746. 1884.]—The principle of this shutter, patented by Mr. Thomas Furnell, consists in the use of two flaps so adjusted

Fig. 1.

Fig. 2.

to each other, by mechanical means, that the amount of exposure that can be given to the foreground, in proportion to the sky, can

Fig. 3.

be governed at will; as the bottom flap can be set and clamped in any desired position, the top flap remaining closed ready for exposure. The bottom flap has a sweep of about two hundred degrees; the top flap only about ninety-five degrees, and remains as a sky shade. Fig. 1 shows the shutter set ready for action; Fig. 2, arrested at full open; Fig. 3, folded for portability. The ratio of movements of the two flaps are so arranged, that the first slow movement of the bottom flap causes a first rapid movement of the top flap, which slows as it rises. This gives a greater proportion of exposure to foreground, and less to the sky; and to counterbalance this, the bottom flap commences slow and increases in speed as it rises, and so cuts off the exposure of sky portion. The following are the different positions taken by the flaps:—

Fig. 4.　　Fig. 5.　　　Fig. 6.　　　Fig. 7.

If the bottom flap be set, as shown in Fig. 4 or instantaneous work, the foreground receives the greatest amount of exposure, although the motion is extremely rapid. If the bottom flap be set as at Fig. 5, both flaps rise together until full open, then the top one remains as a sky shade, and the bottom one flies up and closes. If the bottom flap be set as at Fig. 6, it is the most suitable for sea-scapes, as the top flap arrives at the horizon line at the same time as the bottom flap arrives at full open. This flap then flies up and closes, so that the sky portion receives but a very small amount of exposure in proportion. Fig. 7 shows the position of the flaps at the end of exposures. Arrangements are made for prolonging the

ILLUSTRATION 4.2　Wood engraving—"Adjustable Instantaneous Shutter," *Knowledge*, 7, no. 180 (April 10, 1885): 315. © The Trustees of the Natural History Museum, London.

ILLUSTRATION 4.3 Advertisement page—"The Loisettian School of Memory," *Knowledge*, 3, no. 73 (March 23, 1883): 153. © The Trustees of the Natural History Museum, London.

advertisement in *Knowledge*, Prof. A. Loisette promised "instantaneous memory"[17] (Illustration 4.3). In this usage, instantaneity was associated with an unquantifiable psychological concept—that of immediate memory. While Brothers qualified

his notion of instantaneity by giving an exposure time to photographs deemed instantaneous, the usage of the term more broadly within the periodical press was much less stable. Instantaneity, here, had multiple uses and an uncertain meaning.

It should be pointed out that the development of instantaneous photography had a particularly keen importance to the periodical press. The development of photographic technologies and their ability to capture faster ephemeral moments augured well for an industry based on the communication of information. The development of these new chemical and mechanical processes in photography was intimately tied to the development of cheaper and better printing processes, which is partly why the positive/negative process, developed by Talbot, was so favored by the print press.[18] In one particularly revealing passage in the *Pall Mall Gazette*, the integration of print and photographic technologies—and the importance placed on instantaneity—is clear:

> Yet without doubt the search for those unattainable objects [instantaneity and colour] has done much for the attainable, and in the printing processes, by which the negative result is made a positive one, the success from the discovery of other sensitive elements than the metallic salts has been so remarkable that we may confidently anticipate a trustworthy mechanical process by which all sun-pictures may be made as permanent, as uniform, and as cheap as the results of lithography now are.[19]

This passage highlights the interdependence of periodicals with the development of printing and photomechanical processes. It also highlights—similar to the photographic images and objects advertised in the *Graphic* in Chapter 1—that the photograph for the *Pall Mall Gazette* was a technology that made images and information permanent. The photograph and its reproduction in print were given a value not just for its ability to represent, but to continue to represent for a long period of time. Periodicals relied on printing technologies, such as wood engraving and lithography, to communicate their stories visually, but they were ultimately anticipating the successful development of photomechanical printing processes. While this may be a mundane point, what is interesting is that the periodicals tied this hope for photomechanical innovation to the developments of instantaneity. The photograph, the instant, and the print press were intertwined with each other throughout the latter half of the nineteenth century. To speak of one intimated a connection to the others.

Beyond the advertisement space of *Knowledge*, instantaneous photographs were occasionally presented as points of interest for the periodical's readership reproduced through wood engravings. In two instances, separated by a year, *Knowledge* reproduced instantaneous photographs of ephemeral events. By taking a closer look at the organization of these articles, both in terms of how they placed the images on the page and how they described and authenticated their images,

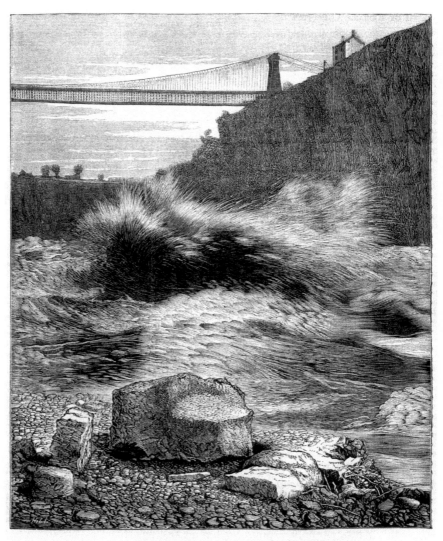

THE WHIRLPOOL RAPIDS, NIAGARA.

(From an Instantaneous Photograph.)

ILLUSTRATION 4.4 Wood engraving—"The Whirlpool Rapids, Niagara," *Knowledge*, 4, no. 97 (September 7, 1883): 153. © The Trustees of the Natural History Museum, London.

we can evaluate the particular way in which instantaneous photographs were mobilized by the periodical press.

The first image to be reproduced in *Knowledge* based on an instantaneous photograph was entitled "The Whirlpool Rapids, Niagara" (Illustration 4.4). This

woodcut encompasses most of the page, with a small amount of text inserted below. The illustration is printed as an accompaniment to an article about the dangers of the popular tourist destination. The text, however, does not describe or accentuate the illustration, rather it describes in detail recent daring and stupid stunts, such as going over the falls in a barrel or honeymooners who fell victim to the fast rapids. The illustration does not create a direct connection with the textual discussion. Rather the connection between the image and the text here is in the content described. While the text details the particular dangers involved in viewing the falls and the rapids, the image gives a direct visual reference for this risk.

Upon examining the image more closely, we find that the surrounding scene is one of great violence, with waves crashing upon each other, and the safety of the cliff in the far distance. The reader is placed directly in this violence with the point of perspective being a small outcropping of rocks, which are level with the waves. The danger of this image is compacted when the reader looks a little below the image. With the subtitle indicating that the image is "From an Instantaneous Photograph," the danger of this point of perspective is all the more vivid. This image and the story that accompanied it were about death: the real danger of death experienced at Niagara Falls and the inherent notion of death inscribed in the instantaneous photograph. This is not the imagination of an artist, but rather shows the real danger that the photographer was in at the time of capturing this image. The fact that it is indicated to be an "instantaneous photograph" reinforces this danger and the value of shortening the time of exposure: this image would have been impossible under earlier photographic technologies, and if attempted would have taken longer to expose and thus have been more dangerous for the photographer. There is no commentary on the image within the article that accompanies it, an absence which is telling. The image acts as a story in itself, not produced by the text, but alongside and in corollary with it.

Looking at a similar depiction of Niagara Falls in a period before the advent of instantaneous photography affirms this interaction between the technology of visualization and the object visualized. In late 1877, the *Graphic* made a similar comment on the dangers of Niagara Falls, but with a direct and comical commentary on taking photographs of the falls. In a two-page foldout illustration entitled, "The Rapids Below Niagara Falls—the Sublime and the Ridiculous" (Illustration 4.5), the *Graphic* was making a commentary on the degree to which tourists were willing to endanger their lives to obtain a photographic image of themselves in front of the falls. The image elicits a very different response from that reproduced seven years later in *Knowledge*. While the visual content of Illustration 4.5 is similar to that of Illustration 4.4—the crashing of the waves and the tumult of the falls are vividly displayed—there is no danger to the participants as it was an imagined scene. The photograph, on the other hand, always imposes a person in the image—whether in front of the camera or behind. In Illustration 4.5, the intention was to relay the humor of the situation rather than the danger.

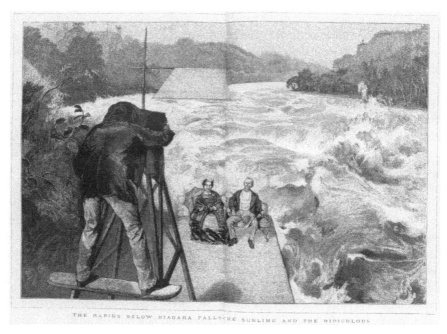

ILLUSTRATION 4.5 Wood engraving—"The Rapids below Niagara Falls—The Sublime and the Ridiculous," *Graphic*, 16, no. 419 (December 8, 1877): 540–541. Reproduced by permission of the University of Leicester Library.

What is particularly interesting about the difference in these two images (Illustrations 4.4 and 4.5) is that the nonphotographic image (Illustration 4.5) related more closely to its accompanying text. Located at the start of the issue, the text described how the itinerant commercial photographer was an annoyance to the tourist. More than an annoyance, they were a danger.

> If there is one place where the nuisance [the travelling photographer] becomes a positive insult, it is in Niagara Falls, where, lost in contemplation of the matchless grandeur of the scene, you are suddenly brought back to earth by the matter-of-fact ruffian thrusting a framed monstrosity before us, and remarking that the "atmosphere" is just in the condition for a "successful sitting," and that the Falls make a "grand natural background."[20]

This danger for the photographer is compounded when looking at the image again. The photographer stands on an uneven platform, himself invading the image, and forcing the participants back toward the water's edge. In a period before the photograph could capture the danger of the falls with verisimilitude, the narrative articulated through text and image was about the danger of the photographer

himself, rather than the danger represented in the photograph. Instantaneous photographs changed the way in which periodicals used photographs, and with this change came a fundamental shift in how they talked about and used photographic images.

In the second instance—where *Knowledge* reproduced an instantaneous photograph for their readership—the "truth value" of the image was very different. In a short half-page article on "Photographing a Flash of Lightning" (Illustration 4.6), the focus of the article was directed toward the innovation of instantaneous photography. The article began by pointing out that "[t]he reproduction of a flash of lightning by photography would, a few years since, have been deemed quite an impossibility, but the introduction of the rapid bromo-gelatin process has rendered it not only possible but comparatively easy of accomplishment."[21] By positioning the value of photographs that pictured very transitory events alongside a narrative that invoked the value of technological and scientific development—the new "rapid bromo-gelatin process"—photography was given an explicit value by *Knowledge* as a tool for visualization which exceeded that of others. Unlike the earlier instantaneous image reproduced in *Knowledge*, the trust in the object on the page was produced through the text that immediately surrounded it.

In the engraving that accompanied the article, there was no subtitle attached to the image, nor any direct inscription of it being "from an instantaneous photograph." Rather, the engraved image was described in the text as, "made directly from a photograph sent to us by Mr. W.C. Gurley, of Marietta Observatory."[22] The trust in this image was made through the invocation of the author of the image, and that it was made "directly from a photograph." The strength of this claim to authenticity was reinforced when the reader continued to read further down, and found a direct testimonial from Mr. Gurley that "the accompanying photograph is from a negative taken by myself during a thunderstorm which passed several miles south of the observatory on the evening of May 4."[23] The reader here was told to trust the image because they could trace the origins of the image, or the chain of translation.[24]

The production of a lightning bolt within *Knowledge* had much broader scientific implications than just within the development of photographic technologies.[25] Lightning, as a subject of scientific research, was a central concern for the investigation of electrical physics, and specifically for Maxwellian field theory.[26] The conceptual understanding of how electricity was conducted, which was a key concern for the telegraph and telephone industries, circulated around investigations of lightning. Oliver Lodge (1851–1940), a central proponent of Maxwell's theory and professor of Physics at University College, Liverpool, used lightning experiments at the end of the 1880s to argue for a wave theory of electricity. What the production of Illustration 4.6 demonstrates is that instantaneous photography was used to help address key concerns within the scientific community by practitioners outside of the scientific elite.

PHOTOGRAPHING A FLASH OF LIGHTNING.

THE accompanying engraving was made directly from a photograph sent to us by Mr. W. C. Gurley, of Marietta Observatory, who writes as follows :—

"The reproduction of a flash of lightning by photography would, a few years since, have been deemed quite an impossibility, but the introduction of the rapid bromo-gelatine process has rendered it not only possible but comparatively easy of accomplishment.

"The accompanying photograph is from a negative taken by myself during a thunderstorm which passed several miles south of the observatory on the evening of May 4.

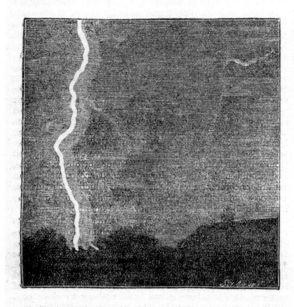

"Wheatstone has demonstrated by direct experiment that the duration of a single flash of lightning cannot possibly exceed a millionth of a second. That a photograph showing the detail of the one mentioned could be taken in this inappreciably short time seems quite wonderful, not to say incredible. The plate employed was one of Cramer's extra rapid, and developed with strong pyrogallic developer.

"It will be observed that the flash is not of the usually depicted zigzag form, and that it seems to be alternately contracted and expanded in its passage through the atmosphere.

"Taking the interval between the flash and the report, I estimated its distance from the camera to have been about five miles."—*Scientific American.*

ILLUSTRATION 4.6 Wood engraving, W.C. Gurley—"Photographing a Flash of Lightning," *Knowledge*, 6, no. 140 (July 4, 1884): 6. © The Trustees of the Natural History Museum, London.

The question remains: why did *Knowledge* feel the need for a longer textual discussion in order to authenticate the lightning bolt while they relied solely on the authority of the subtitle in the image of Niagara Falls? The answer to this lies not in the trust claims of the technology that took the image, but in the content that was being visualized. In the first image, if the reader was a spectator at the falls, they would be able to see what the camera had rendered for them. In the second image, however, the subject was exceedingly fleeting, and therefore unverifiable by the human eye. *Knowledge*, in this instance, had to give a more detailed claim to the authenticity of the image. What becomes clear when examining these two separate examples of the reproduction of instantaneous images is that there was not a stable conception of the instantaneous image, and an instantaneous photograph could have a greater or lesser degree of trust invested in it, depending on whether the referent in the image was verifiable or beyond the scope of human vision.

Muybridge and Marey

The history of the science of instantaneity in the 1870s and 1880s has been tied to two individuals in particular: Eadweard Muybridge, working in San Francisco and Pennsylvania, and Étienne-Jules Marey, working in the outskirts of Paris at his physiological institute. In the historiography of these two individuals, their works are often tied together and have become associated with a narrative about the capturing of time, and the inevitable development of the cinema.[27] The breaking down of time and movement into individually discernable instants, interlinked with each other, did play a fundamental role in both their works; however, the ways in which they evaluated space and time were very different. In particular, they differed in how they regulated the spaces (both temporally and physically) between their images, with Marey being much more attentive to this concern than Muybridge. Because these new photographs showed movements, which could not be discerned by the human eye, the reliability of the images became problematic. The images that Muybridge and Marey created therefore became highly contested objects. The technologies that allowed for image capture, production, and display were subsequently scrutinized for their veracity. While both individuals made claims to the scientific credibility of their images—and the technologies that captured their images—the differences in how they supported their trust claims were significant: Muybridge faced multiple controversies over the reliability of his images, while Marey was extremely fastidious with his images and successfully used them to forward his theory concerning the physiology of animal movement.[28]

The primary site for elucidating the value of Muybridge and Marey's images was not in the closed rooms of the laboratory or even the scientific lecture hall. Rather, it was in the periodical press where images displaying motion circulated, and were either legitimized or rejected.[29] Moreover, it was the reproduction of Muybridge's and

Marey's images across various journals that allowed for their photographs of arrested motion to gain popularity and credibility. Woodcut reproductions of Muybridge's horse in motion or Marey's chronophotographic gun—from the *Scientific American* in New York to *La Nature* in Paris and *Knowledge* and *Nature* in London—demonstrate how mobile these images really were. At the same time, this movement shows just how much they could be altered to reflect the position and argument of a specific journal. The slight change of these images, such as the cropping of the edges, or the changing of the textual narrative that accompanied them, created a new reading of each scientist's images set within the bounds of the particular journal context.

Both men's published works were not easily accessible for the general public. An article in a local Scottish newspaper stated that Muybridge's photographs were "beyond the means of all but a very few private collectors; fortunately, those who are likely to find them of service will probably have access to them in the British Museum, the Royal Academy, the Royal Society, and South Kensington."[30] Considering that the weekly and monthly periodical print press was deeply invested in notions of seriality and the compartmentalization of time into separate pieces of information, the publication of their investigations into instantaneity within the periodical press offers a particularly valuable lens for examining the interaction of these two spatial and temporal sites: the photograph and the periodical press.[31] By refocusing the analysis of each man's images toward their reproduction in periodical print, we gain a better understanding both of how instantaneous images, and technologies, became legitimized and how these images were circulated for varied reading audiences.

Eadweard Muybridge

Eadweard Muybridge was born in Kingston upon Thames under the name Edward James Muggeridge in April 1830. Undergoing numerous adaptations to his name, and a move to California, Muybridge began his career as a photographer in the 1860s. Traveling around the west coast of the United States, Muybridge made and sold several series of mammoth prints and stereoscopic images of Yosemite Valley, San Francisco, and the California coast. He was first and foremost a commercial photographer, and all of his subsequent work needs to be examined within this light.[32] Indeed, Muybridge was most well known in the 1880s for his popular lecture series made in Britain and Europe, where he displayed animals in motion through a device of his own creation called the zoöpraxiscope—an alteration of earlier forms of optical devices that allowed him to project a rotating disk of animal movements onto a screen.[33] The zoöpraxiscope demonstrations did not present a novel form of display or manipulation of instantaneous photographs.[34] Rather what is interesting about the display of Muybridge's work is the way in which his

zoöpraxiscope slides entered the periodical press: they were images made to be cut out and used to make one's own viewing device and were reproduced across various periodicals. The technological integration of periodical and zoöpraxiscope allowed for instantaneous images to circulate among popular audiences. Before this could happen, however, Muybridge first had to make the photographs.[35]

In 1872, the Governor of California and railway tycoon, Leland Stanford, requested Muybridge's assistance in photographing his horse, Occident, at full stride. The purpose of this investigation was to prove that a horse had all four legs off the ground at one point while running. The outcome of the investigation was valued both in the artistic community—to correct and improve the rendering of animals in art—and in the scientific community—to determine the positions of animal movement. The capturing of a horse in motion was a technological achievement, but one which had a much broader impact in the production of photographs, the formation of visual scientific data, and their subsequent reproduction in print.[36]

Before examining the ways in which Muybridge's work on animal movement was reproduced within the periodical press, it is important to first place his broader photographic work within the print press. Similar to Gaston Tissandier (discussed in Chapter 3) and Jules Janssen (discussed in Chapter 5), Muybridge was a continual point of discussion in the print press both for his photographic work and for the intrigues of his personal life. Beyond entering the periodical debate because of his near-death stagecoach accident or murder trial concerning the killing of his wife's lover, Muybridge's early photographs gained him considerable recognition within the papers of the period. For example, after traveling through Central America, Muybridge took series of photographic views of local industries and landscapes. One particular set of photographs made in Guatemala were reproduced as a full page of photographic woodcuts in the *Graphic*[37] (Illustration 4.7). What is particularly striking about these images is that they represent the involvement of machines—both of production and communication—in global trade networks. The photographic camera, for Muybridge, was not just a technology invested in time, but was socially embedded in politics, economies, and print communication.

Upon examining these eight images more closely, we find that they show various stages of the process of coffee cultivation and production. This plate represents a selected set of images; Muybridge made over eighty photographic prints of Guatemala in general and at least nineteen photographs of coffee production.[38] Moving to the text that accompanies these images, the reader finds that they were intended to illustrate a specific point that the author of the article wanted to describe. For instance, the article points out that "our last engraving shows the shipment of coffee at Champerico by means of surf boats, as the breakers on this coast are very heavy, sometimes twenty-four feet high."[39] Similar to John Thomson's photographs of China discussed in Chapter 1, Muybridge's photographs were valuable for their ability to visualize a place and set of practices that the readership of the *Graphic* would never have seen.

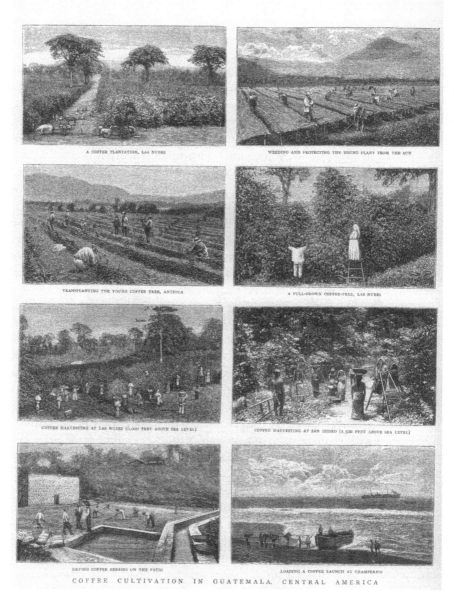

COFFEE CULTIVATION IN GUATEMALA, CENTRAL AMERICA

ILLUSTRATION 4.7 Wood engraving—"Coffee Cultivation in Guatemala, Central America," *Graphic*, 16, no. 412 (October 20, 1877): 376. Reproduced by permission of the University of Leicester Library.

These images are not particularly unique in either their organization or content, as photographs were used as the basis of woodcuts from the inception of the *Graphic* (see Chapter 1). Neither was it particularly unusual for a travel photographer to reproduce his photographs in periodicals. What is unique about these photographs is the relationship between what they showed and the technologies that were used to show them. The value of being "instantaneous" was ascribed to most of the photographs made by Muybridge that were reproduced in the print press. These photographic reproductions thereby offer a point of comparison for his later photographs, both in their organization and content. Unlike the photographs described earlier, when Muybridge's instantaneous photographs were reproduced in the periodical press, the value of what was in the image (or the photographic referent) was privileged. Moreover, instantaneous photographs brought up new questions of authorship, content, and reproduction and complicated how these images were used and how they were trusted. These questions were particularly important with regard to Muybridge's early work on the motion of the horse.

Muybridge's work on capturing the gait of a horse in motion progressed throughout the 1870s. By 1873, he had been able to capture an image of the horse in motion, which he used to prove Stanford's claim that a horse had all four feet off the ground at a particular point during its trot. After this, Stanford asked Muybridge to make a larger study of the movement of the horse, which he completed, after numerous gaps, toward the end of the decade. What is especially interesting about the photographs Muybridge made in this period is that they lack fine detail and are—in shape and form—silhouettes. For example, upon examining a glass plate of a single frame of one of Stanford's horses (Abe Edgington) in motion, we can see that the boundaries of the horse are blurred and fine details are not present (Illustration 4.8). Further to this, upon investigating one of Muybridge's printed series containing the above negative, the detail of the horse's legs is lost within both the single frame and within the series (Illustration 4.9). The photograph, for Muybridge, did not serve the purpose of capturing the deep detail and gradient of tone that allowed for greater simulacrum in the photographic referent. Rather, the camera was valuable for capturing a moment in time, and for giving enough detail to discern the position of the animal in that moment of time. The veracity of the image therefore lay not in what the object looked like, but where it was positioned in space and time.

When discussions of Muybridge and his images entered into the periodical press, questions over the value of his photographic project were at the fore. For example, a short article in the *Dundee Courier & Argus and Northern Warder* from September 1877 (which itself had reproduced this story from the San Francisco *Alta*) reported that Muybridge was embarking upon a larger investigation of the movement of the horse. The end of the article pointed out that "each picture will be taken by a double lens, so as to be adapted for the stereoscope, and will thus furnish the most conclusive proof to connoisseurs that it is faithfully taken

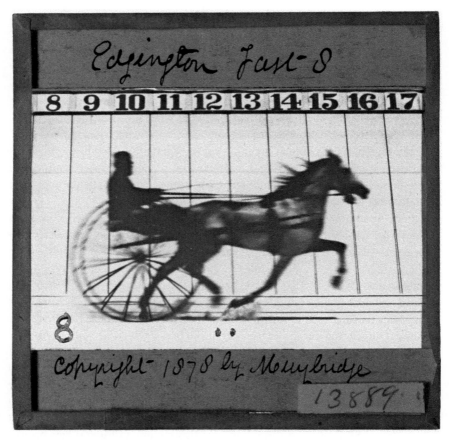

ILLUSTRATION 4.8 Glass positive, collodion on glass lantern slide, Eadweard Muybridge—"Abe Edgington Fast 8 1878." Iris & B. Gerald Cantor Center for Visual Arts at Stanford University; Stanford Family Collections.

by photography, and not materially changed by retouching."[40] The trust placed in the photographs here was twofold: that they were taken with a stereoscopic camera and thus creating two simultaneous images from slightly varied points of perspective; and that the images were not retouched. What is intriguing about this statement is that stereoscopic images were not typically associated with claims of scientific credibility and were more often associated with commercial photography. Muybridge also did significantly retouch his photographs and changed the sequence of the photographs to create a better rendering of motion when projected through his zoöpraxiscope.[41]

The fallibility of Muybridge's images, and their use to display motion was not overlooked within the periodical press. In one particular set of articles in *Knowledge*, the editors endeavored to reproduce for their readers the motion of the

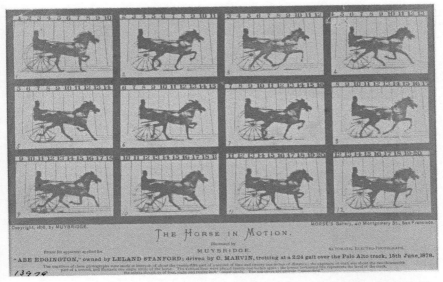

ILLUSTRATION 4.9 Albumen print, Eadweard Muybridge—"The Horse in Motion: 'Abe Edgington' 1878". Iris & B. Gerald Cantor Center for Visual Arts at Stanford University; Stanford Family Collections.

horse that Muybridge had been displaying in lectures throughout North America and England. They did this by producing a wheel printed with the motions of the horse, and instructing their readers on how to make their own zoetrope (or spinning wheel). However, before giving their reader this information, they began with a very telling preamble, which points to the problems of printing and questions over the validity of the images themselves: "We had hoped to present our younger readers this week with a drawing of a trotting horse in the various positions successively assumed by the animal (as instantaneously photographed), for use of the ingenious instrument in the accompanying cut."[42] With this statement, *Knowledge* was ascribing to the image of the horses in motion a complicated set of trust claims: they were drawings, but based on instantaneous photographs. In addition, they were pointing to a woodcut attached directly below the text, which elaborated and visualized the machine being discussed, but was not based on a photograph (Illustration 4.10).

Later in the article, the author further complicated the relationship between the image and the text:

On carefully examining the picture in the *Scientific American*, [where the original image and article were taken from] we found that there was an error which would have caused the picture to produce an imperfect illustration of the horse's action. Twelve positions had been taken from the photographer's

THE MAGIC WHEEL.

WE had hoped to present our younger readers this week with a drawing of a trotting horse in the various positions successively assumed by the animal (as instantaneously photographed), for use with the ingenious instrument illustrated in the accompanying cut. But, on carefully examining the picture in the *Scientific American*, we found that there was an error which would have caused the picture to produce an imperfect illustration of the horse's action. Twelve positions had been taken from the photographer's series without its being noticed that the last two were almost exact repetitions of the first two (in other words, a complete double

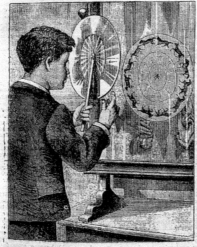

step was illustrated in the first ten pictures). The delay caused by the corrections prevents us from giving the picture this week, but next week we shall have a set of ten positions of a trotting horse, arranged for use as in the accompanying figure, illustrating a highly ingenious method for avoiding the difficulties involved in the construction of a zoetrope. We shall later give a series of views of a galloping horse. In the meantime we leave our younger readers to puzzle out the meaning of the accompanying cut, and in particular to find out how it is that the various parts of a properly-constructed zoetrope are provided for here by so simple a construction.

PRIMARY COLOURS.

IT is impossible to construct a consistent theory based on three primary colours, whether the three be the older set—blue, yellow, and red, or violet, green, and red—the newer set of the theory considered by some to have been established by Clerk Maxwell in his paper to the Royal Society in 1860. Clerk Maxwell's paper contains serious errors. He forms equations with different kinds of quantities, implicitly attributing to the units of those quantities values which, regarded relatively to each other, are purely accidental or arbitrary, and his results are, consequently, fallacious.

As is apparently recognised by Rood, in "Modern Chromatics," a correct and complete theory of colour vision ought to enable us to construct a circular diagram of colours, with complementary colours diametrically opposite to each other, and with the colours distributed with uniform gradation round the circle, and in accordance with their true relations to each other. Now, any diagram cannot be constructed on the assumption that the primaries are three in number, without assuming certain colours, or combinations of colour, to be complementary, which are proved by actual experiment not to be so. The assumption also involves the absurdity that a colour can be (in a sense) complementary to itself; or in other words, that two diametrically opposite colours or combinations of colour which are complementary to each other may each contain the same colour as an ingredient.

When proceeding to arrange colours in a circular diagram, we have first to classify them. For this purpose I take so-called primaries and secondaries together, and for convenience call them simply distinct colours. To the blue-yellow-red theorists I say that to my eyes green and violet are as "distinct" as any of the three, but orange is not to the violet-green-red theorists. I say blue and yellow are as "distinct" as any of the three, but purple or crimson is not. How many "distinct" colours, then, are there to be assigned to equidistant points on the diagram? In my opinion the human mind cannot conceive of more than five colours which are as distinct from each other as red from yellow or from violet, or as blue from green or from violet, or as yellow from green. If, then, there are only five colours of the first class, or of the first and second classes together, it is impossible to construct a theory with three primaries, for such a theory implies three secondaries, or six colours of the first and second classes taken together.

With reference to seeing red in the violet of the solar spectrum, I may mention the case of a person who sees the violet of the spectrum as a dim grey only, and yet, when [two spectra overlap, so that the red end of one combines with the blue part of the other, he apparently experiences the same sensations of violet and purple as normal-eyed persons.

It is held by Helmholtz and others, and I think there can be no doubt of the fact, that mentally we cannot really distinguish in any colour-sensation any components, but only a single resultant sensation. We may experience a sensation which may be called pure as regards its colouredness; for example, we may experience the sensation of a green, which inclines neither to yellow nor to blue, but it is quite certain that for a normal-eyed person it is impossible for light to act on the eye in a perfectly simple or pure manner. In this sense a perfectly pure colour is not obtainable even from the solar spectrum itself, however much it be dispersed, or however narrow a portion of it be taken. To explain my meaning, I will suppose separate nerve fibres of the retina are sensitive to the different primary colours, whatever they may be ; then, what I assert, and can prove, is that no part of the spectrum, however small, acts on a single fibre (excepting, perhaps, at and near the extreme ends of the spectrum). Assuming this to be true, it follows that experiments, like those recently described by Lord Rayleigh, in which the green and red of the spectrum are combined and produce the sensation of yellow, do not in the least prove that the sensation of yellow is necessarily a compound sensation, or that yellow is not a primary colour. A great deal of the difficulty arising in the consideration of the effects of mixing colours disappears when it is understood that colours neutralise rather than combine with or add to each other, the resultant sensation being one which may be described as a mixture of more or less white or uncoloured light, with as much of the colouredness as is not neutralised. E. H.

Glasgow, *Dec.* 3, 1881.

CHARLES BRUSH, of Cleveland, Ohio, is declared to have perfected a new invention for storing electricity. The design consists of a battery in the same sense as in Plante's and Faure's, but the details are entirely different, and do not infringe upon the rights of either. Mr. Brush uses for his storage reservoir metal plates, so arranged that they are capable of receiving a very large charge of electricity and of holding it for an indefinite time. The storage reservoirs vary in size as desired, may be transported from place to place, and used as desired. Each citizen may then run his own electric light as he pleases ; the plates can be put on street-cars, connected with the axles, and made to run the cars without horses, and steam-cars may be ultimately run in the same way. The practical character of the invention is said to be settled, and it is simply a matter of expense, but the details of the methods are not made public.—*Frank Leslie's Magazine.*

series without it being noticed that the last two were almost exact repetitions of the first two (in other words, a complete double step was illustrated in the first ten pictures). The delay caused by the correction prevents us from giving the

picture this week, but next week we shall have a set of ten positions of a trotting horse, arranged for use as in the accompanying figure, illustrating a highly ingenious method for avoiding the difficulties involved in the construction of a zoetrope.[43]

In this article, *Knowledge* was correcting a visual mistake made in another periodical, *Scientific American*, while at the same time making its own value of the horse in motion. This is a prime example of the ways in which images were augmented when moving across various periodical spaces. *Knowledge* corrected what it saw as a significant error: the reproduction of an extra stride in the motion of the horse. In correcting this image, the periodical was creating a claim to a more authentic version of the horse in motion. This authenticity did not lie in the instantaneous photograph, although its authority was invoked in the text, but rather in the careful eye of the journal's editor. The interaction of the editor in the production of the authority of this image is important: images that did not implicitly produce their own meaning could be much more easily molded to the needs of the journal. Because the image from the *Scientific American* had a flaw, *Knowledge* was allowed to both define what the image meant, at the same time as buoying the authenticity of the image and the editors' credibility as science communicators.

When *Knowledge* eventually did reproduce its version of the horse in motion, the value of the images invoked was equally as complicated as in the first article. It was still a serial image, showing movement reproduced in a periodical space, but the main difference was that Richard Anthony Proctor, the editor for *Knowledge*, had corrected the image and made it trustworthy. In two further articles, *Knowledge* reproduced two sets of zoetrope rings that depicted the horse both at a walk and at a run (Illustrations 4.11 and 4.12). These two zoetropes were given greater truth values than other optical toys because

the views have not been made by guess-work, as in most of the series used for zoetropes, but are from a series of actual photographs taken instantaneously at equally successive intervals of time during the trotting past of the celebrated racer, Abe Edgington. They were obtained by Muybridge, of San Francisco.[44]

Here, the crucial aspect was that photographs could be taken instantaneously. Without this technology, the zoetrope slide, according to *Knowledge*, could not have realistically reproduced the motion of the horse. In addition to this, Muybridge was invoked as the author of these images. His name would have been well known to the readers of the periodical press, as it has already been pointed out, due to his association with instantaneous photography and the widespread publication of his works within *Knowledge* specifically, and the periodical press generally.

Muybridge, of San Francisco. Next week, or the week after, we shall give a series showing a galloping horse.

The above views are from the *Scientific American*; but, as mentioned in our last, the series showing a trotting horse had to be modified before it could be used for the purpose of the magic wheel.

It is hardly necessary to say that the wheel can be readily made to turn uniformly by being put on a small axle, round which a string may be twined. But twirling with the hand will suffice to show how well worth while it is to provide for a more satisfactory method.

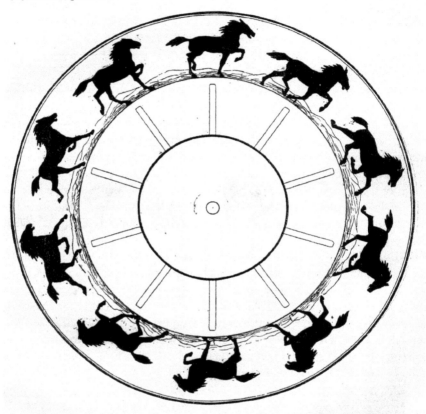

THE PLANETS AND SOLAR SPOTS.

M DUPONCHEL considers that the maximum of solar spot frequency will not occur "as all the world, and M. Fagein particular," predict, in 1882, but not earlier than 1890. It may possibly occur as early as 1888, but far more probably will be as late as 1892. He bases this on the supposed relation between the sun spots and planetary movements, a relation which has not been established, but on the contrary, seems more and more unlikely the more the evidence is examined. Those who fondly imagine that the world is to come to an end in 1882 (the prediction of Mother Shipton—of fully equal value in our opinion—having failed for 1881) because of planetary perihelion passages, and resulting sun disturbances (also because the pyramid grand gallery is 1881·59 inches long, or ought to be), may breathe freely again, that is if they are disposed to prefer M. Duponchel as an authority to Professor Grimmer. For our own part we believe the world is quite as likely to come to an end in 1888, or 1890, or 1892, as in 1882. It has been coming to an end, at intervals of two or three years, for the last century, and probably, though we have no evidence as to details, ever since it seemed so certain to every one that the year 1,000 was to see the end of all things mundane. And so far as can be seen, one prediction in the past and for future dates has been as good as another—in other words, not one has been worth a straw.

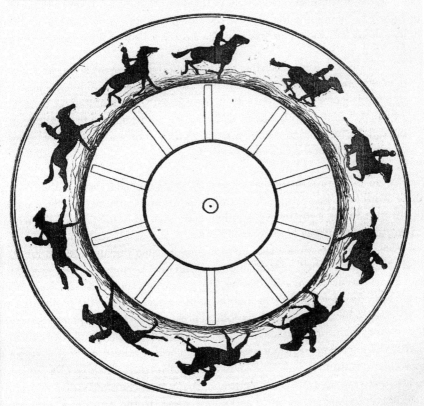

THE MAGIC WHEEL.

WE give, this week, the series of pictures of a galloping horse. We have to notice, however, that the instructions given in the *Scientific American* are erroneous. If a slit is cut exactly beneath each figure of a horse, we get a view of a horse galloping without advancing. Eleven slits should be cut (which the reader will find no difficulty in doing), at equal distances, when the horse will not only be found to move his legs, tail, &c., but to advance, as might reasonably be expected from a galloping horse. The same remarks apply, of course, to the trotting horse, in number 10, in fact, the trotting horse alone is taken from the *Scientific American*, the ten views of a galloping horse being from a series kindly supplied to the editor by Mr. Muybridge, of San Francisco, who photographed them.

Twelve slits will produce the desired illusion even better than eleven, a correspondent notes, and their places are more easily measured.

THE MOON AND THE WEATHER.

IT is held by a large number of educated people that a belief in the influence of the moon on the weather is a remnant of a past and now discredited system of divination by which all the events of life were referred to the influence of the heavenly bodies. It should, however, be borne in mind that the germs of truth may be found in every system of religion and philosophy, and that the interests of truth are served better by seeking for the truth underlying any particular theory, than by denouncing it as false because it lies beyond the range of superficial observers.

In the first place, the theory of lunar influence upon the atmosphere stands apart in a great degree from the old system of astro-meteorology; for, as may be seen in the text-books containing the

In the final article on the horse in motion in this series, *Knowledge* again brought into question the credibility of the periodical from which it had taken the original illustration. The editors pointed out that, in addition to the error of including a repetition in the stride of the Horse, *Scientific American* had also erred in instructing its readers on how to make a zoetrope out of the image produced:

> We have to notice, however, that the instructions given in the *Scientific American* are erroneous. If a slit is cut exactly beneath each figure of a horse, we get a view of a horse galloping without advancing. Eleven slits should be cut (which the reader will find no difficulty in doing), at equal distance, when the horse will not only be found to move his legs, tail, &c, but to advance, as might reasonably be expected from the galloping horse.[45]

They were keen to point out that while this advice applied to both of the zoetrope slides *Knowledge* had produced, it was particularly apt for the first illustration of the trotting horse, as that was the only image taken from the *Scientific American*, and for this reason was fundamentally flawed.[46]

What these sets of articles demonstrate is that the images produced by Muybridge had varied reproductions within the periodical press and could face considerable claims of fallibility. However, the claim that they were "from instantaneous photographs" was not the point at issue. Rather, the problems came in their reproduction within the periodical press, and their subsequent use beyond the confines of the printed page. Moreover, what this example vividly demonstrates is that the instantaneous photographs of Muybridge moved through a series of reproductions: from the glass plate, to the negative, to the making of a sequence, to an engraving, to a printed image, and finally to an instrument cut out of the newspaper and spun around to make movement. In the periodical press, these images were produced and reproduced in ways that reflect the interconnection of the text, the image, and the reader.

The reproduction of Muybridge's photographs in the periodical press was not always straightforward. The sets of photographs that Muybridge took under the commission of Stanford were subject to a long controversy over the rights of the images. The *Horse in Motion* (which was the name of the book that printed Muybridge's photographs) was not authored by Muybridge but had been quietly and secretly given to Dr. Jacob Davis Babcock Stillman (1819–1888), an employee of Stanford's, and was surreptitiously published in 1882. Muybridge claimed authorship over his photographs and said that it was his genius that had invented the instantaneous apparatus and his art as a photographer that allowed for them to be produced. Stanford, on the other hand, claimed that it was his money and his idea in the first place which led to the production of the images, and that Muybridge was his employee.[47] What this controversy meant for the periodical press was that Muybridge's photographs were not always available for print.

After the printing of the *Horse in Motion*, Muybridge went to great lengths to defend his authorship of the photographs in the book. One of the most useful fora for Muybridge to assert his authorship over his images, while at the same time buoying his scientific credibility, was in the pages of *Nature*. After *Nature* produced a review of Stillman's book without citing or crediting Muybridge, Muybridge proceeded to write a "letter to the editor" that was subsequently printed. He was quick to point out that:

> In *Nature*, vol. xxv. p. 591, you notice the publication of a work entitled "The Horse in Motion," by Dr. Stillman, and remark: "the following extract from Mr. Stanford's preface shows the exact part taken by each of those concerned in the investigations." Will you permit me to say, if the subsequently quoted "extract" from Mr. Stanford's preface is suffered to pass uncontradicted, it will do me a great injustice and irreparable injury.[48]

This injury and injustice was the loss of his credibility in relation to the images, and the concomitant scientific authority. This plea was responded to by *Nature*, and in all subsequent discussions of the *Horse in Motion*, Muybridge was not overlooked.[49]

The inclusion of Muybridge in subsequent discussions of the *Horse in Motion* extends beyond the superficial. Later in 1882, Francis Galton (1822–1911), Charles Darwin's famous cousin, was deeply immersed in his work on composite photography and wrote an article in *Nature* on the *Horse in Motion*.[50] The article utilized Galton's process of overlaying photographic negatives to create a composite image, or idealized type, to address the question of the "Conventional Representation of the Horse in Motion."[51] The question of the position of the horse's legs while running had considerable consequences for both the scientific and the artistic communities. For the scientific community, it brought a better understanding of animal physiology, but for the artistic community it brought into question the reliability of the artistic eye: with Muybridge's photographs, the conventional position of horses' legs in paintings was shown to be false.

Before examining Galton's article in more detail, it is important to first position this debate within the broader periodical press, and in the uses and perceptions of Muybridge's work during the period in which the *Horse in Motion* was published. In the visual arts, the traditional conception of the horse in motion depicted the animal splay-legged, with the forelegs advanced in front and the hind legs stretched to the back. With the use of his instantaneous photographs, Muybridge showed that the horse was never in this position.[52]

In an article in *Knowledge*, there is a woodcut that was used to expand on the artistic and scientific view of the horse in motion (Illustration 4.13). The top two images of this woodcut show two different conventional conceptions of the horse in motion, and the bottom image shows the corrected version of horse movement.

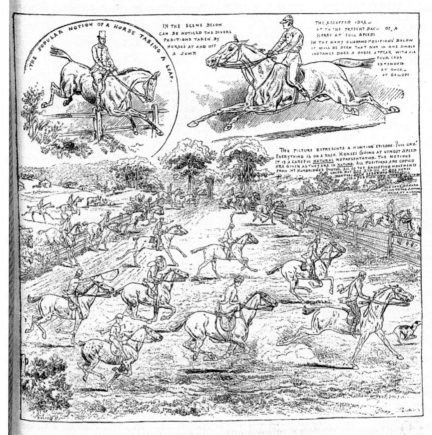

SCIENCE OF THE HORSE'S MOTION.

THE remarkable pictures of the horse in motion, as revealed by Mr. Muybridge's instantaneous photographs, taken in California, at the instance of Governor Stanford, show that the impressions produced upon the human mind through the eyes, in closely watching the motions of a horse when running a certain distance, are very different from the impressions which will be made during the same run upon a highly sensitive photographic plate.

In a recent number of the *American Queen*, we find a peculiar drawing, which is of value as illustrating at one view these extraordinary differences of impressions.

The two upper figures show the impressions ordinarily made upon the mind's eye by the horse and rider in the acts of running and leaping. Here we have grace, vigour, and strength very well exemplified. The smaller figures below are mostly made from the instantaneous photographic pictures before mentioned, with this important qualification, however, that while many of the positions of the horses are correctly taken from the photographs, the positions of the riders are, we suppose, the work of the fancy of the artist. There is an old adage, that things are not

ILLUSTRATION 4.13 Wood engraving—"Science of the Horse's Motion," *Knowledge*, 2, no. 50 (October 13, 1882): 323. © The Trustees of the Natural History Museum, London.

Upon examining these images more closely, the lines between the drawing and photographs become blurred. While the top two images are drawn, the bottom image is a composite of drawing and photography. The text, which describes the bottom image, is set within the image itself rather than being placed outside of that matrix. After first describing the scene of the image to be a hunting episode at "full cry," the image goes on to state that "[t]he motions are given as they are in Nature. All positions are copied from Mr. Muybridge's photos."[53] The image thus uses photographs to legitimize the position of the horse, but at the same time these photographs are subordinated to the whole scene being depicted. The drawing and the photograph operate on the same visual plane in this image, and thus significantly complicate the narrative concerning the use of Muybridge's photographs within the periodical press.

Returning to Galton's article in Nature, we see a similar complication of the use of instantaneous photography. In writing this article, Galton attempted to show that the misconception of artists in their renderings of horses was not due to a lack of attention to detail, but to the deception of their own eyes. He argued that the eye sees a horse with both legs fully extended during a gallop because those are the positions that are held for the longest point in the stride, with the leg terminating its extension and beginning its movement back toward the center of the body.[54] Unlike the camera, the eye cannot discern the exact positions of the horse's legs at any one point in time, nor correlate one leg's position with another.

Galton demonstrated his point by showing composite images he made of Muybridge's photographs of eight movements of a horse (Illustrations 4.14, 4.15, and 4.16). Illustrations 4.14 and 4.15 show four strides each of the horse: the first being the movement of the forelegs and the second being the movement of the hind legs. Illustration 4.16 is a composite of the composites, with only the terminal positions of the legs of the first two images being included. With this third illustration, Galton was showing how the photograph could be turned into the conventional conception of the horse's legs during a gallop. Through the reproduction of these photographs in the periodical press, Galton was designating a value for photography bound by the forms of print reproduction (the wood engraving) and commenting on the uses of drawings. Moreover, the article as a whole pointed to one of the central concerns regarding the use of photography in the nineteenth century: where did the eyes fail to accurately see, and how could the photograph be used to see what the eyes could not.[55] The instantaneous photograph in this example was able to freeze time and thereby show a motion beyond the scope of human vision. When it came to communicating these instantaneous photographs in periodicals, they were serialized to create a new visual narrative and were remade through print mediums that were not invested with a notion of mechanical veracity. For Galton, the periodical press allowed him to remake Muybridge's images and to produce his own kind of seriality, a seriality that imposed its own order, and thereby his own reading and meaning of the photographic images.

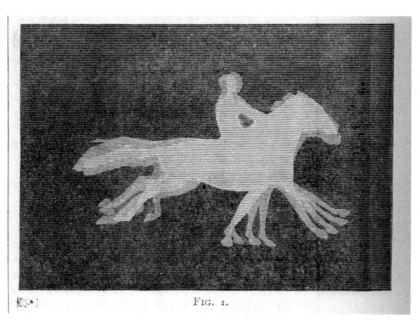

FIG. 1.

ILLUSTRATION 4.14 Wood engraving, Francis Galton—"Fig. 1," *Nature*, 26, no. 662 (July 6, 1882): 228. Reproduced by permission of the University of Leicester Library.

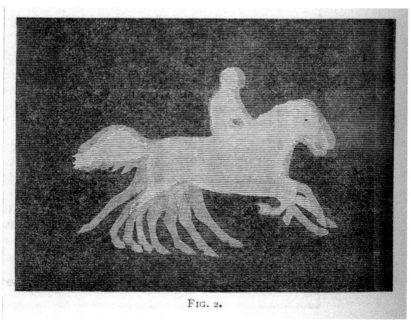

FIG. 2.

ILLUSTRATION 4.15 Wood engraving, Francis Galton—"Fig. 2," *Nature*, 26, no. 662 (July 6, 1882): 228. Reproduced by permission of the University of Leicester Library.

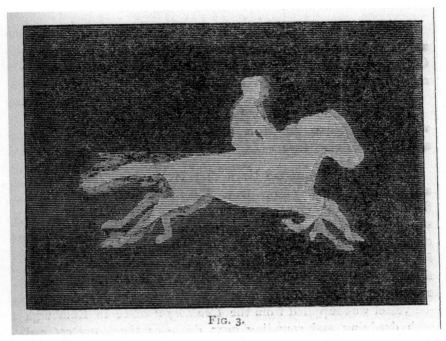

ILLUSTRATION 4.16 Wood engraving, Francis Galton—"Fig. 3," *Nature*, 26, no. 662 (July 6, 1882): 229. Reproduced by permission of the University of Leicester Library.

This article by Galton was also an important example of the controversy over questions of access to Muybridge's photographs. Galton began his article by pointing out that "I wish I could reproduce on a scale, however small, any one of the many plates published in 'The Horse in Motion;' but it appears that the copyright of the photographs is disputed, and there are difficulties in the way of doing so, and I must make shift without them."[56] Galton did reproduce photographs made by Muybridge from the *Horse in Motion*, but he did so by making them into composites. Galton does not detail how he got access to the images and whether he produced his own composites from Muybridge negatives, or whether he used the positives taken from the *Horse in Motion*. The placement of authorship of the images produced in this article in *Nature* lay somewhere in between Muybridge and Galton. This raises important questions over what counted as ownership over images when produced in the periodical press—and specifically within the illustrated scientific press, where the production of an image was often tied to claims of scientific credibility. While images were often reproduced with or without credit of any form—such as was the case with Illustration 4.13, taken from *Scientific American*, which in turn had been taken from the *American Queen*—the reproduction of Muybridge's photographs carried a greater claim of authorship. As has already been pointed

out, Muybridge had laid claim to his ownership of the photographs of the *Horse in Motion* earlier that year in *Nature*. The use of Muybridge's instantaneous photographs in this article points to the specific ways that photographs which contested human vision were presented within the periodical press; as well as demonstrating how precarious the relationship of authorship, trust, and veracity was in the production and reproduction of photographic images within the late nineteenth-century illustrated periodical press.

The claim to authorship over the instantaneous photographs of the horse in motion was important for more than just commercial reasons. In the historiography of instantaneity, the relationship between Muybridge and Marey in the development of instantaneous photography is invariably discussed. Muybridge is said to be an influence on Marey, citing Muybridge's visit to Paris in the fall of 1881 as the first time that Marey realized the value of the camera to his investigations of human and animal physiology. A story of technological progression, moving from Muybridge to Marey, is invested in narratives about the development of instantaneous photography, inevitably leading to the Lumière brothers and the invention of cinema. While it is clear that there were influences between Muybridge and Marey in the use and development of photographic technologies to understand movement, this story is not straightforward; nor was the adoption of instantaneous photographic technologies by Muybridge or Marey based on similar motivations.

The relationship between Muybridge and Marey had been well established within the periodical press. *Nature* in particular pointed to the influence of Muybridge's photographs on Marey after he exhibited them at lectures given in England. Yet, the key influence on Marey adopting the photographic camera was given to the newspapers themselves:

> The *Scientific American*, however, and afterwards *La Nature*, have published cuts taken from the photographs [of Muybridge], and much general interest has been awakened in these researches. Among these specifically interested is Prof. Marey, who desired to be put in communication with Mr. Muybridge, as he wanted to ask his aid in solving certain physiological problems, so difficult to solve otherwise.[57]

While *Nature* here clearly pointed to the influence of Muybridge on Marey in his later work on animal locomotion, and specifically his work on the flight of birds, the key technology here is the periodical press—not the photograph. Without the "cuts taken from photographs" being reproduced in the scientific periodicals of America and France, Marey might not have become aware of Muybridge's work. The periodical therefore played a fundamental role in this story of the development of instantaneous photography and its application to animal movement.

Étienne-Jules Marey

Étienne-Jules Marey was an exact contemporary of Muybridge, his birth and death having taken place in the same years (1830–1904). Marey, however, lived a very different life to that of Muybridge. He was born and raised in Beaune, France, and was educated at Collège Monge (a local private boys' school that excelled in engineering). Later, he achieved his bachelorette at Dijon and eventually trained as a medical doctor in Paris.[58] Although Marey's qualification was in medicine, his real passion lay in engineering and the construction of machines. His skill both as a machine maker and as a doctor shaped the way that he addressed questions of the movement of humans and animals later in his life. Marta Braun, in her seminal biography of Marey, argues that his work in the 1880s, and beforehand, was motivated by scientific concerns, and that understanding his photographic investigations is impossible without understanding his experimental aims. In contrast, Muybridge's instantaneous photographs, she argues, had little—if anything—to do with science.[59] While this difference may have been manifest in the organization and content of Marey's photographic work itself, the way that this work was reproduced within the periodical press more expressly highlights Marey's and Muybridge's different modes of visual epistemology. Through an examination and comparison of each man's instantaneous photographic work in the periodical press, we can better understand how the process of print production and image reproduction was either complementary to or in contradiction to claims of experimental credibility.

Marey began his work on human and animal movement through what he called the graphic method. He used various machines delicately applied to birds, various quadrupeds, and humans, to measure, transmit, and record on paper the processes of movement. Marey called this the graphic method because the machines traced the movements directly on paper allowing for the ephemerality of movement to be captured for later analysis. Marey's early work, while distinct from his experiments with photography, had visual and experimental corollaries to this later work. In both his early and later works, he was interested in using machines to visualize and stabilize actions made over a very short period of time: a period of time that otherwise escaped human observation.

Marey's work on the graphic investigation of animal movement, while rooted in the science of physiology, had a much wider association with related sciences. Marey began his investigation into animal movement just after the end of the Siege of Paris.[60] Thus, his research on the flight of birds had as much to do with finding out how they moved, as it did in improving the science of flight.[61] Like Muybridge, Marey's work on flight, motion, and movement in the early 1870s was communicated within the periodical press; and it was through this publication that he gained the popularity and credibility that would later mobilize his work in photography.

Marey began his investigations into animal movement by breaking down the individual actions of the muscles and limbs while in motion. He did this by building very delicate and precise measuring devices, which could calculate the time and distance between these movements and translate these actions into lines on a piece of paper. After Muybridge's successful horse series, Marey was convinced of the utility of photography to his own investigations of movement.[62] Using his particular technical acuity of instruments, Marey developed a device to capture what he called chronophotography, or time photography. For Marey, the measurement of the movement of animals was essentially tied to space and time, as the addition of "chrono" to the name of the photographic instrument itself made clear. This spatial and temporal aspect was positioned in similar ways to the narratives of Gaston Tissandier in his use of pigeons, hot air balloons, and photography in the Franco-Prussian War discussed in Chapter 3: a technology was mobilized to effect a particular notion of movement and visualization, and the uses of these technologies were tied together. By investigating the particular ways in which Marey investigated movement during flight through technologies of vision, and how he communicated this within technologies of print, we can see more explicitly the correlation between space, time, and the production of photographs for scientific investigation.

While Marey studied a number of different animals and their movement (including humans), among the most difficult animals to measure were birds—they did not have a stable background upon which to position the measuring instrument. Marey pointed to this difficulty when he wrote, in his large work on *Animal Mechanism*, that "the graphic method which enabled us so easily to determine the frequency of the strokes of the insect's wing cannot be employed under the same conditions when we experiment on the bird."[63] In order to study the flight of birds, Marey developed an ingenious instrument that allowed him to measure the regularity of the beating of a pigeon's wings while in flight. In *Animal Mechanism*—where Marey published his account of measuring the flight of birds—he reproduced two pictures that visualized his instrument for making these measurements. Illustration 4.17, which shows the mechanism in operation, is spatially reminiscent of the application of the photographic quill on the pigeon in Illustration 3.8 from Chapter 3; they both demonstrate how the technology of importance (in the case of Illustration 4.17, the measuring device) was made operable. In contrast, Illustration 4.18 carries a very different visual organization. The image and the text do two jobs: they demonstrate how the very intricate instrument works; and they establish the interrelationship between the bird and the technology which measures and transmits the bird—in this instance, a measuring drum attached through a circular flight ring.

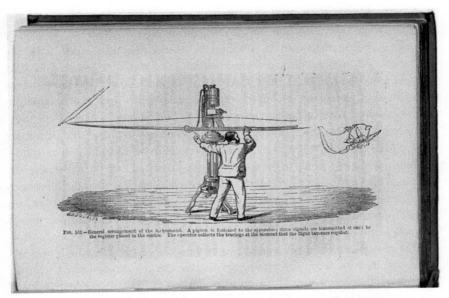

ILLUSTRATION 4.17 Wood engraving, Etienne Jules Marey—"General Arrangement of the Instrument," *Animal Mechanism: A Treatise on Terrestrial and Aerial Locomotion*, London: Henry S. King & Co., 1874, 248. © The Trustees of the Natural History Museum, London.

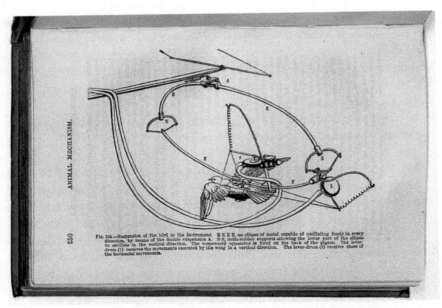

ILLUSTRATION 4.18 Wood engraving, Etienne Jules Marey—"Suspension of the Bird in the Instrument," *Animal Mechanism: A Treatise on Terrestrial and Aerial Locomotion*, London: Henry S. King & Co., 1874, 250. © The Trustees of the Natural History Museum, London.

For Marey, the integration of birds and technologies of measurement was more than just investigation for investigation's sake. Similar to Tissandier and de Fonvielle discussed in Chapter 3, Marey was concerned with the practicalities of making human flight possible. For Tissandier and de Fonvielle, this was manifested through their advocacy of hot air balloons, and the resultant integration of alternative technologies, such as pigeons and photography, in buoying the legitimacy of balloon science. For Marey, human flight was dependent on understanding the mechanisms of animal flight—and in order to do that, there needed to be quantifiable data on how birds moved. In the introduction to *Animal Mechanism*, Marey pointed to the fact that aerial flight had long been fantasized by man, and due to this fantasy, it had often been argued that, with enough research (data), this question could be answered.[64] Marey's answer to this question of how to collect data was a visual one: at first he used the graphic method and later moved on to the chronophotographic method.

This movement from the graphic to chronophotographic methods was not developed in a vacuum. The photographic gun was closely associated with the photographic revolver developed by Jules Janssen discussed in Chapter 5 and was an important technological precedent for Marey in the development of his chronophotographic method. Muybridge's work on instantaneous photography was also foundational. Returning briefly to the statement made in *Nature* earlier in this chapter which showed the influence of Muybridge on Marey's decision to use photography, we see that the production of priority claims was particularly important within the scientific press. At the same time, it is clear that the editors of *Nature* saw the value of Marey's and Muybridge's works to be more than just scientific; they were also aesthetic. The periodical later stated, in relation to Muybridge's work: "What beautiful zootropes [sic], too, might be had! Mr. Muybridge's cartoons representing the fast gallop give a key to the breaking down of so many horses."[65]

In similar ways, when the *Graphic* learned of Marey's use of photography, it immediately associated this with Muybridge:

Mr. Marey has, for the purpose of studying the motions of a bird in flight, contrived a photographic fowling-piece, which, pointed at a bird on the wing, will take twelve instantaneous pictures in as many as a fraction of a second. These pictures arranged for projection on a screen, by means of the phenakistiscope, after the manner of Mr. Muybridge's trotting horse, would reproduce the movements of the winds, and those movements could be analysed. Mr. R.A. Proctor is so impressed with the value of this new method of studying the attitude of animals in motion that he offers a prize of 50*l.* towards the expense of photographing a rowing match, so that a perfect style, such as that of Hanlan, may be handed down to posterity in the form of pictures which would show the details of which that style is made up.[66]

For Mr. R.A. Proctor (Richard Anthony Proctor, the astronomer and founder of *Knowledge* discussed in Chapters 2 and 5), Marey's work demonstrated an advance in photography, which would allow one to photograph the previously impossible: the movement of rowers rowing. For *Nature* and the *Graphic*, Marey's use of photography was both a scientific one and an achievement of public spectacle. While Marey and Muybridge may have had very different motivations in making their photographic studies, when it came to their discussion in the periodical press, they were the same.

After learning about Muybridge's work using instantaneous photographs to capture a horse in motion, Marey soon began his own investigations using the camera. The work he proposed, however, was practically very different from that of Muybridge: he wanted to extend the work he did using the graphic method to photograph the flight of birds. The periodical press, in its reporting of this work, was quick to comment on the difference between Marey's and Muybridge's works. Shortly after Muybridge exhibited his photographs in his European lectures, the *Manchester Times* reported that "Professor Marey lately suggested that the method [of instantaneous photography] should be applied in studying the flight of birds, and Mr. Muybridge intends modifying his apparatus for that purpose. Of course this case presents special difficulties." The special difficulties they pointed out could be solved by adopting Marey's method:

> A French captain M. Vassel, has proposed in *La Nature* an apparently feasible way of realising M. Marey's idea of a "photographic gun" (so called) for fixing birds in their flight. The gun, which is fitted with Bertach's automatic camera obscura, is actuated by means of a trigger, but this trigger, instead of the usual action, releases a rectangular sliding screen, which has a round aperture in the centre to let the light pass, while it intercepts it by its two extremities.[67]

The question of the flight of birds was not, as the above article suggested, immediately solved by Muybridge, but rather was addressed by Marey and his new photographic technology, the photographic gun.[68]

Between 1879 and 1882, Marey developed his work on photographing the flight of birds, and in 1882 (the same year as the publication of the *Horse in Motion*), Marey published his work in *La Nature*, which was subsequently published in *Nature*. The separation in time and this movement across space (from *La Nature* to *Nature*) is important to emphasize as it demonstrates the multiple forms of reproduction that images and article underwent in the late nineteenth-century periodical press. In these two articles on Marey, republished in *Nature* (which were separated from each other by five years), the instantaneous photograph was discussed and visualized as a formative technology for the experimental program devised by Marey to isolate and discern the flight of birds. Through these articles, the camera, the photograph, and the print press become entangled in their production of scientific credibility.

The first article, published in May 1882, was three pages long and was the first time that *Nature* gave a detailed description of the photographic gun discussed in the *Manchester Times* article. The gun itself was reproduced over two separate illustrations: the first showing the gun in action and the second giving a dissected view of the instrument (Illustrations 4.19 and 4.20). These two images were paired with each other: they showed the gun in operation and provided a visual description of how it worked. Yet, upon examining the text that surrounds the images, there is no reference to how they were made. What is made clear in the textual descriptions, however, is the value of the instant. When describing Illustration 4.19, *Nature* pointed out that

As the result of a good deal of thought and labour, an apparatus was constructed about the size of a sporting-piece (Fig. 1), which would take twelve images, in one second of an object on which the piece was continually sighted. The time of exposure of each image was about 1–720th of a second.[69]

Similarly, the description of Illustration 4.20 emphasized the regularity of the mechanisms and their ability to capture time. After giving a general description of the mechanisms, and again stressing the 1/720th of a second exposure time, the text leads the reader through the image: "The teeth to arrest its movement [the disk of sensitized plates] are seen at C, Fig. 2, No. 2, while the excentric [sic] at F, Fig. 2, No. 2, keeps up the regularity of movement."[70] The images here operate as aids to the text. Moreover, Illustration 4.20 was both an image and a text with points of reference inscribed on the image to aid in the reading and interpretation of the object. The point of reference in both of these images was the photographic instrument. The mode of representation did not need to be validated because there was no trust claim in these images or in the text. Thus, the process of reproduction was not invoked, and the reader was not told how the image was produced.

There is one image in the article that did need to be authenticated. Positioned slightly below Illustration 4.20 was a reproduction of a ring of exposed and sensitized plates, which constituted a set of twelve photographs of a seagull in flight (Illustration 4.21). The image is subtitled "Fig. 3—Sea-gull, flying: heliograph of twelve plates obtained by the process."[71] A heliograph, which is a synonym for photogravure, was a form of printing that exposed a photograph directly onto a sensitized copper-etching plate.[72] Unlike the woodcut or line engraving, the heliograph removed the human intermediary in the printing process. By inscribing this image with the value of being an instantaneous photograph reproduced by heliograph, *Nature* was positioning this image as being extraordinary. The text that described it reinforced this added emphasis, arguing that in "Fig. 3 there will be seen the photographic representations of a sea-gull, in which the twelve successive attitudes assumed during the space of single second by this bird during flight are ascertained."[73] While the earlier illustrations used the images to demonstrate the point of the mechanism, Illustration 4.21 was the proof of the experiment and

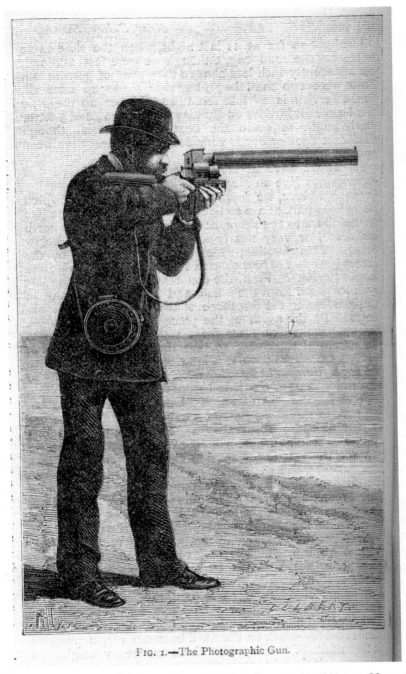

FIG. 1.—The Photographic Gun.

ILLUSTRATION 4.19 Wood engraving—"The Photographic Gun," *Nature*, 26, no. 656 (May 25, 1881): 84. Reproduced by permission the University of Leicester Library.

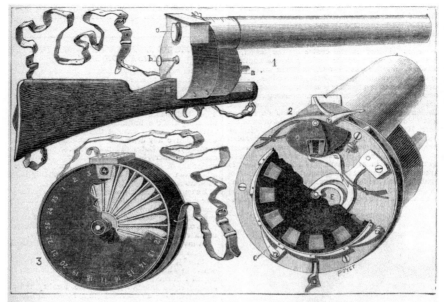

FIG. 2.—Mechanism of Gun. 1, General view; 2, Windowed disc; 3, Box with 25 sensitive plates.

ILLUSTRATION 4.20 Wood engraving—"Mechanism of Gun. 1, General View; 2, Windowed Disc; 3, Box with 25 Sensitive Plates," *Nature*, 26, no. 656 (May 25, 1881): 85. Reproduced by permission of the University of Leicester Library.

thus contained its own visual credibility. This reminds us that when it came to the reproduction of serial images, the most important technology was not the photograph, but rather the place where it was published—the periodical press. The language therefore changed when referring to this illustration from the descriptive—"this is what is in the image"—to the direct—"you will see in this image." Unlike the instantaneous images reproduced in the periodical press by Muybridge, Marey's images were not clouded in questions of authorship. The visual and textual narratives told in the Marey articles in *Nature* did not need to justify themselves, except when it came to presenting experimental proof.

This separation between Muybridge's and Marey's visual and scientific credibility was explicitly stated within the article itself. Close to the beginning of the article it specified that

In September, 1881, on a visit of Mr. Muybridge to Paris, he brought with him some photographs of birds taken on the wing, but these, unlike the invaluable series taken by the same gentleman of horses and men, were not the representation of a series of continuous attitudes, but rather represented the bird in the position it happened to be in at a moment of time; whereas, to explain the fall and rise of the wings and the positions of the body, it was, above

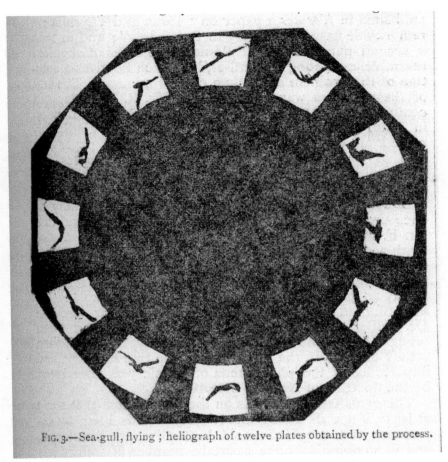

FIG. 3.—Sea-gull, flying ; heliograph of twelve plates obtained by the process.

ILLUSTRATION 4.21 Heliograph—"Sea-gull, Flying; Heliograph of Twelve Plates Obtained by the Process," *Nature*, 26, no. 656 (May 25, 1881): 85. Reproduced by permission of University of Leicester Library.

all things, important to have a series of rapid photographs taken of the same bird over a period during which the whole mechanism was in action, so as to allow of the movement to be afterwards studied at leisure.[74]

Here, the article was making a comment about the scientific value of Muybridge's photographs. While Muybridge was certainly able to take photographs of birds in flight, there was no regularity. For Marey, the necessity of having a regulated set of serial images was the key aspect to understanding the flight of birds. The photograph may be a useful tool, but without the human observer defining the space between the images, the value of the images for science was naught. By reproducing the image that showed this serial regularity by mechanical means, the article reinforced the epistemological position of the photograph.

In his second article in *Nature*, published in 1888, Marey expanded his argument about the flight of birds and presented his audience with new examples of his photographic investigations. First, the piece emphasized the temporal and spatial separation between the publication of the first article, and the reproduction of the same argument in *Nature* from *La Nature*. The article began by stating: "Through the courtesy of the editor of our French contemporary we are able to reproduce the figures illustrating M. Marey's interesting paper."[75] While the rest of the document was set in the first-person voice of Marey (as reproduced from *La Nature*), this passage places the emphasis on the reproduction of the images. Given that there are eleven illustrations over the six pages of the article, the need for taking the reproductions of these images from *La Nature* is evident: the images dominate the main space of each page, and without them, the argument would not be able to be made.

Unlike the first Marey article, the second article was not focused, either visually or textually, on demonstrating the technology that made the pictures. In fact, the only reference in the second article to photographic technologies was when Marey wrote: "Since that time [the publication of the first article] the photographic method has been perfected and the numbers of species of birds to which my researches have extended have been multiplied."[76] The perfection in the photographic method to which Marey was referring was a complete shift in the photographic technologies he used for his experiments. Abandoning the photographic gun, Marey adopted a new method that allowed for multiple exposures to be made on the same plate. The difference between these two methods explains what Marey was hoping for in his experiments: with exposures of the same plate, Marey was able to better examine the path of movement and the correlation between one position and the next.[77] It should be pointed out, however, that this is one of the significant differences between Marey and Muybridge: Marey adapted his technologies to fit his experimental needs, while Muybridge used separate images because he could display them in his zoöpraxiscope. If he had adopted Marey's later method, he would have lost the performative aspect of his photographs.[78]

In reproducing his photographic experiments in his second article, Marey displayed similar subjects to those in his first articles. While he reproduced images of the seagull, heron, pigeon, and pelican, the seagull was repeated a number of times and was given primacy of place in the ordering of the images. Marey reproduced the seagull from three different angles and showed these various positions only for the seagull (Illustrations 4.22, 4.23, and 4.24). Showing different positions of the seagull in flight was essential because when "seen only under one aspect, representations of a bird on the wing do not give us correct ideas or movements of the wings; we must photograph the bird under several aspects in order thoroughly to comprehend this mechanism."[79] For Marey, a single serial set of photographic exposures was not enough to understand the motion of flight, but rather various series needed to be examined together to gain any understanding of

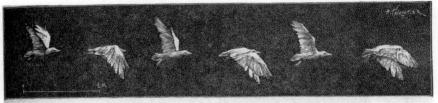

FIG. 1.—Sea-gull. Transverse flight. Ten images per second.

ILLUSTRATION 4.22 Photograph, Etienne Jules Marey, Heliograph, H. Thiriat—"Sea-gull, Flying; Heliograph of Twelve Plates Obtained by the Process," *Nature*, 37, no. 955 (February 16, 1888): 369. Reproduced by permission of the University of Leicester Library.

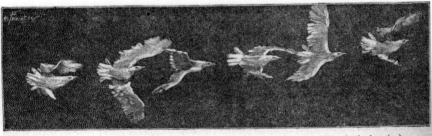

FIG. 6.—Sea-gull seen from above. Ten images per second. (Fac-simile of instantaneous photographs taken by the author.)

ILLUSTRATION 4.23 Photograph, Etienne Jules Marey, Heliograph, H. Thiriat—"Sea-gull Seen from Above. Ten Images per Second (Fac-similie of Instantaneous Photographs Taken by the Author)," *Nature*, 37, no. 955 (February 16, 1888): 370. Reproduced by permission of the University of Leicester Library.

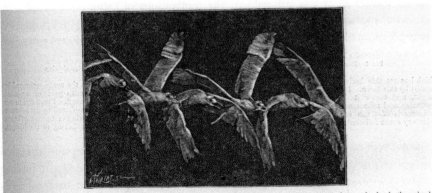

FIG. 7.—Sea-gull flying obliquely in the direction of the photochronographic apparatus. (Fac-simile of instantaneous photograph taken by the author.)

ILLUSTRATION 4.24 Photograph, Etienne Jules Marey, Heliograph, H. Thiriat – "Sea-gull Flying Obliquely in the Direction of the Photochronographic Apparatus (Fac-similie of Instantaneous Photograph Taken by the Author)," *Nature*, 37, no. 955 (February 16, 1888): 371. Reproduced by permission of University of Leicester Library.

how birds move their wings during flight. What is particularly remarkable about this argument is that it positions the place of photography very differently than Muybridge did in either the reproduction of his own images or how the periodical press in general utilized photographs. For Marey, photographs were useful *only* in a series; and moreover that series needed to be compared with other series. Marey was looking for serialized seriality in his images.

The position of the photograph in Marey's second article changed because of the shift in the technology. While Marey used serial photographs in his first article, they were individual images placed together and then reproduced as a series. In the second article, the individuality of each movement was lost because the camera disallowed it, and therefore the photographic referent was subordinated to the serialization of motion.

What is particularly interesting is that the need to authenticate the photographic reproductions did not change. While only two of the three illustrations (Illustrations 4.23 and 4.24) indicate in their subtitle that they were "fac-similies" of instantaneous photograph taken by the author," the style, layout, and image quality of all three images did not change. The absence of a claim to Illustration 4.22 being "from a photograph" may lie in the problems of reproduction between *La Nature* and *Nature*, as the original article in *La Nature* subtitled Illustration 4.22 as "Reproduction par l'héliogravure d'un cliché obtenu à l'aide du fusil photographique" or "Reproductions by heliogravure printing of a plate obtained using the photographic gun."[80] Nevertheless, Marey and the author for *Nature* felt it necessary to claim the veracity of at least two of the three images of the flight of the seagull by labeling them as a "fac-similie." The photograph therefore plays a very complicated role in this article. While as a technology it was subsumed in the larger experimental project of ascertaining the flight of birds, as a source material for reproduction, it was still valued. The motivations of using photography for studying motion may have been very different for Marey and Muybridge, but when it came to the reproduction of photographic images in periodical print, the same processes of validation and authentication were used.

Conclusion

The concept of the instant was neither a singular nor a stable concept. It was used in a variety of contexts within the periodical press, ranging from the idea of having instantaneous memory to the inscription of an image being from "an instantaneous photograph." When instantaneous photographs were reproduced within the print press, the stability of these claims was more complicated than when an image was merely "from a photograph." The trust claims associated with instantaneous photographs differed, depending on what was being depicted. When the

instantaneous object in the picture was reproducible, or had a point of reference, such as a wave, the image reproduced within the press did not need claims of authenticity. When the image was not verifiable, greater claims of authenticity were necessary. These claims of authenticity were intimately tied to claims of scientific credibility. This relationship between photographic authenticity and scientific credibility—reproduced through the periodical press—reached its apex (as we will see in Chapter 5) during the attempt to photograph the 1874 Transit of Venus. A photograph that captured and translated time into a visual codification—such as the break of a wave or the progress of a planetary body across the Sun—was given a truth value dependent on who produced the image, where it was reproduced, and how it was contextualized. Thus, the position of Muybridge's and Marey's images, reproduced within the periodical press, came under different forms of scrutiny. By examining the place of instantaneous photographs in the periodical press, our historical understanding of the development of instantaneity is repositioned. This perspective also allows us to better understand the ways in which a shift in technology affected the organization, augmentation, and reproduction of visual evidence in periodical print media.

5 PHOTOGRAPHY AT A DISTANCE: REPRODUCING THE 1874 TRANSIT OF VENUS ENTERPRISE

A rare astronomical event occurred very late in the year 1874, which was observed in numerous locations throughout the world. On December 8, 1874, Venus slowly crossed the face of the Sun. This was the event that took Swithin St. Cleeve, in Hardy's *Two on a Tower*, away from the love of his life. It was, for Hardy and for nineteenth-century astronomers and readers of the periodical press, the most important scientific event of the century. As it passed, hundreds of real, nonliterary observers were sitting with their instruments watching a small black spot slowly make its way across the Sun. These instruments were essential to their observations: some had telescopes, some were standing by clocks, while others were for the first time photographing Venus with their newly made photoheliographs. The use of photographic devices for the observation of an astronomical event is a moment in the history of scientific inquiry located in a critical period of change in the 1870s. The photograph, with its ability to capture the distant and unseen by the human eye, was able to bring, through the periodical press, an astronomical event that was inaccessible to the British public. It was an event that was impossible to see from England and, even where visible, required some form of telescope or mirror to act as intermediary between the Sun and the human eye. Due to its unobservable nature, the reproduction of images from the Transit of Venus in the periodical press was the only way for the majority of the Victorian public to witness this spectacle. Moreover, this astronomical event is key in understanding the uses of photographic instruments in science, and how these instruments were displayed, used, discussed, and illustrated for a popular audience.

The Transit of Venus is inherently a serial phenomenon. It occurs at regular intervals and was observed by technologies invested in the serial production

of images. Astronomy, with its observations of celestial and planetary bodies circulating around a center of gravity, is itself a science deeply intertwined with seriality. Hopwood, Schaffer, and Secord in their introduction to a set of articles on the relationship between seriality and science in the long nineteenth century argue that there is a relationship, or set of shared practices, between the seriality in scientific investigation and the publication of scientific argument in serial print.[1] While this relationship is difficult to pin down, when we examine more closely the way in which the images and arguments concerning the Transit of Venus moved into the periodical press, this relationship becomes, for a moment, clearer. The associations between technologies that allowed for the observation of Venus; the discussion about these technologies; the images produced by these technologies; and their relevance to the publication of scientific proof become particularly essential when we examine more closely the reproduction of the Transit of Venus in the illustrated periodical press. While Chapters 3 and 4 examined examples where either the spatial or the temporal aspect of a photograph was key in making its meaning in print, for the Transit of Venus photography necessarily captured time, but was only valuable when it could be moved back to sites of calculation and communication. Much more so than the photomicrograph or the instantaneous photograph, those images made for the 1874 Transit of Venus were serial objects where space and time were both internal and external concerns.

During the latter half of the nineteenth century, significant shifts in the optical observation of celestial bodies and phenomenon were taking place in England, and particularly at the Royal Observatory Greenwich (ROG). The ROG was the hub for British institutional astronomical science in the 1870s and was run with military precision. The development of new technologies such as photography and spectroscopy presented new opportunities for the observation of astronomical phenomena with ever greater accuracy. The desire for technological accuracy in astronomy in the 1870s can be attributed to a number of factors, such as the movement toward the eradication of the personal equation discussed in Chapter 4. The training, preparation, organization, and subsequent communication of the results of the 1874 Transit of Venus (hereafter referred to as "the Transit") is therefore necessarily governed by the input, both publicly and privately, of the ROG and its resident astronomers. However, the key issues relating to the Transit—where and how it should be observed—were fought over in the periodical press. The production of these debates—both textually and visually— in the periodical was a fundamental aspect in legitimizing the grand expenditure of public funds on a single astronomical event. The debates that entered the print press circulated around two central concerns: the history of Transit observations and the visual technologies that were going to be used to solve previous problems of observations.

The value placed on these instruments can be understood through the locations and reproductive authenticity that were ascribed to the photomechanical devices of astronomical observation during the 1870s. This decade is particularly illuminating because it was in the 1870s that photography was tested as a tool for observation, a test that it ultimately failed.[2] Holly Rothermel, in her seminal article on astronomical photography, locates the increase in the use of photography in astronomy to the introduction of bromide dry plates in 1871. By 1874, the use of photography was thus well established in astronomy.[3] The story of the adoption of the camera for the Transit is not just a technological one. Rather, it is a story that necessarily moves between textual and visual descriptions about a global observational expedition outside the living memory of any person who organized, participated in, or read about earlier episodes of the event itself.

The debate over mechanical versus human observation pervaded Victorian cultural spaces. It moved from the desk of the astronomer, to the halls of the scientific club and scientific societies and out into the local and national papers. It was at the same time a public and an institutional debate. And by looking at how the terms of observation were debated in these two spaces, we can start to evaluate the multiple values given to a technology of observation for an astronomical event, itself encumbered with problems of seeing. Alex Pang has convincingly demonstrated that the application of photography to astronomical science, starting in the 1860s and culminating in the 1870s, was essential to the science of photography itself.[4] It is easy to make the assumption that the photographic products that came out of the Transit were essential elements of the making of modern scientific knowledge through their visual iconography. However, Rothermel has pointed out that photography in terms of the Transit "became a silent, objective, scientific tool, successfully removed from the focus of criticism and effectively 'black-boxed.'"[5] The objects of the Transit photographic endeavor were, for Rothermel, transformed into intangible objects removed from their original referent and used only as data. While this is a very useful point when examining the use of photography in science, it is the contention of this chapter that images of photographic instruments and the products of those technologies were used to represent photographic authenticity in new and divergent ways. Furthermore, it was in the spaces of the illustrated periodical that this photographic authenticity was mobilized. The display of instrument images appeared in both the public and scientific press throughout the period leading up to the Transit, and continued after it had taken place. Moreover, the production of this photographic authenticity cannot be removed from the historical contexts of the Transit itself. It is in this print space where images were reproduced, repositioned and recontextualized, and placed against the historic problems of observation and the development of visual technologies that the application of photographic authenticity in a science fundamentally based on visual observation can be more accurately understood.

The history of the Transit of Venus

The Transit had a long history within astronomical observation—a history that was circumscribed by observational difficulties. These difficulties were embedded in questions over the limits of human observation; the application of new technologies to extend vision; and concerns over how to move from visual observation to material data. When nineteenth-century science popularizers wrote their accounts of the history of Transit observations up to the nineteenth century, their focus was twofold: to give a general outline of the key British characters in making these observations and to highlight the problems associated with their observations.[6]

The first aspect of these histories was fairly stable within the British press, with a similar narrative given across print mediums and authors. Three books in particular, written by three astronomers and astronomical administrators, came out in the year of the Transit and detailed the histories of Transit observation up to 1874.[7] Although the three books differ considerably in their organization, use of images, and the credibility of the authors, the narratives they gave about the history of Transit observations were very similar.[8] The histories that Richard Anthony Proctor, George Forbes (1849–1936), and Robert Grant (1814–1892) provided were essential in legitimizing the 1874 Transit expedition. Each of the authors was embedded in the organization of the Transit in one way or another, and the publication of their books only a few months before the expedition was to leave England meant they were able to legitimize the Transit expedition to the reading public. This was essential because it was being funded from the public purse and those readers would later read their reports of the expedition in the periodical press.

Each book gives the details of four Transits before 1874, starting with that of 1631. Forbes, for instance, points out that "the first prediction of a Transit of Venus was made by Kepler, and was calculated from his Rudolphine Tables."[9] Forbes then continues that the Transit in 1631 occurred during the night and was therefore impossible to observe from England.[10] The Transit of 1639, however, was considered more of a success, with the reason for this success attributed to an English amateur astronomer named Jeremiah Horrocks (1618–1641). Proctor, for example, stressed that the first Transit to be closely observed in England was by Horrocks in 1639 in Much Hoole, Lancashire. Proctor pointed out that Horrocks was a young Cambridge graduate who had closely followed the work of Kepler and Tycho Brahe in producing the *Rudolphine Tables*.[11] Horrocks, according to Proctor, was interested in ascertaining the size of Venus, rather than observing the exact timing of the Transit.[12] For these authors, the planning and purpose of the seventeenth-century Transits were very different from those of the eighteenth century, as they argued that seventeenth-century observations were concerned with witnessing the Transit rather than measuring it.

For nineteenth-century astronomers and popularizers of science, the expeditions of the eighteenth century came to be of central importance for the

justification of nineteenth-century expeditions. The first character who took on importance for eighteenth-century observation was Edmund Halley (1656–1742), the later Royal Astronomer. Grant, in his narrative, pointed out that "two methods of determining the solar parallax, on the basis of the transit of Venus over the Sun's disc, have been devised by astronomers. The earliest of these methods was that proposed by Halley."[13] For these three authors, the eighteenth century was an important historical period because it reflected the motivations of the nineteenth-century Transit observations, to ascertain the distance of the earth from the Sun.[14]

The story of eighteenth-century Transit observations also circulated around the promulgation of nationalist history, which was personified in the story of Captain James Cook's (1728–1779) voyage of 1769. Cook was a national British figure who has come to represent imperial pride and naval dominance. Aside from "discovering" numerous islands such as Hawaii and Kerguelen Islands (where later Transit observations would take place), Captain Cook was also an important figure in the 1769 Transit expedition.[15] Captain Cook's expedition on the *HMS Endeavour* importantly moved an observer to a place where a good observation could be made.[16] Jessica Ratcliff points out that the history of the Transit, with an emphasis on the celebrity of Captain Cook, was essential to the production of popular appeal for the expedition.[17] What this implies is that the history of previous Transits, and particularly the implications of Cook's expeditions in the eighteenth century for the expansion of the British Empire, influenced the way that the narratives—both visual and textual—of the 1874 Transit expedition were reproduced within the print press. Both of these aspects became central to understanding questions surrounding material culture and imperial expansion in the nineteenth-century Transit expeditions. For authors like Proctor in particular, who was an advocate of amateur astronomy and a popular science journalist, Captain Cook was a crucial character in the historical narrative of the eighteenth-century Transit enterprise.[18]

Besides the addition of Australia and Hawaii, Captain Cook's voyages focused attention on a central issue in the technological observation of the Transit. The black drop phenomenon was believed to be an optical and/or atmospheric problem that caused Venus to become elongated when the planet either entered onto or exited the disk of the Sun, otherwise known as ingress and egress. During ingress and egress, a "ligament" or "arm" appeared to remain attached to Venus, creating uncertainty as to the exact determination of contact. Proctor described the problem in the following terms:

> an optical phenomenon which had not attracted Halley's attention was presented during the transit of 1761, and caused the observations to be much less reliable than they would otherwise have been. The disc of Venus was found to assume near the time of internal contact a distorted form. In some cases she seemed to be attached to the edge of the sun by a dark ligament of greater

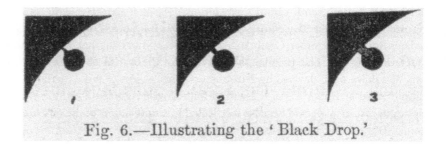

Fig. 6.—Illustrating the 'Black Drop.'

or less breadth, as shown at 1, 2, and 3, fig.6; in other cases she appeared like a pear, while in others she was altogether distorted by the combined effect of atmospheric disturbances and the optical distortion (whatever its real nature may be) which causes the black drop and pear-shaped figures.[19]

The focus in this description was on accuracy: the atmospheric or the instrumental problems prevented the eighteenth-century astronomers from acquiring accurate information from their observations. This was a problem that nineteenth-century astronomers, and specifically Astronomer Royal George Biddell Airy (1801–1892) at Greenwich, wanted to prevent. Their solution to this problem lay in the application of a new technology: that of photography.[20]

More than just the application of a new technology, the creation and maintenance of the history of previous Transit observations and expeditions were central to both the credibility of Airy's planned 1874 expedition and to the popular conception of astronomical science. The narrative given above was publicized in a popular treatise entitled *Transits of Venus: A Popular Account of Past and Coming Transits* (published just before the 1874 Transit expedition was to take place) in order to fill what the author considered to be a gap in the historical knowledge of English observations of Transits.[21] As shown in Chapter 2, Proctor was both a controversial member of the Royal Astronomical Society (RAS) and a prolific publisher.[22] Partially motivated to write popular scientific treaties due to a lack of finances, Proctor penned a number of astronomical books including a study of Saturn and a book on *Other Worlds Than Ours*.[23] Importantly, Proctor was also a significant character in periodical press publication. *Knowledge*, which was intended to present scientific news to a popular audience, was established under the leadership of Proctor as a competitor of the larger and more well-known illustrated scientific journals *Nature* and *Science*.

Wood engraving – "Fig 6. Illustrating the Black Drop," *Transits of Venus. A Popular Account of Past and Coming Transits*. London: Longmans, Green, and Co., 1874, 57. Reproduced by permission of the Cambridge University Library.

Let us now turn to Proctor's printed work in order to tease apart these differences in the reproduction of an astronomical image in different print genres. Although the *Transits of Venus* was densely illustrated, there are five images relating to the history of Transit observation that take on specific significance when you examine their reproduction in print. Proctor produced plates XI through XV to demonstrate the different paths of both Venus across the Sun and the Sun across the Earth during the 1874 and 1882 Transits (Illustrations 5.1–5.5).[24] These images were meant to be read both as physical representations of mathematical calculations and as serial images. However, all of the images are considerably different from both the photographic reproductions of the Transit and the Transit instruments. Through these images, Proctor gave a configuration of the Transit that could never be made by a photograph. They are idealized images of the Earth and the Sun with artificial lines of latitude and longitude and the path of the Transit superimposed on the images. Illustrations 5.2 and 5.3, for Proctor, were intended to represent the path of the Transit as seen from the Sun for 1874, while Illustrations 5.4 and 5.5 depict the same for the 1882 Transit. Illustration 5.1, on the other hand, shows the paths of the Transits across the Sun from the perspective of the Earth during both the 1874 and 1882 Transits. These five images were doing a lot of work for Proctor: they transposed complex temporal and spatial movements of the Sun, Venus, and the Earth onto a series of grouped images that effectively translated these movements into visual terms. It is unsurprising that these images did not simply remain in Proctor's book, but rather moved into the periodical. What *is* surprising, however, is just how different these images became when placed in a new spatial and textual context.

Proctor's set of Transit images were reproduced on two separate occasions in two very different periodicals, a year before they were published in *Transits of Venus*. The first appearance of these images occurred in the *Illustrated London News* (*ILN*) (Illustration 5.6) in April 1873 and the second in the *Astronomical Register* in June of the same year (Illustrations 5.7–5.11). The shift of the publication of these images from a book to a periodical fundamentally changed the way in which the argument was read. The images in the periodical were situated around the serial publication of text, while in the book the narrative and the use of images were static. The images in the *ILN* were ordered sequentially in the same manner as in *Transits of Venus*; however, the placement of all the images on the same page lends itself to a significantly different reading than that of the book layout. In *Transits of Venus*, Proctor used these images to speak about each Transit individually, whereas in the *ILN* the images were all placed on the same page together. Furthermore, the text that accompanies the images in *Transits of Venus* is dissociated from the images entirely and they are placed on their own individual sheets. In the *ILN*, on the other hand, the images are intermeshed with the text, which creates a greater fluidity of meaning between text and image. Given that both the book and the article were written by Proctor, the implications of reading the spacing of the

PLATE XI.

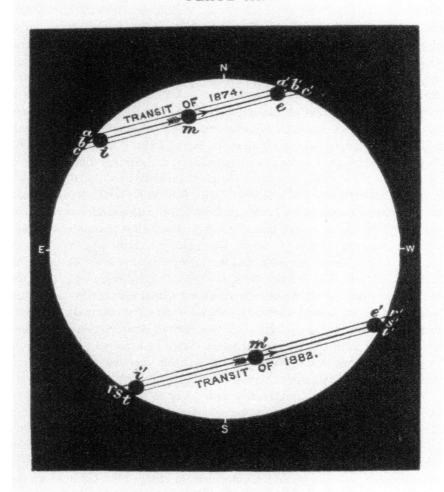

TRANSITS OF 1874 AND 1882.

ILLUSTRATING INTERNAL CONTACTS AND MID-TRANSIT, AND SHOWING RELATIVE
DIMENSIONS OF THE DISCS OF VENUS AND THE SUN.

ILLUSTRATION 5.1 Lithograph—"Transit of 1878 and 1882," *Transits of Venus. A Popular Account of Past and Coming Transits.* London: Longmans, Green, and Co., 1874, Plate XI. Reproduced by permission of the Cambridge University Library.

PLATE XII.

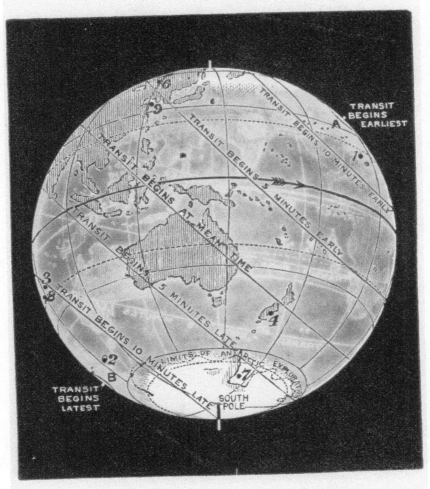

SUN-VIEW OF THE EARTH AT THE BEGINNING OF THE TRANSIT OF 1874.

1. Station at Hawaii.
2. „ „ Kerguelen Island.
3. „ „ Rodriguez.
4. „ „ New Zealand.
6. „ „ Nertschinsk.
7. „ (proposed only) at Possession Island.
8. „ „ Mauritius.
9. „ in North China.

ILLUSTRATION 5.2 Chromolithograph—"Sun View of the Earth at the Beginning of the Transit of 1874," *Transits of Venus. A Popular Account of Past and Coming Transits*. London: Longmans, Green, and Co., 1874, Plate XII. Reproduced by permission of the Cambridge University Library.

PLATE XIII.

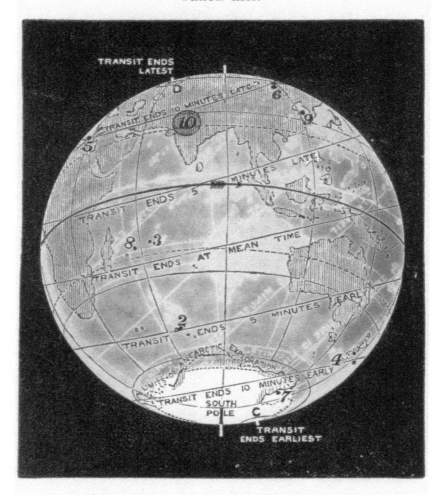

SUN-VIEW OF THE EARTH AT THE END OF THE TRANSIT OF 1874.

2. Station at Kerguelen Land.
3. „ „ Rodriguez.
4. „ in New Zealand.
5. „ at Alexandria.
6. „ „ Nertschinsk.
7. „ (proposed only) at Possession Island.
8. „ „ Mauritius.
9. „ in North China.
10. The North Indian Region (now occupied).

ILLUSTRATION 5.3 Chromolithograph—"Sun View of the Earth at the End of the Transit of 1874," *Transits of Venus. A Popular Account of Past and Coming Transits.* London: Longmans, Green, and Co., 1874, Plate XIII. Reproduced by permission of the Cambridge University Library.

PLATE XIV.

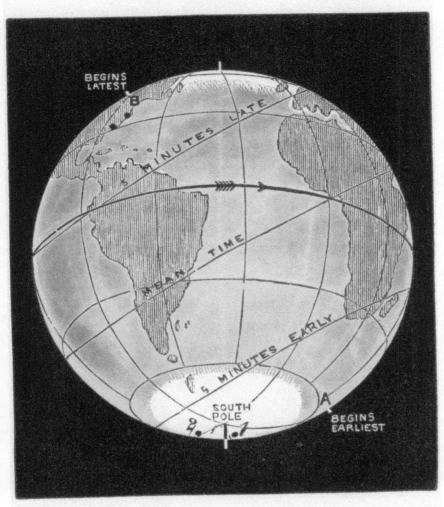

SUN-VIEW OF THE EARTH AT THE BEGINNING OF THE TRANSIT OF 1882.

1. Sir G. Airy's proposed station at Repulse Bay.
2. ,, ,, on Possession Island.

ILLUSTRATION 5.4 Chromolithograph—"Sun View of the Earth at the Beginning of the Transit of 1882," *Transits of Venus. A Popular Account of Past and Coming Transits*. London: Longmans, Green, and Co., 1874, Plate XIV. Reproduced by permission of the Cambridge University Library.

PLATE XV.

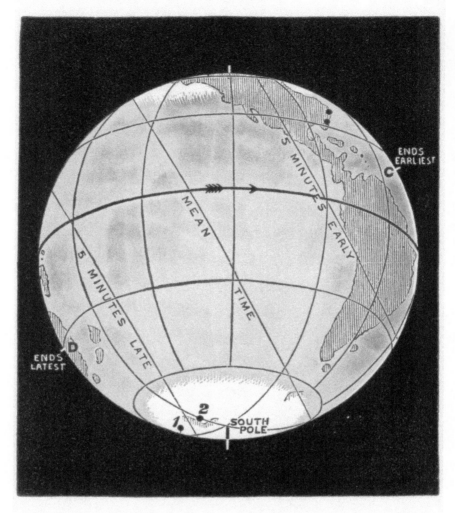

SUN-VIEW OF THE EARTH AT THE END OF THE TRANSIT OF 1882.

1. Sir G. Airy's proposed station at Repulse Bay.
2. „ „ on Possession Island.

ILLUSTRATION 5.5 Chromolithograph—"Sun View of the Earth at the End of the Transit of 1882," *Transits of Venus. A Popular Account of Past and Coming Transits.* London: Longmans, Green, and Co., 1874, Plate XV. Reproduced by permission of the Cambridge University Library.

THE APPROACHING TRANSIT OF VENUS.

BY RICHARD A. PROCTOR,
HONORARY SECRETARY OF THE ROYAL ASTRONOMICAL SOCIETY.

I hope in what follows to succeed in explaining clearly the chief circumstances of the transit of Venus in December, 1874, already attracting much attention, and the subject, indeed, of some difference of opinion among those who have studied it with more or less consideration. I shall distinguish between what is admitted on all sides and certain points which are at issue among students of astronomy. It will be seen that the latter points do not now involve any astronomical question whatever, and can be decided upon as well by those least familiar with astronomy as by the most practised students of the science.

Fig. 1. The paths followed by Venus during the transit of 1874 and 1882.

Fig. 2. The face of the earth turned towards the sun at the beginning of the transit of 1874: including, therefore, all places where the beginning of the transit will be visible.

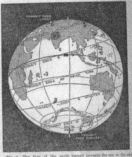

Fig. 3. The face of the earth turned towards the sun at the end of the transit of 1874: including, therefore, all places where the end of the transit will be visible.

Fig. 4. The face of the Earth turned towards the Sun at the beginning of the transit of 1882.

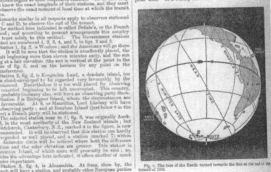

Fig. 5. The face of the Earth turned towards the Sun at the end of the transit of 1882.

images must be based on the genre of the print medium, not on the author's bias. When placed in an illustrated periodical, these images were intended to be read together with the text, offering interplay between the image and the text, while in a book-length treatise on the same subject, the image could be disjointed from the text and therefore contain a different set of information. In books, the images were typically used as illustrative additions to text and thus the placement of the image on the page was not essential. In the periodical, the image functioned with its own set of claims to authenticity and descriptive quality. The image in the periodical necessarily worked alongside the text and its placement was of greater importance. For these images, the periodical thus takes on a significantly different role in the formation of knowledge about contemporary Transits.

In June 1873, Proctor reproduced the same images in the same sequential order in the *Astronomical Register* (Illustrations 5.7–5.11). The placement of these images on the page encompasses a middle ground between their placement in *Transits of Venus* and the *ILN*. In the *Astronomical Register*, the images were placed within the text, but on separate pages. This placement can be partially attributed to space—the *ILN* was a large folio-sized paper measuring 40 × 30 centimeters, while both *Transits of Venus* and the *Astronomical Register* were the size of a typical quarto, 19 × 14 centimeters and 21 × 14 centimeters, respectively. Further to this, while the sizes of the publications vary, the size of the images reproduced did not. In all three publications, the images were reproduced at exactly the same size: 8.75 × 7.50 centimeters. This indicates that the same block was likely used for the printing of all these images.

The difference in size for each of the three publications is important as it renders a varying visual effect for each of the images. The *ILN* presentation is large and encompasses the entire visual space of the reader, thus allowing for greater visual impact of the images. The images in the *Astronomical Register* on the other hand, are the sole image on the page, ensuring that the reader gives greater contemplation to each individual image while at the same time giving equal space to the textual discussion and contextualization of the image. Finally, the images in *Transits of Venus* were distinctly separated and raised above the text by placing them on hard paper and hiding them away behind a thin protective layer. The placement of these images in the *ILN*, *Astronomical Register*, and *Transits of Venus* therefore changes the interpretation of the images significantly and thereby augments the way in which the narrative of the Transit enterprise was to be understood by the reading audience.

The most important aspect of these three reproductions by Proctor is that they are seen as serial and spatial objects. Once read together they create a new conceptualization of the Transit. In the preface to *Transits of Venus*, Proctor reinforced this serialization.[25] He stated, "for the use of the Plates XI., XII., XIII., XIV., and XV., I have to thank the Editor of the 'Astronomical Register,' Rev. S. J. Jackson. These pictures originally appeared in the 'Illustrated London News,' for

1874, in the fact that the observer will be less hurried at the critical epochs.

Let us next turn to Fig. 2, shewing the face of the Earth turned sunwards at the beginning of the transit of 1874, and the progress of the edge of Venus's shadow across the face of the Earth. This figure illustrates the determination of places suitable applying Delisle's method at the beginning of transit. We note that the stations for seeing the transit begin as early as

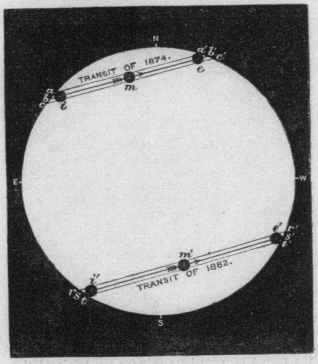

Fig. 1.

possible near A, while around the opposite point B lie the stations for seeing the transit begin as late as possible. The selected British (Government) stations for observing this phase, are at 1, 2, and 3,—8 being Lord Lindsay's station at Mauritius. The station marked 6 is Nertschinsk, and 9 is Tchefoo. All round 6 the Russians will have stations, though manifestly not with the object of seeing the transit begin very early : we shall presently see why these regions are occupied.

ILLUSTRATION 5.7 Process unknown—"Fig. 1," *Astronomical Register*, 11, no. 126 (June 1873): 142. Reproduced by permission of the *Cambridge University Library*.

Fig. 3 illustrates the end of the transit, and shews the retiring edge of the shadow. This figure illustrates the determination of places for applying Delisle's method to the end of the transit. Around C lie stations where the end of the transit occurs earliest; and near the opposite point D, lie stations where the end occurs latest. Our selected stations are 4 and 5. We notice that the *best* stations by C are in Antarctic and sub-Antarctic regions. The best stations by D are in Russian territory. North India

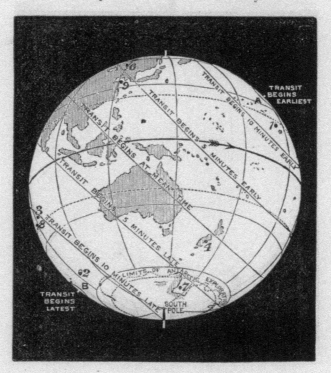

Fig. 2.

gives a region marked 10, where the circumstances are better on the whole than at 5. (It has been one of my offences against the unwritten law which makes it treason to perceive omissions in certain quarters, that I have called attention to this region as one which Great Britain is specially bound to occupy. It will be seen that 6 and 9, and the whole region thereabouts, lie far away from D.)

Thus far as to the plans laid down by the Astronomer Royal

ILLUSTRATION 5.8 Process unknown—"Fig. 2," *Astronomical Register*, 11, no. 126 (June 1873): 143. Reproduced by permission of the Cambridge University Library.

in 1868. Nothing further was then indicated for this country; and it was suggested that other countries should also congregate round the regions A, B, C, and D, to apply Delisle's method. Halley's method was dismissed as "failing totally;" while so far as words could make the matter plain, and so far as the calling together of leading authorities could give weight to statements so made, the scientific world was taught that the utilization of the approaching transit would begin and end with Delisle's method.

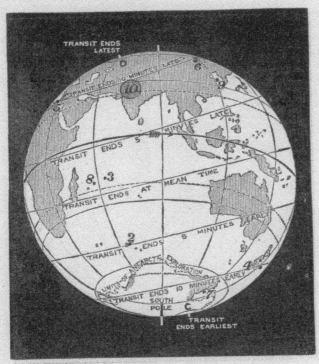

Fig. 3.

(That photography was not then thought of cannot be wondered at; but other omissions are less easily explicable.)

But before I proceed to shew what else can be done, besides what the Astronomer Royal indicated, let me recall to the attention of my readers the position of affairs, with the special object of shewing how careful I have been, while such care was possible and right, to avoid dwelling unduly on the omissions in question :—

When the Astronomer Royal published the remarkable paper

ILLUSTRATION 5.9 Process unknown—"Fig. 3," *Astronomical Register*, 11, no. 126 (June 1873): 144. Reproduced by permission of the Cambridge University Library.

Figs. 2 and 3 of themselves prove my case. Let it be noticed that no one questions that the Earth *will* be as shewn in these figures, or that the shadow's edge will pass over the Earth in the way indicated. It is only necessary then to remark that at 6 there is an acceleration of the beginning by more than 5 minutes, and a retardation of the end by 10 minutes, to perceive that as I stated in 1869, the transit will last more than 15 minutes longer

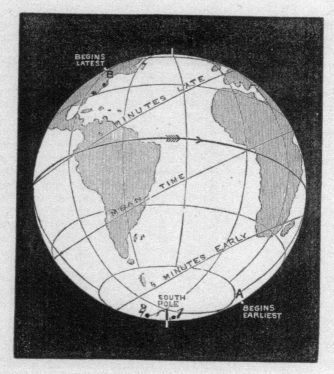

Fig. 4.

at this station (Nertschinsk) than as supposed to be seen from the Earth's centre. At 2 it will begin nearly 12 minutes late, and end about 5 minutes early. Here then it will last more than 17 minutes less than the mean. So that at once we have a difference of more than 32 minutes as compared with Nertschinsk, It will be seen that 3 and 4 are very inferior to 2 when examined in the same way. Station 7, the famous Possession Island so much lauded by the Astronomer Royal's authorities in 1869, for the

ILLUSTRATION 5.10 Process unknown—"Fig. 4," *Astronomical Register*, 11, no. 126 (June 1873): 146. Reproduced by permission of the Cambridge University Library.

are busily propagating* would be implicitly believed, I should not change my course a hair's breadth.

The circumstances of the transit of 1882 are indicated in Figs. 4 and 5, which are interpreted precisely like Figs. 2 and 3. The Astronomer Royal, by the way, considers that we ought at present to limit our attention to the earlier transit. This seems to me a mistake, even as it would be a mistake to limit our attention to any particular method. I much prefer the earlier view of the

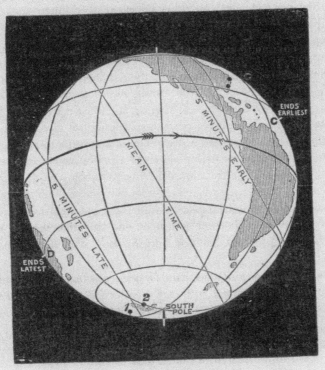

Fig. 5.

Astronomer Royal, who, in 1857, and again in 1864, '65, and '69, regarded the transit of 1882 as deserving of consideration. In

* Let it be clearly understood that I am not here speaking of the Astronomer Royal, or any of those who justly admire his great services to science in former years. I refer to the action of a person and his intimates (very busy just now), who cannot forgive me for being proved right in a controversy recently brought to a close. Here, as always, detraction is the homage which failure pays to success. I am not without hope that, by further offences against error, I may give occasion for further detraction.

ILLUSTRATION 5.11 Process unknown—"Fig. 5," *Astronomical Register*, 11, no. 126 (June 1873): 148. Reproduced by permission of the Cambridge University Library.

which journal I drew them."[26] By referring back to his use and reproduction of these images, Proctor was doing two things. First, he was legitimizing his analysis of the Transit by creating a visual link between his previous and current work on the same subject and thus establishing a cross-connection between print genres. Second, he was asserting the value of certain images over others, indicating to the reader that plates XI through XV were important enough to be reproduced in other works. Through this statement in his preface, Proctor was skewing both the reading and sequential temporality of these images for his readers.

One other consideration is essential when examining the impact of these images. The print genre in which they appeared is an important factor to the reader impact of these visual objects. The *ILN*, *Astronomical Register*, and *Transits of Venus* were three very different publications with significantly different content organization and readerships. While the *ILN* was a popular illustrated periodical with a primarily middle-class readership, the *Astronomical Register* was directed at amateur astronomers. In fact, the *Astronomical Register* was one of the most important journals for astronomical science, published between 1863 and 1886. The journal, unlike an explicitly professional periodical like the *Journal of the Royal Astronomical Society*, had a readership and contributors, which included both amateur and professor astronomers. In a period when the boundaries of who could participate in astronomical science were being more clearly defined, the *Astronomical Register* straddled the border between amateur and professional. Although they are both serial publications, the *ILN* and the *Astronomical Register* were intended for very different audiences, and this difference in audience is demonstrated in the physical and visual organization of the material print objects themselves.

Transits of Venus, on the other hand, was intended as a general reader, with both scientific information and historical relevance. The audience for the textual information contained in *Transits of Venus* would have been very similar to that of the *ILN*. However, because it was in book format, the images and the reading of those images changed.

Visual technologies and the 1874 Transit of Venus

The narrative of Transit observations culminated for Proctor with the 1874 Transit. However, his contribution to the contemporary debate of the first nineteenth-century Transit did not end with *Transits of Venus*. Proctor entered into a heated argument over the organization of the 1874 Transit expedition with Airy, fought primarily in the periodical press.[27] In early 1870, Proctor published an article in *Nature* arguing for the reorganization of the Transit expedition.

Proctor maintained that "the choice of stations for observing the transits of 1874 has been founded on calculations admittedly inexact, and it would be to the credit of English astronomy that the whole matter should be re-examined while there is yet time for a change to be made."[28] In presenting this argument here, Proctor was entering into a debate with the most influential astronomer in this period in a periodical that had clear editorial inclinations toward Airy. Norman Lockyer, who had established *Nature* in 1869 as an illustrated journal of science, was an influential figure in the scientific community as both a publisher and an astronomer. Proctor would come to alienate Lockyer when he sided against Lockyer in a bid to establish a solar observatory at the government's expense.[29] The fact that Proctor was publishing his concerns in *Nature* at the start of the 1870s does, however, raise an important question concerning the 1874 Transit: how should the Transit have been observed?

The answer to this question came for Proctor, Lockyer, Airy, and other astronomers, during the late nineteenth century with the introduction of the photoheliograph. The genesis of photography's use in astronomy began a decade and a half before the 1874 Transit. Warren De la Rue, who later moved out of photography and into electric discharge physics, as discussed in Chapter 2, was, in the 1860s and 1870s, one of the most important astronomical photographers. De la Rue's earliest astronomical research focused on the concerns of photographing an eclipse in order to investigate the solar corona.[30] The outer atmosphere of the Sun was a mystery to nineteenth-century astronomers, and it was believed that if the Sun could be photographed while obscured by the moon, then the atmosphere, and what looked like flares from the Sun, called "solar prominences," could be examined. Although there had been numerous attempts to draw the corona of the Sun, photography was believed to have significant advantages over hand drawings.[31] De la Rue explained his photographic observation during the 1860 eclipse in his Bakerian lecture to the Royal Society in 1862.[32] "The main objective of the observation of the total eclipse of 1860 was to ascertain whether the luminous prominences were objective phenomena belonging to the Sun, or whether they are merely subsidiary, produced by some action of the moon's edge or light emanating originally from the Sun."[33]

To solve the problem, De la Rue applied an adapted camera (which he termed a photoheliograph) to the observation of this lunar event. He explained the success of his results from these observations in a letter to Airy in the following terms:

My Dear Sir, I have the pleasure to say that my success is complete—the light of the red flame was very interim and if I had known I *could* have obtained an instantaneous picture. The red flames belong to the sun and in my opinion the corona is a consequence of that light. I have two photograph of the red flames *imperfect only from the going of the clock*. I consider my success complete is all respects—but I did not note the time of totality.[34]

Here De la Rue was justifying to Airy his use of photography. Moreover, the kind of photography that De la Rue was advocating—with his invocation of being able to take an "instantaneous picture"—was one where the photograph eliminated the problems of time and observational inaccuracy.[35] Through the photoheliograph, De la Rue could claim that the "red flames belong to the sun and in my opinion the corona is a consequence of that light." This claim to accuracy through the photoheliograph, and the development of a professional relationship with Airy would become very important ten years later when the preparations for the Transit began.[36]

Between the period of his first photographic observation of the 1860 eclipse and the Transit of 1874, De la Rue continued to work with the application of photography to the examination of the Sun. Working at Kew observatory in London, De la Rue applied the photoheliograph to the daily observation of Sun spots. The work at Kew helped to further establish both De la Rue, and his photo-astronomical method within the scientific community. This reputation would become essential during the early 1870s when Airy was trying to figure out the best method for observing the Transit.

Although Airy had little personal experience with photography, he was keen to apply photomechanical methods to the observation of the Transit.[37] In the early 1850s, Airy had first looked to the inventor of the negative process, William Henry Fox Talbot, to lend advice on applying photography to solar eclipse observations.[38] Talbot suggested that—while he could not go out and organize any photographic observations himself—solar eclipse photographs were possible as long as a slight displacement in the image was considered acceptable. Talbot wrote to Airy in 1851, "as to the point whether a photographic image can be obtained, without the necessity of having the telescope moved by clockwork or otherwise, which would be highly inconvenient except in a fixed Observatory what amount of displacement of the image would be tolerable on a Daguerreotype plate."[39] When it came to the Transit of Venus, Airy had long been thinking about the uses of photography in solar astronomy, and he turned to the man who had successfully done in 1860 what Talbot had suggested in his 1851 letter. De la Rue was a natural choice as photographic adviser for Airy, as he had both expertise in photography and had been funded by the ROG during the 1860 expedition. De la Rue recommended that Airy purchase five photoheliographs from the instrument maker John Henry Dallmeyer. These five instruments would come to be known as the Dallmeyer photoheliographs, and they played a central part in the observation of the 1874 Transit.

John Henry Dallmeyer (1830–1883) was an optician and photographic equipment retailer working in London in the second half of the nineteenth century. He was well known for his improvements in both lenses and photographic devices as well as his close attention to scientific developments.[40] Dallmeyer was also a member of the RAS, so he was closely associated with and aware of the concerns

surrounding the preparation for the Transit. With De la Rue as the intermediary—who had Dallmeyer build him a similar photoheliograph for his work on sunspots at Kew—he was commissioned to build five photoheliographic cameras that were attached to the bottom of a telescope.[41]

After much discussion over the location of the Transit sites (most of the argument being conducted in the scientific periodicals as demonstrated in the controversy between Airy and Proctor analyzed earlier), five locations were chosen, spread around the globe: Station A, Egypt; Station B, Honolulu; Station C, Rodrigues Island, Mauritius; Station D, Christchurch, New Zealand; and Station E, Christmas Harbour, Kerguelen Island. One of the Dallmeyer photoheliographs was sent to each of these locations alongside numerous telescopes, Transit instruments, clocks, and devices for measuring longitude and latitude. The logistics of both transporting and building these mechanical sites of science in foreign spaces required the institutional and colonial context of the late nineteenth century. In order to produce accurate images of the Sun, the expeditions needed the cooperation of British and colonial governments. This cooperation was centralized through the influence of one man: George Biddle Airy.

The concern over how to observe the Transit was a central interest for Airy in particular, but also for much of the astronomical community. The question of the "personal equation" discussed in Chapter 4, where the individual accuracy of each observer was weighed and measured against that of another observer, was a serious problem for Transit observation. Technologies for practicing observation, such as the Transit model invented by Charles Woolf and implemented at Greenwich by Airy—where an artificially timed star transited across a background—allowed for Transit observers to train their exact timing of ingress and egress.[42] The technological solution offered by Woolf, however, did not solve the problem as the fallibility of human reaction times could not be entirely trained away, and expedition planners turned instead to an invention by the French astronomer, Jules Janssen.

Janssen, who was born and worked most of his adult life in Paris—most notably as the director of the Observatory of Meudon—spent much of his time in astronomical work investigating the Sun. Before participating in the 1874 Transit expedition to Japan, where he used his photographic revolver to take successive photographs of ingress and egress, Janssen's solar eclipse observations were well known throughout the scientific communities in France and England. Janssen was especially known for the eclipse observation he made in Algiers in 1870—not for the results that he obtained but rather for the fact that he escaped from besieged Paris in a balloon to make the observations.[43] Like his compatriot Gaston Tissandier (see Chapter 3), Janssen's astronomical work was framed through the stories told about his work in the periodical press.

The incident that first brought him into the scientific limelight was his spectroscopic investigation of the Sun's atmosphere.[44] In 1868, alongside Norman

Lockyer, Janssen discovered that the application of a spectroscopic telescope could expose the elements of the Sun to the astronomical observer outside of the event of an eclipse.[45] Janssen and Lockyer's discovery, however, was not without controversy. In a set of letters to the editor published in *Nature*, the credibility of Janssen and Lockyer as the founders of solar spectroscopy was called into question. The actors in this controversy—and the locations in which it took place—shed light on the ways in which Janssen's scientific credibility in particular was shaped by the English rivalries articulated through and across various forms of print.[46]

In two letters to the editor—the first on February 20, 1873, and the second on March 20, 1873—Balfour Stewart (1828–1887), the Scottish physicist and director of meteorology at the observatory at Kew, wrote to *Nature* to defend the honor and priority of Lockyer and Janssen. Proctor had written in *The English Mechanic*—which was a periodical directed toward the scientifically disenfranchised—that the credit for the use of spectroscopy applied to the observation of the Sun belonged to William Huggins (1824–1910), a gentleman astronomer living in London.[47] Importantly, this debate was set against the background of the upcoming Transit expedition. All of the participants were involved in the planning of the Transit observation, and Proctor—as has already been pointed out—had three years previously entered into a vehement argument with Airy in *Nature* about where and how the Transit should be observed. Janssen, as the outsider in this debate, was given credibility for his ingenuity in allowing for greater depths of solar observation. A year later, when his photographic revolver was adopted for the Transit, this credibility came into play on a much larger stage.

This debate about spectroscopy offers a glimpse into the discussions of a new science, where similar technological and visual narratives as those used to talk about photography were invoked—while simultaneously the reproduction of the photomechanical spectroscopic plates was being presented in the scientific periodical press.[48] In the very first issue of *Nature*, Lockyer wrote an article on the solar eclipse observed in America two months earlier, in August 1869.[49] Lockyer accompanied his article with two images: his own spectroscopic engraving made during an eclipse a year earlier, showing that the red prominences visible in the eclipse are part of the Sun and are composed primarily of hydrogen (see Illustration 5.12); and an engraving of a photograph of the August eclipse made, and sent to Lockyer, by Professor Morton (see Illustration 5.13). What is particularly compelling about this article—and the images that Lockyer reproduced—is that they show that photography and spectroscopy were pointed to as interlinked technologies in the production and communication of solar astronomy. This interlink is most clearly demonstrated by the fact that the lines represented on the spectroscopic image (Illustration 5.12) were reproduced on the engraving of the eclipse photograph (Illustration 5.13). The photograph and the spectroscopic image, though coming from different sources, become paired visual images.

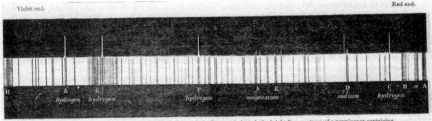

ILLUSTRATION 5.12 Process unknown—"Fig. 1—Showing the Solar Spectrum, with the Principal Fraunhofer Lines," *Nature*, 1, no. 1 (November 3, 1869): 14. Reproduced by permission of the University of Leicester Library.

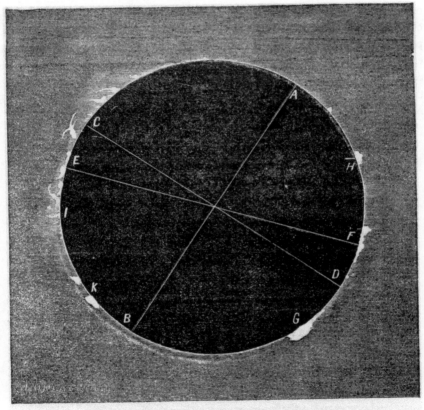

FIG. 2.—Copy of a photograph of the Eclipse of August 7, obtained by Professor Morton's party

ILLUSTRATION 5.13 Wood engraving—"Copy of a Photograph of the Eclipse of August 7, Obtained by Professor Morton's Party," *Nature*, 1, no. 1 (November 3, 1869): 13. Reproduced by permission of the University of Leicester Library.

The reproduction of spectroscopic images in the periodical press followed a similar trajectory to that of the photographic image, with the majority of spectroscopic images between the late 1860s through to the 1870s being made from lithographs.[50] Moreover, like photography, a similar language of fidelity to nature was ascribed to spectroscopy and the occasional inscription of "from a photograph" was used when the image was reproduced through lithography.[51] When speaking of astronomical photography in the latter half of the nineteenth century, and especially in reference to solar astronomy, the two technologies of visual observation and data capture were tied materially and ideologically together. More specifically, when talking about Janssen, his work in photography is necessarily situated within the broader scope of his work on visual technologies.

Janssen's solution to the problems of ingress and egress was to make a series of photographic exposures at the points of contact between Venus and the disk of the Sun. The apparatus that he developed to solve this problem he called a photographic revolver—a device that allowed for a single photographic plate to be exposed in succession through a set of timed slits.[52] The mechanism that Janssen devised to make this careful operation was detailed by Camille Flammarion— the astronomer, balloonist, and popular scientist discussed in Chapter 3—in *La Nature* five months after the Transit expedition took place[53] (Illustration 5.14).

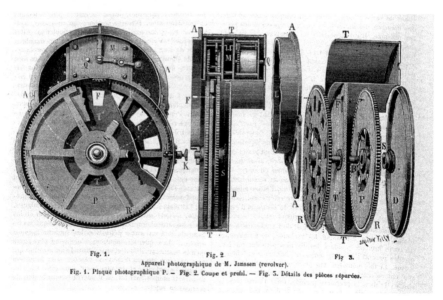

Fig. 1. Fig. 2 Fig. 3.
Appareil photographique de M. Janssen (revolver).
Fig. 1. Plaque photographique P. — Fig. 2. Coupe et profil. — Fig. 3. Détails des pièces séparées.

ILLUSTRATION 5.14 Wood engraving, drawn by Bonnafoux, engraved by J. Smeeton Auguste Tilly—"Photographic Apparel of M. Janssen (Revolver)," *La Nature*, 3(2), no. 101 (May 10, 1875): 356. © The Trustees of the Natural History Museum, London.

This illustration was the first published image of Janssen's photographic revolver, as Janssen himself did not publish his invention until 1876 in the *Bulletin de la Société Française de Photographie*.[54] Interestingly, Flammarion chose to represent the instrument in a deconstructed view, showing the internal mechanisms and describing visually the way in which the images were mechanically timed to create an even succession of image captures. On turning over the page of *La Nature*, the reader was given a contextualized view of the use of the instrument (Illustration 5.15). In this illustration, instead of the operation of mechanical technology being the focus, the attention was directed toward the operation of the machine in situ. Upon investigating the image, we can see a similarity in the centrality of time in the production of Janssen's images. The photographic revolver, which was sheltered from the external world in the observation hut, was pointed at a mirror that redirected the image of the Sun and Venus. The images being captured by the photographic revolver were thus indirect exposures.

The technology that did make a direct inscription of the image was the clock. Hanging just above the revolver, a large pendulum clock beat out the time, which was so essential to the production and reduction of ingress and egress contacts. The clock in this image pointed to one of the central concerns in making astronomical observations: a clock was a necessary but insufficient condition for making an

Fig. 5. — Revolver photographique de M. Janssen. — Vue de l'appareil en fonctionnement pendant le passage de Vénus.

ILLUSTRATION 5.15 Wood engraving, drawn by Bonnafoux engraved by J. Smeeton Auguste Tilly—"Photographic Revolver of M. Janssen," *La Nature*, 3(2), no. 101 (May 10, 1875): 357. © The Trustees of the Natural History Museum, London.

observatory. Without the clock, the observations made by the photographic revolver would have been useless. The revolver and the clock were therefore paired technologies in this image and demonstrate with striking clarity the way in which these two technologies transformed a fundamentally time-based phenomenon into a spatial object.

This reproduction of the images of Janssen's photographic revolver did not move outside of the French periodical press. Janssen's revolver itself was not actually adopted by the French government during the 1874 Transit, with the exception of Janssen himself who brought his instrument along for his own observations in Japan.[55] Airy, under De la Rue's guidance and with the technical expertise of the instrument maker Dallmeyer, adapted Janssen's device and the three men made their own revolver for the observations conducted at the various stations.[56] As in the images reproduced for *La Nature*, time was the central inscription on the image in the negatives of Janssen's device, one of which lies in the archives of the ROG (Illustration 5.16). Where the serial aspect of the images start and end is unclear when looking at the glass plate, however, the timing that these images inscribe is clearly written on the center of the glass plate. These sets of images show ingress of Venus between 12:27:30 p.m. and 12:28:50.20 p.m. The timing is

ILLUSTRATION 5.16 Photographic negatives on glass by Jules Janssen—"Janssen Revolver Negative Taken at Roorkee India," Royal Observatory Greenwich, AST1086. © National Maritime Museum, Greenwich, London.

exact. This image, however, did not enter the broader public domain through the periodical press, and instead was used and conceptualized as an object of data rather than an object of communication.

When Janssen's work did enter the periodical press, the images that were made from his device were not shown, but rather the problem of observing ingress and egress was illustrated for the reader by showing single photographs made from Dallmeyer's photoheliographs. In Illustration 5.17, two reproductions were given from photographic plates made in Honolulu. These plates show two stages of ingress. On the left side of the illustration, Venus is halfway through the contact with the outer edge of the Sun, called external contact; and on the right, Venus has just entered fully onto the disk of the Sun, or inner contact. Outer contact and inner contact are the stages of ingress and egress most fraught with visual problems: this is when the black drop phenomenon was observed, and when the timing of the contact became problematic. While the problem of ingress and egress is fundamentally a visual and temporal problem (when it happened it was tied to seeing and timing), when the communication of this problem entered the periodical, the limitations of the number of images that could be printed and the detail that those images needed to express altered the visual content that was displayed. These two images—although very closely associated with time— were used to communicate the problem of ingress and egress because they are unambiguous in terms of their association with time and space. They represent two single moments of time separated by fifteen minutes. If, on the other hand, a Janssen plate had been used, timing would have been the central object in the image with each photographic exposure being reduced to a set in a series, rather than a stable image of Venus entering onto or exiting the Sun.[57]

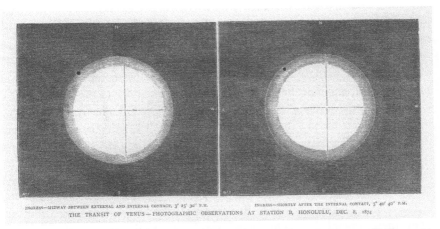

INGRESS—MIDWAY BETWEEN EXTERNAL AND INTERNAL CONTACT, 3ʰ 25′ 30″ P.M. INGRESS—SHORTLY AFTER THE INTERNAL CONTACT, 3ʰ 40′ 40″ P.M.

THE TRANSIT OF VENUS — PHOTOGRAPHIC OBSERVATIONS AT STATION B, HONOLULU, DEC. 8, 1874

ILLUSTRATION 5.17 Wood engraving—"The Transit of Venus—Photographic Observations at Station B. Honolulu, Dec. 8, 1874," *Graphic*, 11, no. 270 (January 30, 1875): 116. Reproduced by permission of the University of Leicester Library.

These two photographic reproductions are, however, more explicitly linked to Janssen when read alongside the text. The author of the article, after first pointing to De la Rue's importance in initially suggesting photography for the observation of the Transit, went on to explain Janssen's essential role:

> Janssen, a French astronomer, invented an ingenious arrangement, by which a large circular plate can be so turned during the ingress and egress of Venus that picture after picture of her advancing and retiring disc is depicted round the edge of the plate. The exact instant when each picture is taken is known, and by examining the series it becomes possible to tell exactly when Venus was in contact with the sun.[58]

In this narrative, Janssen's photographic technology allowed for problems of observation to be overcome. When communicating these visual problems, it was not a Janssen plate that was used, but a single photographic exposure that did a better job.

A label of authenticity still needed to be ascribed to the photograph. This came later in the same article when the author pointed out that "the photograph here engraved (by the kind permission of the Astronomer Royal) was taken at Station B, Honolulu, and represents two phases of the ingress of Venus, the first, midway between external and internal contact, the second, some fifteen seconds later, shortly after internal contact."[59] The chain of translation of the image (see Chapter 2) allowed for the image to be traced back to Greenwich. The tracing of this image also demonstrates the power dynamics at play: Airy, who held the photograph, had to allow the reproductions to be engraved from the originals. Interestingly, although the image is inferred by the *Graphic* to be a direct copy, this fact did not prevent the journal from making a mistake in the interpretation of the image itself. The author of the article gave the duration between the two images to be fifteen seconds, when the reality is that 3° 25' 30" pm and 3° 40' 40" pm (the times given under the image) is a separation of fifteen minutes and ten seconds.[60] This mistake in publication is similar to that made when reproducing Alfred Brothers' photograph of the solar corona (see Chapter 2) and the misspelling of Gaston Tissandier's name in the *ILN* (see Chapter 3). For Illustration 5.16, this mistake points to the fact that the inscription on the photographs, and the images themselves, gave a more faithful recording of the contact of Venus and the Sun than the article itself.

When reproductions of photographic objects made during the Transit entered the periodical press, they were often considered more trustworthy than the text describing them. Because of this attention, the images that were produced from these photoheliographs have already received considerable attention within the secondary literature.[61] One of the most compelling arguments within this historiography is that, during the Transit, the photograph was not needed

to solve any "visual questions" but instead was used as a quantitative device to measure "the times of ingress and egress of the limbs of Venus and the sun."[62] Thus, for Rothermel, it is not the material products of the photoheliograph that were important, but instead the calculations made from them. The photographic images themselves were not valued for their material referent, but for the data that they encoded. It is the contention of this chapter, however, that the photographic referent was important when examining images of the instruments themselves in the context of print reproduction.

Airy, being the careful organizer that he was, made sure that everything under his command was cataloged. Alongside paper documents, Airy also included photographs of each of the instruments used in the Transit expeditions. Many of these photographs remain in the ROG archives, but one of them stands out for its use in public spaces. *Station B Honolulu* is a photograph of the Dallmeyer photoheliograph, made by an unknown photographer, set up inside its hut (Illustration 5.18). It is unclear whether this was a photograph taken on the actual site, or whether it was taken at Greenwich before the device was taken apart and sent to Hawaii. Either way, what matters is that this photograph gives the viewer detailed information about the way in which the Transit was photographed. Even without understanding how the instrument works, one can imagine the enclosed space that the observer sat in while waiting patiently for Venus to show itself on the face of the Sun. The viewer can also see the great degree of organization that went into these expeditions: the date, station, and number of the photoheliograph are written numerous times across the wood hut. Through these markings, and the photoheliograph itself, one can also read the temporality of this set up: these are spatial items, impermanent and transient. All of this can be read in this image without any accompanying textual description.

These spatial and temporal notions of *Station B Honolulu* were transposed into the public realm in both the scientific and popular press. Lockyer utilized this photograph in two different publications: first in his own journal, *Nature*, and later in a popular science book on astronomy entitled *Stargazing: Past and Present*. Unlike the original photographic image, Lockyer's reproductions of *Station B Honolulu* were surrounded by textual material, and their recoding in these separate spheres of print must be understood within these contexts.

The first reproduction of *Station B Honolulu* occurred within a set of seven articles in *Nature* entitled "The Coming Transits of Venus," penned by George Forbes (Illustration 5.19).[63] At 23, Forbes was Professor of Natural History at Anderson's University in Glasgow; by 25, he was leading the ROG team to Hawaii for the Transit observations.[64] Forbes was deeply invested in the Transit observations and had spent a long apprenticeship training his observational timing through the Transit model installed at Greenwich.[65] Moreover, while at Greenwich, Forbes worked on experiments to answer the question of the "black drop" and argued that when Venus was at ingress or egress there was not enough

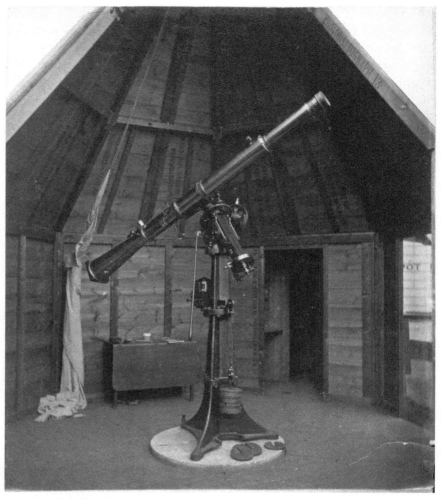

ILLUSTRATION 5.18 Photograph—"Station B Honolulu," RGO 6/276 f.18. Reproduced by permission of the Cambridge University Library.

light passing between the Sun and the edge of Venus to be perceptible to the human eye.[66] The production of this article for *Nature* was the closest to the official Greenwich report that would be given in the periodical press.

Illustration 5.19 was featured in the last article on the Transit, and also acted as the final image within this serial article. The placement of Illustration 5.19 as the last image that the reader encountered emphasizes the value of photography as the culmination of astronomical technology. Moreover, the placement of the photoheliograph at this particular point ends a textual and visual narrative, which is wrapped up in notions of space and time within a print genre which itself was

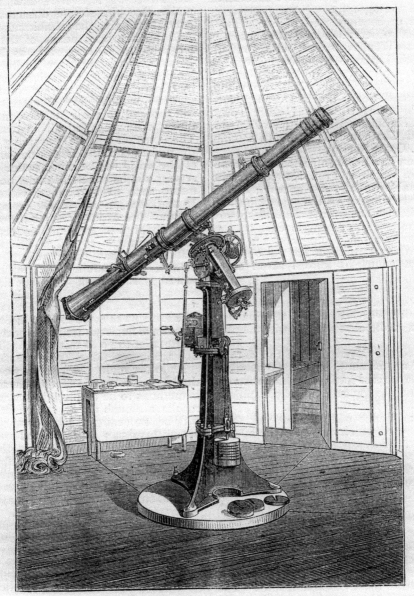

FIG. 19.—Photo-heliograph of the British Expeditions.

ILLUSTRATION 5.19 Wood engraving—"Photo-Heliograph of the British Expeditions," *Nature*, 10, no. 240 (June 4, 1874): 88. Reproduced by permission of the University of Leicester Library.

produced over space and across time. The periodical, as has been pointed out in Chapters 2 and 4, was fundamentally concerned with time, and through the placement of the reproduction of the photoheliographs at the end of a series of articles published over a period of weeks; the camera by association became an object situated around time.

Illustration 5.19 is a very close reproduction of the original photograph; however, it is missing one important detail from the original photograph—the writing on the wall. Within this reproduction, the walls of the hut show none of the information about the date, name, and placement of the Dallmeyer photoheliograph. The exclusion of this information from the reproduction may be in part due to the fact that the text gave much of the contextual information that was originally contained within the image itself. Within *Nature*, the image was reinscribed to fit with the accompanying text.

The second instance of the reproduction of the same image within a more public text was Lockyer's *Stargazing: Past and Present* (Illustration 5.20). Much like Proctor's *Transits of Venus*, *Stargazing* was intended to give a historical account of astronomy. While Proctor's work focused on one specific astronomical question, Lockyer's work was intended to give a longer history of astronomy, ending with contemporary astronomical efforts and the introduction of photomechanical observation. While the reproduction of *Station B Honolulu* was a replica of the *Nature* image (save for a small difference in the shading), the placement within the textual argument is very different. In *Nature*, the photoheliograph was used to represent the narrative culmination of Transit observations, while in *Stargazing*, it was used to speak to the advancement of astronomical science in general. The use of this image, in two very different locations, represents the importance placed on photography as a tool for scientific observation during the late nineteenth century.

What is compelling about Lockyer's use of this image in both *Nature* and *Stargazing* is the difference in value he placed on varying forms of visual objects and their uses in print and science. Pang points out that Lockyer believed that "woodcuts were acceptable for use in newspapers and textbooks, but they could not sustain the level of detail necessary for real scientific work."[67] Thus for Lockyer, a drawing was acceptable for a nonscientific text, but not as a piece of observational evidence. What Lockyer omitted, however, was the use of photographs as the original source of these reproductions.

The use of this single photograph extended beyond the nineteenth century and into the historical debates concerning the late Victorian institutionalization of science. In his history of the ROG, Derek Howse focuses his analysis on the instrumental and physical organization of astronomical science at Greenwich. In his section on the late nineteenth century, Howse reproduces the engraving from *Stargazing*[68] (Illustration 5.21). What makes his use of this image surprising is that, while Howse had access to the Greenwich archives, he chose to reproduce the image from Lockyer. This implies that the reproduction actually had much more cultural

and of course a siderostat is employed. In this way

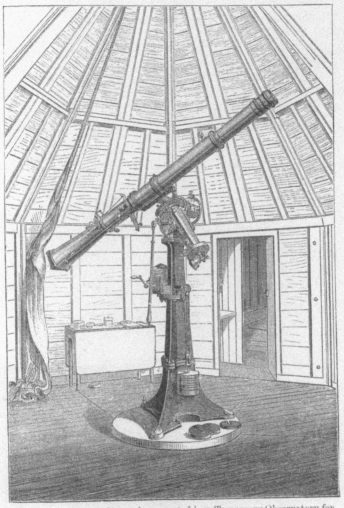

FIG. 211.—Photoheliograph as erected in a Temporary Observatory for Photographing the Transit of Venus in 1874.

Professor Winlock obtained photographs of the sun which have surpassed the limits of Mr. Newall's re-

ILLUSTRATION 5.20 Wood engraving—"Photoheliograph as Erected in a Temporary Observatory for Photographing the Transit of Venus 1874," *Stargazing: Past and Present*, London: Macmillan and Co., 1878, 461. Reproduced by permission of the Cambridge University Library.

Fig. 84. PHOTOHELIOGRAPH ERECTED IN TRANSIT–OF–VENUS PORTABLE OBSERVATORY, 1874
From N. Lockyer *Stargazing past and present* (1878), p. 461.

Fig. 85. PHOTOGRAPH OF SUN FROM 6-INCH GLASS PLATE TAKEN IN 1883
From 1884, 10-inch plates were used.

ILLUSTRATION 5.21 Full page including a reproduced wood engraving and photographic plate—*Greenwich Observatory: Volume 3*. London: Taylor & Francis, 1975, 84. Reproduced by permission of the University of Leicester Library.

impact than the original photograph. Further to this, Howse reproduces an original photoheliograph plate of the Transit alongside the Dallmeyer photoheliograph. By placing these images alongside each other, Howse brought together the material presence of the instrument with the product of that instrument. The fact that the print is an actual photograph, while the photoheliograph is an engraving, complicates this continuity. For Howse, the connection is uncomplicated, while for nineteenth-century astronomers, the connection was nothing but complicated.

One of the other images—situated in the Greenwich archives but moved into the public sphere through its reproduction in print—is a photograph of the Transit huts used for the 1874 Transit (Illustration 5.22). This image offers the opposite scene from that of *Station B Honolulu*: the huts and scenery are the main focus, and the photoheliograph is only depicted through the telescopic arm that sticks out of the hut. Although this image is tangentially about the Dallmeyer photoheliograph, the real attention is on the setting for the use of this instrument. The source and use of the reproduction of this image are therefore considerably different from that of *Station B Honolulu*.

The photograph of the Transit huts was used as a source for reproduction in the June 27, 1874, issue of the *Graphic* (Illustration 5.23). The engraving follows

ILLUSTRATION 5.22 Photograph—No Title, RGO 6/276 f.24. Reproduced by permission of the Cambridge University Library.

PHOTO-HELIOGRAPH HUTS

ILLUSTRATION 5.23 Wood engraving—"Photo-Heliograph Huts," *Graphic*, 9, no. 239 (June 27, 1874): 624. Reproduced by permission of the University of Leicester Library.

the content, spatial organization, and detail of the photograph relatively closely and only augments the image by enhancing the details of the photoheliograph sticking out of the Transit huts. This image is set among five other engravings; three of which are engravings of other observational instruments, one group photograph of members of the expedition, and an image of the other assembled huts. All of these images were engraved from photographs too; however, it is the photoheliograph huts that draw particular attention as they represent the visual outcome of a photographic technology prepared for popular illustrated periodicals—as opposed to a scientific periodical such as *Nature*.

The fact that the *Graphic* chose to reproduce the outside of the tent, instead of the image used by Lockyer, is particularly revealing. Set alongside the other instruments displayed on the page, one would expect the visual description of the Dallmeyer photoheliograph in the *Graphic* to be one similar to *Station B Honolulu*. Instead, the reader was shown the outside of the hut, rather than the material object to which the text referred. The textual description that accompanied these images indicated what should be read from this image:

Lastly, five magnificent photo-heliographs have been constructed, one to each principal station. The photographs taken by these will be free from all distortions and imperfections, and will be mathematically precise and sharp of

outline. Like the telescopes, the photo-heliographs are equatorially mounted, and are carried along by clockwork with the same velocity as the sun. All these huts and instruments have been erected at Greenwich, and the instruments put in perfect adjustment. When complete they were taken down and packed, and will afterwards be re-established and readjusted.[69]

Much like the discussions of the use of photography in both Lockyer's and Proctor's writings, the relationship between the technologies of image capture and the outcome of those processes (the photographic negatives) is that the machine allows the image to be "mathematically precise," "sharp of outline," and dictated by time. Even for the *Graphic*, the photographs from the Transit were data. Yet, unlike the scientific press, for the *Graphic*, the focus of editorial attention was less on the instrument itself but the way in which it was made. This was an artificial setup (artificial in the sense that it was not set in its intended location, but instead at Greenwich), yet the reader only came to understand this by reading the text. The placement of these huts and instruments at Greenwich tangibly demonstrates the link between the Transit expedition and the institutional power of Greenwich. For *Station B Honolulu*, this link was exhibited through the markings on the hut, which were conspicuously missing in the engraving. The use of the Transit hut image for the *Graphic* was about the production of a sense of place and institutional authority, not the depiction of the instrument itself. For the scientific press, it was the other way around. For the *Graphic*, the image and text worked in tandem to relay to the reader the importance of observational instruments to the institutional setting of the Greenwich observatory.

The final print location for the examination of the photographic importance of the 1874 Transit expeditions comes from the end of the nineteenth century, through the voice of an insider at the ROG. Walter E. Maunder (1851–1928) was the first employee at the ROG hired a year before the 1874 Transit to run full-time observations on spectroscopy. Maunder (whose position at Greenwich was established after Airy consulted with De la Rue on his work at Kew on solar spectroscopy) began his solar observations by analyzing the appearance of Sun spots. Maunder was thus highly enmeshed in the introduction of the new technologies of photography and spectroscopy during the early 1870s at Greenwich.

Although Maunder did not participate in the 1874 or 1882 Transits, he was later an important member of the astronomical community: first as a member of the RAS, and later a founder member of the British Astronomical Association (BAA). The BAA was established by Maunder and others as a society of astronomers to encourage amateur astronomy, while the RAS was much more concerned with the professionalization of astronomy, and thereby the exclusion of amateur practitioners. With his work in these two societies, Maunder sat on the border between an increasingly important divide in the nineteenth century—the

distinction of amateur and professional astronomer. Maunder was avowedly not an amateur, but his efforts to establish the BAA indicates a desire on his behalf to address the growing inequities between those with power and position and those without. As we will see, this desire for inclusion was not limitless. Speaking briefly of Maunder, Pang notes that he was among a group of astronomers between Cambridge, Oxford, and Greenwich, who dominated astronomical expedition planning in the latter half of the nineteenth century.[70] While Maunder was a member of this influential network, Pang argues that the RAS was much more influential in the planning and execution of the eclipse and Transit expeditions during the late nineteenth century, and for this reason, the BAA and Maunder do not fit in with his analysis.[71] While Maunder may not have been an influence in the actual planning of the Transit of Venus, his work in the public promotion of astronomical and instrumental science helped to create a key narrative of this astronomical event after the fact. Looking at Maunder's influence in this light helps to tie together the seemingly disparate threads of nineteenth-century amateur and professional astronomy and popular print communication through the lens of photographic science.

In the closing years of the nineteenth century, Maunder published a history of the Greenwich Observatory that emphasized the centrality of Greenwich to Victorian astronomical science. This was a particularly polemical point of view for the amateur astronomer, as it wrenched any influence out of the hands (or eyes as it may be) of the individual working at his telescope in the backyard by giving primacy to an institution.[72] This argument was made in multiple print genres, and this movement across print was essential to the influence it held. Controversy and polemic were only truly established when Maunder's argument for Greenwich's primacy moved from his pen out into the periodical press.[73]

Maunder first published his history of Greenwich as a set of articles printed between 1897 and 1898 in *The Leisure Hour*, and then later in a book entitled *The Royal Observatory Greenwich*, published in 1900. Both *The Leisure Hour* and *The Royal Observatory Greenwich* were published by the Religious Tract Society—an organization that advocated and printed morally upright treatises and novels.[74] Maunder's historical narrative in both of these print locations is located within the scope of genteel Sunday reading: it was informative, moral, and refrained from being unnecessarily complex. The articulation of this moral, straightforward narrative by Maunder is evident in his textual argument, but more specifically it can be seen in his choice and placement of images.

Maunder's historical narrative of Greenwich relied on three contiguous themes: character history (more specifically the relevance of each Astronomer Royal), the history of place, and the history of the instruments. Although all three of these themes were intermeshed within Maunder's narrative (much like the narratives created by Proctor, Forbes, and Grant), read together they create a grand narrative within the late nineteenth century culminating in personal, physical,

and technological achievement. For the purposes of this chapter, however, we will focus on the narrative theme of technology as it highlights the ways in which Maunder's use of text and image create an interrelationship between the history of Transit observations and the technologies that helped to address the problems of human observation of astronomical events—tied to the precise and minute movements of time and space.

For Maunder, the culmination of his narrative of Greenwich came with the introduction of four new departments at Greenwich in the 1870s: the heliographic department, the astrographic department, the spectroscopic department, and the double-star department. Maunder reinforced this grand narrative by ending his book with one chapter on each of these departments. The first of these departments was of particular interest to Maunder as it was there that the Dallmeyer photoheliographs found their purpose after being used for the 1874 Transit. Maunder illustrated their historical and technological importance by inserting a photograph in his book of the Dallmeyer photoheliograph installed at Greenwich (Illustration 5.24). This image is unlike the photograph reproduced by Lockyer of the Dallmeyer photoheliograph in 1878 in a number of ways. First, it is a close-up depiction of the photoheliograph, and only includes the physical background for contextual purposes. There is no writing on the wall like that

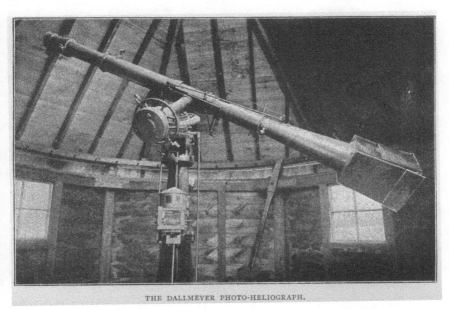

THE DALLMEYER PHOTO-HELIOGRAPH.

ILLUSTRATION 5.24 Photogravure print—"The Dallmeyer Photo-Heliograph," *The Royal Observatory Greenwich*, London: Religious Tract Society, 1900, 254. Reproduced by permission of the University of Leicester Library.

of *Station B Honolulu*, and instead the main focus of the reproduction of this photograph is to illustrate the mechanisms of the photoheliograph itself.

The photograph of the photoheliograph was earlier reproduced in Maunder's version of this narrative in *The Leisure Hour* (Illustration 5.25). The only difference in this image was the subscript "from a photograph by Mr. E Walter Maunder." The inclusion of Maunder's authorship of this photograph is particularly revealing, as he chose to exclude this particular piece of information when reprinting the same photograph in his book. This disparity between the subtitles used in these two forms of print points to a need for authorial authenticity when printing an image in the periodical press.

The other main difference between Maunder's reproduction of the Dallmeyer photoheliograph and that of Lockyer is in the medium of reproduction. By the end of the nineteenth century, reproductive techniques were advanced and relatively cost-efficient, allowing for the reproduction of photographic prints over engravings. For Lockyer, this would have been logistically impossible in the 1870s for both articles in *Nature* and *Stargazing*.[75] Maunder was therefore able to present a notion of simulacrum when presenting his visualization of the

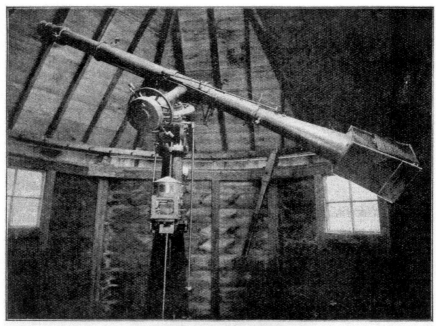

THE "DALLMEYER" PHOTO-HELIOGRAPH.
(*From a photograph by Mr. E. Walter Maunder.*)

ILLUSTRATION 5.25 Photogravure print—"The 'Dallmeyer' Photo-Heliograph (From a Photograph by Mr. E. Walter Maunder)," *Leisure Hour*, 47 (1898): 376. Reproduced by permission of the University of Leicester Library.

Dallmeyer photoheliograph to his reading audience, thus giving him greater claim to visual legitimacy. This legitimacy allowed Maunder to reinforce his technological grand narrative of Greenwich Observatory. For Maunder, by the end of the nineteenth century, Greenwich was the singular most important location for astronomical science in England. The reason why Greenwich was so important was, for Maunder, tied to the inclusion of photography in the daily operation of astronomical observation.

Conclusion

The typical nineteenth-century narrative of Transit observations, such as those of Proctor and Lockyer, tends to end with promulgations about upcoming Transits. Invariably, there were discussions about the 1882 Transit, and, on some occasions, they even stretched their narratives to include the 2004 and 2012 Transit. For the photoheliograph, however, the story ended in 1874: afterward there was a movement away from mechanistic observation, while at the same time the ROG played a significantly reduced role in the planning and execution of the expeditions. There is still much room for analysis of the 1882 Transit since the subtle reasons for this movement away from photography can help shed light on variations in mechanistic science in the late Victorian period.

Nevertheless, the period of 1870–1880 is a particularly revealing one for the history of visual observation. Science writers, journalists, and popular historians (with individual writers sometimes fitting into all three categories) wrote about the Transit enterprise in terms of technological advancement. The history of the Transit observation, for these writers, was key in mobilizing public interest in, and understanding of, natural phenomena. Whether published in a periodical or book-length treatise, the textual discussion and visual reproduction within these print formats formed a distinct conception of the value of science and technology. Although the visual and textual narratives necessarily changed depending on their genre and the audience for which they were published, one thing remained constant: photography, whether as a source material or visual referent, was valued for its ability to represent "true" science.

CONCLUSION

The periodical is the starting point. Instead of taking the development of photographic technologies, such as wet collodion or instantaneous photography, as the historical incidents that generate the focus of this analysis, I started by looking at the reproduction of these technological developments within print. Moreover, I looked for these developments within a very particular period—the 1870s and 1880s—because of the changes that occurred in both print and photographic technologies during these decades. By doing so, I moved away from a technologically reductionist argument to one which examined the development and application of photographic and print technologies as products not just of science, but of the very forms through which science and popular culture were communicated. This is why the analysis moves from the general print press [such as the *Illustrated London News (ILN)* and the *Graphic*] to the specialist print press (such as *Nature*, *Astronomical Register*, and *Knowledge*). As Altick has reminded us for print culture specifically, and Fyfe and Lightman have pointed out for scientific practice more broadly, the reproduction of science within popular or mass culture changes the product and forms of reception for science itself.[1]

Returning to Thomas Hardy's *Two on a Tower*, the picture that so shocked Lady Constantine in the introduction was not just an image, but a piece of news. Hardy reminds us in his description that the picture would only have shocked Lady Constantine and was "possibly harmless enough in its effect upon others."[2] For Hardy, and for nineteenth-century periodicals—whether popular or scientific—the value of the image reproduced within the periodical was not in its realism, but rather in its ability to move information across space and time, and to be reproduced. Through the multiple forms of reproduction an image underwent before being printed in a periodical, the image could be made to conform to the perspective of that specific periodical. This is a particularly striking point considering that photographs have been attributed with a value of realism—that they show with fidelity what was in front of the camera when a photograph was exposed.[3] This photographic realism is taken to be independent of the context of

production and reproduction of a photographic image. When a periodical gave the designation of an image as being "from a photograph," this reinforced both the realism and invariance of photography. However, this label also created an ambiguity about the value of the photographic object on the page: it reinforced photography as an authentic source, and therefore trustworthy, at the same time that the distance from this source, or the processes of reproduction, was also highlighted.

The photograph for the illustrated periodical was an object and a technology that allowed a periodical to reproduce an image and invest it with a form of credibility. Importantly, this credibility was fashioned around the analytical categories of the scientific and popular presses, the seriality of print production and scientific experimentation, and the compartmentalization of space and time. These categories are not solely historical categories, but were central concerns of the actors within this book in the period under investigation. Thus, the vociferous debates between Norman Lockyer and Richard Anthony Proctor over the locations of the Transit of Venus and the value of the scientific periodical in the 1870s were also fundamentally arguments about the value of science communication, the production of scientific credibility, and the use of visual technologies.

This book has therefore looked at photography as a multifaceted technology and object of communication. It has taken this multifaceted nature of photography to be particularly relevant when looking at the reproduction of images in print. This has created a number of methodological questions—particularly how to look at two historical areas with distinct historiographies, which themselves have very different ways of "looking." The history of photography, and the history of art and visual culture more broadly, has taught me how to make a close reading of the visual objects in the periodical, as well as highlighting that the text which surrounds these images is equally important.[4] Conversely, the history of periodical print has framed some of the broader concerns—such as the place of print media in creating and communicating a scientific community, as well as the importance of authorial and editorial concerns and the reception and interaction of the readership to a particular periodical. Together these two approaches have allowed me to look at periodical history and photographic history in a way that reveals new insights: first, that the technologies of nineteenth-century communication are fundamentally connected to each other; second, that periodicals simultaneously discussed and reproduced photographs of science and photographic science, and that this helped to both formulate the way in which photography was understood more broadly within Victorian culture while helping to create a value of photographic authenticity for the scientific and popular presses; and finally, that the conceptualization, organization, and reproduction of space and time in scientific experimentation; the use and discussion of photography; and the organization of the periodical print press all worked to validate each other.

I have integrated these two approaches by relying upon three specific ways of looking, which address both how photographs *seem* and how they *see*: Bruno Latour's chain of reference, W.J.T. Mitchell's image and text, and the notion of seriality discussed by Hopwood et al. and Chitra Ramalingam. These three concepts, although they are mobilized differently, allow me to make a close reading of the application of photography to the periodical press, while speaking to larger issues in periodical print and photographic history. So, for example, a different history emerges when we look at the technological development and reproduction of instantaneous images in the late 1870s and early 1880s through a methodology that incorporates the serialization of the image, the relationship between the image and the text, and the processes through which an image was legitimized. In this kind of story, individuals like Eadweard Muybridge and E.J. Marey become decentralized, and the discourse and reproduction of photographic technology take precedence.

This investigation of the use of photography within the nineteenth-century print press—in addition to creating a way of looking—opens some broader questions about the relationship between the communication of science and scientific expertise and credibility. Historians are familiar with the writings of Lightman and Frank Turner, who remind us that we cannot take for granted what constituted science in the Victorian period.[5] The boundaries of science, both in the public and in the private realm, were constantly being fought over, and debates over the professionalization of science and the formulation of expertise reflect the ways in which this battle was fought. Where these controversies took place, however, has yet to be fully fleshed out. What this book has shown is that the study of a forum for debate (the periodical) and a topic of debate (photography) reflect the instability of the boundaries of science. Moreover, the boundaries of a specific controversy can inform wider concerns about the practice and production of nineteenth-century science. When someone like Alfred Brothers reproduced his photographs in both the popular and the scientific presses, he was simultaneously creating and commenting on the credibility of the periodical, his images, and his own reputation within the scientific community.

Additionally, the editors of the SciPer Project point out that the periodical press was one of the important—if not *the* most important—sites for producing scientific credibility in the nineteenth century.[6] This is why the controversies between Winstanley and Alfred Brothers and questions over the value of the photographic society, discussed in Chapter 2, were debated within the pages of *Nature*. Photography within this culture of controversy is a unique example: it is both a science itself and an object that was used to make science. It also shows us that the characters in this analysis—Warren De la Rue, Jules Janssen, Gaston Tissandier, and Henry Baden Pritchard, among others—though all different practitioners of science with different expertise and credibility, were all deeply enmeshed in photography. Thus, it is difficult to look at individuals, institutions,

or practices of science in the late nineteenth century without thinking about photography. When photographs entered the periodical press, it was not just their value as a technology of representation, but rather the discussions about photography that created some of their meanings. These meanings also created a practical value for the reproduced photographic image at the same time that it reflected larger concerns over the shifting boundaries of late Victorian science.

Unlike a single image or set of photographic images (even the most famous ones), the images reproduced in this book were seen by tens of thousands—and in some instances, hundreds of thousands—of people. Periodicals like *Nature*, the *ILN*, and the *Graphic* had weekly readerships of approximately 10,000 people each, and on some occasions sold over 200,000 copies of a single issue.[7] The *Graphic*, for example, sold over 200,000 copies of its Christmas editions and during the highly sensational Tichborne Trial in 1874, while the *ILN* sold over 120,000 issues a week in the 1850s.[8] When we think about the movement of a single image across periodical spaces—such as Illustration 2.5 that was originally reproduced in *La Nature* before it was printed in *Nature*—and when we think about the fact that a single issue of a periodical was commonly passed around to friends and families, the amount of people that read, interpreted, and were exposed to these pictures is, for the nineteenth century, very high. Looking at photographic images in the nineteenth-century periodical is therefore about more than just what was in the picture, how it was made, where it was placed, or how it contributed to scientific culture: it was also fundamentally an object of popular culture and mass consumption.

A promise to look

While the readerships for the periodicals I have discussed were large, the space of time over which I have examined the use of photography within the periodical press has been relatively short. The focus on the 1870s, with occasional excursions into the 1880s, has allowed me to investigate the juncture between two communication technologies and to see where and how they worked together or against each other. The forms of visual epistemology that I have argued for in the 1870s and 1880s however do not, and cannot, work after the 1880s and beyond. Once periodicals were able to reproduce photographic images photomechanically—either through photogravure or halftone processes—the way that photographic images were used and their concomitant forms of visual authenticity changed. Further investigation of the reproduction of images from the 1890s and throughout the first two decades of the twentieth century—extending a methodological gaze that incorporates history of science and art history—will open up new but related questions. For instance, a similar analysis of the development of instantaneity to that made in Chapter 4 could be carried out for the development of cinema in the periodical

press in the early twentieth century to understand the visual and technological values invested in these two forms of communication.

The other central issue that has surfaced in this analysis, but which has not been the central focus, is the relationship between the uses of the foreign—whether as a textual piece of information or as a visual reproduction of a person, place, or object—and the use of the periodical press and the photograph. An investigation of individuals like John Thomson, discussed in Chapter 1, and the ways in which his photographs of China, Malacca, and Cyprus were reproduced within the periodical presses more widely would highlight how the visual content of the illustrated and non-illustrated periodical presses acted as spaces for familiarizing English reading audiences with the foreign, while also making the local foreign. Through the reproduction of Thomson's images in print, the local and the foreign were put under a common visual rubric, thereby placing the mundane and the exotic on the same plane. The position of photography in this process of making the foreign local reflects, moreover, is another way in which photography was invested with a value of trust. Establishing whether photographic images of foreign people and places were valued over other types of images, and how these images got reproduced within the periodical press would extend the argument made in this book concerning the value of photography as a tool of representation, science, and communication. Through this kind of investigation, instances like the use of photography for the Transit of Venus, discussed in Chapter 5—instead of being discussed solely as a scientific and visual project—could be situated much more explicitly within the scope of an imperial framework, where photographic images are objects of transmission, reproduction, and communication at the same time as being objects of representation.

The ways of looking that I have advocated for are not a polemic against the way images and periodicals have been read, but rather a promise to look forward. So, for instance, instead of making a diachronic investigation of periodicals, a synchronic investigation can be made of illustrated and non-illustrated periodicals to see the value of the photographic object in competing and contrasting journal spaces. If we reread *Two on a Tower* within this framework, looking at the use of both images and textual visual tropes within and across a periodical, the reading of Hardy's work changes fundamentally. Thus, Hardy's words that precede his description of Lady Constantine's reaction to the illustrated periodical take on a special resonance. The image that we, as periodical readers, do not see is described by Hardy as "[Sir Blount] was represented standing with his pistol to his mouth, his brains being in the process of flying up to the roof of his chamber, and his native princess rushing terror-stricken away to a remote position in a thicket of palms which neighboured the dwelling."[9] While there is no picture to see, the visual language of this passage was certainly not harmless. The illustrated periodical sent to Lady Constantine to inform her of her husband's death thereby becomes not just a plot device, but a visual object enmeshed in a larger culture of photography,

periodical print publication, and Victorian science; and a textual description with dynamic visual effect.

So finally, whether it is in the reading of a good novel, or the perusing of the weekly news, we are reminded that, in the nineteenth-century illustrated periodical press, the use of photographic objects, the explication of photographic evidence, and the explanation of the development of photographic and print technologies were intimately connected. While this has not been an easy story to tell, when we look more closely at the images, the texts, and the stories told about each of these, the bigger picture of the relationship between photography, print culture, and scientific culture comes just a bit more into focus.

NOTES

Introduction

1 Thomas Hardy, *Two on a Tower*, ed. Sally Shuttleworth (London: Penguin Books, 1999), 202.

2 Sally Shuttleworth, in her introduction to the 1999 reprint of *Two on a Tower*, points out that astronomy was, for Hardy, intended to be not just a backdrop but also a fundamental aspect of the love story. Hardy, *Two on a Tower*, xx. Also see the reflection of this argument in Anne Dewitt, "'The Actual Sky Is a Horror': Thomas Hardy and the Arnoldian Conception of Science," *Nineteenth-Century Literature*, 26, no. 4 (March 2007): 502. For recent and important work on the embedded nature of astronomy to the Victorian novel, see Jim Barloon, "Star-Crossed Love: The Gravity of Science in Hardy's *Two on a Tower*," *The Victorian Newsletter* (Fall 1998): 27–32; Harumi James, "*Two on a Tower*: Science and Religion, Space and Time," *Hardy Review*, 2 (Summer 1999): 141–156; Pamela Gossin, *Thomas Hardy's Novel Universe: Astronomy, Cosmology, and Gender in the Post-Darwinian World* (Aldershot: Ashgate, 2007); and Anna Henchman, *The Starry Sky Within: Astronomy and the Reach of the Mind in Victorian Literature* (Oxford: Oxford University Press, 2014).

3 John North, "Atlantic Monthly Magazine, The" in *Waterloo Directory of English Newspapers and Periodicals, 1800–1900*, online edn, ed. John North (Waterloo, ON: North Waterloo Academic Press, 1997). http://www.victorianperiodicals.com (accessed April 26, 2011).

4 Historians of photography also attribute photography with "double indexicality"— meaning produced through what is in front of the lens of the camera, and meaning made through the intentions and perspectives of the person behind the camera. For one of the most recent, and urgent, discussions in the history of photography and particularly their discussion of double indexicality, see Robin Kelsey and Blake Stimson, "Introduction: Photography's Double Index (A Short History in Three Parts)" in *The Meaning of Photography*, eds. Robin Kelsey and Blake Stimson (Williamstown, MA: Sterling an Francine Clark Art Institute, 2008), xi.

5 Lynda Nead, *The Haunted Gallery. Painting, Photography, Film c. 1900* (New Haven, CT: Yale University Press, 2007), 2.

6 Lynn M. Voskuil, *Acting Naturally: Victorian Theatricality and Authenticity* (Charlottesville: University of Virginia Press, 2004), 3.

7 Alan Thomas, "Authenticity and Charm: The Revival of Victorian Photography," *Victorian Studies*, 10, no. 1 (September 1974): 104.

8 Ibid.

9 Richard Altick, *The Shows of London* (Cambridge, MA: Belknap Press of Harvard University Press, 1978).

10 Geoffrey Cantor and Sally Shuttleworth, *Science Serialized. Representations of the Sciences in Nineteenth-Century Periodicals* (Cambridge, MA: The MIT Press, 2004), 1.

11 For the most recent and compelling histories of photography, Joel Snyder, *American Frontiers. The Photographs of Timothy H. O'Sullivan, 1867–1874* (New York: Aperture, 1981); Joel Snyder, "Visualization and Visibility" in *Picturing Science, Producing Art*, eds. Caroline A. Jones and Peter Galison et al. (New York: Routledge, 1998), 379–400; and Michel Frizot, *A New History of Photography*, trans. Susan Bennett (Koln: Konemann, 1998).

12 For the seminal work on photography and periodical communication in the period following the 1890s—with the wide-scale application of photomechanical printing—see Gerry Beegan, *The Mass Image: A Social History of Photomechanical Reproduction in Victorian London* (Basingstoke: Palgrave Macmillan, 2008).

13 This necessity of an integrated approach to photography and print reproduction has recently been forwarded by Jordan Bear. See Jordan Bear, "Index Marks the Spot? The Photo-Diagram's Referential System," *Philosophy of Photography*, 2, no. 2 (2011): 325–344; and Jordan Bear, *Disillusioned: Victorian Photography and the Discerning Subject* (Philadelphia, PA: Penn State University Press, 2015).

14 Topham, John, "Scientific Publishing and the Reading of Science in Nineteenth-Century Britain: A Historiographic Survey and Guide to Sources." *Studies in History and Philosophy of Science Part A* 31, no. 4 (2000): 559–612; Topham, John. "Technicians of Print and the Making of Natural Knowledge." *Studies in History and Philosophy of Science* 35, no. 2 (2004): 391–400. For recent and important work on the production and reproduction of science through the periodical from the late eighteenth through to the twentieth centuries, see Alex Csiszar, "Broken Pieces of Fact: The Scientific Periodical and the Politics of Search in Nineteenth-Century France and Britain" (PhD diss., Harvard University, 2010); Iain P. Watts, "'We Want No Author': William Nicholson and the Contested Role of the Scientific Journal in Britain, 1797–1813," *British Journal for the History of Science*, 47, no. 174 (2014): 397–419; and Melinda Baldwin, *Making Nature: The History of a Scientific Journal* (Chicago, IL: University of Chicago Press, 2015).

15 Joanne Shattock and Michael Wolfe, *The Victorian Periodical Press: Samples and Soundings* (Leicester: Leicester University Press, 1982); Margaret Beetham, "Towards a Theory of the Periodical as a Publishing Genre" in *Investigating Victorian Journalism*, eds. Laurel Brake et al. (Basingstoke: Macmillan, 1990), 19–32; Laurel Brake, "Writing, Cultural Production, and the Periodical Press in the Nineteenth Century" in *Writing and Victorianism*, ed. J.B. Bullen (London: Longman, 1997), 54–72; and Geoffrey Cantor and Gowan Dawson et al., *Science in the Nineteenth-Century Periodical: Reading the Magazine of Nature* (Cambridge: Cambridge University Press, 2004). There is one article in this collection that deals directly with images—Richard Noakes, "*Punch* and Comic Journalism in Mid-Victorian Britain" in *Science in the Nineteenth-Century Periodical: Reading the Magazine of Nature*, eds. Geoffrey Cantor et al. (Cambridge: Cambridge University Press, 2004), 91–124.

16 Peter Sinnema, *Dynamics of the Pictured Page: Representing the Nation in the Illustrated London News* (Aldershot: Ashgate, 1998). Also see Brian Maidment,

Reading Popular Prints, 1790–1870 (Manchester, NH: Manchester University Press, 1996) for a discussion of the image/text relationship in print more broadly.

17 James Mussell, *Science, Time and Space in the Late Nineteenth-Century Periodical Press. Movable Types* (Aldershot: Ashgate, 2007), 1.

18 James A. Secord, "Knowledge in Transit," *Isis*, 95, no. 4 (December 2004): 661.

19 Jonathan Crary, *Techniques of the Observer* (Cambridge, MA: The MIT Press, 1990), 14.

20 John Tagg, *The Burden of Representation, Essays on Photographies and Histories* (Minneapolis: University of Minnesota Press, 1988), 5.

21 See Lorraine Daston and Peter Galison, *Objectivity* (New York: Zone Books, 2007). Their argument about the development of mechanical objectivity away from a notion of objectivity associated with what they call "truth to nature" has been in circulation since the early 1990s. For their early work on objectivity, see Lorraine Daston and Peter Galison, "The Image of Objectivity," *Representations* (Autumn 1992): 81–128.

22 For a discussion of this division, see James Elkins, "Art History and Images That Are Not Art," *The Art Bulletin*, 77, no. 4 (December 1995): 553–571.

23 Horst Bredekamp, "A Neglected Tradition? Art History as *Bildwissenschaft*," *Critical Inquiry*, 29, no. 3 (Spring 2003): 418–428. For a comprehensive discussion of how *bildwissenschaft* can be applied to photography, see Hort Bredekamp and Brigit Schneider et al., *Das Technische Bild. Kompendium zu einer Stilgeschichte wissenschaftlicher Bilder* (Berlin: Akademie Verlag, 2008).

24 See Stephen Bann, *Parallel Lines: Printmakers, Painters and Photographers in Nineteenth-Century France* (New Haven, CT: Yale University Press, 2001), particularly in chapter 3 "The Inventions of Photography." See also Stephen Bann, *Distinguished Images: Prints and the Visual Economy in Nineteenth Century France* (New Haven, CT: Yale University Press, 2013)—an updated discussion and methodology for undermining teleological narratives of photographic and print histories.

25 Alfred Gell, *Art and Agency: An Anthropological Theory* (Oxford: Clarendon Press, 1998). Also see the recent discussion by Liana Chua and Mark Elliot, *Distributed Objects: Meaning and Matter after Alfred Gell* (New York: Berghahn Books, 2013) on the legacy of Gell's work.

26 Steve Edwards, *The Making of English Photography: Allegories* (Philadelphia: The Pennsylvania State University Press, 2006), 2.

27 Jennifer Tucker, *Nature Exposed: Photography as Eyewitness in Victorian Science* (Baltimore, MD: Johns Hopkins University Press, 2005). See in particular chapter 2, 65–125.

28 Expanding outward, James Ryan has shown that photography in an imperial setting was based around and through earlier forms of visual representation, such as the notion of the picturesque and the science of hunting. James Ryan, *Picturing Empire: Photography and the Visualization of the British Empire* (Chicago, IL: University of Chicago Press, 1997), 119–121.

29 Elizabeth Edwards, *Raw Histories, Photographs, Anthropology and Museums* (Oxford: Berg, 2001), 13. Edwards later extended this argument to say that photographs are fundamentally "relational objects," meaning that the viewing of a photographic image cannot be separated from its material and performative aspects. See Elizabeth

Edwards, "Photography and the Sound of History," *Visual Anthropology Review*, 21, nos. 1 and 2 (Spring/Fall 2005): 27.

30 Kelley Wilder, *Photography and Science* (London: Reaktion Books Ltd, 2009), 13.

31 For a discussion of the value of the photomechanical illustration in the British periodical press, and the application of the label of "from a photograph" from the 1890s, see Beegan, *The Mass Image*. For a discussion of the meaning of inscription and photography, see Mirjam Brusius, "Inscription in a Double Sense: The Biography of an Early Scientific Photograph of Script," *Nuncius*, 24, no. 2 (2009): 367–392; and Mirjam Brusius, "From Photographic Science to Scientific Photography: Talbot and Decipherment at the British Museum around 1850" in *William Henry Fox Talbot. Beyond Photography*, eds. Mirjam Brusius, Katrina Dean, and Chitra Ramalingam (New Haven and London: Yale University Press, 2013).

32 Bruno Latour, *Pandora's Hope. Essays on the Reality of Science Studies* (Cambridge, MA: Harvard University Press, 1999). In particular, see chapter 2 "Circulating Reference. Sampling the Soil in the Amazon Forest," 24–79.

33 W.J.T. Mitchell, *Iconography. Image, Text, Ideology* (Chicago, IL: University of Chicago Press, 1986), 10.

34 Ibid., 47. Also see theory of image and text in Roland Barthes, *Image, Music, Text*, trans. Steven Heath (London: Flamingo, 1984).

35 Tom Gretton, "The Pragmatics of Page Design in Nineteenth-Century General-Interest Weekly Illustrated News Magazines in London and Paris," *Art History*, 33, no. 4 (September 2010): 682.

36 For the classic studies of changes in time, see Lewis Mumford, *Technics and Civilization* (New York: Harcourt, Brace & World, Inc., 1934). See also E.P. Thompson, "Time, Work-Discipline and Industrial Capitalism" in *Customs in Common* (New York: The New York Press, 1993), 352–403 for a critique of the development of time as an organizational form of life and work, and Stephen Kern, *The Culture of Time and Space 1880–1918* (London: Weidenfeld and Nicolson, 1983) for a discussion of changes in time at the end of the nineteenth century.

37 Jimena Canales points out that the instant became a psychological concept in the nineteenth century and thereby affected the material, commercial, and specifically scientific world of the Victorian period. See Jimena Canales, *A Tenth of a Second—A History* (Chicago, IL: Chicago University Press, 2009).

38 Nick Hopwood et al., "Seriality and Scientific Objects in the Nineteenth Century," *History of Science*, 48, no. 161 (December 2010): 259.

Chapter 1

1 Jennifer Green-Lewis, *Framing the Victorians: Photography and the Culture of Realism* (Ithaca: Cornell University Press, 1996). Green-Lewis is very helpful in framing the context of Victorian photography, but the propagation of photographic trust is largely unexplored. Other key sources which do not evaluate the locations of photography in the periodical press are: Tucker, *Nature Exposed*; Edwards, "Photography and the Sound of History"; Christopher Pinney, *Camera Indica: The*

Social Life of Indian Photographs (London: Reaktion, 1997); Ryan, Picturing Empire; Jon Darius, Beyond Vision (Oxford: Oxford University Press, 1984); and Ann Thomas, Beauty of Another Order: Photography in Science (New Haven, CT: Yale University Press, 1997). Conversely the historiography of the printed press, although increasingly focused on visual culture, has not focused on the impact of photography on the periodical press. See Cantor et al., Science in the Nineteenth-Century Periodical; Louise Henson et al., Culture and Science in the Nineteenth-Century Media (Aldershot: Ashgate, 2004); Shattock and Wolfe, The Victorian Periodical Press; Celina Fox, Graphic Journalism in England during the 1830s and 1840s (New York: Garland, 1988); Estelle Jussim, Visual Communication and the Graphic Arts: Photographic Technologies in the Nineteenth Century (New York: R. R. Bowker, 1983); Renato G. Mazzolini, Non-Verbal Communication in Science Prior to 1900 (Florence, SC: Leo S. Olschki, 1993).

2 For technical manuals from the nineteenth century, see Hermann Vogel, The Chemistry of Light and Photography in Its Application to Art, Science, and Industry (London: King, 1875); Robert Hunt, Photography: A Treatise on the Chemical Changes Produced by Solar Radiation, and the Production of Pictures from Nature, by the Daguerreotype, Calotype, and Other Photographic Processes (London: John J. Griffin & Co., 1851); Charles Collins, The Hand-Book of Photography: Illustrating the Process of Producing Pictures by the Chemical Influence of Light on Silver, Glass, Paper, and Other Surfaces/to Which Is Added an Appendix Containing Full Instructions for the Preparation of, and Mode of Using, the Chemicals and Other Substances Employed (London: C. W. Collins, 1853). For photographic periodicals, see Photographic Art Journal, 1 (1870); Illustrated Photographer, 1–2 (1870); Amateur Photographer, 1–59 (1869–1921).

3 Although the term "Victorian Public" is fairly vague, for the purposes of this work, it will refer to the educated middle-class readership that formed the basis of the audience of the illustrated press. For an analysis of the readership of the late nineteenth-century press, see Cantor et al., Science in the Nineteenth-Century Periodical.

4 For an example of an analysis that focuses on the relationship between image and text in the ILN, see Sinnema, Dynamics of the Pictured Page. In both Sinnema's interpretation and the application of the relationship between image and text, he refers to the evaluation of the content and impact of an image by examining the interplay between the image and text. Especially in the periodical press, the analysis of imagery cannot be separated from the textual material that surrounds it. Integral to this investigation of photography in the Graphic is a similar analysis of the image and text relationship.

5 For a thorough examination of the history of photography, see in particular Helmut Gernsheim, The History of Photography from the Camera Obscura to the Beginning of the Modern Era (London: Thames & Hudson, 1969), and more recently Frizot, A New History of Photography.

6 In this chapter, the term "photograph" will be used; however, this term does not refer to the original photographic print, but the reproduction of a photograph through various printing mediums. For an important study of the French case with significant parallels, see Thierry Gervais, "D'apres Photographie. Premiers Usages de la Photographie dans le Journal L'Illustration (1843–1859)," Etudes Photographiques, no. 13 (July 2003): 56–85; and Jean-Pierre Bacot, La Presse Illustrée au XIXe Siècle: Une Histoire Oubliée (Limoges: Presses Universitaires de Limoges, 2005).

7 C.N. Williamson, "Illustrated Journalism in England: Its Development," *Magazine of Art* (1890): 392.

8 Mark Bills, "Thomas, William Luson (1830–1900)" in *Oxford Dictionary of National Biography*, online edn, ed. Lawrence Goldman (Oxford: Oxford University Press, 2004). http://www.oxforddnb.com/view/article/27248 (accessed March 30, 2011).

9 Williamson, "Illustrated Journalism in England: Its Development," 393.

10 Preface to *Graphic*, vol. 4 (July–December 1871): v.

11 Barthes, *Image, Music, Text*. For a further discussion of this, see Chapter 4.

12 For a discussion of the importance of commerce to photography, see Edwards, *The Making of English Photography*.

13 *Graphic*, 1, no. 5 (January 1, 1870): 115.

14 I use the *Graphic* as a singular voice because the articles were anonymous and were intended to be read as the single voice of the editorial staff.

15 This is not to argue that the Victorian public wholly accepted photographs as an incontestable source of truthful representation. In fact, much work has already been done to undermine this notion and demonstrate that the Victorian public was considerably skeptical of the images it was presented with. Tucker, *Nature Exposed*. Through her work, Tucker has clearly demonstrated the sites of photographic contestation in the nineteenth century; however, the periodical press was not one of those sites. This chapter, therefore, does not intend to undermine the multivalent nature of photographic reception in Victorian England, but instead looks to evaluate how photographs were treated when presented through the formative lens of the periodical press.

16 For a discussion of the debates over theories of photographic portraiture in the mid-Victorian period, see Jan von Brevern, "Resemblance after Photography," *Representations*, 123, no. 1 (Summer 2013): 1–22.

17 *Graphic*, 3, no. 68 (March 18, 1871): 246.

18 Walter Benjamin, "Little History of Photography" in *Walter Benjamin Selected Writings, vol. 2 (1927–1934)*, ed. Michael W. Jennings (Cambridge, MA: Belknap/Harvard University Press, 1999), 514.

19 The exposure time of photography was a key technological question for photography in the latter half of the nineteenth century. For a discussion on the relationship of time with photography and the development of instantaneous photography, see Chapter 4.

20 *Graphic*, 3, no. 69 (March 25, 1871): 279.

21 Walter Bentley Woodbury (1834–1885) was a photographer and inventor who invented a form of carbon printing called woodburytype. A woodburytype is a photographic print made from a lead mold. The mold is generated from pressing carbon print into the lead to leave a negative impression. The lead mold is then filled with gelatin to reproduce the original photograph. The process was more durable (being a lead mold) and less expensive (using no silver) than printing from the negative. See Anita McConnell, "Woodbury, Walter Bentley (1834–1885)" *Oxford Dictionary of National Biography*, online edn, ed. Lawrence Goldman (Oxford: Oxford University Press, 2004). http://www.oxforddnb.com/view/article/29906 (accessed June 5, 2011) for a description of Woodbury. Also see Richard Benson, *The Printed Picture* (New York: Museum of Modern Art, 2008), 132 and 330 for a description of the woodburytype process.

22 *Graphic*, 19, no. 496 (May 31, 1879): 530.

23 *Graphic*, 4, no. 87 (July 29, 1871): 110. Other examples of this sort are *Graphic*, 3, no. 76 (May 13, 1871): 431; *Graphic*, 3, no. 78 (May 21, 1871): 479. Also see Elizabeth Jay, *Mrs. Oliphant: "A Fiction to Herself" A Literary Life* (Oxford: Clarendon Press, 1995) for a discussion of Oliphant's work.

24 Fox, *Graphic Journalism in England*, 12.

25 According to Gascoigne, from the 1860s onward, it was common practice to base a woodcut or engraving on a photographic negative which had been projected directly onto the wood block, thus allowing for a direct reproduction of the image. Bamber Gascoigne, *How to Identify Prints, A Complete Guide to Manual and Mechanical Processes from Woodcut to Inkjet* (London: Thames & Hudson, 2002), 6c. Also see William M. Ivins, *Prints and Visual Communication* (Cambridge, MA: The MIT Press, 1969); and William M. Ivins, *How Prints Look: An Illustrated Guide* (London: Murray, 1998).

26 Tagg, *The Burden of Representation*, 4.

27 Benjamin, "Little History of Photography," 510.

28 Group portraits and animal portraits were also reproduced in the *Graphic* with 42 group portraits and six animal portraits appearing in the *Graphic* between 1869 and 1879.

29 *Graphic*, 19, no. 493 (May 10, 1879): 470.

30 The portraits not reproduced are that of the Duchess of Edinburgh (1853–1920), otherwise known as the Grand Duchess Maria Alexandrovna of Russia, who was the daughter of Alexander II of Russia; William Ewart Gladstone (1809–1898), the prime minister of England 1868–1874; 1880–1885; 1886; and 1892–1894; Otto von Bismarck (1815–1898) the first chancellor of Germany; Edward Henry Stanley (1826–1893) the 15th earl of Darby; Léon Gambetta, prime minister of France 1881–1882; Helmuth Von Moltke (1800–1891) chief of the Prussian Army; and Alfred Lord Tennyson (1809–1892) English poet laureate.

31 According to an unnamed journalist for the *Birmingham Paper*, during a reading by Dickens in the 1850s, Dickens' personal attendant had entered the stage to place a glass of water at the reading desk. Upon his entrance, the attendant was greeted with applause by the audience, and after placing the glass down and bowing, the attendant withdrew from the stage. Only after the real Dickens entered the stage did the audience realize its mistake. *Graphic*, 1, no. 29 (June 18, 1870): 691.

32 One of the most famous photographs Rejlander made for *The Expressions and Emotions of Man and Animal* was labeled "Baby Ginx" which showed a baby crying. This image was reproduced and discussed in many periodicals of the period, including the *Graphic*. Rejlander was therefore very well established as the famous photographer of Ginx baby. For an analysis of this image, see Jonathan Smith, *Charles Darwin and Victorian Visual Culture* (Cambridge: Cambridge University Press, 2006).

33 *Graphic*, 3, no. 77 (May 20, 1871): 468.

34 It is an interesting corollary that one of the original inventors of the photographic process, William Henry Fox Talbot, was himself a keen Assyriologist and many of his early photographic subjects were based on classical statues and busts from antiquity.

35 For a specific discussion of the use of photographs in archaeology as mobile objects, see Brusius, "Inscription in a Double Sense"; and Mirjam Brusius, "Preserving the Forgotten." William Henry Fox Talbot, "Photography, and the Antique" (PhD diss., University of Cambridge, 2011). For broader discussion of the movement of photographs, see Edwards, *Raw Histories*; and Bruno Latour, "Drawing Things Together" in *Representation in Scientific Practice*, eds. Michael Lynch and Steve Woolgar (Cambridge, MA: The MIT Press, 1990), 19–68. For a discussion of the relationship between photographs as transportable objects and the reproduction of these photographs in the periodical press, see Chapter 3.

36 *Graphic*, 7, no. 176 (April 12, 1873): 336.

37 Both the translation and the original Greek and Hebrew come from *Graphic*, 10, no. 257 (October 31, 1874): 415.

38 For a discussion of the relationship between photography, the periodical, time, and space, see Chapter 3.

39 For the Chaldean tablet, this statement occurs in *Graphic*, 6, no. 160 (December 21, 1872): 578; for the boundary stone of Gezer, see *Graphic*, 10, no. 257 (October 31, 1874): 415. It is also interesting to note that the *Graphic*'s major competitor *ILN* does not illustrate either of these discoveries.

40 Sadiah Qureshi, *Peoples on Parade. Exhibitions, Empire, and Anthropology in Nineteenth-Century Britain* (Chicago: University of Chicago Press, 2011). For a discussion of the epistemology of observational practices in anthropology, see Efram Sera-Shriar, *The Making of British Anthropology, 1813–1871* (London: Pickering and Chatto, 2013).

41 Edward Said, *Orientalism* (New York: Vintage Books, 1979), 4.

42 John Thomson, *Illustrations of China and Its People* (London: S. Low, Marston, Low, ad Searle, 1873); John Thomson, *Through Cyprus with the Camera in the Autumn of 1878* (London: Trigraph, 1985); and John Thomson, *The Straits of Malacca, Indo-China and China; or, Ten Years' Travels, Adventures and Residence Abroad* (London: S. Low, 1875). For a later reproduction of *Illustrations of China and Its People* as wood engravings, see John Thomson, *The Land and the People of China: A Short Account of the Geography, History, Religion, Social Life, Arts, Industries, and Government of China and Its People* (London: Society for the Promotion of Christian Knowledge, 1876). James Ryan has evaluated Thomson's photographs as objects of an imperial gaze. Interestingly, however, Ryan did not evaluate the reception or dissemination of these images in the periodical press. Ryan, *Picturing Empire*.

43 Thomson, *Illustrations of China and Its People*, Preface.

44 Edwards, *Raw Histories*.

45 The fact that this image was placed as the frontispiece is interesting, because it is the only one of Thomson's photographs to be placed on the front cover.

46 Reproducing part of a photograph was a common occurrence in the illustrated press, but did not compromise the visual integrity of the image. According to Gascoigne, the mixing of reproduction methods and source material was a common technique for engravers to attain the best picture quality. See Gascoigne, *How to Identify Prints*, 29.

47 *Graphic*, 7, no. 163 (January 11, 1873): 35.

48 Thomson, *Illustrations of China and Its People*, vol. 1, plate 4.

49 See the introduction to Thomson, 1982, viii.

50 *Graphic*, 6, no. 143 (August 24, 1872): 162.

51 For a discussion of the relationship between photography and the visualization of technological objects, see Chapter 4.

52 *Graphic*, 6, no. 139 (July 27, 1872): 75.

53 See Chapter 3 for the use of photographs to transmit information outside of besieged Paris during the Franco-Prussian War.

54 *Graphic*, 20, no. 526 (December 27, 1879): 636.

55 *Graphic*, 16, no. 402 (August 11, 1877): 123.

56 Ibid., 125.

57 Gowan Dawson et al., "Introduction" in *Science in the Nineteenth-Century Periodical: Reading the Magazine of Nature*, eds. Geoffrey Cantor et al. (Cambridge: Cambridge University Press, 2004), 16.

Chapter 2

1 Latour, *Pandora's Hope*, 24–79. Latour argues that circulating reference, or the chain of translation, is the process through which an experiment in a distant observational space, such as the Amazon rainforest, gets translated through processes of transportation and reinterpretation, both geographically and textually, with the final textual document, or article, only maintaining a form of observational authenticity when the steps and processes of translation are textually documented. Conversely, this book argues that the chain of translation between the production and reproduction of an image within a print medium is essential to the formation of a claim to the visual authenticity of a scientific experiment within the illustrated scientific press.

2 There has already been a significant amount of research done on *Nature* as a place for the production of science, a scientific community, and for its visual and textual content. For the most recent and compelling history of the journal, see Baldwin, *Making Nature*. For the classic studies on *Nature*, see Roy M. MacLeod, "A Note on *Nature* and the Social Significance of Scientific Publishing, 1850–1914," *Victorian Periodicals Newsletter*, 1, no. 3 (November 1968): 16–17; David A. Roos, "The 'Aims and Intentions' of *Nature*" in *Victorian Science and Victorian Values: Literary Perspectives*, eds. James Paradis and Thomas Postlewait (New Brunswick: Rutgers University Press, 1981), 159–180. Also see Roy M. MacLeod, "Science in Grub Street," *Nature*, 224, no. 5218 (November 1, 1969): 423–461 for a series of articles on the 100th anniversary of *Nature*. Also see the articles from the recent SciPer project, Ruth Barton, "Scientific Authority and Scientific Controversy in *Nature*: North Britain against the X Club" in *Culture and Science in the Nineteenth-Century Media*, eds. Louise Henson and Geoffrey Cantor et al. (Aldershot: Aldgate, 2004), 159–180; and Peter Kjaergaard, "'Within the Bounds of Science': Redirecting Controversies to *Nature*" in *Culture and Science in the Nineteenth-Century Media*, eds. Louise Henson and Geoffrey Cantor et al. (Aldershot: Aldgate, 2004), 211–221.

3 Richard Yeo, *Defining Science. William Whewell, Natural Knowledge and Public Debate in Early Victorian Britain* (Cambridge: Cambridge University Press, 1993), 32.

4 See Frank Turner, *Contesting Cultural Authority* (Cambridge: Cambridge University Press, 1993); Iwan Rhys Morus, *When Physics Became King* (Chicago: University of Chicago Press, 2005); and David M. Knight, *The Age of Science: The Scientific World-View in the Nineteenth Century* (Oxford: Basil Blackwell, 1986).

5 Lockyer, in addition to being the editor of *Nature*, had a private astronomical observatory in his home in southwest London where he worked on numerous astronomical problems, and specifically on spectroscopy and the chemical analysis of the Sun. He was also a keen supporter of the establishment of a separate (from Greenwich) government-run observatory for astronomical physics. Astronomical issues, and the application of new technologies to astronomy, thus played an important part in the content of *Nature* during Lockyer's time as editor. For further details of Lockyer's interest in astronomy and the intersections between astronomy and *Nature*, see A. J. Meadows, *Science and Controversy. A Biography of Sir Norman Lockyer* (London: Macmillan, 1972).

6 Photography was used for multiple purposes within science, art, and commerce, and these uses often had competing aims which affected their credibility within each discipline. John Ruskin, the first Slade Professor of Art at Oxford, was notable for his disdain of photography within art and lamented the removal of the artist's skill in producing a picture. Moreover, photographers like Eadweard Muybridge (as seen in Chapter 4) produced photographs as scientific, commercial, and art objects and faced considerable criticism for this.

7 Dawson et al., "Introduction," xix.

8 Barton, "Scientific Authority and Scientific Controversy in *Nature*," 225.

9 For a discussion of the split within the scientific community, see Adrian Desmond, *The Politics of Evolution. Morphology, Medicine, and Reform in Radical London* (Chicago: University of Chicago Press, 1989).

10 Barton points out that *Nature*, selling less than 5000 copies per week until the 1880s, did not make a profit until the turn of the century. Barton, "Scientific Authority and Scientific Controversy in *Nature*," 212. Nevertheless, it was clear that *Nature* had a captive audience, and Proctor strove to expand on this market by including nonprofessional readers.

11 Meadows, *Science and Controversy*, 98–103.

12 For a more specific example of controversy between Lockyer and Proctor, and specifically the relationship between amateur and professional astronomers, see Chapter 5.

13 For a discussion of the X-Club, and specifically T.H. Huxley's influence in the creation of *Nature*, see Meadows, *Science and Controversy*, 25–38. For the separation between Lockyer and Proctor in the scientific community, and specifically within astronomy, see Chapter 5.

14 Bernard Lightman, *Victorian Popularizers of Science* (Chicago: University of Chicago Press, 2007), 300.

15 On the title page, *Nature* describes itself as an "illustrated journal of science," while *Knowledge* defines itself as an "illustrated magazine of science."

16 James Mussell, "Arthur Cowper Ranyard, *Knowledge* and the Reproduction of Astronomical Photographs in the Late Nineteenth-Century Periodical Press," *BJHS*, 42, no. 153 (September 2009): 345–380.

17 This is the same comet which appeared in Thomas Hardy's *Two on a Tower* (discussed in Introduction) and which roused the protagonist, Swithin St. Cleeve, from his self-pity.

18 Seabroke's name was misspelled in the article as "Seabrooke."

19 R.S. Newall et al., "The Comet," *Nature*, 24, no. 609 (June 30, 1881): 197–201; R.S. Newall et al., "The Comet," *Nature*, 24, no. 610 (July 7, 1881): 221–224.

20 "Photograph of Comet B, 1881," *Nature*, 25, no. 631 (December 2, 1881): 132.

21 *Nature*, 24, no. 609 (June 30, 1881): 198–199.

22 R.A. Proctor, "Comets Part II," *Knowledge*, 1, no. 2 (November 11, 1881): 27.

23 *Nature*, 24, no. 609 (June 30, 1881): 198.

24 See Chapters 4 and 5 for a discussion of the use and development of the Janssen Gun.

25 This is an example of how, according to Secord (2004), scientists used the periodical press and photography to make their discoveries news. By telling the reader to anticipate the reproduction of the photograph later in the year, *Nature* was creating anticipation, and therefore the value of the image before it was even reproduced.

26 *Nature*, 25, no. 631 (December 2, 1881): 132.

27 Ibid.

28 For more on the importance of Jules Janssen to photographic and astronomical science, see Chapters 4 and 5.

29 R.A. Proctor, "Comets," *Knowledge*, 1, no. 1 (November 4, 1881): 3.

30 Ibid., 8.

31 John Hannavy, "Royal Photographic Society" in *Encyclopedia of Nineteenth Century Photography*, ed. John Hannavy (London: Routledge, 2008), 1221.

32 For example, Jonathan Smith, in his work on Darwin and visual culture, points out that John Ruskin as the first Slade Professor of Fine Art at Oxford vehemently attacked the process of photography in both art and science. See Smith, *Charles Darwin and Victorian Visual Culture*, 24.

33 For example, the Photographic Society did not become the Royal Photographic Society until 1894 and was not granted a Royal charter until 2004.

34 "The Photographic Society," *Nature*, 9, no. 223 (February 5, 1874): 264.

35 A later article in *Nature* outlines the problems within the society. See "The Photographic Society," *Nature*, 9, no. 225 (February 19, 1874): 303.

36 *Nature*, 9, no. 223 (February 5, 1874): 263.

37 *Nature*, 9, no. 225 (February 19, 1874): 303.

38 Pritchard is an interesting character, as he encompassed the journalistic, scientific, and photographic worlds during the 1870s and 1980s. Pritchard contributed regularly to *Nature*, specifically on the relationship of science and photography. For more on this, see the section on Pritchard later in this chapter, as well as the discussion of Pritchard's article "Photography as an Aid to Science" in Chapter 3.

39 It is unclear whether Pritchard was asking *Nature* to reprint the articles from the *JPS* or if he wanted the entire journal advertised within the pages of *Nature*. Henry Baden Pritchard, "The Photographic Society," *Nature*, 9, no. 224 (February 12, 1874): 280.

40 During the 1870s, Pritchard wrote nine articles for *Nature*, Prof. Stokes wrote two, and Captain William de Wiveleslie Abney wrote six.

41 In his letter, Pritchard asked specifically for it to be published so that he could respond to the criticisms; Pritchard, "The Photographic Society," 280.

42 Dr. Désiré Van Monckhoven (1834–1882) was a Belgian photographic scientist who, after receiving his doctorate from the University of Ghent in 1863, went on to study and publish on photographic science, including his work on photographic optics and enlarging devices detailed in the *Nature* article above. See Steven F. John "Désiré Van Monckhoven (1834–1882)" in *Encyclopedia of Nineteenth Century Photography*, ed. John Hannavy (London: Routledge, 2008), 1438–1439.

43 These three authors were central protagonists of photography in the periodical press during the 1870s and for this reason reoccur throughout the book. For more on Brothers, see his discussions of instantaneity in Chapter 4; for more on Pritchard, see Chapter 3; and for more on De la Rue, specifically with reference to instantaneous photographs and solar astronomy, see Chapters 4 and 5, respectively.

44 According to the *Encyclopedia of Nineteenth-Century Photography*, Brothers was the first person to use magnesium lighting for the capturing of photographic images and produced the first photograph of a cave. John Hannavy, "Brothers, Alfred (1826–1912)" in *Encyclopedia of Nineteenth Century Photography*, ed. John Hannavy (London: Routledge, 2008), 222.

45 Ibid.

46 It is also interesting to note that in the first volume of *Knowledge*, Brothers offered a series of eight articles on photography for amateurs. What is particularly intriguing is that within these articles, he does not use any images. See A. Brothers, "Photography for Amateurs," *Knowledge*, 1, no. 19 (March 1, 1882); *Knowledge*, 1, no. 30 (May 26, 1882).

47 For a further discussion of this, see Chapter 1 on the popular press and Chapter 4 on the instantaneous process.

48 A. Brothers, *Nature*, 3, no. 69 (February 23, 1871): 327. This text is dislocated from the image. The first few sentences are placed on the previous page, and the reader would have had to turn the page to see the image to which Brothers was referring. This is a particular example of lack of authorial control in the production of an article—a problem which Brothers also faced in the reproduction of his photograph.

49 A. Brothers, *Nature*, 3, no. 69 (February 23, 1871): 328.

50 Ironically, Brothers mirrors the mistake in the production of the image with his title—which is a textual inversion of the original article title. From "Eclipse Photographs" to "Photographs of the Eclipse." This may have been an intentional inversion of the title, as *Nature* offered many serial articles which ran over a number of weeks and carried the same title. Furthermore, because Brothers referenced his previous article, he was clearly working on the assumption that his readers would have either already read, or would read, the previous article with the mistake. With this in mind, it is curious that he chose to invert the title.

51 Brothers ends this sentence with a footnote citing blame for this mistake on the printers: "This vexing mistake was due to a blunder of the printer in reversing the block after it had been placed on the machine." A. Brothers, "Photographs of the Eclipse," *Nature*, 3, no. 71 (March 9, 1871): 369.

52 The fact that he needed to correct this image was particularly relevant because it was being presented in *Nature*. The readers against whom Brothers was directing his argument toward were men who were highly knowledgeable in both various sciences generally and astronomy specifically. The correction of mistakes, whether intentional or not, was thus particularly essential within the scientific press.

53 A. Brothers, *Nature*, 3, no. 71 (March 9, 1871): 370.

54 In an article on the same solar eclipse by Norman Lockyer, entitled "The Mediterranean Eclipse, 1870," Lockyer gives an account of the Syracuse expedition and how various photographs and drawings were made of the eclipse. Norman Lockyer, "The Mediterranean Eclipse, 1870," *Nature*, 3, no. 69 (February 23, 1871): 321–323. Pang also has a short reference to Brothers in his chapter on "Drawing and Photographing the Eclipse." Alex Sun Jung-Kim Pang, *Empire and the Sun, Victorian Solar Eclipse Expeditions* (Stanford: Stanford University Press, 2002), 95.

55 For a discussion of how controversies have been "redirected" within *Nature*, see Kjaergaard, "Within the Bounds of Science."

56 D. Winstanley, "The Eclipse Photographs," *Nature*, 4, no. 83 (June 1, 1871): 85.

57 Pang deals with the struggle between the amateur and professional astronomer, specifically through his analysis of RAS, and the establishment of the British Astronomical Society, Pang, *Empire and the Sun*. This struggle is also evident in the debates between Proctor and Lockyer, which were addressed earlier in this chapter. See also Tucker, *Nature Exposed*; and Grace Seiberling and Carolyn Bloore, *Amateurs, Photography, and the Mid-Victorian Imagination* (Chicago: University of Chicago Press, 1986).

58 Winstanley, "The Eclipse Photographs," 85. There is another chain of correspondence over eclipse photography between Henry Davis and J. Boesinger within "Letters to the Editor" over the usefulness of photography to astronomy. J. Boesinger questioned the need for a long exposure and argued instead that he was able to get a photograph of the eclipse, with a short exposure, and that he used it as a "memento." Davis responded by asserting that a memento may be nice for Boesinger, but that science required more out of the photograph and thus needed a longer exposure time. This discussion between Boesinger and Davis further demonstrates the position that people like Brothers were trying to give to photography within science, and the counter claims against amateurs that he had to respond to. See J. Boesinger, "The Total Eclipse as Seen at Ootacamund," *Nature*, 5, no. 120 (February 15, 1872): 300; Henry Davis, "Eclipse Photography," *Nature*, 5, no. 121 (February 22, 1872): 321.

59 Winstanley, "The Eclipse Photographs," 85.

60 A. Brothers, "The Eclipse Photographs," *Nature*, vol. 4, no. 85 (June 15, 1871): 121.

61 Michael Pritchard, "Henry Baden Pritchard" in *Encyclopedia of Nineteenth Century Photography*, ed. John Hannavy (London: Routledge, 2008), 1175–1176.

62 Henry Baden Pritchard, *Beauty Spots of the Continent* (London: Tinsley Brothers, 1875); Henry Baden Pritchard, *The Photographic Studios of Europe* (London: Piper & Carter, 1882). Both of these texts work as guides for photography in the late nineteenth century, however, with two very different purposes. The former was intended as a travel guide for capturing picturesque scenes on the continent. Areas covered in the book include Switzerland, Bavaria, Norway, the Pyrenees,

and Italian Lakes (to name but a few). The latter was intended—primarily although not entirely—as a guide to photographic firms in England. There are full-page descriptions of the important photographic firms and studios, as well as descriptions of the latest developments in photographic technology and science. Both books were intended for a broad reading audience and were published into second volumes.

63 While it is beyond the scope of this chapter, it would be interesting to examine the separation in Pritchard's writing between his photographic and war articles, as there was a clear break between when he stopped writing about photography and started writing about science and war.

64 Henry Baden Pritchard, "Photography as an Aid to Science," *Nature*, 6, no. 134 (May 23, 1872): 62.

65 See William Henry Fox Talbot, *The Pencil of Nature* (London: Longman, Brown & Green, 1844).

66 See Chapter 5 for a discussion of the use and value of photography within astronomy in the 1870s.

67 Pritchard, "Photography as an Aid to Science," 63.

68 Tucker, *Nature Exposed*, 166–167 shows that microphotographs were subjected to significant criticism for their veracity from nineteenth-century scientists as well as general viewers.

69 For a discussion of the relationship between photography and the minuscule, see Chapter 3. For a detailed discussion of photography and picturing the far away, see Chapter 5.

70 Henry Baden Pritchard, "The History of Photography," *Nature*, 5, no. 119 (February 8, 1872): 285. For a discussion of the historical importance of Niépce, see Beaumont Newall, *The History of Photography from 1839 to the Present Day* (New York: Museum of Modern Art, 1949), 13.

71 For a commemoration of Talbot, see *Nature*, 16, no. 413 (September 27, 1877): 464–465; and for a similar article on Herschel, see *Nature*, 4, no. 82 (May 25, 1871): 70.

72 Henry Baden Pritchard, "The History of Photography," *Nature*, 2, no. 33 (June 16, 1870): 127.

73 Henry Baden Pritchard, "Photographic Processes of the Present Day," *Nature*, 3, no. 62 (January 9, 1871): 188. This is the same process as that discussed in Chapter 1.

74 Henry Baden Pritchard, "Photography In and Out of the Studio," *Photographic News*, 24, no. 1119 (February 13, 1880): 73.

75 Brian Liddy, "Warren De La Rue" in *Encyclopedia of Nineteenth Century Photography*, ed. John Hannavy (London: Routledge, 2008), 394.

76 For a discussion of De la Rue and his influence on photography and astronomy during the 1870s and his connection to the scientific community, see Chapter 5.

77 Chitra Ramalingam, "Natural History in the Dark: Seriality and the Electric Discharge in Victorian Physics," *History of Science*, 48, no. 161 (December 2010): 376.

78 Central to this analysis was the use of "virgin," or unused glass tubes, as the phenomena of the discharge changed after a current had already been passed

through a tube. This required a significant number of tubes. Ramalingam, "Natural History in the Dark" has already analyzed the significance of this form of seriality within her article.

79 For an example of the importance of photography to disciplines of science where the invisible, or very far, was the object of analysis, see Pritchard's comment given earlier. For an examination of photography, science, and the invisible, see specifically Tucker, *Nature Exposed*, chapter 4. Also see Chapter 4 in this book on instantaneous photography.

80 Ramalingam, "Natural History in the Dark," 373. Seriality also played an important role in astronomical photographs during the Transit of Venus. For more on this, see Chapter 5.

81 Warren De la Rue and Hugo Müller, "The Electric Discharge with the Chloride of Silver Battery," *Nature*, 20, no. 503 (June 19, 1879): 174–218; *Nature*, 20, no. 504 (June 26, 1879).

82 While *Nature* was intended as a scientific periodical which was published and read by the scientific community at large, the *Philosophical Transactions* was intended as a publication for the members of the Royal Society and only reproduced papers that were read at their meetings.

83 Warren De la Rue and Hugo Müller, "Experimental Researches on the Electric Discharge with the Chloride of Silver Battery," *Phil. Trans.*, 169, no. 5 (1878): 55–121; Warren De la Rue and Hugo Müller, "Experimental Researches on the Electric Discharge with the Chloride of Silver Battery," *Phil. Trans.*, 169, no. 7 (1878): 155–231.

84 These articles' original appearance in the *Phil. Trans.* is cited on the first page of the article. *Nature*, 20, no. 503 (June 19, 1879): 174. The relationship between time, space, and the periodical press was a very important aspect of the publication of photographic images. For more specific examples, see Chapters 3, 4, and 5.

85 While it has already been pointed out that there were two different types of images presented within these articles, this point will be addressed later in this chapter. Because these two types of images were reproduced across genres in a similar manner, the focus will instead be on a singular image and its representation of seriality.

86 Both the boxed lettering of the caption at the bottom of the page, and the gradation of the gray and white areas, indicate that it is a photolithograph. For an explanation of the photolithographic process, see Gascoigne, *How to Identify Prints*, 41c.

87 Ramalingam, 2010, 379.

88 De la Rue and Müller, "Experimental Researches on the Electric Discharge," plate 15.

89 These terms are used loosely here—especially "line drawing" and "illustrative." The two terms are used to highlight the difference in use and production of the image—"line drawings" means the image is void of extraneous detail to give clarity of form, while "illustrative" is meant for images that have details in the image which demonstrate the use of the instrument.

90 Warren De la Rue and Hugo Müller, *Nature*, 20, no. 504 (June 26, 1879): 200.

91 For a discussion of the relationship between the image and the text, see Chapter 1.

Chapter 3

1 For the central works on photography as an object of communication, see Pinney, *Camera Indica*; and Edwards, *Raw Histories*.

2 Particularly with regard to the formation of instantaneity discussed in Chapter 4. For discussion regarding the relationship between photography and other technologies of communication and movement in the nineteenth century, see Simone Natale, "Photography and Communication Media in the Nineteenth Century," *History of Photography*, 36, no. 4 (2012): 452.

3 Lady Blunt wrote a series of diaries between 1847 and 1917. British Library, W MSS (283B) Add 53817–54061.

4 Toward the end of the nineteenth century, Lady Blunt, with her husband Wilfrid Scawen Blunt (who was himself a poet and foreign diplomat), lived occasionally in the Middle East where she was an avid breeder of Arabian horses. For Lady Blunt's later letters when she was in the Middle East, see Rosemary Archer, "Blunt, Anne Isabella Noel, suo jure Baroness Wentworth (1837–1917)" in *Oxford Dictionary of National Biography*, online edn, ed. Lawrence Goldman (Oxford: Oxford University Press, 2004). http://www.oxforddnb.com/view/article/31937 (accessed March 30, 2011); Rosemary Archer and James Fleming, *Lady Anne Blunt, Journals and Correspondence 1878–1917* (Cheltenham: Alexander Heriot & Co., 1986).

5 Patrizia Di Bello, *Women's Albums and Photography in Victorian England: Ladies, Mothers and Flirts* (London: Ashgate Publishing, 2007), 2.

6 For a discussion of the use of scrapbooks in examining the history of visual culture and the history of science, see James A. Secord, "Scrapbook Science: Composite Caricatures in Late Georgian England" in *Figuring It Out. Science, Gender, and Visual Culture*, eds. Ann B. Shteir and Bernard Lightman (Hanover, NH: Dartmouth College Press, 2006), 164–191.

7 British Library, W MSS (283B) Add 53834.

8 Ibid.

9 "was" *del btwn* "where his son" and "a boy of 13." February 28, 1871, British Library, W MSS (283B) Add 53834.

10 Ibid., March 2, 1871.

11 Ibid.

12 For a discussion of the photographic album as an object of memory, see Verna Posever Curtis, "Page by Page: The Album as Object" in *Photographic Memory: The Album in the Age of Photography*, ed. Verna Posever Curtis (New York: Aperture), 2011.

13 Susan Stewart, *On Longing. Narratives of the Miniature, the Gigantic, the Souvenir, the Collection* (Durham: Duke University Press, 1994), 135.

14 Geoffrey Wawro, *The Franco-Prussian War. The German Conquest of France in 1870–1871* (Cambridge: Cambridge University Press, 2003).

15 For a discussion of the tactical use of the chassepot gun and the mitrailleuse by the French during the war, see Wawro, *The Franco-Prussian War*, chapter 2. In terms of the use of technologies, Wawro points out that while the chassepot was far superior to the guns the Prussians had, the use of these guns tactically by the French was

inefficient and therefore largely ineffective. The Prussians, on the other hand, relied more heavily on the railway for their deployment into France, and Wawro points out that a slower deployment or a quicker reaction by the French would have easily tipped the war in France's favor. Finally, Prussia was acutely aware of the importance of telegraph lines, as they were one of the first items to be cut when Paris was besieged.

16 See Maurice Crosland, "Science in the Franco-Prussian War," *Social Studies of Science*, 6, no. 2 (May 1976): 185–214.

17 Bernhard Siegert, *Relays. Literature as an Epoch of the Postal System*, trans. Kevin Repp (Stanford, CA: Stanford University Press, 1999), 99. Also see David M. Henkin, *The Postal Age. The Emergence of Modern Communication in Nineteenth-Century America* (Chicago, IL: University of Chicago Press, 2006).

18 David Edgerton, *The Shock of the Old. Technology and Global History since 1900* (London: Profile Books, 2008), 11.

19 *Nature* estimates that over 1000 pigeons were used to send messages across the border during the war. See Pritchard, "Photography as an Aid to Science": 62.

20 Carrier pigeons can only fly in one direction and back to their home to roost. To make use of the pigeons during the siege, they needed to be both shipped out and into Paris. The benefit of using pigeons was that a large number could be flown out with the air balloons, and it would also cut in half the number of flights the air balloon would have to make.

21 For a history of the carrier pigeon, see Salvador Bofarull, *Pigeon Mail through History* (Stuart Rossiter Fund: London), 2001.

22 Catherine De Lorenzo, "Tissandier, Gaston (1843–1899)" in *Encyclopedia of Nineteenth Century Photography*, ed. John Hannavy (London: Routledge, 2008), 1393.

23 Jules Janssen, one of Tissandier's contemporaries who worked in photography and astronomy, also used the hot air balloon to escape Paris during the siege, but for different reasons. Rather than aiming to communicate with the rest of France, he left to observe a solar eclipse. For more on this, see Chapter 5.

24 "The War: M. Issandier's [sic] Balloon from Paris Descending near Dreux," *ILN*, 57, no. 1619 (October 22, 1870): 429.

25 Ibid., 429–430.

26 *ILN*, 55, no. 1546 (July 3, 1869): 2; *ILN*, 56, no. 1863 (April 24, 1875): 286; *ILN*, 56, no. 1864 (May 1, 1875): 421; *ILN*, 57, no. 1900 (December 25, 1875); and *ILN*, 85, no. 2372 (October 4, 1884): 319.

27 *ILN*, 57, no. 1619 (October 22, 1870): 430.

28 Ibid.

29 W. De Fonvielle, "Balloon Ascents for Military Purposes," *Nature*, 3, no. 58 (December 8, 1870): 116.

30 At the end of his article, De Fonvielle noted that he was able to communicate his news after taking a balloon outside of Paris and landing in Belgium, where he continued on to London. He also noted that he would later attempt to fly back to Paris. De Fonvielle was therefore the transmitter of news, not the content of his balloon. De Fonvielle, "Balloon Ascents for Military Purposes," 116.

31 As a point of comparison, Tissandier's own periodical *La Nature* commented on the carrier pigeon twice in the last two-and-a-half decades of the nineteenth century: the first instance in reference to a carrier pigeon used during the siege being found at sea by a German boat (*La Nature*, 3rd year, 2nd semester, no. 122 [October 2, 1875]: 287) and the second, a short note on the printing on wings of carrier pigeons (*La Nature*, 24th year, 2nd semester, no. 1216 [September 19, 1896]).

32 Raphael Meldola was a chemist and industrial dye research scientist with a keen interest in photography. By 1885, he was a professor of chemistry at Finsbury Technical College and a founding member of the Institute of Chemistry. For more on Meldola, see K.R. Webb, "Meldola, Raphael (1849–1915)" in *Oxford Dictionary of National Biography*, online edn, ed. Lawrence Goldman (Oxford: Oxford University Press, 2004). http://www.oxforddnb.com/view/article/37755 (accessed June 6, 2011).

33 Gaston Tissandier, "Les Merveilles de la Photographie," *La Nature*, 2nd year, 1st semester, no. 27 (December 6, 1873): 12.

34 "A History and Handbook of Photography," *Nature*, 13, no. 324 (January 13, 1876): 206.

35 Ibid., 205.

36 It is also important to note that, like the photomicrograph, this illustration also underwent many transmissions of reproductions. The first appearance of Illustration 3.4 was in Tissandier's *La Nature*: Gaston Tissandier, "Les Ascensions Aerostatiques" *La Nature*, 2nd year, 1st semester, no. 47 (April 25, 1874): 329.

37 "Aerial Voyages" *ILN*, 56, no. 1576 (January 16, 1870): 84. In addition to being Glaisher's companion on his aerial voyages, Coxwell also played an important role in ballooning during the Franco-Prussian War. Coxwell, according to a later account by a Prussian aeronaut, was given the task of establishing the balloon division for the Prussian army. See A. Hildebrant, *Balloons and Airships*, W.H. Story (Wakefield, Yorkshire: EP Publishing Limited, 1973), 141.

38 James Glaisher et al., *Travels in the Air* (London: Richard Bentley, 1871), 57.

39 See Bruno Béguet, *La Science Pour Tous. Sur la Vulgarisation Scientifique en France de 1850 à 1914* (Paris: Bibliothèque Du Conservatoire National Des Arts et Métiers, 1990).

40 Hans Ulrich Gumbrecht and K. Ludwig Pfeiffer, in their seminal work, have helped to bring the focus of scholarship toward the material process (in particular technologies) that made scientific communication possible. See K. Ludwig Pfeiffer, "The Materiality of Communication," in *Materialities of Communication*, ed. Hans Ulrich Gumbrecht and K. Ludwig Pfeiffer (Stanford, CA: Stanford University Press, 1994), 1–12.

41 Glaisher et al., *Travels in the Air*, 396.

42 Jennifer Tucker argues that ballooning in the nineteenth century was a mixture between science and commercialism and that *Travels in the Air* was a specific attempt by Glaisher, Flammarion, de Fonvielle, and Tissandier to establish hot air balloons as "laboratories in the air"; Jennifer Tucker, "Voyages of Discovery on Oceans of Air: Scientific Observation and the Image of Science in an Age of 'Balloonacy,'" *Osiris*, 2nd Series, 11, Science in Field (1996): 162.

43 Importantly, Tissandier did later publish a book on aerial photographs entitled *Photographie en Balloon* (1886). The timing of this book is essential, as it was

published when taking a photograph and the process of publishing photographs was becoming easier and more cost-efficient.

44 This is an example of the way in which the processing speed of photographic technology affected both the science being done, as well as the ways in which an experiment could be communicated to a reading audience. If this book had come out ten years later, Tissandier and de Fonvielle could have used instantaneous photographs, and the visual impact of their argument would have been very different.

45 Glaisher et al., *Travels in the Air*, 398.

46 Thomas Baldwin drew and published sketches made from his balloon ascent over Chester in 1783 which show various views of the landscape, clouds, and perspectives, looking down from the balloon. See Thomas Baldwin, *Airopaidia: Containing the Narrative of a Balloon Excursion from Chester, the Eighth of September, 1785, Taken from Minutes Made during the Voyage* (London: J. Fletcher, 1786).

47 Glaisher et al., *Travels in the Air*, 398.

48 Nancy M. Shawcross, "Nadar (Gaspard-Felix Tournachon) (1820–1910)" in *Encyclopedia of Nineteenth Century Photography*, ed. John Hannavy (London: Routledge, 2008), 971.

49 Charles Remus, *Daumier. 120 Great Lithographs* (New York: Dover Publications Inc., 1978), 133.

50 Honoré-Victorin Daumier, "Nadar, Élevant la Photographie Á la Hauteur de L'Art" in *Daumier. 120 Great Lithographs*, ed. Charles F. Ramus (New York: Dover Publications Inc., 1978), #102. Daumier published his work in a number of different periodicals, including *Le Charivari* which was the influence for *Punch, or the London Charivari*.

51 This is visually reminiscent of the image made of Glaisher and Coxwell's accident (see Illustration 3.4).

52 Glaisher et al., *Travels in the Air*, 333.

53 Ibid., 329.

54 Gaston Tissandier, *A History and Handbook of Photography* (London: Sampson Low, Marston, Low, & Searle, 1876). Interestingly, the English version of Tissandier's book was translated by John Thomson, the travel photographer who made photographic travel books of China, Malacca, and Cyprus throughout the 1860s. For a discussion of Thomson in the print press, see chapter 2. For a broader discussion of Thomson, see Ryan, *Picturing Empire*; and Geoffrey Belknap, "Through the Looking Glass: Photography, Science and Imperial Motivations in John Thomson's Photographic Expeditions," *History of Science*, 52, no. 1 (2014): 73–97.

55 Tissandier separated his book into three sections representing the important aspects of his notion of photographic value: Section 1, the history of photography; Section 2, the operation and processes of photography; and Section 3, the applications of photography. Tissandier also gave a detailed account of the production of photoglypty in his own periodical; see Gaston Tissandier, "La Photoglyptie," *La Nature*, 2nd year, 1st semester, no. 37 (February 14, 1874): 168–169.

56 Tissandier, *A History and Handbook of Photography*, 235.

57 Ibid., 236.

58 The use of photographs as objects of data rather than objects of visual reference will be elaborated upon in Chapter 5 when addressing the use of photography in astronomical observations of the 1874 Transit of Venus.

59 Ibid., 237.

60 Ibid., 238.

61 Stewart, *On Longing*, 66.

62 Tissandier, *A History and Handbook of Photography*, 243.

63 See Iwan Rhys Morus, "Seeing and Believing Science" *Isis*, 97, no. 1 (March 2006): 101–110, for his point about the expertise required to operate a magic lantern as well as the fact that the magic lantern and other performative technologies and spaces were essential in forming the way in which audiences "saw science." For a much earlier discussion of the uses of the magic lantern in popular lectures in the nineteenth century, see Altick, *The Shows of London*.

64 Marina Benjamin, "Sliding Scales: Microphotography and the Victorian Obsession with the Minuscule" in *Cultural Babbage. Technology, Time and Invention*, eds. Francis Spufford and Jenny Uglow (London: Faber & Faber, 1996), 99–122.

65 In the same way in which Tissandier valued the photographic object in chapter 6, the photographic objects he reprints in chapter 5 were carefully labeled as "facsimiles." See Tissandier, *A History and Handbook of Photography*, figures 48–53, 230–233.

66 Ibid., 221.

67 The use of photography for astronomical science was a key concern in the 1870s and was taken up by many of Tissandier's contemporaries in Paris. See in particular the discussion on Jules Janssen in Chapter 5.

68 Ibid., 249.

69 Ibid., 250. For a more detailed discussion of photographic authenticity and astronomy, see Chapter 5.

70 Ibid., 248.

71 Ibid.

Chapter 4

1 There are multiple forms of time when speaking of Hardy's novels. The plots invoked different spaces of time, from gaps of years to the instantaneous, at the same time that the novels themselves were reproduced within a print medium over time.

2 Simon Schaffer demonstrates how the nineteenth-century astronomical community—situated in the large European observatories—addressed the personal equation through the application of technologies and the strict regimentation of human observation. Christoph Hoffman shows that in the early nineteenth century, specifically in the work of Friedrich Wilhelm Bessel, the personal equation could be overcome strictly through methodology and self-control. See Simon Schaffer, "Astronomers Mark Time: Discipline and the Personal Equation," *Science in Context*, 2 (1988): 115–145; and Christoph Hoffmann, "Constant Differences: Friedrich

Wilhelm Bessel, the Concept of the Observer in Early Nineteenth-Century Practical Astronomy and the History of the Personal Equation," *BJHS*, 40, no. 3 (2007): 333–365.

3 Canales, *A Tenth of a Second.*

4 Ibid., 16.

5 For a discussion of instantaneous photography in relation to the production and investigation of invisible phenomenon, see Ramalingam, "A Science of Appearances."

6 A. Brothers, *Knowledge*, 1, no. 29 (May 19, 1882): 602.

7 A. Brothers, *Knowledge*, 2, no. 32 (June 9, 1882): 22.

8 Beaumont Newhall, in his classic history of photography, notes that the dry plate significantly changed the way photographs were made—the tripod could be dispensed with and the hand camera became practicable; and photographs did not have to be immediately developed. Newhall, *The History of Photography*, 89. Also see Gernsheim, *The History of Photography.*

9 Brothers, *Knowledge*, 2, no. 32 (June 9, 1882): 22.

10 Ibid.

11 Brothers, *Knowledge*, 1, no. 29 (May 19, 1882): 602. The dry plate, although it can be enlarged, has a greater degree of distortion when undergoing enlargement than the wet plate. In terms of astronomical images, the measurement of the difference between points on the image was its primary value. Additionally, the notion of instantaneity was also an important concern for astronomers, particularly Warren De la Rue. See Chapter 5 for more on this point. Moreover, Brothers articulated a specific value of photography outside of instantaneity when he presented a photograph of the solar corona in *Nature* in 1871 (see Chapter 2).

12 Brothers, *Knowledge*, 2, no. 38 (July 21, 1882): 127.

13 A mechanical shutter, as opposed to stopping the exposure by hand, allowed the photographic operator to control the time of exposure with much more precision.

14 See Roland Barthes, *Camera Lucida* (New York: Hill and Wang, 1980); and Susan Sontag, *On Photography* (New York: Picador, 1973).

15 For discussions on the development of camera technology, and particularly the use of shutters, see Brian Coe, *Cameras: From Daguerreotypes to Instant Pictures* (London: Marshall Cavendish, 1978); and Colin Harding, *Classic Cameras* (Lewes: Photographer's Institute, 2009).

16 Barthes, *Camera Lucida*, 32.

17 *Knowledge*, 3, no. 87 (June 22, 1883): viii.

18 As opposed to the Daguerreotype process that developed photographic positives on a metal plate and that removed the possibility of making multiple reproductions.

19 *Pall Mall Gazette* (December 7, 1871): 12.

20 *Graphic*, 16, no. 419 (December 8, 1877): 534.

21 *Knowledge*, 6, no. 140 (July 4, 1884): 6.

22 Ibid.

23 Ibid. Charles Wheatstone, the prolific inventor, in his unpublished work on the perception of visual impressions and electricity, noted that lightning was a key

example of a natural action that was beyond the point of human perception. Wheatstone argued that using rotating mirrors, and later photography, would allow for an instantaneous object to be visualized and measured. See Charles Wheatstone, "Luminous Rays. Visual Duration of the Impressions of Light," Loose sheet, single page, c. 1834, Folder 4/1, Papers of Charles Wheatstone, Archives of King's College London—reproduced in Chitra Ramalingam, "A Science of Appearances: Vision, Visualization and Experimental Physics in Victorian England" (PhD diss., Harvard University, 2009), 105.

24 See Latour, *Pandora's Hope* for his definition of the chain of translation. Also see a longer discussion of this in Chapter 2.

25 For discussions of the use of photography for the investigation of lightning, see Tucker, *Nature Exposed*, 142–158; and Canales, *A Tenth of a Second*, 137–142.

26 Bruce J. Hunt, *The Maxwellians* (Ithaca, NY: Cornell University Press, 1991), 146–151.

27 For work on Muybridge, see Kevin MacDonnell, *Eadweard Muybridge: The Man Who Invented the Moving Picture* (Boston, MA: Little, Brown & Co., 1972); Gordon Hendricks, *Eadweard Muybridge: The Father of the Motion Picture* (New York: Grossman Publishers, 1975); Phillip Prodger, *Time Stands Still: Muybridge and the Instantaneous Photography Movement* (Oxford: Oxford University Press, 2003); Rebecca Solnit, *Motion Studies. Time, Space & Eadweard Muybridge* (London: Bloomsbury, 2003); and Marta Braun, *Eadweard Muybridge* (London: Reaktion Books Ltd, 2010). For that on Marey, see Marta Braun, *Picturing Time—The Work of Étienne-Jules Marey (1830–1904)* (Chicago, IL: University of Chicago Press, 1992); H.A. Snellen, *E.J. Marey and Cardiology: Physiologist and Pioneer of Technology. Selected Writings in Facsimile with Comments and Summaries, a Brief History of Life and Work, and a Bibliography* (Rotterdam: Kooyker, 1980); and Josh Ellenbogen, *Reasoned and Unreasoned Images: The Photography of Bertillon, Galton, Marey* (Philadelphia: Pennsylvania State University Press, 2012).

28 While Muybridge's life was mired in controversy for various reasons, his acquittal for the murder of his estranged wife and her lover was the most sensational event of his life.

29 While Muybridge's early photographs were published in J.B.D. Stillman's *Horse in Motion*, his work at the University of Pennsylvania in the 1880s was published in a very expensive folio that was sent to subscribers. Marey's work, in contrast, sold well enough for the original French version—E.J. Marey, *La Machine Animale: Locomotion Terrestre et Aérienne* (Paris: Librairie Germer Baillière, 1873) —to be reproduced in English a year later—E.J. Marey, *Animal Mechanism: A Treatise on Terrestrial and Aerial Locomotion* (London: Henry S. King & Co., 1874).

30 For instance in the *Aberdeen Weekly Journal*, no. 10691 (May 13, 1889): 6.

31 For secondary source work on the periodical and seriality, see Mussell, *Science, Time and Space*; and Alex Csiszar, "Seriality and the Search for Order: Scientific Print and Its Problems in the Late Nineteenth Century," *History of Science*, 48, no. 161 (December 2010): 399–434; see also Chapters 3 and 5.

32 For a similar and more comprehensive argument about Muybridge's commercial work, see Philip Brookman, *Eadweard Muybridge* (London: Tate Publishing, 2010).

33 Braun, *Eadweard Muybridge*, 159. For a history of optical devices, see Ramalingam, "A Science of Appearances"; and Iwan Rhys Morus, *Frankenstein's Children: Electricity, Exhibition, and Experiment in Early-Nineteenth-Century London* (Princeton, NJ: Princeton University Press, 1998).

34 Muybridge did not reproduce his photographs for the zoöpraxiscope's slide, because the projection process distorted the image and he had to pay draftsmen to draw the animal motions in elongated form on the slides so they would look proportional on the screen.

35 For Muybridge's work on photography, animal locomotion, and vision, see Eadweard Muybridge, *Animal Locomotion. An Electro-Photographic Investigation of Consecutive Phases of Animal Movements. 1872–1885* (Philadelphia: University of Pennsylvania, 1887); Eadweard Muybridge. *The Attitudes of Animals in Motion: A Series of Photographs Illustrating the Consecutive Positions Assumed by Animals in Performing Various Movements* (San Francisco, CA: Muybridge, 1881); Eadweard Muybridge, *Descriptive Zoopraxography, or, The Science of Animal Locomotion Made Popular* (Philadelphia: University of Pennsylvania, 1893); and Eadweard Muybridge, *The Human Figure in Motion an Electro-Photographic Investigation of Consecutive Phases of Muscular Actions*, 6th edn (London: Chapman & Hall, 1901).

36 Philip Prodger argues that Muybridge has mainly been remembered as an inventor of the technology of instantaneity, but that he was primarily a photographer and the other images he created have tended to be neglected in favor of his instantaneous images. Prodger, *Time Stands Still*, 23.

37 These Muybridge's engravings were also displayed in a recent exhibition on Muybridge at the Tate Britain; however, they did not get reproduced in the exhibition book—Brookman, *Eadweard Muybridge*.

38 See Tulane University, Sidney M. Markham Collection of Muybridge Prints, Latin American Library, Collection 8, Boxes 1 and 2.

39 *Graphic*, 16, no. 412 (October 20, 1877): 375.

40 *Dundee Courier & Argus and Northern Warder*, no. 7540 (September 21, 1877).

41 Prodger, *Time Stands Still*, 145.

42 *Knowledge*, 1, no. 9 (December 30, 1881): 179.

43 Ibid.

44 *Knowledge*, 1, no. 10 (January 6, 1882): 198–199.

45 *Knowledge*, 1, no. 12 (January 20, 1882): 247.

46 Ibid.

47 Questions regarding the ownership of these images have been dealt with within the secondary source literature extensively. This controversy raises questions over intellectual property rights in the late nineteenth century and concerns over who owned a particular invention: the person that paid for it or the person that did the work involved in inventing it? These discussions, while fruitful, are beyond the scope of this chapter. For a discussion of the ways in which visual controversies were shaped within the periodical press, see Chapter 2.

48 *Nature*, 25, no. 652 (April 27, 1882): 605.

49 For instance, see a later review in *Nature* of Stillman's book for the focus which is given to Muybridge. *Nature*, 26, no. 661 (June 29, 1882): 196.

50 For work on Galton's composite photography, see Ryan, *Picturing Empire*, 170–173; David Green, "Veins of Resemblance: Photography and Eugenics," *Oxford Art Journal*, VII (1984): 3–16; and David Burbridge, "Galton's 100: An Exploration of Francis Galton's Imagery Studies," *BJHS*, 27 (1994): 443–463.

51 See Francis Galton, "Conventional Representation of the Horse in Motion," *Nature*, 26, no. 662 (July 6, 1882): 228–229.

52 There is an important repositioning of the place of the horse within the artistic community. Both Ernest Meissonier and Frederic Remington were said to have changed their depictions of horses after seeing Muybridge's photographs. See Andreas Mayer, "The Physiological Circus: Knowing, Representing, and Training Horses in Motion in Nineteenth-Century France," *Representations III* (Summer 2010): 88–120.

53 *Knowledge*, 2, no. 50 (October 13, 1882): 323

54 Galton, "Conventional Representation of the Horse in Motion," 228.

55 In particular, see Tucker's discussion of "Photography and the Invisible," *Nature Exposed*, 159–193. See also Chapter 5 on the relationship between the personal equation and the use of photography to observe the 1874 Transit of Venus.

56 Ibid., 228.

57 *Nature*, 19, no. 492 (April 3, 1879): 517.

58 Braun, *Picturing Time*, 2–3.

59 Ibid., xvii.

60 Ibid.

61 See Chapter 3 for more on the relationship between the Franco-Prussian War, photographs, and flight.

62 As Braun, *Picturing Time*, xvi, points out, Marey and Muybridge have been grouped together within the historiography, often with more attention being paid to Muybridge for the significance of his discovery for science. However, Muybridge and Marey had very different objectives in the visualization of animal movement—for Muybridge, instantaneous photographs were much more invested in the aesthetics of the image and its value within the public as a spectacular image, while for Marey, the use of photography was about measurement and its value for science.

63 Marey, *Animal Mechanism*, 227.

64 Ibid., 4.

65 *Nature*, 19, no. 492 (April 3, 1879): 517.

66 *Graphic*, 23, no. 648 (April 29, 1882): 430.

67 *Manchester Times* (May 17, 1879), supplement, 159.

68 The photograph as a metaphor for shooting has been discussed in the contexts of colonial photography and the hunting of animals—see Ryan, *Picturing Empire*. A photographic gun of a similar kind had also been developed by Jules Janssen in his astrophotography and used to photograph the Transit of Venus in 1874. For Marey, however, the photographic gun was developed because it offered the greatest flexibility for his experimental aims. Braun, *Picturing Time*, 55.

69 "Instantaneous Photography of Birds in Flight," *Nature*, 26, no. 656 (May 25, 1882): 85.

70 Ibid., 85–86.

71 Ibid., 85.

72 Gascoigne, *How to Identify Prints*, 37.

73 "Instantaneous Photography of Birds in Flight," 85.

74 Ibid.

75 "The Mechanisms of the Flight of Birds," *Nature*, 37, no. 955 (February 16, 1888): 369.

76 Ibid.

77 Braun, *Picturing Time*, 66.

78 Edwards, *Raw Histories*, 18–20, points out that all photographs have an aspect of "performativity," or an ability to make the object visualized relevant to the present. Thus, photographic images always change their meaning depending on the context of their reading.

79 "The Mechanisms of the Flight of Birds," 369–370.

80 E.J. Marey, "Le Fusil Photographique," *La Nature*, 10th year, 1st semester, no. 464 (April 22, 1882): 329.

Chapter 5

1 Hopwood et al., "Seriality and Scientific Objects," 251–252 and 259–261.

2 Photography was not used on a large scale for the Transit of 1882. It has been argued that the reason photography was not used was due to its failure to supply accurate results for the 1874 Transit. See Pang, *Empire and the Sun*; Jessica Ratcliff, *The Transit of Venus Enterprise in Victorian Britain* (London: Pickering & Chatto, 2008); and Holly Rothermel, "Images of the Sun: Warren de La Rue, George Biddle Airy and Celestial Photography," *BJHS*, 26, no. 2 (1993): 137–169.

3 Photography was used for many different forms of observation and calculation in astronomy, including eclipse photographs, spectroscopy, selenography (photography of the moon), and heliophotography (photography of the Sun). For a specific example, see the discussion of De la Rue's early astronomical photographs later in this chapter.

4 Pang, *Empire and the Sun*, 7.

5 Rothermel, "Images of the Sun," 163.

6 For more on the popularization of science through the periodical press, see discussions of Norman Lockyer and Richard Anthony Proctor in Chapter 2, and Gaston Tissandier, Camille Flammarion, and William de Fonvielle in Chapter 3.

7 For books on the Transit of 1874, see R.A. Proctor, *Transits of Venus. A Popular Account of Past and Coming Transits* (London: Longmans, Green, and Co, 1874); Robert Grant, *The Transits of Venus in 1874* (Glasgow: J. Maclehose, 1874); George Forbes, *The Transit of Venus: By George Forbes* (London: Macmillan and Co, 1874). For a later discussion of the Transit, and its situation within astronomy more broadly, see Norman Lockyer, *Stargazing: Past and Present* (London: Macmillan, 1878).

8 Forbes was the Professor of Natural Philosophy at Anderson's University in Glasgow and led the 1874 British Transit expedition site on Honolulu (see a longer discussion of Forbes later in this chapter); Grant was the Professor of Astronomy at the University of Glasgow and a longtime fellow of the RAS.

9 Forbes, *The Transit of Venus*, 8. For similar discussions, see Proctor, *Transits of Venus*, 5; and Grant, *The Transits of Venus in 1874*, 16–17.

10 This is an interesting point, as the Transits of 1761, 1769, 1874, and 1882 would not be missed by English observers due to geographical location. Unlike the 1631 Transit, for later Transits, the British government would fund great expeditions to ensure that the best locations were chosen for the observation of these celestial events. Although these efforts often ended in vain (many of the observation stations were clouded over during the transits), after 1769, the observation of the Transit became closely tied to the imperial agenda, and thus would not be missed on account of geographical circumstances.

11 Proctor, *Transits of Venus*, 16–17. See also Forbes, *The Transit of Venus*, 8–9; and Grant, *The Transits of Venus in 1874*.

12 Proctor, *Transits of Venus*, 17

13 Grant, *The Transits of Venus in 1874*, 52. In 1716, Edmund Halley published a paper on the benefits of observing the Transit of Venus for the determination of solar parallax. Solar parallax was essential for measuring the distance of the Earth from the Sun, or the solar unit. The solar unit is the base for which all other distance calculations in the universe are made. An exact measurement of the distance between the Earth and the Sun was therefore the central concern of the observations of the Transit in the eighteenth and nineteenth centuries. In his article, Halley argued that Mercury—although it passes the Sun more regularly than Venus—is unsuited to the determination of parallax because it was too far from the earth, and therefore the variation in the observed position of the planet on the face of the Sun would be negligible. Halley's discussion of the Transit is represented in Proctor, *Transits of Venus*, 35 where it is quoted from Ferguson's translation of Halley; James Ferguson, *A Plain Method of Determining the Parallax of Venus: By Her Transit over the Sun: And from Thence, by Analogy, the Parallax and Distance of the Sun, and of All the Rest of the Planets* (London: Mr. Miller, Mr. Nairne & Mr. Watkins, 1761).

14 According to Woolf, the 1761 Transit was witnessed by 120 observers from sixty-two stations, and in 1769 it was witnessed by 138 observers from sixty-three stations. Only fifteen of those stations were the same in both years. Harry Woolf, *The Transits of Venus, a Study of Eighteenth-Century Science* (Princeton, NJ: Princeton University Press, 1959), 21.

15 Hawaii played an important role in the histories of Transit observation in both the eighteenth and nineteenth centuries. For a discussion of the organization, interaction, and importance of the 1874 Transit observations in Hawaii, see Michael Chauvin, *Hōkūloa. The British 1874 Transit of Venus Expedition to Hawai'i* (Honolulu: Bishop Museum Press, 2004).

16 Proctor, *Transits of Venus*, 76–77; and Grant, *The Transits of Venus in 1874*, 69.

17 Ratcliff, *The Transit of Venus Enterprise*, 3.

18 Although the black drop is also a central concern during the 1769 Transit, and thereby necessitated the observation of Venus in 1874, Proctor deals primarily with the black drop in his section on the 1761 Transit.

19 Grant, *The Transits of Venus in 1874*, 57–58.

20 See Allan Chapman, "Airy, Sir George Biddell (1801–1892)" in *Oxford Dictionary of National Biography*, online edn, ed. Lawrence Goldman (Oxford: Oxford University Press, 2004). http://www.oxforddnb.com/view/article/251 (accessed March 30, 2011).

21 Proctor, *Transits of Venus*, 76–77; and Grant, *The Transits of Venus in 1874*, v.

22 Proctor was elected as secretary of the RAS in 1872 but resigned the post shortly after returning from the 1874 Transit due to his criticisms of George Biddle Airy, the Royal Astronomer and President of the Royal Society at the time. Roger Hutchins, "Proctor, Richard Anthony (1837–1888)" in *Oxford Dictionary of National Biography*, online edn, ed. Lawrence Goldman (Oxford: Oxford University Press, 2004). http://www.oxforddnb.com/view/article/22838 (accessed March 30, 2011).

23 Proctor had lost all his money and went £13,000 into debt after the collapse of the New Zealand Bank in 1866. Hutchins, "Proctor, Richard Anthony."

24 Illustrations 5.1–5.5 and 5.7–5.11 have been separated onto individual pages, as they would have been read in the respective spaces on which they were printed. The sizes of the images have been reproduced as closely as possible to that of the original reproductions.

25 For more on the serialization of images in print, see Chapter 4.

26 Proctor, *Transits of Venus*, vii.

27 For a discussion of the implications of scientific controversy in the periodical press and the use of images in the production and solution of these controversies, see Chapter 2.

28 R.A. Proctor, "The Transits of Venus in 1874 and 1882," *Nature*, 1, no. 25 (April 21, 1870): 627.

29 Hutchins, "Proctor, Richard Anthony." For a further discussion of the Proctor-Lockyer rivalry, see Pang, *Empire and the Sun*, 30 and 53.

30 The constitution of the solar corona was the same issue which Brothers, in Chapter 2, was trying to solve with his photographs in 1871.

31 The debate over human versus mechanistic observation is a very important issue in the history of photography in general and photographic astronomy in particular. Some of the issues of concern for drawing center on notions of accuracy, replication, and comparability. These issues have been dealt with very well by Rothermel, "Images of the Sun"; and Pang's, *Empire and the Sun*, chapter 3 on "Drawing the Corona." Also see the recent work by Omar W. Nasim, *Observing by Hand: Sketching the Nebulae in the Nineteenth Century* (Chicago, IL: University of Chicago Press, 2014).

32 The Bakerian lecture is a yearly lecture by a fellow of the Royal Society on a discovery or particularly relevant issue relating to science. This lecture was later published in the *Philosophical Transactions*.

33 Warren De la Rue, "The Bakerian Lecture: On the Total Solar Eclipse of July 18, 1860, Observed at Rivabellosa, Near Miranda de Ebro, in Spain," *Philosophical Transactions of the Royal Society of London*, 152 (January 1, 1862): 407.

34 Private letter from Warren De la Rue to George Airy, undated, Cambridge University Library, GBR/0180/RGO/6/123/284.

35 In 1860, De la Rue would not have been able to take photographs much shorter than a one-second exposure. However, his use of the term "instantaneous" infers a belief in the photographic camera's ability to capture time. For a deeper discussion of the relationship of time and the photograph, and specifically De la Rue's later work in electric discharges, see Chapter 4.

36 Pang argues that the eclipse expeditions starting in 1860 and continuing until the 1874 Transit were crucial sites for training in observational technique for those who would observe the Transit. Pang, *Empire and the Sun*, 22.

37 In fact, Airy was much more of an organizer than he was an observer. Due to his low visual acuity (Airy wore glasses most of his life), his ability to make observations was limited. His interest in the use of instruments to augment astronomical observation is clear when examining his tenure as Royal Astronomer at Greenwich. A good discussion of Airy's focus on instrumentation is contained in Meadows, *Science and Controversy*. For discussions of Airy's observational limitations and the way in which he perceived the value of observational technique, see Alan Chapman, *The Victorian Amateur Astronomer. Independent Astronomical Research in Britain 1820–1920* (Chichester: Praxis Publishing Ltd, 1998); and Elizabeth Green Musselman, *Nervous Conditions. Science and the Body Politic in Early Industrial Britain* (New York: State University of New York, 2006).

38 Rothermel, "Images of the Sun," 149.

39 Cambridge University Library, RGO 6/119/508-9.

40 David Stone, "Dallmeyer, John Henry (1830–1883) & Thomas Ross (1859–1906)" in *Encyclopedia of Nineteenth Century Photography*, ed. John Hannavy (London: Routledge, 2008), 376.

41 Ratcliff, *The Transit of Venus Enterprise*, 63.

42 For a discussion of Woolf, see Canales, "A Tenth of a Second," 88. Also see Ratcliff, *The Transit of Venus Enterprise*, 85, and Chauvin, *Hōkūloa*, 53.

43 See for instance *Nature*, 3, no. 62 (January 5, 1871): 197. See also Chapter 3 for a discussion of the ways in which the Siege of Paris during the Franco-Prussian War created a specific use of photography, articulated through the periodical press, as a technology of communication.

44 The spectroscope was a technology entering the large observatories at the same time as the photographic departments were being set up, and there is a close correlation between the ways in which they were seen as technologies that allowed astronomers to gain visual data of the Sun, invisible to the human eye. In Greenwich, the solar photographic department was first established in 1873, and then later in the decade, spectroscopy was added to the department. E. Walter Maunder, *The Royal Observatory Greenwich* (London: Religious Tract Society, 1900), 112–113.

45 In an article in *Nature* two years after the discovery, an anonymous author pointed to the importance of Janssen and Lockyer's use of spectroscopy for removing the need to wait for an eclipse to observe the atmosphere of the sun. *Nature*, 1, no. 24 (April 14, 1870): 599. The author continued to point out that solar eclipse observations were still necessary to solve the question of the solar corona of the Sun, which was a key concern for astronomers such as Alfred Brothers, whose photographs of the solar corona are reproduced in Illustrations 2.8 and 2.9. This letter was later reproduced in the *English Mechanic*, 61, no. 415 (March 7, 1873): 600–601.

46 The use of spectroscopy for the Transit was proposed to the scientific community first in the *Times* and later in *Nature*, shortly after the observations for the 1874 Transit were made. See the reproduction of the *Times* article in *Nature*, 11, no. 270 (December 31, 1874): 171–173.

47 For Proctor's article, see R.A. Proctor, "Solar Protuberances," *English Mechanic*, 61, no. 410 (January 31, 1873): 479.

48 For a discussion of the reproduction techniques used to display spectroscopic plates in the periodical press, see Klaus Hentschel, *Mapping the Spectrum. Techniques of Visual Representation in Research and Teaching* (Oxford: Oxford University Press, 2002), chapters 4 and 5.

49 Norman Lockyer, "The Recent Total Eclipse of the Sun," *Nature*, 1, no. 1 (November 4, 1869): 12–13.

50 Hentschel, *Mapping the Spectrum*, has noted that the first spectrum to be reproduced photomechanically was that of Henry Draper, an American photographer and spectroscopist, in 1874. Similar to the images reproduced by Lockyer, Draper's spectral photographs moved between periodical spaces. See Henry Draper, "On Diffraction Spectrum Photography," *Nature*, 9, no. 221 (January 22, 1874): 224–226. Hentschel also notes that the period between 1870 and 1885 was a "transitional period" for spectrum reproduction in print.

51 See Hentschel's, *Mapping the Spectrum* for a discussion of the importance of self-registry in photography and spectroscopy (189), as well as his analysis of the use of "from a photograph" in the spectroscopic images of Frank McClean (238).

52 While this chapter is fundamentally concerned with the serial organization of images, there is a connection between the work of Janssen, E.J. Marey (see Chapter 4) and the Lumière Brothers which is discussed elsewhere. Specifically, see Jimena Canales' discussion of Janssen's development of his photographic revolver, and the importance of this to serial images and particularly cinematography: Jimena Canales, "Photogenic Venus: The 'Cinematographic Turn' and Its Alternatives in Nineteenth-Century France," *Isis*, 93, no. 4 (December 2002): 585–613.

53 C. Flammarion, "Le Passage du Venus," *La Nature*, 3rd year, 1st semester, 4, no. 101 (May 10, 1875): 356–358.

54 Jules Janssen, "Présentation du Revolver Photographique et d'Epreuves obtenues avec cet Instrument," *Bulletin de la Société Française de Photographie*, xxii (1876): 100–102. Françoise Launay and Peter Hingley, "Jules Janssen's 'Revolver Photographique' and Its British Derivative, 'The Janssen Slide'," *JHA*, 36 (2005): 62–63.

55 Canales, "Photogenic Venus," 603.

56 See Launay and Hingley, "Jules Janssen's 'Revolver Photographique'," for a discussion of the adoption of Janssen's device in England, and specifically page 70 for a list of remaining Janssen plates.

57 One of the other reasons why the Janssen photographs may not have been used was that the photographs from Honolulu using this device were misaimed and only showed half of Venus. Chauvin, *Hōkūloa*, 115.

58 "Photographic Observations of the Transit of Venus," *Graphic*, 11, no. 270 (January 30, 1875): 102.

59 Ibid.

60 Chauvin, *Hōkūloa*, reproduces in his book the positives of these same moments of contact. See figures 54 and 55, page 114.

61 See Ratcliff, *The Transit of Venus Enterprise*; Pang, *Empire and the Sun*; and Rothermel, "Images of the Sun."

62 Rothermel, "Images of the Sun," 164.

63 Forbes' articles in *Nature* were reproduced in a book, discussed previously, entitled *The Transit of Venus*. The book was published as part of Macmillan's "Nature Series," which included short books made out of content previously published in *Nature*. Illustration 5.19 was further reproduced by Forbes in his book and acted as the frontispiece. Forbes, *The Transit of Venus*, frontispiece.

64 James McGrath, "Forbes, George (1849–1936)" in *Oxford Dictionary of National Biography*, online edn, ed. Lawrence Goldman (Oxford: Oxford University Press, 2004). http://www.oxforddnb.com/view/article/31937 (accessed April 5, 2011).

65 For a discussion of Forbes practicing at Greenwich, see Chauvin, *Hōkūloa*, 50–54.

66 Ratcliff, *The Transit of Venus Enterprise*, 80–81.

67 Pang, *Empire and the Sun*, 15.

68 Derek Howse, *Greenwich Observatory: Volume 3, The Buildings and Instruments* (London: Taylor & Francis, 1975).

69 *Graphic*, 9, no. 239 (June 27, 1874): 610.

70 Pang, *Empire and the Sun*, 37.

71 Ibid., 13.

72 On this point, see Chapman, *The Victorian Amateur Astronomer*; John Lankford, "Amateurs and Astrophysics: A Neglected Aspect in the Development of a Scientific Specialty," *Social Studies of Science*, 11 (August 1981): 275–303; and John Lankford, "Photography and the 19th-Century Transits of Venus," *Technology and Culture*, 28, no. 3 (July 1987): 648–657.

73 See also Chapter 2 for the ways in which scientific controversy was carried out through the periodical press.

74 John North, "The Leisure Hour" in *Waterloo Directory of English Newspapers and Periodicals, 1800–1900*, online edn, ed. John North (Waterloo, ON: North Waterloo Academic Press, 1997). http://www.victorianperiodicals.com (accessed December 13, 2008).

75 For a discussion of the history of reproductive technologies, see Gascoigne, *How to Identify Prints*.

Conclusion

1 Richard Altick, *The English Common Reader: A Social History of the Mass Reading Public, 1800–1900* (Chicago, IL: University of Chicago Press, 1957); and Aileen Fyfe and Bernard Lightman, *Science in the Marketplace: Nineteenth-Century Sites and Experiences* (Chicago, IL: University of Chicago Press, 2007).

2 Hardy, *Two on a Tower*, 202. This is repeated from the introduction to this book.

3 For discussions about the "realism" of photography, or the indexicality of an image (the ability of a photograph to truthfully represent the subject in the picture), see Tagg, *The Burden of Representation*; John Tagg, *The Disciplinary Frame: Photographic Truths and the Capture of Meaning* (Minneapolis: University of Minnesota Press, 2009); and James Elkins, *Photography Theory* (New York: Routledge, 2007).

4 For work on Victorian visual culture and photography, see Walter Benjamin, "The Work of Art in the Age of Mechanical Reproduction" in *Illuminations*, ed. Hannah Arendt, trans. Harry Zorn (London: Pimlico, 1999), 211–244; James Elkins, *The Domain of Images* (Ithaca, NY: Cornell University Press, 1999); M.J.S. Rudwick, "The Emergence of a Visual Language for Geological Science 1760–1840," *History of Science*, 14, no. 3 (September 1976): 149–195; M.J.S. Rudwick, *Scenes from Deep Time: Early Pictorial Representations of the Prehistoric World* (Chicago, IL: University of Chicago Press, 1992); Smith, *Charles Darwin and Victorian Visual Culture*; Pinney, *Camera Indica*; Edwards, *Raw Histories*; Tucker, *Nature Exposed*; Prodger, *Time Stands Still*; and Green-Lewis, *Framing the Victorians*.

5 Lightman, *Victorian Popularizers of Science*; and Tuner, *Contesting Cultural Authority*.

6 Cantor et al., *Science in the Nineteenth-Century Periodical*; Cantor and Shuttleworth, *Science Serialized*; and Henson et al., *Culture and Science*.

7 Altick, *The Shows of London*, 395.

8 Ibid., 394.

9 Hardy, *Two on a Tower*, 202.

BIBLIOGRAPHY

Museum collections

Iris & B. Gerald Cantor Center for Visual Arts, Stanford University.
Papers of Charles Wheatstone, Archives of King's College London.
Royal Observatory Greenwich.
Science Museum, London.
Sidney M. Markham Collection of Muybridge Prints, Tulane University, Latin American
 Library.

Manuscript collections

Diary of Lady Anne Blunt, *British Library*, W MSS (283B) Add 53817–54061.
Archives of George Biddle Airy, *Cambridge University Library*, GBR/0180/RGO/6.

Periodicals

Aberdeen Weekly Journal
Amateur Photographer
Astronomical Register
Bulletin de la Société Française de Photographie
Dundee Courier & Argus and Northern Warder
English Mechanic
Graphic
Illustrated London News
Illustrated Photographer
Journal of the Photographic Society
Knowledge
La Nature
Le Charivari
Leisure Hour
Magazine of Art
Manchester Times

Nature
Pall Mall Gazette
Philosophical Transactions of the Royal Society
Photographic Art Journal
Punch, or the London Charivari
Scientific American

Primary sources

Baldwin, Thomas. *Airopeaidia: Containing the Narrative of a Balloon Excursion from Chester, the Eighth of September, 1785, Taken from Minutes Made during the Voyage*. London: J. Fletcher, 1786.

Collins, Charles. *The Hand-Book of Photography: Illustrating the Process of Producing Pictures by the Chemical Influence of Light on Silver, Glass, Paper, and Other Surfaces/ to Which Is Added an Appendix Containing Full Instructions for the Preparation of, and Mode of Using, the Chemicals and Other Substances Employed*. London: C.W. Collins, 1853.

Ferguson, James. *A Plain Method of Determining the Parallax of Venus: by Her Transit over the Sun: and from Thence, by Analogy, the Parallax and Distance of the Sun, and of All the Rest of the Planets*. London: Mr. Miller, Mr. Nairne & Mr. Watkins, 1761.

Forbes, George. *The Transit of Venus: By George Forbes*. London: Macmillan and Co., 1874.

Glaisher, James et al. *Travels in the Air*. London: Richard Bentley, 1871.

Grant, Robert. *The Transits of Venus in 1874*. Glasgow: J. Maclehose, 1874.

Hardy, Thomas. *Two on a Tower*, edited by Sally Shuttleworth. London: Penguin Books, 1999.

Hunt, Robert. *Photography: A Treatise on the Chemical Changes Produced by Solar Radiation, and the Production of Pictures from Nature, by the Daguerreotype, Calotype, and Other Photographic Processes*. London: John J. Griffin & Co., 1851.

Lockyer, Norman. *Stargazing: Past and Present*. London: Macmillan & Co., 1878.

Marey, E. J. *Animal Mechanism: A Treatise on Terrestrial and Aerial Locomotion*. London: Henry S. King & Co., 1874.

Marey, E. J. *La Machine Animale: Locomotion Terrestre et Aérienne*. Paris: Librairie Germer Baillière, 1873.

Maunder, Walter E. *The Royal Observatory Greenwich*. London: Religious Tract Society, 1900.

Muybridge, Eadweard. *Animal Locomotion. An Electro-photographic Investigation of Consecutive Phases of Animal Movements. 1872–1885*. Philadelphia: University of Pennsylvania, 1887.

Muybridge, Eadweard. *The Attitudes of Animals in Motion: A Series of Photographs Illustrating the Consecutive Positions Assumed by Animals in Performing Various Movements*. San Francisco, CA: Muybridge, 1881.

Muybridge, Eadweard. *Descriptive Zoopraxography, or, The Science of Animal Locomotion Made Popular*. Philadelphia: University of Pennsylvania, 1893.

Muybridge, Eadweard. *The Human Figure in Motion an Electro-photographic Investigation of Consecutive Phases of Muscular Actions*, 6th edn, London: Chapman & Hall, 1901.

Pritchard, H. Baden. *Beauty Spots of the Continent*. London: Tinsley Brothers, 1875.

Pritchard, H. Baden. *The Photographic Studios of Europe*. London: Piper & Carter, 1882.

Proctor, R. A. *Transits of Venus. A Popular Account of Past and Coming Transits*. London: Longmans, Green, and Co., 1874.

Talbot, Henry Fox. *The Pencil of Nature*. London: Longman, Brown & Green, 1844.

Thomson, John. *Illustrations of China and Its People. A Series of Two Hundred Photographs, with Letterpress Descriptive of the Places and People Represented*. London: S. Low, Marston, Low, and Searle, 1873.

Thomson, John. *The Land and the People of China: A Short Account of the Geography, History, Religion, Social Life, Arts, Industries, and Government of China and Its People*. London: Society for the Promotion of Christian Knowledge, 1876.

Thomson, John. *The Straits of Malacca, Indo-China and China; or, Ten years' Travels, Adventures and Residence Abroad*. London: S. Low, 1875.

Thomson, John. *Through Cyprus with the Camera in the Autumn of 1878*. London: Trigraph, 1985.

Tissandier, Gaston. *A History and Handbook of Photography*. London: Sampson Low, Marston, Low & Searle, 1876.

Vogel, Hermann. *The Chemistry of Light and Photography in Its Application to Art, Science, and Industry*. London: King, 1875.

Secondary sources

Altick, Richard. *The English Common Reader: A Social History of the Mass Reading Public, 1800–1900*. Chicago: University of Chicago Press, 1957.

Altick, Richard. *The Shows of London*. Cambridge, MA: Belknap Press of Harvard University Press, 1978.

Archer, Rosemary. "Blunt, Anne Isabella Noel, suo jure Baroness Wentworth (1837–1917)." In *Oxford Dictionary of National Biography*, online edn, edited by Lawrence Goldman. Oxford: Oxford University Press, 2004. http://www.oxforddnb.com/view/article/31937 (accessed March 30, 2011).

Archer, Rosemary and James Fleming. *Lady Anne Blunt, Journals and Correspondence 1878–1917*. Cheltenham: Alexander Heriot & Co., 1986.

Bacot, Jean-Pierre. *La Presse Illustrée au XIXe Siècle: Une Histoire Oubliée*. Limoges: Presses Universitaires de Limoges, 2005.

Baldwin, Melinda. *Making Nature: The History of a Scientific Journal*. Chicago: University of Chicago Press, 2015.

Bann, Stephen. *Distinguished Images: Prints and the Visual Economy in Nineteenth Century France*. New Haven, CT: Yale University Press, 2013.

Bann, Stephen. *Parallel Lines: Printmakers, Painters and Photographers in Nineteenth-Century France*. New Haven, CT: Yale University Press, 2001.

Barloon, Jim. "Star-Crossed Love: The Gravity of Science in Hardy's *Two on a Tower*." *The Victorian Newsletter* (Fall 1998): 27–32.

Barthes, Roland. *Camera Lucida*. New York: Hill and Wang, 1980.

Barthes, Roland. *Image, Music, Text*, translated by Steven Heath. London: Flamingo, 1984.

Barton, Ruth. "Scientific Authority and Scientific Controversy in *Nature*: North Britain against the X Club." In *Culture and Science in Nineteenth-Century Media*, edited by Louise Henson and Geoffrey Cantor et al., 223–235 Aldershot: Aldgate, 2004.

Bear, Jordan. *Disillusioned: Victorian Photography and the Discerning Subject*. Philadelphia: Penn State University Press, 2015.

Bear, Jordan. "Index Marks the Spot? The Photo-Diagram's Referential System." *Philosophy of Photography*, 2, no. 2 (2011): 325–344.

Beegan, Gerry. *The Mass Image: A Social History of Photomechanical Reproduction in Victorian London*. Basingstoke: Palgrave Macmillan, 2008.

Beetham, Margaret. "Towards a Theory of the Periodical as a Publishing Genre." In *Investigating Victorian Journalism*, edited by Laurel Brake et al., 19–32. Basingstoke: Macmillan, 1990.

Béguet, Bruno. *La Science Pour Tous. Sur la Vulgarisation Scientifique en France de 1850 à 1914*. Paris: Bibliothèque Du Conservatoire National Des Arts et Métiers, 1990.

Belknap, Geoffrey. "Through the Looking Glass: Photography, Science and Imperial Motivations in John Thomson's Photographic Expeditions." *History of Science*, 52, no. 1 (2014): 73–97.

Benjamin, Marina. "Sliding Scales: Microphotography and the Victorian Obsession with the Minuscule." In *Cultural Babbage. Technology, Time and Invention*, edited by Francis Spufford and Jenny Uglow, 99–122. London: Faber & Faber, 1996.

Benjamin, Walter. "Little History of Photography." In *Walter Benjamin Selected Writings*, vol. 2 (1927–1934), edited by Michael W. Jennings, 507–530. Cambridge, MA: Belknap/Harvard University Press, 1999.

Benjamin, Walter. "The Work of Art in the Age of Mechanical Reproduction." In *Illuminations*, edited by Hannah Arendt, translated by Harry Zorn, 211–244. London: Pimlico, 1999.

Benson, Richard. *The Printed Picture*. New York: Museum of Modern Art, 2008.

Bills, Mark. "Thomas, William Luson (1830–1900)." In *Oxford Dictionary of National Biography*, online edn, edited by Lawrence Goldman. Oxford: Oxford University Press, 2004. http://www.oxforddnb.com/view/article/27248 (accessed March 30, 2011).

Bofarull, Salvador. *Pigeon Mail through History*. Stuart Rossiter Fund: London, 2001.

Brake, Laurel. "Writing, Cultural Production, and the Periodical Press in the Nineteenth Century." In *Writing and Victorianism*, edited by J.B. Bullen, 54–72. London: Longman, 1997.

Braun, Marta. *Eadweard Muybridge*. London: Reaktion Books Ltd, 2010.

Braun, Marta. *Picturing Time—The Work of Étienne-Jules Marey (1830–1904)*. Chicago: University of Chicago Press, 1992.

Bredekamp, Horst. "A Neglected Tradition? Art History as *Bildwissenschaft*." *Critical Inquiry*, 29, no. 3 (Spring 2003): 418–428.

Bredekamp, Horst, Brigit Schneider et al. *Das Technische Bild. Kompendium zu einer Stilgeschichte wissenschaftlicher Bilder*. Berlin: Akademie Verlag, 2008.

Brookman, Philip. *Eadweard Muybridge*. London: Tate Publishing, 2010.

Brusius, Mirjam. "From Photographic Science to Scientific Photography: Talbot and Decipherment at the British Museum around 1850." In *William Henry Fox Talbot. Beyond Photography*, edited by Mirjam Brusius, Katrina Dean and Chitra Ramalingam, 219–244. New Haven and London: Yale University Press, 2013.

Brusius, Mirjam. "Inscription in a Double Sense: The Biography of an Early Scientific Photograph of Script." *Nuncius*, 24, no. 2 (2009): 367–392.

Burbridge, David. "Galton's 100: An Exploration of Francis Galton's Imagery Studies." *BJHS*, 27 (1994): 443–463.

Canales, Jimena. "Photogenic Venus: The "Cinematographic Turn" and Its Alternatives in Nineteenth-Century France." *Isis*, 93, no. 4 (December 2002): 585–613.

Canales, Jimena. *A Tenth of a Second—A History*. Chicago: Chicago University Press, 2009.

Cantor, Geoffrey and Sally Shuttleworth. *Science Serialized. Representations of the Sciences in Nineteenth-Century Periodicals.* Cambridge, MA: The MIT Press, 2004.

Cantor, Geoffrey, Gowan Dawson et al. *Science in the Nineteenth-Century Periodical: Reading the Magazine of Nature.* Cambridge: Cambridge University Press, 2004.

Chapman, Allan. "Airy, Sir George Biddell (1801–1892)." In *Oxford Dictionary of National Biography*, online edn, edited by Lawrence Goldman. Oxford: Oxford University Press, 2004. http://www.oxforddnb.com/view/article/251 (accessed March 30, 2011).

Chapman, Allan. *The Victorian Amateur Astronomer. Independent Astronomical Research in Britain 1820–1920.* Chichester: Praxis Publishing Ltd, 1998.

Chauvin, Michael. *Hōkūloa. The British 1874 Transit of Venus Expedition to Hawai'i.* Honolulu: Bishop Museum Press, 2004.

Chua, Liana and Mark Elliot. *Distributed Objects: Meaning and Matter after Alfred Gell.* New York: Berghahn Books, 2013.

Coe, Brian. *Cameras: From Daguerreotypes to Instant Pictures.* London: Marshall Cavendish, 1978.

Crary, Jonathan. *Techniques of the Observer.* Cambridge, MA: The MIT Press, 1990.

Crosland, Maurice. "Science in the Franco-Prussian War." *Social Studies of Science*, 6, no. 2 (May 1976): 185–214.

Csiszar, Alex. "Seriality and the Search for Order: Scientific Print and Its Problems in the Late Nineteenth Century." *History of Science*, 48, no. 161 (December 2010): 399–434.

Curtis, Verna Posever. "Page by Page: The Album as Object." In *Photographic Memory: The Album in the Age of Photography*, edited by Verna Posever Curtis, 6–13. New York: Aperture, 2011.

Darius, Jon. *Beyond Vision.* Oxford: Oxford University Press, 1984.

Daston, Lorraine and Peter Galison. "The Image of Objectivity." *Representations* (Autumn 1992): 81–128.

Daston, Lorraine and Peter Galison. *Objectivity.* New York: Zone Books, 2007.

Daumier, Honoré-Victorin. "Nadar, Élevant la Photographie Á la Hauteur de L'Art." In *Daumier. 120 Great Lithographs*, edited by Charles F. Ramus, #102. New York: Dover Publications Inc., 1978.

Dawson, Gowan et al. "Introduction." In *Science in the Nineteenth-Century Periodical: Reading the Magazine of Nature*, edited by Geoffrey Cantor et al., 1–36. Cambridge: Cambridge University Press, 2004.

De Lorenzo, Catherine. "Tissandier, Gaston (1843–1899)." In *Encyclopedia of Nineteenth Century Photography*, edited by John Hannavy, 1393–1394. London: Routledge, 2008.

Desmond, Adrian. *The Politics of Evolution. Morphology, Medicine, and Reform in Radical London.* Chicago: University of Chicago Press, 1989.

Dewitt, Anne. "'The Actual Sky Is a Horror': Thomas Hardy and the Arnoldian Conception of Science." *Nineteenth-Century Literature*, 26, no. 4 (March 2007): 479–506.

Di Bello, Patrizia. *Women's Albums and Photography in Victorian England: Ladies, Mothers and Flirts.* London: Ashgate Publishing, 2007.

Edgerton, David. *The Shock of the Old. Technology and Global History since 1900.* London: Profile Books, 2008.

Edwards, Elizabeth. "Photography and the Sound of History." *Visual Anthropology Review*, 21, nos. 1, 2 (Spring/Fall 2005): 27–46.

Edwards, Elizabeth. *Raw Histories, Photographs, Anthropology and Museums.* Oxford: Berg, 2001.

Edwards, Steve. *The Making of English Photography: Allegories.* Philadelphia: The Pennsylvania State University Press, 2006.

Elkins, James. "Art History and Images That Are Not Art." *The Art Bulletin*, 77, no. 4 (December 1995): 553–571.

Elkins, James. *The Domain of Images*. Ithaca, NY: Cornell University Press, 1999.

Elkins, James. *Photography Theory*. New York: Routledge, 2007.

Ellenbogen, Josh. *Reasoned and Unreasoned Images: The Photography of Bertillon, Galton, Marey*. Philadelphia: Pennsylvania State University Press, 2012.

Fox, Celina. *Graphic Journalism in England during the 1830s and 1840s*. New York: Garland, 1988.

Frizot, Michel. *A New History of Photography*, translated by Susan Bennett. Koln: Konemann, 1998.

Fyfe, Aileen and Bernard Lightman. *Science in the Marketplace: Nineteenth-Century Sites and Experiences*. Chicago: University of Chicago Press, 2007.

Gascoigne, Bamber. *How to Identify Prints, A Complete Guide to Manual and Mechanical Processes from Woodcut to Inkjet*. London: Thames & Hudson, 2002.

Gell, Alfred. *Art and Agency: An Anthropological Theory*. Oxford: Clarendon Press, 1998.

Gernsheim, Helmut. *The History of Photography from the Camera Obscura to the Beginning of the Modern Era*. London: Thames & Hudson, 1969.

Gervais, Thierry. "D'apres Photographie. Premiers Usages de la Photographie dans le Journal *L'Illustration* (1843–1859)." *Etudes Photographiques*, 13 (July 2003): 56–85.

Gossin, Pamela. *Thomas Hardy's Novel Universe: Astronomy, Cosmology, and Gender in the Post-Darwinian World*. Aldershot: Ashgate, 2007.

Green, David. "Veins of Resemblance: Photography and Eugenics." *Oxford Art Journal*, VII (1984): 3–16.

Green-Lewis, Jennifer. *Framing the Victorians: Photography and the Culture of Realism*. Ithaca, NY: Cornell University Press, 1996.

Green Musselman, Elizabeth. *Nervous Conditions. Science and the Body Politic in Early Industrial Britain*. New York: State University of New York, 2006.

Gretton, Tom. "The Pragmatics of Page Design in Nineteenth-Century General-Interest Weekly Illustrated News Magazines in London and Paris." *Art History*, 33, no. 4 (September 2010): 680–709.

Hannavy, John. "Brothers, Alfred (1826–1912)." In *Encyclopedia of Nineteenth Century Photography*, edited by John Hannavy, 222. London: Routledge, 2008.

Hannavy, John. "Royal Photographic Society." In *Encyclopedia of Nineteenth Century Photography*, edited by John Hannavy, 1220–1221. London: Routledge, 2008.

Harding, Colin. *Classic Cameras*. Lewes: Photographer's Institute, 2009.

Henchman, Anna. *The Starry Sky Within: Astronomy and the Reach of the Mind in Victorian Literature*. Oxford: Oxford University Press, 2014.

Hendricks, Gordon. *Eadweard Muybridge: The Father of the Motion Picture*. New York: Grossman Publishers, 1975.

Henkin, David M. *The Postal Age. The Emergence of Modern Communication in Nineteenth-Century America*. Chicago: University of Chicago Press, 2006.

Henson, Louise et al. *Culture and Science in the Nineteenth-Century Media*. Aldershot: Ashgate, 2004.

Hentschel, Klaus. *Mapping the Spectrum. Techniques of Visual Representation in Research and Teaching*. Oxford: Oxford University Press, 2002.

Hildebrant, A. *Balloons and Airships*, translated by W.H. Story. Wakefield, Yorkshire: EP Publishing Limited, 1973.

Hoffmann, Cristoph. "Constant Differences: Friedrich Wilhelm Bessel, the Concept of the Observer in Early Nineteenth-Century Practical Astronomy and the History of the Personal Equation." *BJHS*, 40, no. 3 (2007): 333–365.

Hopwood, Nick et al. "Seriality and Scientific Objects in the Nineteenth Century." *History of Science*, 48, no. 161 (December 2010): 251–285.

Howse, Derek. *Greenwich Observatory: Volume 3, The Buildings and Instruments*. London: Taylor & Francis, 1975.

Hunt, Bruce J. *The Maxwellians*. Ithaca, NY: Cornell University Press, 1991.

Hutchins, Roger. "Proctor, Richard Anthony (1837–1888)." In *Oxford Dictionary of National Biography*, online edn, edited by Lawrence Goldman. Oxford: Oxford University Press, 2004. http://www.oxforddnb.com/view/article/22838 (accessed March 30, 2011).

Ivins, William M. *How Prints Look: An Illustrated Guide*. London: Murray, 1998.

Ivins, William M. *Prints and Visual Communication*. Cambridge, MA: The MIT Press, 1969.

James, Harumi. "*Two on a Tower*: Science and Religion, Space and Time." *Hardy Review*, 2 (Summer 1999): 141–156.

Jay, Elizabeth. *Mrs. Oliphant: "A Fiction to Herself" A Literary Life*. Oxford: Clarendon Press, 1995.

John, Steven F. "Désiré Van Monckhoven (1834–1882)." In *Encyclopedia of Nineteenth Century Photography*, edited by John Hannavy, 1438–1439. London: Routledge, 2008.

Jussim, Estelle. *Visual Communication and the Graphic Arts: Photographic Technologies in the Nineteenth-Century*. New York: R.R. Bowker, 1983.

Kelsey, Robin and Blake Stimson. "Introduction: Photography's Double Index (A short History in Three Parts)." In *The Meaning of Photography*, edited by Robin Kelsey and Blake Stimson, xvii–xxxi. Williamstown, MA: Sterling and Francine Clark Art Institute, 2008.

Kern, Stephen. *The Culture of Time and Space 1880–1918*. London: Weidenfeld and Nicolson, 1983.

Kjaergaard, Peter. "'Within the Bounds of Science': Redirecting Controversies to *Nature*." In *Culture and Science in the Nineteenth Century Media*, edited by Louise Henson et al., 211–221. Aldershot: Aldgate, 2004.

Knight, David M. *The Age of Science: The Scientific World-View in the Nineteenth Century*. Oxford: Basil Blackwell, 1986.

Lankford, John. "Amateurs and Astrophysics: A Neglected Aspect in the Development of a Scientific Specialty." *Social Studies of Science*, 11 (August 1981): 275–303.

Lankford, John. "Photography and the 19th-Century Transits of Venus." *Technology and Culture*, 28, no. 3 (July 1987): 648–657.

Latour, Bruno. "Drawing Things Together." In *Representation in Scientific Practice*, edited by Michael Lynch and Steve Woolgar, 19–68. Cambridge, MA: The MIT Press, 1990.

Latour, Bruno. *Pandora's Hope. Essays on the Reality of Science Studies*. Cambridge, MA: Harvard University Press, 1999.

Launay, Françoise and Peter Hingley. "Jules Janssen's 'Revolver Photographique' and Its British Derivative, 'The Janssen Slide'." *Journal for the History of Astronomy*, 36 (2005): 57–79.

Liddy, Brian. "Warren De La Rue." In *Encyclopedia of Nineteenth Century Photography*, edited by John Hannavy, 394. London: Routledge, 2008.

Lightman, Bernard. *Victorian Popularizers of Science*. Chicago: University of Chicago Press, 2007.

MacDonnell, Kevin. *Eadweard Muybridge: The Man Who Invented the Moving Picture*. Boston, MA: Little, Brown & Co., 1972.

MacLeod, Roy M. "A Note on Nature and the Social Significance of Scientific Publishing, 1850–1914." *Victorian Periodicals Newsletter*, 1, no. 3 (November 1968): 16–17.

MacLeod, Roy M. "Science in Grub Street." *Nature*, 224, no. 5218 (November 1 1969): 423–461.

Maidment, Brian. *Reading Popular Prints, 1790–1870*. Manchester: Manchester University Press, 1996.

Mayer, Andreas. "The Physiological Circus: Knowing, Representing, and Training Horses in Motion in Nineteenth-Century France." *Representations III* (Summer 2010): 88–120.

Mazzolini, Renato G. *Non-Verbal Communication in Science Prior to 1900*. Florence: Leo S. Olschki, 1993.

McConnell, Anita. "Woodbury, Walter Bentley (1834–1885)." In *Oxford Dictionary of National Biography*, online edn, edited by Lawrence Goldman. Oxford: Oxford University Press, 2004. http://www.oxforddnb.com/view/article/29906 (accessed June 5, 2011).

McGrath, James. "Forbes, George (1849–1936)." In *Oxford Dictionary of National Biography*, online edn, edited by Lawrence Goldman. Oxford: Oxford University Press, 2004. http://www.oxforddnb.com/view/article/31937 (accessed April 5, 2011).

Meadows, A. J. *Science and Controversy. A Biography of Sir Norman Lockyer*. London: Macmillan, 1972.

Mitchell, W. J. T. *Iconography. Image, Text, Ideology*. Chicago: University of Chicago Press, 1986.

Morus, Iwan Rhys. *Frankenstein's Children: Electricity, Exhibition, and Experiment in Early Nineteenth-Century London*. Princeton, NJ: Princeton University Press, 1998.

Morus, Iwan Rhys. "Seeing and Believing Science." *Isis*, 97, no. 1 (March 2006): 101–110.

Morus, Iwan Rhys. *When Physics Became King*. Chicago: University of Chicago Press, 2005.

Mumford, Lewis. *Technics and Civilization*. New York: Harcourt, Brace & World, Inc., 1934.

Mussell, James. "Arthur Cowper Ranyard, *Knowledge* and the Reproduction of Astronomical Photographs in the Late Nineteenth-Century Periodical Press." *BJHS*, 42, no. 153 (September 2009): 345–380.

Mussell, James. *Science, Time and Space in the Late Nineteenth-Century Periodical Press. Movable Types*. Aldershot: Ashgate, 2007.

Nasim, Omar W. *Observing by Hand: Sketching the Nebulae in the Nineteenth Century*. Chicago: University of Chicago Press, 2014.

Natale, Simone. "Photography and Communication Media in the Nineteenth Century." *History of Photography*, 36, no. 4 (2012): 451–456.

Nead, Lynda. *The Haunted Gallery. Painting, Photography, Film c. 1900*. New Haven, CT: Yale University Press, 2007.

Newhall, Beaumont. *The History of Photography from 1839 to the Present Day*. New York: Museum of Modern Art, 1949.

Noakes, Richard. "*Punch* and Comic Journalism in Mid-Victorian Britain." In *Science in the Nineteenth-Century Periodical: Reading the Magazine of Nature*, edited by Geoffrey Cantor et al., 91–124. Cambridge: Cambridge University Press, 2004.

North, John. "Atlantic Monthly Magazine, The." In *Waterloo Directory of English Newspapers and Periodicals, 1800–1900*, online edn, edited by John North. Waterloo, ON: North Waterloo Academic Press, 1997. http://www.victorianperiodicals.com (accessed April 26, 2011).

North, John. "Leisure Hour, The." In *Waterloo Directory of English Newspapers and Periodicals, 1800–1900*, online edn, edited by John North. Waterloo, ON: North Waterloo Academic Press, 1997. http://www.victorianperiodicals.com (accessed December 13, 2008).

Pang, Alex Sun Jung-Kim. *Empire and the Sun, Victorian Solar Eclipse Expeditions.* Stanford, CA: Stanford University Press, 2002.

Pfeiffer, K. Ludwig. "The Materiality of Communication." In *Materialities of Communication*, edited by Hans Ulrich Gumbrecht and K. Ludwig Pfeiffer, 1–12. Stanford, CA: Stanford University Press, 1994.

Pinney, Christopher. *Camera Indica: The Social Life of Indian Photographs.* London: Reaktion, 1997.

Pritchard, Michael. "Henry Baden Pritchard." In *Encyclopedia of Nineteenth Century Photography*, edited by John Hannavy, 1175–1176. London: Routledge, 2008.

Prodger, Phillip. *Time Stands Still: Muybridge and the Instantaneous Photography Movement.* Oxford: Oxford University Press, 2003.

Qureshi, Sadiah. *Peoples on Parade. Exhibitions, Empire, and Anthropology in Nineteenth-Century Britain.* Chicago: University of Chicago Press, 2011.

Ramalingam, Chitra. "Natural History in the Dark: Seriality and the Electric Discharge in Victorian Physics." *History of Science*, 48, no. 161 (December 2010): 371–398.

Ratcliff, Jessica. *The Transit of Venus Enterprise in Victorian Britain.* London: Pickering & Chatto, 2008.

Remus, Charles. *Daumier. 120 Great Lithographs.* New York: Dover Publications Inc., 1978.

Roos, David A. "The 'Aims and Intentions' of *Nature*." In *Victorian Science and Victorian Values: Literary Perspectives*, edited by James Paradis and Thomas Postlewait, 159–180. New Brunswick, NJ: Rutgers University Press, 1981.

Rothermel, Holly. "Images of the Sun: Warren de La Rue, George Biddle Airy and Celestial Photography." *British Journal of the History of Science*, 26, no. 2 (1993): 137–169.

Rudwick, M. J. S. "The Emergence of a Visual Language for Geological Science 1760–1840." *History of Science*, 14, no. 3 (September 1976): 149–195.

Rudwick, M. J. S. *Scenes from Deep Time: Early Pictorial Representations of the Prehistoric World.* Chicago: University of Chicago Press, 1992.

Ryan, James. *Picturing Empire: Photography and the Visualization of the British Empire.* Chicago: University of Chicago Press, 1997.

Said, Edward. *Orientalism.* New York: Vintage Books, 1979.

Schaffer, Simon. "Astronomers Mark Time: Discipline and the Personal Equation." *Science in Context*, 2 (1988): 115–145.

Secord, James A. "Knowledge in Transit." *Isis*, 95, no. 4 (December 2004): 654–672.

Secord, James A. "Scrapbook Science: Composite Caricatures in Late Georgian England." In *Figuring It Out. Science, Gender, and Visual Culture*, edited by Ann B. Shteir and Bernard Lightman, 164–191. Hanover, NH: Dartmouth College Press, 2006.

Seiberling, Grace and Carolyn Bloore. *Amateurs, Photography, and the Mid-Victorian Imagination.* Chicago: University of Chicago Press, 1986.

Sera-Shriar, Efram. *The Making of British Anthropology, 1813–1871.* London: Pickering and Chatto, 2013.

Shattock, Joanne and Michael Wolfe. *The Victorian Periodical Press: Samples and Soundings.* Leicester: Leicester University Press, 1982.

Shawcross, Nancy M. "Nadar (Gaspard-Felix Tournachon) (1820–1910)." In *Encyclopedia of Nineteenth Century Photography*, edited by John Hannavy, 971–974. London: Routledge, 2008.

Siegert, Bernhard. *Relays. Literature as an Epoch of the Postal System*, translated by Kevin Repp. Stanford, CA: Stanford University Press, 1999.

Sinnema, Peter. *Dynamics of the Pictured Page: Representing the Nation in the Illustrated London News.* Aldershot: Ashgate, 1998.

Smith, Jonathan. *Charles Darwin and Victorian Visual Culture*. Cambridge: Cambridge University Press, 2006.

Snellen, H. A. *E.J. Marey and Cardiology: Physiologist and Pioneer of Technology. Selected Writings in Facsimile with Comments and Summaries, a Brief History of Life and Work, and a Bibliography*. Rotterdam: Kooyker, 1980.

Snyder, Joel. *American Frontiers. The Photographs of Timothy H. O'Sullivan, 1867–1874*. New York: Aperture, 1981.

Snyder, Joel. "Visualization and Visibility." In *Picturing Science, Producing Art*, edited by Caroline A. Jones and Peter Galison et al., 379–400 New York: Routledge, 1998.

Solnit, Rebecca. *Motion Studies. Time, Space & Eadweard Muybridge*. London: Bloomsbury, 2003.

Sontag, Susan. *On Photography*. New York: Picador, 1973.

Stewart, Susan. *On Longing. Narratives of the Miniature, the Gigantic, the Souvenir, the Collection*. Durham: Duke University Press, 1994.

Stone, David. "Dallmeyer, John Henry (1830–1883) & Thomas Ross (1859–1906)." In *Encyclopedia of Nineteenth Century Photography*, edited by John Hannavy, 376. London: Routledge, 2008.

Tagg, John. *The Burden of Representation, Essays on Photographies and Histories*. Minneapolis: University of Minnesota Press, 1988.

Tagg, John. *The Disciplinary Frame: Photographic Truths and the Capture of Meaning*. Minneapolis: University of Minneapolis Press, 2009.

Thomas, Alan. "Authenticity and Charm: The Revival of Victorian Photography." *Victorian Studies*, 10, no. 1 (September 1974): 103–111.

Thomas, Ann. *Beauty of Another Order: Photography in Science*. New Haven: Yale University Press, 1997.

Thompson, E. P. "Time, Work-Discipline and Industrial Capitalism." In *Customs in Common, 352–403*. New York: The New York Press, 1993.

Topham, John, "Scientific Publishing and the Reading of Science in Nineteenth-Century Britain: A Historiographic Survey and Guide to Sources." *Studies in History and Philosophy of Science Part A* 31, no. 4 (2000): 559–612.

Topham, John. "Technicians of Print and the Making of Natural Knowledge." *Studies in History and Philosophy of Science* 35, no. 2 (2004): 391–400.

Tucker, Jennifer. *Nature Exposed: Photography as Eyewitness in Victorian Science*. Baltimore: Johns Hopkins University Press, 2005.

Tucker, Jennifer. "Voyages of Discovery on Oceans of Air: Scientific Observation and the Image of Science in an Age of 'Balloonacy.'" *Osiris*, 11, no. 2, Science in Field (1996): 144–176.

Turner, Frank. *Contesting Cultural Authority*. Cambridge: Cambridge University Press, 1993.

von Brevern, Jan. "Resemblance after Photography." *Representations*, 123, no. 1 (Summer 2013): 1–22.

Voskuil, Lynn M. *Acting Naturally: Victorian Theatricality and Authenticity*. Charlottesville: University of Virginia Press, 2004.

Watts, Iain P. "'We Want No Author': William Nicholson and the Contested Role of the Scientific Journal in Britain, 1797–1813." *BJHS*, 47, no. 174 (2014): 397–419.

Wawro, Geoffrey. *The Franco-Prussian War. The German Conquest of France in 1870–1871*. Cambridge: Cambridge University Press, 2003.

Webb, K. R. "Meldola, Raphael (1849–1915)." In *Oxford Dictionary of National Biography*, online edn, edited by Lawrence Goldman. Oxford: Oxford University Press, 2004. http://www.oxforddnb.com/view/article/37755 (accessed June 6, 2011).

Wilder, Kelley. *Photography and Science*. London: Reaktion Books Ltd, 2009.
Woolf, Harry. *The Transits of Venus, A Study of Eighteenth-Century Science*. Princeton, NJ: Princeton University Press, 1959.
Yeo, Richard. *Defining Science. William Whewell, Natural Knowledge and Public Debate in Early Victorian Britain*. Cambridge: Cambridge University Press, 1993.

Unpublished theses

Brusius, Mirjam. "Preserving the Forgotten. William Henry Fox Talbot, Photography, and the Antique." PhD diss., University of Cambridge, 2011.
Csiszar, Alex. "Broken Pieces of Fact: The Scientific Periodical and the Politics of Search in Nineteenth-Century France and Britain." PhD diss., Harvard University, 2010.
Ramalingam, Chitra. "A Science of Appearances: Vision, Visualization and Experimental Physics in Victorian England." PhD diss., Harvard University, 2009.

INDEX

For Product Safety Concerns and Information please contact our EU
representative GPSR@taylorandfrancis.com
Taylor & Francis Verlag GmbH, Kaufingerstraße 24, 80331 München, Germany